Advanced AutoCAD 2015

EXERCISE WORKBOOK

OFFICIALLY WITHDRAWN

by
Cheryl R. Shrock
Professor, retired
Drafting Technology
Orange Coast College, Costa Mesa, Ca.
Autodesk Authorized Author

Updated for AutoCAD 2015
by
Steve Heather
Former Lecturer of
Mechanical Engineering &
Computer Aided Design

INDUSTRIAL PRESS

Industrial Press Inc.
32 Haviland Street, Unit 2C
South Norwalk, CT. 06854

10 9 8 7 6 5 4 3 2 1

Many thanks are due to Cheryl Shrock for allowing me to continue on with her Exercise Workbook series. And special thanks to John Carleo, Editorial Director of Industrial Press, for having faith in me.

Steve Heather

AutoCAD Books by Cheryl R. Shrock:

Beginning AutoCAD **2011**....................ISBN 978-0-8311-3416-7
Advanced AutoCAD **2011**....................ISBN 978-0-8311-3417-4

Beginning AutoCAD **2012**....................ISBN 978-0-8311-3430-3
Advanced AutoCAD **2012**....................ISBN 978-0-8311-3431-0

Beginning AutoCAD **2013**....................ISBN 978-0-8311-3456-3
Advanced AutoCAD **2013**....................ISBN 978-0-8311-3457-0

Beginning AutoCAD **2014**....................ISBN 978-0-8311-3473-0
Advanced AutoCAD **2014**....................ISBN 978-0-8311-3474-7

Beginning AutoCAD **2015**....................ISBN 978-0-8311-3497-6
Advanced AutoCAD **2015**....................ISBN 978-0-8311-3499-0

AutoCAD Pocket Reference
5th Edition, Releases 2011/2012............ISBN 978-0-8311-3428-0

AutoCAD Pocket Reference
6th Edition, Releases 2013/2014............ISBN 978-0-8311-3484-6

For information about these books visit: www.industrialpress.com

Table of Contents

Lesson 5

Lesson 6

Lesson 7

Lesson 8

Lesson 13

Lesson 14

Lesson 15

Lesson 16

Lesson 17

Lesson 18

Lesson 19

Lesson 20

Lesson 21

Lesson 22

Projects
Architectural
Electro-Mechanical
Mechanical

Appendix

Index

INTRODUCTION

About this workbook

This workbook is designed to <u>follow</u> the ***Beginning** AutoCAD 2015,* **Exercise Workbook**. It is excellent for classroom instruction or self-study. There are 22 lessons and 3 *on-the-job* type projects in Architectural, Electro-Mechanical and Mechanical. Lessons 1 thru 14 continue your education in basic 2D commands.
Lessons 15 thru 22 introduce you to many basic 3D commands.

Each lesson starts with step-by-step instructions followed by exercises designed for practicing the commands you learned within that lesson. The *on-the-job* projects are designed to give you more practice in your desired field of drafting.

Important
The files **2015-Workbook-Helper** and **2015-3D Demo** should be downloaded from our website:

http://new.industrialpress.com/ext/downloads/acad/2015-3d-demo.zip

Enter the address into your web browser and the download will start automatically.

AutoCAD 2015 vs. AutoCAD LT 2015

The LT version of AutoCAD has approximately 80 percent of the capabilities of the full version. It was originally created to be installed on the small hard drives that Laptops used to have. Hence, the name LT. (LT does not mean "Lite") In order to reduce the size of the program AutoCAD removed some of the high-end capabilities, such as Solid Modeling. As a result, some of the commands may not be available to LT users. Consider this an opportunity to see the commands that you are missing and you can determine if you feel it necessary to upgrade.

About the Authors

Cheryl R. Shrock is a retired Professor and was Chairperson of Computer Aided Design at Orange Coast College in Costa Mesa, California. She is also an Autodesk® registered author. Cheryl began teaching CAD in 1990. Previous to teaching, she owned and operated a commercial product and machine design business where designs were created and documented using CAD. This workbook is a combination of her teaching skills and her industry experience.

Steve Heather is a former Lecturer of Mechanical Engineering and Computer Aided Design in England, UK. For the past 5 years he has been a Beta Tester for Autodesk®, testing the latest AutoCAD® software. Previous to teaching and for more than 30 years, he worked as a Precision Engineer in the Aerospace and Defense industries.

Steve can be contacted for questions or comments at: *steve.heather@live.com*

CONFIGURING YOUR SYSTEM

Note: If you have already configured your system for the 2015 "Beginning" Workbook you may skip to Lesson 1.

AutoCAD ® allows you to customize it's configuration. While you are using this workbook it is necessary for you to make some simple changes to your configuration so our configurations are the same. This will ensure that the commands and exercises work as expected. The following instructions will guide you through those changes.

1. Start AutoCAD®

2. Type: ***options*** then press the **<enter>** key. (not case sensitive)

 The text that you type will appear in the Dynamic Input box, as shown below

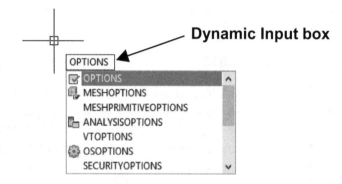

NOTE:

AUTOCAD LT USERS:
You may find that some of the settings appear slightly different.
But they are mostly the same.

Configuration Settings

3. Select the *Display* tab and change the settings on your screen to match the dialog box below.

You may select different colors for your display

4. Select the *Open and Save* tab and change the settings on your screen to match the dialog box below.

Configuration Settings

5. Select the *Plot and Publish* tab and change the settings on your screen to match the dialog box below.

You may use this setting or select the actual name of the printer

6. Select the *System* tab and change the settings on your screen to match the dialog box below.

Configuration Settings

7. Select the *User Preferences* tab and change the settings on your screen to match the dialog box below.

Rt-click Cust.
Select this
button and
change the
settings
shown below

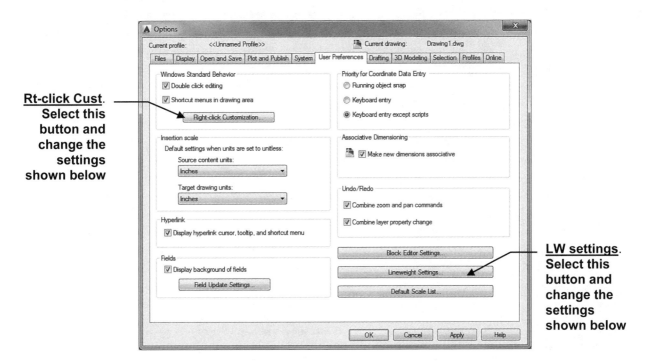

LW settings.
Select this
button and
change the
settings
shown below

8. After making the setting changes shown below select **Apply & Close** button.

Right-click Customization

Lineweight Settings

Configuration Settings

9. Select the *Drafting* tab and change the settings on your screen to match the dialog box below.

10. Select the *Selection* tab and change the settings on your screen to match the dialog box below. (Note: 3D Modeling tab was skipped)

Configuration Settings

11. Select the **Apply** button.

12. Select the **OK** button.

13. Now you should be back to the AutoCAD screen.

AutoCAD 2015 System Requirements for 32-bit

Description	Requirement
Operating System	• Microsoft Windows 7® Enterprise • Microsoft Windows 7® Ultimate • Microsoft Windows 7® Professional • Microsoft Windows 7® Home Premium • Microsoft Windows 8/8.1® • Microsoft Windows 8/8.1® Pro • Microsoft Windows 8/8.1® Enterprise
Browser	Internet Explorer® 9.0 or later
Processor	Intel Pentium 4 or AMD Athlon™ Dual Core, 3.0 GHz or Higher with SSE2 technology
Memory	2 GB RAM (3 GB Recommended)
Display Resolution	1024 x 768 (1600 x 1050 or higher recommended) with True Color
Disk Space	Installation 6.0 GB
Pointing Device	MS-Mouse Compliant
Media	Download and installation from DVD
.NET Framework	.NET Framework 4.5
Additional requirements for large datasets, point clouds, and 3D modeling	Intel Pentium 4 processor or AMD Athlon™, 3.0 GHz or greater or Intel or AMD Dual Core processor, 2.0 GHz or greater 3 GB RAM 6 GB free hard disk available not including installation requirements 1280 x 1024 True color video display adapter 128 or greater, Pixel Shader 3.0 or greater, Direct3D® capable workstation class graphics card Note: 64-bit operating systems are recommended if you are working with large datasets, point clouds and 3D Modeling - please refer to the AutoCAD 2015 64-bit System Requirements on the next page

Continued on the next page...

AutoCAD 2015 System Requirements for 64-bit

Description	Requirement
Operating System	• Microsoft Windows 7® Enterprise • Microsoft Windows 7® Ultimate • Microsoft Windows 7® Professional • Microsoft Windows 7® Home Premium • Microsoft Windows 8/8.1® • Microsoft Windows 8/8.1® Pro • Microsoft Windows 8/8.1® Enterprise
Browser	Internet Explorer® 9.0 or later
Processor	AMD Athlon™ 64 with SSE2 technology AMD Opteron™ with SSE2 technology Intel Xeon® with Intel EM64T support and SSE2 technology Intel Pentium® 4 with Intel EM64T support and SSE2 technology
Memory	2 GB RAM (8 GB Recommended)
Display Resolution	1024 x 768 (1600 x 1050 or higher recommended) with True Color
Disk Space	Installation 6.0 GB
Pointing Device	MS-Mouse Compliant
Media	Download and installation from DVD
.NET Framework	.NET Framework 4.5
Additional requirements for 3D modeling	8 GB RAM or more 6 GB free hard disk available not including installation requirements 1280 x 1024 True color video display adapter 128 or greater, Pixel Shader 3.0 or greater, Direct3D® capable workstation class graphics card

Customizing your Wheel Mouse

A Wheel mouse has two or more buttons and a small wheel between the two topside buttons. The default functions for the two top buttons and the Wheel are as follows:
Left Hand button is for **input** and can't be reprogrammed.
Right Hand button is for **Enter** or the **shortcut menu**.
The Wheel may be used to <u>Zoom and Pan</u> or <u>Zoom and display</u> the Object Snap menu.
You will learn more about this later.

The following describes how to select the Wheel functions. After you understand the functions, you may choose to change the setting.
To change the setting you must use the **MBUTTONPAN** variable.

MBUTTONPAN setting 1: (Factory setting)

ZOOM Rotate the wheel forward to zoom in
 Rotate the wheel backward to zoom out

ZOOM Double click the wheel to view entire drawing
EXTENTS

PAN Press the wheel and drag the mouse to move the drawing on the screen.

MBUTTONPAN setting 0:

ZOOM Rotate the wheel forward to zoom in
 Rotate the wheel backward to zoom out

OBJECT Object Snap menu will appear when you press the wheel
SNAP

To change the setting:

1. Type: **mbuttonpan <enter>**
2. Enter **0** or **1 <enter>**

Command Line **Dynamic Input**

LEARNING OBJECTIVES

After completing this lesson you will be able to:

1. Open Multiple Drawings.
2. Easily switch from one open drawing to another.
3. Test your current AutoCAD skills.
4. Plot from Model Space.

Note:
*This lesson should be used to determine whether or not you are ready for this level of instruction. If you have difficulty creating Exercises 1A, 1B and 1C you should consider reviewing the "**Exercise Workbook for Beginning AutoCAD 2015**" before going on to Lesson 2.*

LESSON 1

OPEN MULTIPLE FILES

The **File Tabs** tool allows you to have multiple drawings open at the same time. If the File Tabs tool is switched on, you can open existing saved drawings or create new ones.

The **File Tabs** tool is located on the **Interface** panel of the **View** tab, and is a Neon Blue color when switched on.

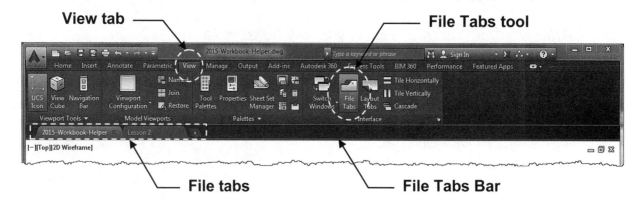

View tab ——

File Tabs tool

File tabs

File Tabs Bar

How to open an existing saved drawing from the File Tabs

1. Right mouse click on the '**+**' icon.

2. Select **Open** from the menu.

3. Locate the Directory and Folder for the previously saved file.

4. Select the File you wish to open.

5. Select the **Open** button.

OPEN MULTIPLE FILES....continued

How to open a new drawing from the Files Tab.

1. Right mouse click on the '**+**' icon. (Refer to page 1-2)

2. Select **Drawing Template (*.dwt)** from the **Files of type** drop-down list.

3. Select the Template you require.

4. Select the **Open** button.

Note:
If you right mouse click on any **File Tab** a menu appears with various options, including closing all open drawing tabs except the one you just clicked on.

You can also select a **New Tab** page where you can access online resources and the **Learn** and **Create** pages. You can also left mouse click on the '**+**' icon to access the **New Tab** page.

OPEN MULTIPLE FILES....continued

The File Tabs drawing previews allow you to quickly change between open drawings. If you hover your mouse over any open File Tab, a preview of the Model and the Layout tabs are displayed. You can click on any of the previews to take you to that particular open drawing or view.

Hover the mouse over any File Tab to see a preview of the Model and Layout Tabs

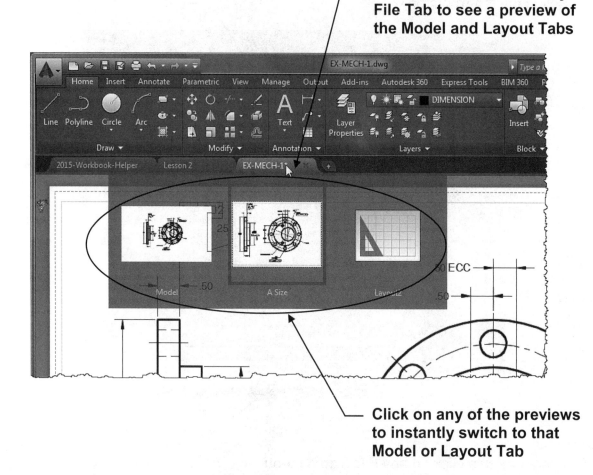

Click on any of the previews to instantly switch to that Model or Layout Tab

If an asterisk is displayed on a file Tab it means that particular drawing has not been saved since it was last modified. The asterisk will disappear when the drawing has been saved.

These two drawings are showing the asterisk and have not been saved

WARM UP DRAWINGS

The following drawings have been included for two purposes:

<u>First purpose:</u> To make sure you remember the commands taught in the Beginning Workbook and to get you prepared for the new commands in this Advanced Workbook.

<u>Second purpose:</u> To confirm that you are ready for this level of instruction.

IMPORTANT, PLEASE READ THE FOLLOWING:

*This workbook assumes you already have enough basic AutoCAD knowledge to easily complete Exercises 1A, 1B and 1C. If you have difficulty with these exercises, you should consider reviewing "**Exercise Workbook for <u>Beginning</u> AutoCAD**". If you try to continue without this knowledge you will probably get confused and frustrated. It is better to have a good solid understanding of the basics before going on to Lesson 2.*

PRINTING
Exercises 1A, 1B and 1C should be printed from Model space on any letter size printer. Instructions are on page 1– 9.

EXERCISE 1A

INSTRUCTIONS:
1. Start a **NEW** file using **2015-Workbook Helper.dwt** (Refer to Intro-1)
2. Draw the objects below using layers Object Line and Centerline.
3. Do not dimension
4. Save as **EX1A**
5. Plot using the instructions on page 1-9

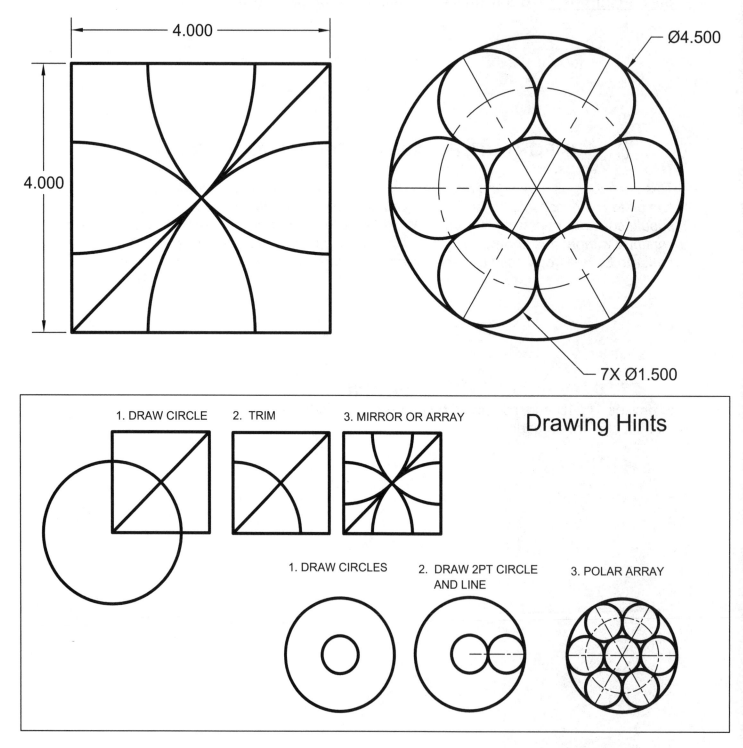

EXERCISE 1B

INSTRUCTIONS:
1. Start a NEW file using **2015-Workbook Helper.dwt** (Refer to Intro-1)
2. Draw the objects below using layer Object Line
3. Do not dimension
4. Save as **EX1B**
5. Plot using the instructions on page 1-9

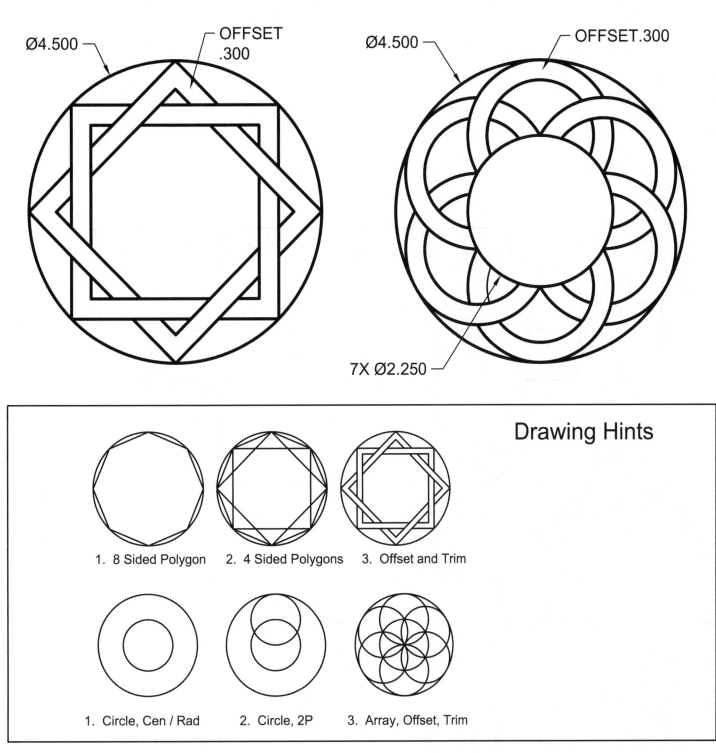

Ø4.500 OFFSET .300

Ø4.500 OFFSET.300

7X Ø2.250

Drawing Hints

1. 8 Sided Polygon 2. 4 Sided Polygons 3. Offset and Trim

1. Circle, Cen / Rad 2. Circle, 2P 3. Array, Offset, Trim

EXERCISE 1C

INSTRUCTIONS:

1. Start a **NEW** file using **My Decimal Setup.dwt** (from the Beginning workbook)
2. Draw the objects below using layers Object Line, Centerline and Dimension
3. Dimension using: Dim-Decimal.
4. Save as **EX1C**
5. Plot using the instructions on page 1-9

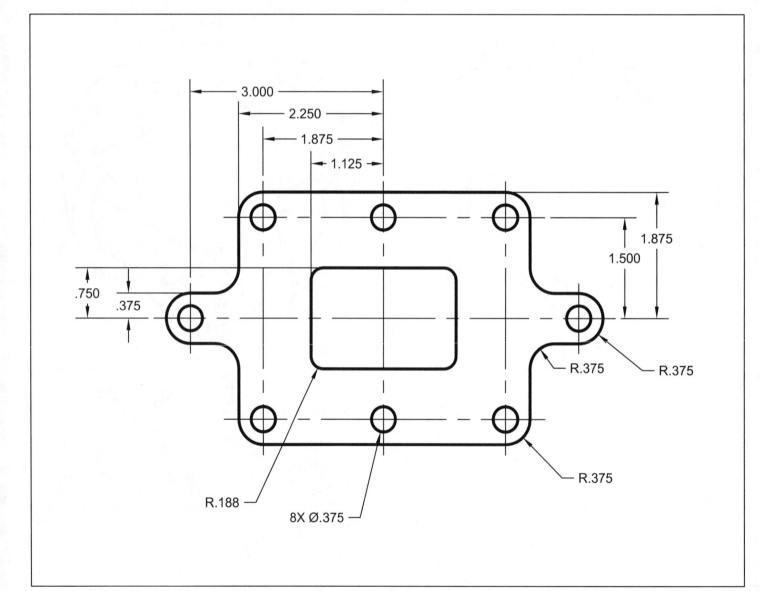

Basic Plotting from Model Space

1. **Important:** Open the drawing you want to plot.
2. Select: **Zoom / All** to center the drawing within the plot area.
3. Select the **Plot** command using one of the following;

 Quick Access toolbar =

 Ribbon = Output tab / Plot Panel /

 Keyboard = Plot <enter>

The Plot –Model dialog box will appear.

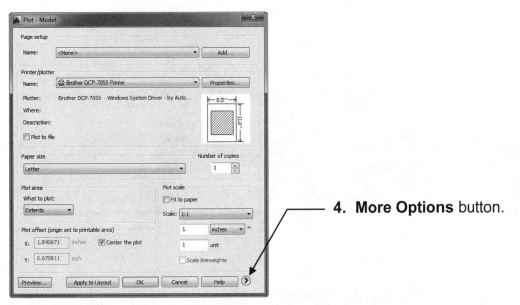

4. **More Options** button.

4. Select the **"More Options"** button to expand the dialog box.

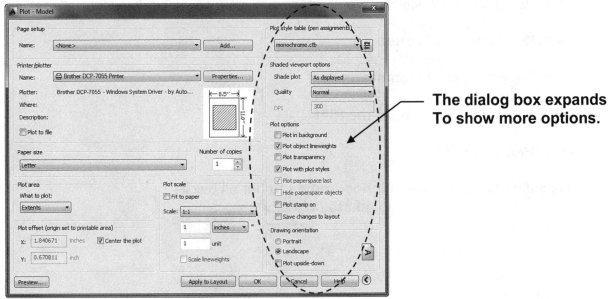

The dialog box expands
To show more options.

Continued on the next page...

Plotting from Model Space....continued

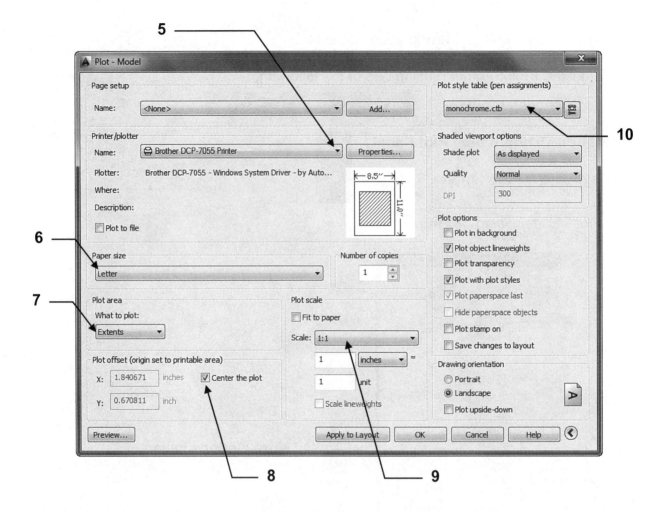

5. Select your printer from the drop down list or "Default windows system printer.pc3"
 Note: If your printer is not shown in the list you should configure your printer within AutoCAD. This is not difficult. Refer to Appendix-A for step by step instructions.

6. Select the Paper size: **Letter**

7. Select the Plot Area: **Extents**

8. Select the Plot Offset: **Center the Plot**

9. Select Plot Scale: **1:1**

10. Select the Plot Style table: **Monochrome.ctb** (for all black)
 Acad.ctb (for color)

Continued on the next page...

Plotting from Model Space....continued

11. If the following dialog box appears, select **Yes**

12. Select the **Preview** button.

Does your display appear as shown below?
If yes, press **<enter>** and proceed to 13.
If not, recheck 1 through 11.

Continued on the next page...

Plotting from Model Space....continued

13. Select the **Apply to Layout** button.

13 ——— 14

14. Select the **OK** button to send the drawing to the printer or <u>select Cancel if you do not want to print the drawing at this time. The Page Setup will still be saved.</u>

15. Save the entire drawing again. The Plot settings will be saved to the drawing.

LEARNING OBJECTIVES

After completing this lesson, you will be able to:

1. Customize the Workspace
2. Customize the Ribbon
3. Customize the Status Bar
4. Customize the Quick Access Toolbar
5. Select, Export, Import and Delete a Workspace

LESSON 2

Customizing the Workspace

At this stage of your AutoCAD education you are probably not too interested in customizing AutoCAD. But I would like to at least introduce you to the **Custom User Interface** to familiarize you with a few of the customizing options that are available. It is relatively easy to use and sometimes helpful. If you find it intriguing you may explore further using the AutoCAD "Help" system discussed in Lesson 1 in the Beginning workbook.

Start by opening the **Customize User Interface** dialog box using one of the following:

RIBBON = MANAGE TAB / CUSTOMIZATION PANEL /

KEYBOARD = CUI

The following dialog box should appear.

Continued on the next page...

Creating a New Workspace

Have you found yourself wishing that you could move some of the commands from one Ribbon Panel to another? Or possibly Add, Remove or Move the Tabs. Well you can. You can create a **Workspace** all of your own very easily.

Important: Before you begin customizing your workspace it is important to create a **Duplicate Workspace** rather than modify an existing workspace. This will allow you to revert back to the original AutoCAD default workspace appearance.

Don't be afraid to experiment. I will also show you how to easily return to the AutoCAD default workspace.

1. Open the **Customize User Interface** dialog box as shown on the previous page.

2. Duplicate the **Drafting & Annotation** workspace as follows:
 A. Right click on **Drafting & Annotation** and select **Duplicate.**

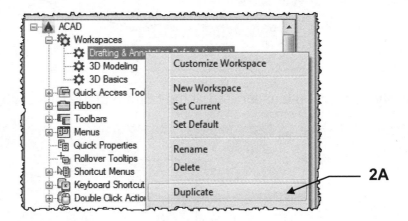

3. Rename the duplicate workspace as follows:
 A. Right click on **Copy of Drafting & Annotation 1** and select **Rename**.

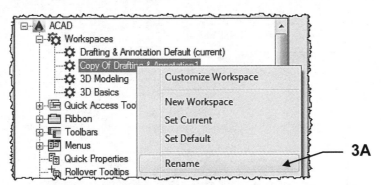

4. Enter the New Workspace name **Class Workspace Demo** <enter>

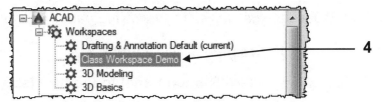

Continued on the next page...

Creating a New Workspace....continued

5. Right Click on the New Workspace **Class Workspace Demo** and select **Set current**.

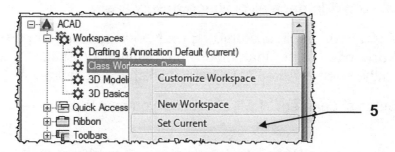

6. The New Workspace should now be displayed as shown below.

6.
Note: Your list may appear in a different order.

7. Select **Apply** and **OK** buttons located at the bottom of the CUI dialog box.

Now you have a workspace to customize. The following pages will guide you through:

1. **Creating a new Ribbon tab.**

2. **Adding a new Ribbon Panel to the new tab.**

3. **Adding Commands to the new Panel.**

Create a Ribbon tab

1. Open the Customize User Interface dialog box (Refer to page 2-2)

2. Select **Class Workspace Demo**

3. Click on the **[+]** beside Ribbon to expand.

4. Right Click on <u>**Tabs**</u>

5. Select **New Tab**

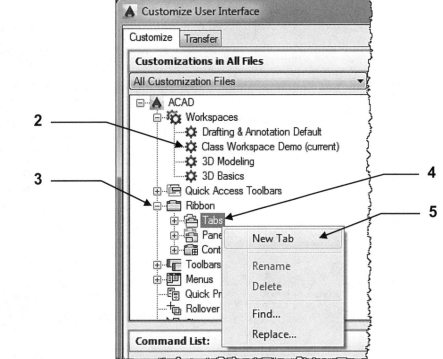

6. Enter a name for the new tab and press **<enter>**. (Note: I entered **Class Tab**)

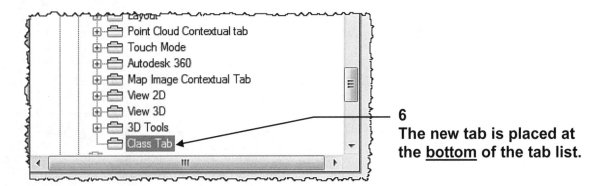

6

The new tab is placed at the <u>bottom</u> of the tab list.

7. Select the **Apply** and then **OK** button at the bottom of the Customize User Interface box.

<u>**Note:**</u>
New Tabs are not automatically added to the workspace.
You must tell AutoCAD that you want to display this new tab in your workspace.
Follow the steps on the following page to "<u>Add a Ribbon Tab to a Workspace</u>".

Add a Ribbon Tab to a Workspace

1. Open the Customize User Interface dialog box (Refer to page 2-2)

2. Select **Class Workspace Demo**

3. Click on **Customize Workspace** button. (It will change to **Done**)

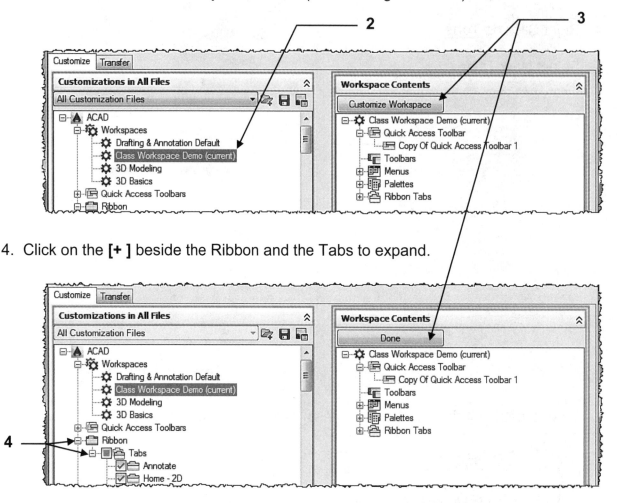

4. Click on the **[+]** beside the Ribbon and the Tabs to expand.

5. Scroll down the list of tabs and click the check box beside the **Class Tab**.

Continued on the next page...

Add a Ribbon Tab to a Workspace....continued

Notice the **Class tab** was added to the **Workspace Contents** also.

6. Click on the **Done** button.

7. Select the **Apply** and **OK** button.

The New Tab should now appear in the Ribbon.

8. Select the **Class Tab**

Notice no Panels are displayed.
Now you may
Add Panels to the New Tab.
Refer to the next page for instructions.

Add a Ribbon Panel to a tab

1. Open the Customize User Interface dialog box. (Refer to page 2-2)

2. Select **Class Workspace Demo**

3. Select the **[+]** beside **Ribbon** to expand.

4. Select the **[+]** beside **Tabs** to expand.

5. Select the **[+]** beside **Panels** to expand.

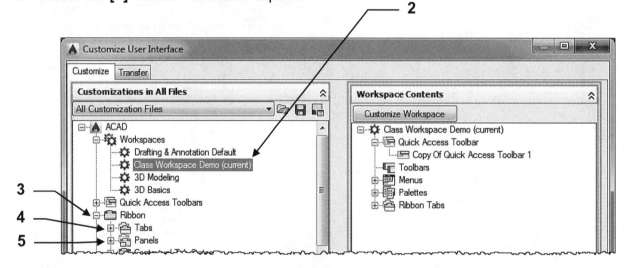

6. Scroll down the list of Panels and select the one you wish to add to the tab.

7. **Right click** on the **Panel** and select **Copy**. from the menu.

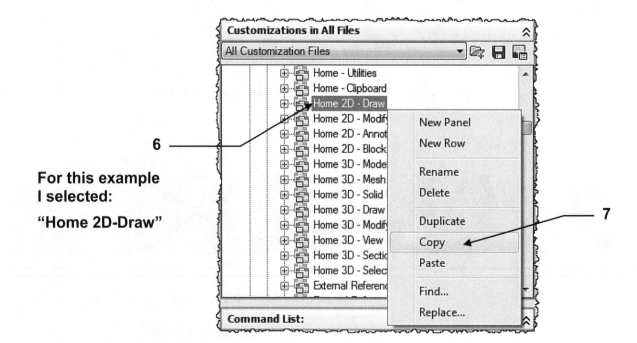

**For this example
I selected:**

"Home 2D-Draw"

Continued on the next page...

Add a Ribbon Panel to a tab....continued

8. Scroll up and find the Tab to which you wish to add the panel.

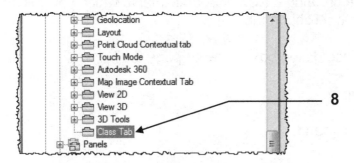

9. **Right Click** on the **Tab name** and select **Paste.**

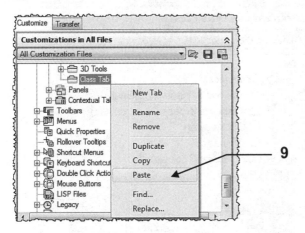

10. The Panel should now be listed under **Class Tab**

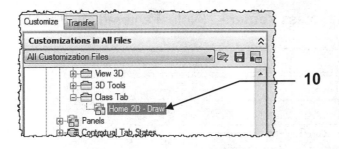

11. Select **Apply** and **OK** buttons located at the bottom of the Customize User Interface box.

12. Select the **Class Tab**. (The added Panel should appear)

Create a New Ribbon Panel

The previous page showed you how to add an **existing** Ribbon Panel to a tab.
The following will guide you through creating a New Ribbon Panel to which you will add commands and then you will add it to a Ribbon tab.

1. Open the Customize User Interface dialog box (Refer to page 2-2)

2. Select **Class Workspace Demo**

3. Select the **[+]** beside **Ribbon** to expand.

4. Right Click on **Panels**

5. Select **New Panel**

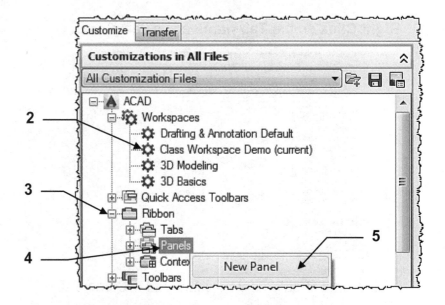

6. Enter a name for the new panel and press **<enter>**. (Note: I entered **My Panel**)

7. Select **Apply** and **OK** buttons.

You will now add commands to the new panel.
*Refer to the next page for **Adding commands to a panel**.*
After adding commands to the panel you will add the new panel to the tab.

Add a Command to a Ribbon Panel

1. Open the Customize User Interface dialog box (Refer to page 2-2)

2. Select **Class Workspace Demo**

3. Select the **[+]** beside **Ribbon** to expand.

4. Select the **[+]** beside **Panels** to expand.

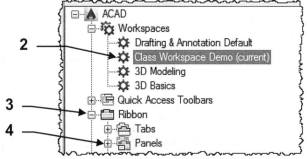

5. Select the **[+]** beside the **Panel name** to which you want to **add commands**.
 (Note: The new panel will be located at the bottom of the list of panels)

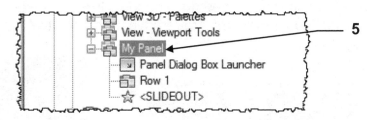

6. Locate the command, that you wish to add, in the Command List area.

7. Click, drag and drop the command on Row 1.
 (Note: I selected **"Save As"** for this example)

8. Now refer back to page 2-8 for instructions to **Add a <u>Ribbon Panel</u> to a <u>Tab</u>**

After adding the **My Panel** to the Class tab it Should appear as shown below.

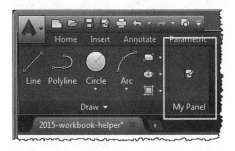

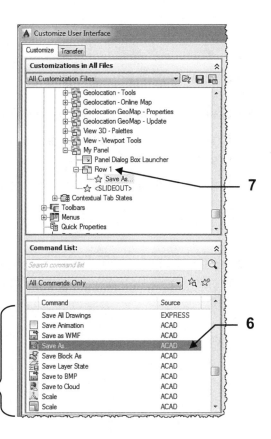

Command List Area

How to customize the Status Bar

AutoCAD allows you to decide what you would like displayed on the **Status Bar**. Customizing the Status Bar is strictly personal preference. You decide.

The Status Bar is located on the bottom of the screen. It displays the current settings. These settings can be turned ON or OFF by clicking on one of the buttons or by pressing a corresponding function key, F2, F3 etc.

When an icon is turned on it will display a neon blue in color.

Model and Layout Tabs **Status Bar Icons**

Status Bar Icons

The status bar provides you with a set of commonly used drawing tools like grid display, snap, object snap and isometric drafting. You can choose to remove some or all of them, or you can choose to add more tools.

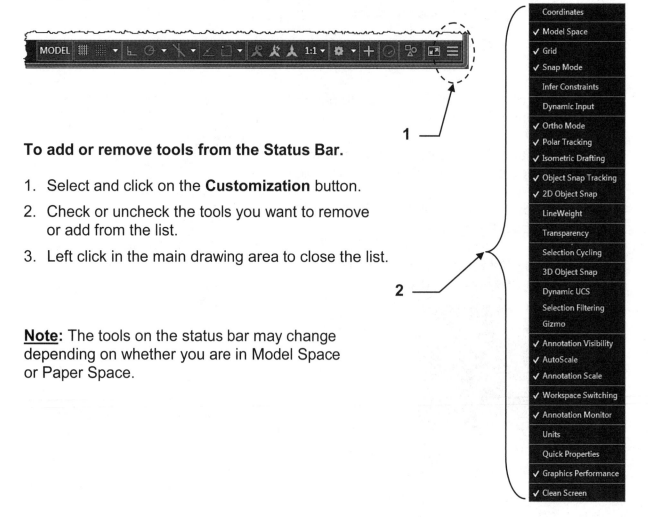

To add or remove tools from the Status Bar.

1. Select and click on the **Customization** button.
2. Check or uncheck the tools you want to remove or add from the list.
3. Left click in the main drawing area to close the list.

Note: The tools on the status bar may change depending on whether you are in Model Space or Paper Space.

Customize the Quick Access Toolbar

Quick Access Toolbar

The **Quick Access Toolbar** is located in the top left corner of the AutoCAD window. It includes the most commonly used tools, such as New, Open, Save, Save as, Print, Undo and Redo.

How to Customize the Quick Access Toolbar
You can add tools with the Customize User Interface dialog box.

For Example:
You will find that you will be using the **"Zoom All"** tool often. So I add the **"Zoom All"** tool to the Quick Access Toolbar. If you would like to add the **"Zoom All"** tool, or any other tool, to your Quick Access Toolbar follow the steps below.

1. Place the Cursor on the Quick Access Toolbar and press the right mouse button.

2. Select **"Customize Quick Access Toolbar..."** from the menu.

3. Scroll through the list of Commands to **"Zoom, All"**

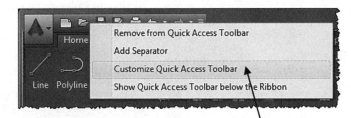

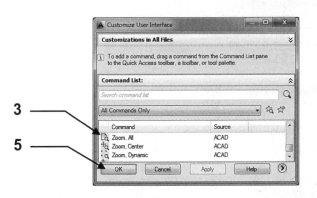

4. Press the Left mouse button on **"Zoom, All"** and drag it to a location on the Quick Access Toolbar and drop it by releasing the left mouse button.

5. Select the **OK** button at the bottom of the Customize User Interface dialog box.

The Customize User Interface dialog box will disappear and the new Quick Access Toolbar is saved to the current Workspace.

To Remove a tool:
Place the cursor on the tool to remove and press the right mouse button.
Select **Remove from Quick Access Toolbar.**

Export a Workspace

Now that you have created your workspace you may wish to **Export** the workspace so you may **Import** the workspace onto another computer.

1. Select the **Customize User Interface EXPORT** using one of the following:

 Ribbon = Manage tab / Customization panel /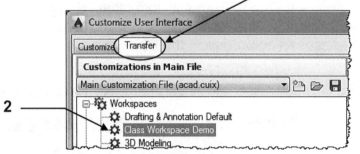
 or
 Keyboard = CUIEXPORT <enter>

2. Select the Workspace you wish to export. **Notice the Transfer tab has been selected**

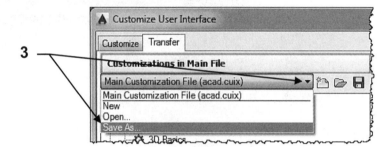

3. Select **Save As** from the drop down list.

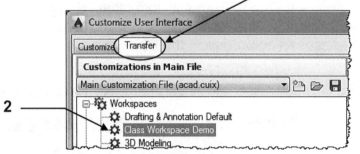

4. Locate where you wish to save the workspace file.
 (Note: This is a fairly large file so make sure you have data area available.)

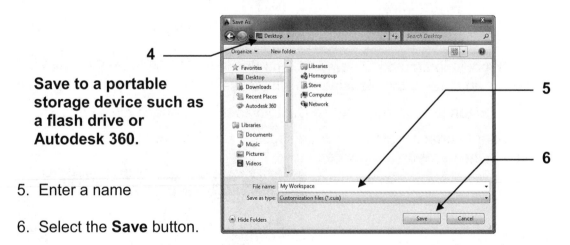

Save to a portable storage device such as a flash drive or Autodesk 360.

5. Enter a name

6. Select the **Save** button.

Your customized workspace is now saved and can be imported onto another computer. Import instructions are on the next page.

Import a Workspace

Now that you have created your workspace you may wish to **Import** the workspace onto another computer. Note: you should be importing the workspace into a computer that does not have the workspace that you wish to import.

1. Select the **Customize User Interface IMPORT** using one of the following:

 Ribbon = Manage tab / Customization panel /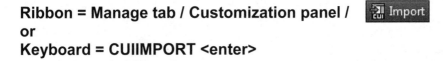
 or
 Keyboard = CUIIMPORT <enter>

2. Select **Open** from the drop down list.

3. Locate the previously saved workspace file.

4. Select the **.cuix** file.

5. Select the **Open** button.

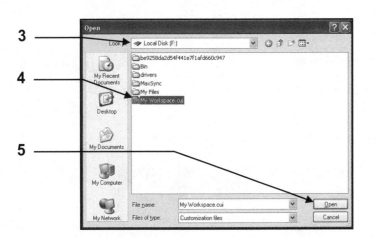

6. **Set Current** if you wish to use it. (Refer to page 2-4)

7. Select the **Apply** and **OK** button located at the bottom of the dialog box.

How to Delete a Workspace

1. Select the **Customize User Interface**.

2. **Right click** on **any** Workspace that you **do not** want to delete.

3. Right Click and select **Set Current.**
 (You can not delete a workspace if it is "current".)

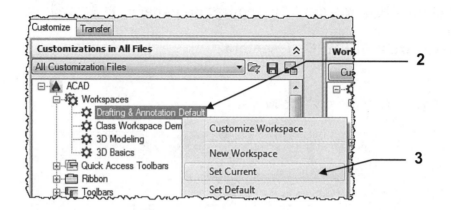

4. **Right click** on the Workspace that you wish to **Delete**.

5. Select **Delete**.

6. Select **Yes** if you really want to delete the workspace.

7. Select **Apply** and **OK** buttons.

LEARNING OBJECTIVES

After completing this lesson, you will be able to:

1. Create a Template for use with Decimals.

LESSON 3

EXERCISE 3A

CREATE A MASTER DECIMAL SETUP TEMPLATE

The following instructions will guide you through creating a "Master" decimal setup template. This setup template is very similar to the setup template you may have made while using the Beginning Workbook but there are a few differences.

NEW SETTINGS

A. Begin your drawing with a different template as follows:
 1. Select the **NEW** command.
 2. Select template file **acad.dwt** from the list of templates.
 3. Select **Open**

B. Set the drawing **Units** as follows:
 1. Type **UNITS <enter>**
 2. Change the **Type** and **Precision** as shown
 3. Select **OK** button

EXERCISE 3A....continued

C. Set the **Drawing Limits** (Size of the drawing area) as follows:
1. Type **Limits <enter>**
2. Select **Off**
"Off" means that your drawing area in Modelspace is unlimited.
You will control the plotting with the layout tabs. (Paperspace)
3. Zoom / All

D. Set the Grids and Snap as follows:
1. Type **DS<enter>**
2. Select the **Snap and Grid** tab
3. Change the settings as shown below.
4. Select the **OK** button.

D2

Drafting Settings

| Snap and Grid | Polar Tracking | Object Snap | 3D Object Snap | Dynamic Input | Quic ◀ ▶ |

☑ Snap On (F9) ☑ Grid On (F7)

Snap spacing

Snap X spacing: `.250`

Snap Y spacing: `.250`

☑ Equal X and Y spacing

Polar spacing

Polar distance: `.000`

Snap type

◉ Grid snap
 ◉ Rectangular snap
 ◯ Isometric snap
◯ PolarSnap

Grid style

Display dotted grid in:
☐ 2D model space
☐ Block editor
☐ Sheet/layout

Grid spacing

Grid X spacing: `1.000`

Grid Y spacing: `1.000`

Major line every: `4`

Grid behavior

☐ Adaptive grid
 ☐ Allow subdivision below grid spacing
☐ Display grid beyond Limits
☐ Follow Dynamic UCS

**Important:
Uncheck
these**

[Options...] [OK] [Cancel] [Help]

D4

3-3

EXERCISE 3A....continued

E. Change **Lineweight** settings as follows:
1. Left click on Lineweight button down arrow located on the status line.
2. Select **Lineweight Settings**
3. Change to inches and adjust the Display scale as shown below.
4. Select the **OK** button.

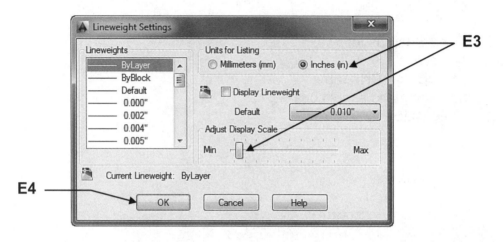

F. Create **new Layers** as follows:
1. Load the linetypes listed below.
 Center2, Hidden, Phantom2

2. Assign names, colors, linetypes, lineweights and plotability as shown below:

Notice these

S...	Name	On	Freeze	Lock	Color	Linetype	Lineweight	Transparency	Plot Style	Plot
	0				white	Continuous	Default	0	Color_7	
	BORDERLINE				white	Continuous	0.039"	0	Color_7	
	CENTERLINE				cyan	CENTER2	Default	0	Color_4	
	DIMENSION				blue	Continuous	Default	0	Color_5	
	GRADIENT				white	Continuous	Default	0	Color_7	
	HATCH				green	Continuous	Default	0	Color_3	
	HIDDEN LINE				magenta	HIDDEN	Default	0	Color_6	
	OBJECT LINE				red	Continuous	0.028"	0	Color_1	
	PHANTOM LINE				white	PHANTOM2	Default	0	Color_7	
	SECTION LINE				white	PHANTOM2	0.031"	0	Color	
	SYMBOL				white	Continuous	0.020"	0	Color_7	
	TEXT				blue	Continuous	Default	0	Color_5	
	THREADS				green	Continuous	Default	0	Color_3	
	VIEWPORT				green	Continuous	Default	0	Color_3	
	WINDOW				green	Continuous	Default	0	Color_3	
	WIPE OUT				white	Continuous	0.035"	0	Color_7	
	XREF				white	Continuous	Default	0	Color_7	

Current layer: OBJECT LINE

Search for layer

Filters
All
All Used Layers

LAYER PROPERTIES MANAGER

Invert filter

All: 17 layers displayed of 17 total layers

EXERCISE 3A....continued

G. Create a new **Text Style** as follows:
1. Select **Text Style**.
2. Create the text style **Text-Classic** using the settings shown below.
3. When complete, select **Set Current** and **Close**.

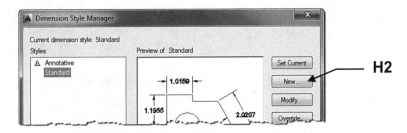

G2

G3

H. Create a **Dimension Style** as follows:
1. Select the **Dimension Style** command.
2. Select the **New** button.

H2

3. Enter **Name, Start with, Annotative, Use for** as shown below.
4. Select **Continue** button.

H4

H3

EXERCISE 3A....continued

5. Select the **Primary Units** tab and change your settings to match the settings shown below.

5. **Primary Units**

New Dimension Style: DIM-DECIMAL

| Lines | Symbols and Arrows | Text | Fit | Primary Units | Alternate Units | Tolerances |

Linear dimensions

Unit format: Decimal

Precision: 0.000

Fraction format: Horizontal

Decimal separator: '.' (Period)

Round off: 0.000

Prefix:

Suffix:

Measurement scale

Scale factor: 1.000

☐ Apply to layout dimensions only

Zero suppression

☑ Leading ☐ Trailing

Sub-units factor: ☑ 0 feet
100.000
 ☑ 0 inches
Sub-unit suffix:

Angular dimensions

Units format: Decimal Degrees

Precision: 0

Zero suppression

☐ Leading

☐ Trailing

[OK] [Cancel] [Help]

1.016
1.196
2.021
60°
R.805

Do not select the OK button yet.

3-6

EXERCISE 3A....continued

6. Select the **Lines** tab and change your settings to match the settings shown below.

6. Lines

Do not select the OK button yet.

EXERCISE 3A....continued

7. Select the **Symbols and Arrows** tab and change your setting to match the settings shown below.

7. **Symbols and Arrows**

Do not select the OK button yet.

EXERCISE 3A....continued

8. Select the **Text** tab and change your settings to match the settings shown below

8. Text

Do not select the OK button yet.

EXERCISE 3A....continued

9. Select the **Fit** tab and change your setting to match the settings shown below.

10. Now select the **OK** button.

9. Fit

New Dimension Style: DIM-DECIMAL

Tabs: Lines | Symbols and Arrows | Text | **Fit** | Primary Units | Alternate Units | Tolerances

Fit options

If there isn't enough room to place both text and arrows inside extension lines, the first thing to move outside the extension lines is:

- ◉ Either text or arrows (best fit)
- ○ Arrows
- ○ Text
- ○ Both text and arrows
- ○ Always keep text between ext lines
- ☐ Suppress arrows if they don't fit inside extension lines

Text placement

When text is not in the default position, place it:

- ◉ Beside the dimension line
- ○ Over dimension line, with leader
- ○ Over dimension line, without leader

Dimensions shown: 1.916, 1.198, 2.021, 60°, R.805

Scale for dimension features

- ☑ Annotative
- ○ Scale dimensions to layout
- ◉ Use overall scale of: 1.000

Fine tuning

- ☑ Place text manually
- ☐ Draw dim line between ext lines

[OK] [Cancel] [Help]

10. NOW select the OK button.

3-10

EXERCISE 3A....continued

Your new style **"DIM-DECIMAL"** should be listed.

11. Select the **"Set Current"** button to make your new style "DIM-DECIMAL" the style that will be used.

12. Select the **Close** button.

13. **Important:** Re-Save your drawing as **My Decimal Setup.**

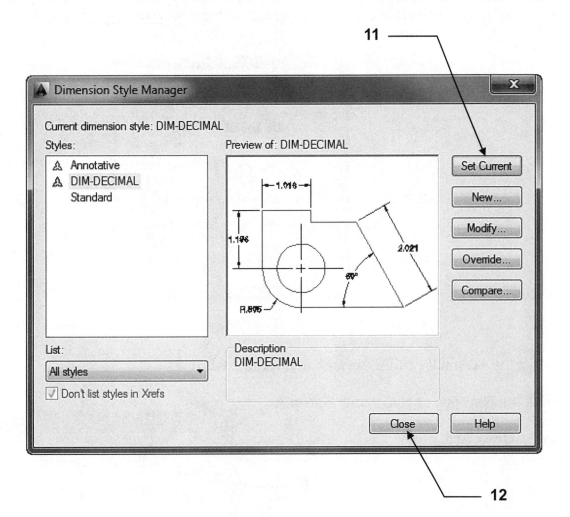

Continue to Exercise 3B

EXERCISE 3B

PAGE SETUP

Now you will select the printer and the paper size to use for printing.
You will use the Layout1 tab (Paper space).

A. Open **My Decimal Setup** (If not already open)

B. Select **Layout1** tab.

> *Note: If the "Page Setup Manager" dialog box shown below does not appear automatically, right click on the Layout tab and select <u>Page Setup Manager</u>.*

C. Select the **New...** button.

C

D. Select the **<Default output device>** in the **Start with**: list.

E. Enter the New page setup name: **Setup A**

F. Select **OK** button.

E

D

(I am assuming that your computer is attached to a printer. If not select Layout1)

F

Continued on the next page...

EXERCISE 3B....continued

This is where you will select the **print device**, **paper size** and the **plot offset**.

G. Select the **Printer / Plotter**
Note: Your current system printer should already be displayed here. If you prefer another select the down arrow and select from the list. If the preferred printer is not in the list you must configure the printer. Refer to Appendix-A)

H. Select the **Paper Size**

I. Select **Plot Offset**

Notice the name you entered is now displayed as the page setup name.

G
(Yours will be different)

H
(Yours may be 8-1/2 x 11)

I
(Should stay at 0.000000)

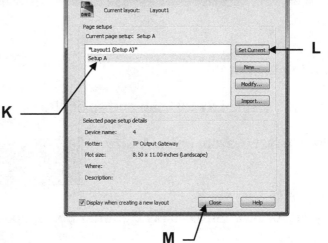

J. Select **OK** button.

K. Select **Setup A**.

L. Select the **Set Current** button.

M. Select the **Close** button.

K

M

Continued on the next page...

EXERCISE 3B....continued

You should now have a sheet of paper displayed on the screen.
This sheet is the size you specified in the "Page Setup".
This sheet is in front of Model Space.

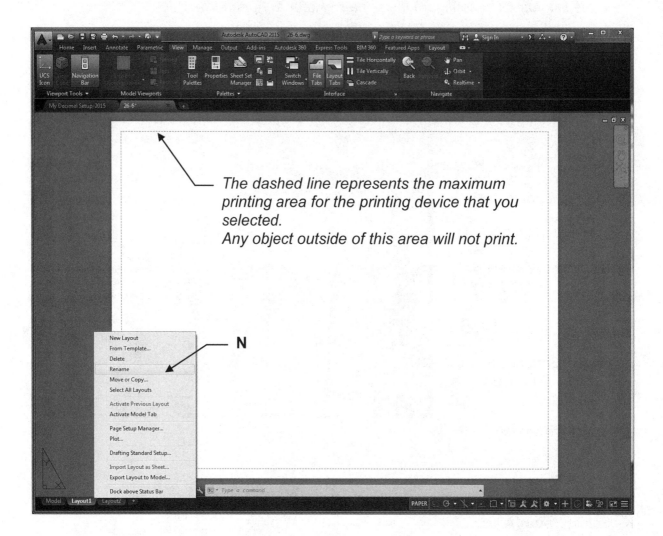

The dashed line represents the maximum printing area for the printing device that you selected.
Any object outside of this area will not print.

N

Rename the Layout tab

N. Right click on the **Layout1 tab** and select **Rename** from the list.

O. Enter the New Layout name **A Size**

P. ***Very important:*** Save as **My Decimal Setup** again.

Q. Continue on to **Exercise 3C**.....you are not done yet.

EXERCISE 3C

CREATE A BORDER AND TITLE BLOCK

A. Draw the <u>border rectangle</u> as large as you can within the dashed lines approximately as shown below using layer **BORDERLINE**,

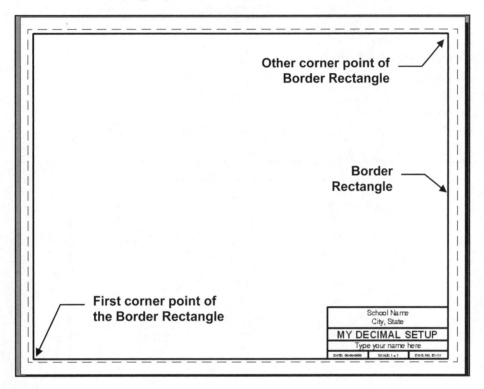

B. Draw the Title Block as shown using:
1. Layers <u>BorderLine</u> and <u>Text</u>.
2. Multiline Text ; Justify <u>Middle Center</u> in each rectangular area.
3. Text Style= Text-Classic Text height = varies.

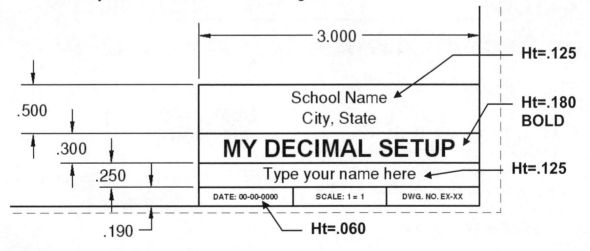

C. ***Very important:*** Save as **My Decimal Setup** again.

D. Continue on to **Exercise 3D**.....you are not done yet.

EXERCISE 3D
CREATE A VIEWPORT

The following instructions will guide you through creating a VIEWPORT in the Border Layout sheet. Creating a viewport has the same effect as cutting a hole in the sheet of paper. You will be able to see through the viewport frame (hole) to Modelspace.

A. Open **My Decimal Setup** (If not already open)
B. Select the **A Size** tab.
C. Select layer **Viewport**
D. Type: **MV <enter>**
E. Draw a Single viewport approximately as shown. (Turn off Object Snap)

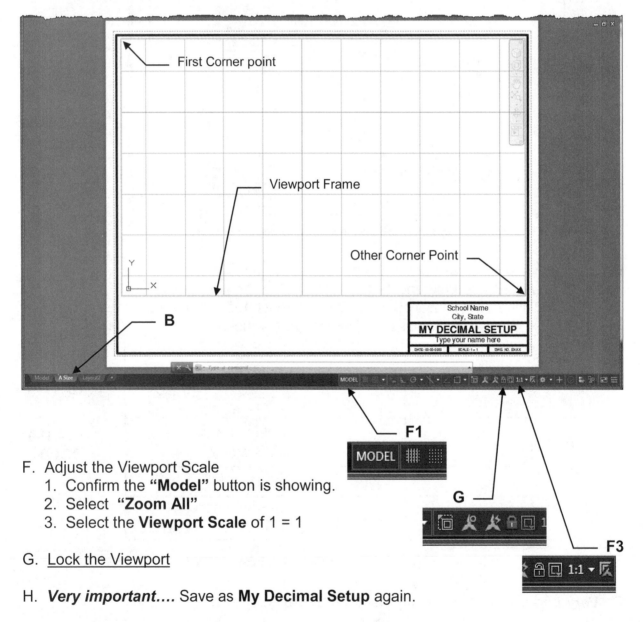

F. Adjust the Viewport Scale
 1. Confirm the **"Model"** button is showing.
 2. Select **"Zoom All"**
 3. Select the **Viewport Scale** of 1 = 1

G. Lock the Viewport

H. ***Very important....*** Save as **My Decimal Setup** again.

I. Continue on to **Exercise 3E**....you are not done yet.

EXERCISE 3E

PLOTTING FROM THE LAYOUT

The following instructions will guide you through the final steps for setting up the master template for plotting. These settings will stay with **My Decimal Setup** and you will be able to use it over and over again.

A. Open **My Decimal Setup**

B. Select the **A Size** layout tab.

C. Select the **Plot** command.

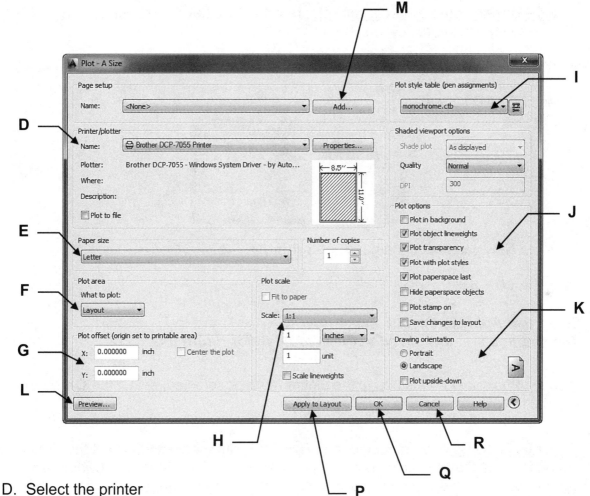

D. Select the printer

E. Select the Paper Size

F. Select the Plot Area

G. Plot offset should be 0.000000 for **X** and **Y**

Continued on the next page...

EXERCISE 3E....continued

H. Select scale 1 : 1

I. Select the Plot Style Table **Monochrome.ctb**

J. Select the Plot options shown

K. Select Drawing Orientation: **Landscape**

L. Select **Preview** button.

> If the drawing appears as you would like it, press the **Esc** key and continue
> on to **M**.

> If the drawing does not look correct, press the **Esc** key and check all your
> settings, then preview again.

Note: The Viewport will not appear in the Preview because it is on a no plot layer.

M. Select the **ADD** button.

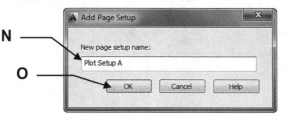

N. Type the New page setup name: **Plot Setup A**

O. Select the **OK** button.

P. Select the "**Apply to Layout**" button.
 The settings are now saved to the layout tab for future use.

Q. If your computer **is** connected to the plotter / printer selected, select the **OK** button
 to plot, then proceed to **S**.

R. If your computer is **not** connected to the plotter / printer selected, select the Cancel
 button to close the Plot dialog box and proceed to **S**. *Note: Selecting Cancel will
 cancel your selected setting if you did not save the page setup as specified in **M**.*

You are almost done.
S. Now Save all of this work as a **Template**.
 1. Select **Application Menu / Save As / AutoCAD Drawing Template**
 2. Type: **My Decimal Setup.dwt**
 3. Select **Save** button.

Your **My Decimal Setup** master template is complete.

LEARNING OBJECTIVES

After completing this lesson, you will be able to:

1. Create a Master Architectural template

LESSON 4

EXERCISE 4A

CREATE A MASTER FEET-INCHES SETUP TEMPLATE

The following instructions will guide you through creating a "Master" Feet-inches setup template. This setup template is very similar to the setup template you may have made while using the Beginning workbook but there are a few differences.

NEW SETTINGS

A. Begin your drawing with a different template as follows:
 1. Select the **NEW** command.
 2. Select template file **acad.dwt** from the list of templates. (**Not** acad3D.dwt)
 3. Select **Open**

B. Set the drawing **Units** as follows:
 1. Type **UNITS <enter>**
 2. Change the **Type** and **Precision** as shown
 3. Select **OK** button

B2

Drawing Units

Length
Type:
Architectural

Precision:
0'-0 1/16"

Angle
Type:
Decimal Degrees

Precision:
0

☐ Clockwise

Insertion scale
Units to scale inserted content:
Inches

Sample Output
1 1/2",2",0"
3"<45,0"

Lighting
Units for specifying the intensity of lighting:
International

B3

[OK] [Cancel] [Direction...] [Help]

EXERCISE 4A....continued

C. Set the **Drawing Limits** (Size of the drawing area) as follows:
1. Type **Limits <enter>**
2. Select **OFF**

"Off" means that your drawing area in Modelspace is unlimited.
You will control the plotting with the layout tabs. (Paperspace)

D. Set the Grids and Snap as follows:
1. Type **DS<enter>**
2. Select the **Snap and Grid** tab
3. Change the settings as shown below.
4. Select the **OK** button.

D2

D4

Important: Uncheck these

Continued on the next page...

EXERCISE 4A....continued

E. Change **Lineweight** settings as follows:
1. Right click on Lineweight button on status line
2. Select **Settings**
3. Change to inches and adjust the Display scale as shown below.
4. Select the **OK** button.

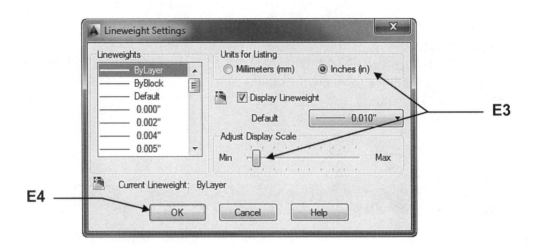

F. Create **new Layers** as follows:
1. Load the linetype **Dashed**.

2. Assign names, colors, linetypes, lineweights and plot ability as shown below:

S...	Name	On	Freeze	Lock	Color	Linetype	Lineweight	Transparency	Plot Style	Plot
	0				white	Continuous	Default	0	Color_7	
	BORDER				white	Continuous	0.039"	0	Color_7	
	CABINETS				cyan	Continuous	0.016"	0	Color_4	
	DIMENSION				blue	Continuous	Default	0	Color_5	
	DOORS				green	Continuous	0.016"	0	Color_3	
	ELECTRICAL				cyan	Continuous	Default	0	Color_4	
	FURNITURE				magenta	Continuous	0.016"	0	Color_6	
	HARDSCAPE				white	Continuous	0.024"	0	Color_7	
	HATCH				green	Continuous	Default	0	Color_3	
	LANDSCAPE				green	Continuous	0.016"	0	Color_3	
	MISC				cyan	Continuous	Default	0	Color_4	
	PLANTS				green	Continuous	0.016"	0	Color_3	
	PLUMBING				9	Continuous	Default	0	Color_9	
	PROPERTY LINE				cyan	PHANTOM2	0.039"	0	Color_4	
	ROOF				white	Continuous	0.016"	0	Color_7	
	TEXT				blue	Continuous	Default	0	Color_5	
	VIEWPORT				green	Continuous	Default	0	Color_3	
	WALLS				red	Continuous	0.031"	0	Color_1	
	WINDOWS				green	Continuous	0.016"	0	Color_3	
	WIRING				cyan	DASHED	Default	0	Color_4	
	XREF				white	Continuous	Default	0	Color_7	

Current layer: WALLS

All: 21 layers displayed of 21 total layers

EXERCISE 4A....continued

G. Create 2 new **Text Styles** as follows:
1. Select **Text Style**
2. Create the text style **Text-Classic** and **Text-Arch** using the settings shown below.

Text Style (TEXT-CLASSIC)

Current text style: TEXT-CLASSIC

Styles:
- Annotative
- Standard
- TEXT-CLASSIC

All styles

AaBbCcD

Font
Font Name: SansSerif
Font Style: Regular
☐ Use Big Font

Size
☑ Annotative
☐ Match text orientation to layout
Paper Text Height: 0'-0"

Effects
☐ Upside down
☐ Backwards
☐ Vertical
Width Factor: 1.0000
Oblique Angle: 0

Set Current | New... | Delete

Apply | Cancel | Help

Text Style (TEXT-ARCH)

Current text style: TEXT-ARCH

Styles:
- Annotative
- Standard
- TEXT-ARCH
- TEXT-CLASSIC

All styles

AaBbCcD

Font
Font Name: CityBlueprint
Font Style: Regular
☐ Use Big Font

Size
☑ Annotative
☐ Match text orientation to layout
Paper Text Height: 0'-0"

Effects
☐ Upside down
☐ Backwards
☐ Vertical
Width Factor: 1.0000
Oblique Angle: 0

Set Current | New... | Delete

Apply | Close | Help

THIS NEXT STEP IS VERY IMPORTANT

H. **Save** all the settings you just created as follows:
1. Save as: **My Feet-Inches Setup**

4-5

EXERCISE 4B

PAGE SETUP

Now you will select the printer and the paper size to use for printing.
You will use the Layout1 tab (Paper space).

A. Open **My Feet-Inches Setup** (If not already open)

B. Select **Layout1** tab.

> *Note: If the "Page Setup Manager" dialog box shown below does not appear automatically, right click on the Layout tab and select Page Setup Manager.*

C. Select the **New...** button.

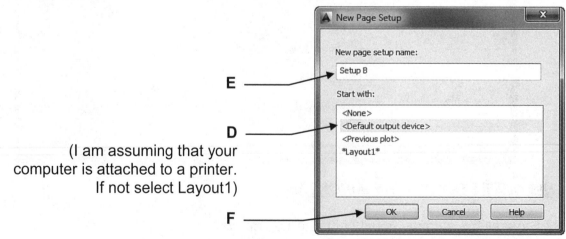

D. Select the **<Default output device>** in the **Start with**: list.

E. Enter the New page setup name: **Setup B**

F. Select **OK** button.

(I am assuming that your computer is attached to a printer. If not select Layout1)

EXERCISE 4B....continued

This is where you will select the **print device**, **paper size** and the **plot offset**.

G. Select the **Printer / Plotter**
 Note: Your current system printer should already be displayed here. If you prefer another select the down arrow and select from the list. If the preferred printer is not in the list you must configure the printer. Refer to Appendix-A for instructions.

H. Select the **Paper Size**

I. Select **Plot Offset**

Notice the name you entered is now displayed as the page setup name.

G

(Yours will be different)

H

(Yours may be 8-1/2 x 11)

I

(Should stay at 0.000000)

J. Select **OK** button.

J

K. Select **Setup B**.

L. Select the **Set Current** button.

M. Select the **Close** button.

K

L

M

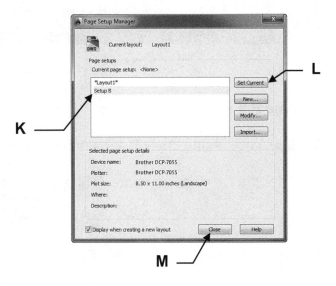

Continued on the next page...

EXERCISE 4B....continued

You should now have a sheet of paper displayed on the screen.
This sheet is the size you specified in the "Page Setup".
This sheet is in front of Model Space.

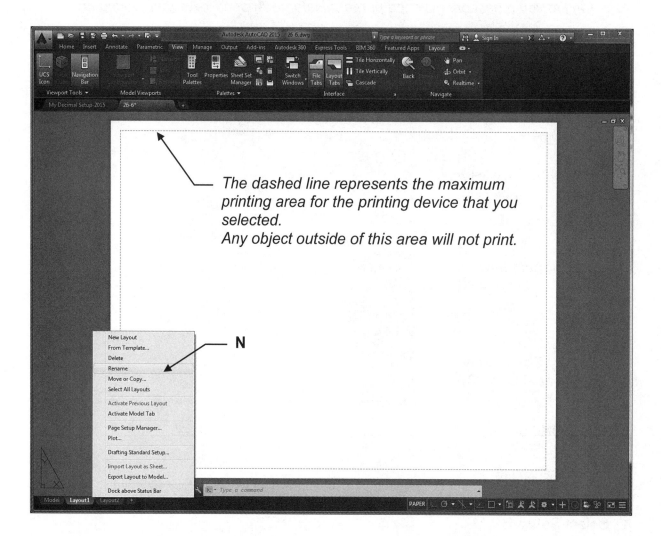

The dashed line represents the maximum printing area for the printing device that you selected.
Any object outside of this area will not print.

Rename the Layout tab

N. Right click on the Layout1 tab and select **Rename** from the list.

O. Enter the New Layout name **A Size**

P. ***Very important:*** Save as **My Feet-Inches Setup** again.

Q. Continue on to **Exercise 4C**.....you are not done yet.

EXERCISE 4C

CREATE A BORDER AND TITLE BLOCK

A. Draw the <u>Border rectangle</u> as large as you can within the dashed lines approximately as shown below using <u>Layer Border</u>.

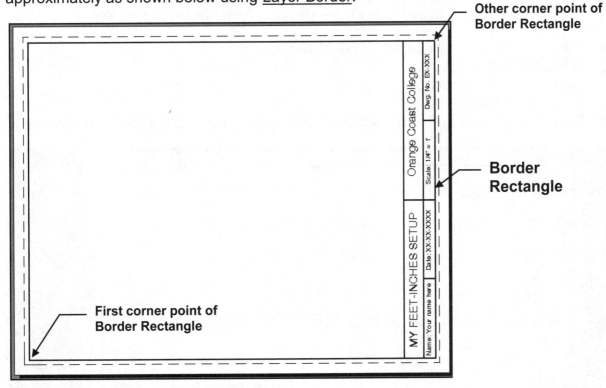

Other corner point of Border Rectangle

Border Rectangle

First corner point of Border Rectangle

B. Draw the Title Block as shown using:
1. Layers <u>Border</u> and <u>Text</u>.
2. **Single Line Text** ; Justify **<u>Middle</u>** in each rectangular area.
 (Hint: Draw diagonal lines to find the middle of each area, as shown)
3. Text Style= Text-Classic Text height noted.

Note: You can draw the Title Block in place and add Text with a rotation angle of 90 <u>or</u> Draw the Title Block horizontal, add Text and then rotate it. You decide.

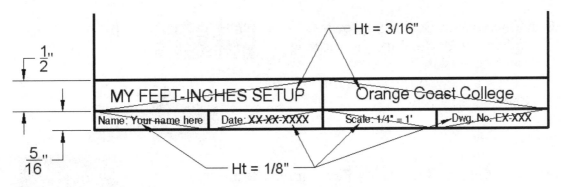

C. ***Very important:*** Save as **My Feet-Inches Setup** again.

D. Continue on to **Exercise 4D**…..you are not done yet.

EXERCISE 4D
CREATE A VIEWPORT

The following instructions will guide you through creating a VIEWPORT in the Border Layout sheet. Creating a viewport has the same effect as cutting a hole in the sheet of paper. You will be able to see through the viewport frame (hole) to Modelspace.

A. Open **My Feet-Inches Setup** (If not already open)
B. Select the **A Size** tab.
C. Select layer **Viewport**
D. Type: **MV <enter>**
E. Draw a Single viewport approximately as shown. (Turn off Object Snap temporarily)

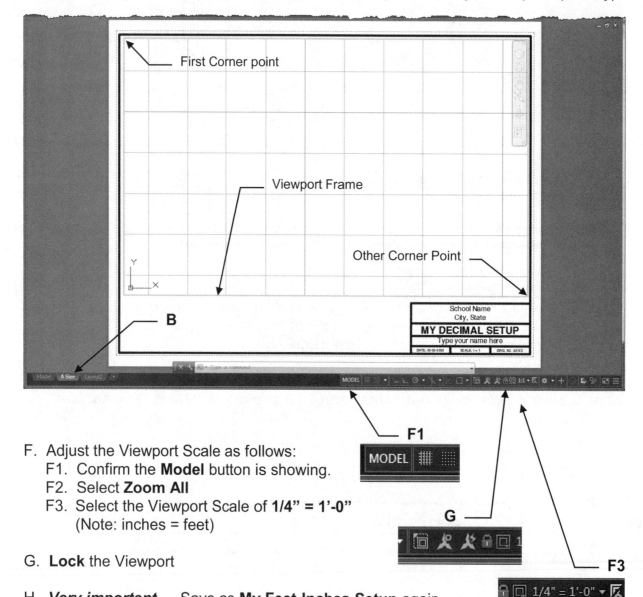

F. Adjust the Viewport Scale as follows:
 F1. Confirm the **Model** button is showing.
 F2. Select **Zoom All**
 F3. Select the Viewport Scale of **1/4" = 1'-0"**
 (Note: inches = feet)

G. **Lock** the Viewport

H. ***Very important....*** Save as **My Feet-Inches Setup** again.

I. Continue on to **Exercise 4E**....you are not done yet.

EXERCISE 4E

PLOTTING FROM THE LAYOUT

The following instructions will guide you through the final steps for setting up the master template for plotting. These settings will stay with **My Feet-Inches Setup** and you will be able to use it over and over again.

In this exercise you will take a short cut by **importing** the **Plot Setup A** from **My Decimal Setup.dwt**. (Note: If the <u>Printer, Paper size and Plot Scale</u> is the same you can use the same Page Setup.)

> **Note: If you prefer <u>not to use</u> Import, you may go to 3-17 and follow the instructions for creating the Plot- page setup.**

A. Open **My Feet-Inches Setup**

B. Select the **A Size** layout tab.

 You should be seeing your Border and Title Block now.

C. Type **Plot <enter>**

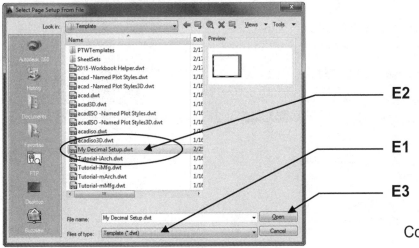

D. Select **Import...** from the Page Setup drop down menu

E. Find **My Decimal Setup.dwt** as follows:
 E1. Select Files of type: **Template [.dwt]**
 E2. Select **My Decimal Setup.dwt**
 E3. Select **Open** button.

Continued on the next page...

EXERCISE 4E....continued

F. Select **Plot Setup A** from the Page Setups list.

G. Select the **OK** button.

H. Select **Plot Setup A** from the Page Setup drop down list.
 (Note: It was not there before. You just imported it in from My Decimal Setup.dwt)

Continued on the next page...

EXERCISE 4E....continued

I. Review all the settings.

J. Select **Preview** button.

> If the drawing appears as you would like it, press the **Esc** key and continue

> If the drawing does not look correct, press the **Esc** key and check all your
> settings, then preview again.

Note: The Viewport will not appear in the Preview because it is on a no plot layer.

K. Select the **Apply to Layout** button.
 (The settings are now saved to the layout tab for future use.)

L. If your computer **is** connected to the plotter / printer selected, select the **OK** button to
 plot, then proceed to **N**.

M. If your computer is **not** connected to the plotter / printer selected, select the Cancel
 button to close the Plot dialog box and proceed to **N**.

N. **Important:** Save the file again as **My Feet-Inches Setup**

O. You are almost done....continue on to 4F.

EXERCISE 4F

CREATE A NEW DIMENSION STYLE

1. Open **My Feet-Inches Setup** (If not already open)

2. Select the **Dimension Style Manager** command

3. Select the **NEW** button.

4. Enter **DIM-ARCH** in the "New Style Name" box.

5. Select **STANDARD** in the **"Start With:"** box.

6. Select **Annotative** box.

7. Select the **CONTINUE** button.

8. Select the **Primary Units** tab and change your settings to match the settings shown below.

8

Do not select the OK button yet

EXERCISE 4F....continued

9. Select the **Lines** tab and change your settings to match the settings shown below.

9

Do not select the OK button yet

EXERCISE 4F....continued

10. Select the **Symbols and Arrows** tab and change your settings to match the settings shown below.

10

Modify Dimension Style: DIM-ARCH

| Lines | Symbols and Arrows | Text | Fit | Primary Units | Alternate Units | Tolerances |

Arrowheads

First:
☑ Oblique

Second:
☑ Oblique

Leader:
▦ Closed filled

Arrow size:
1/8"

Center marks
○ None
○ Mark 1/8"
◉ Line

Dimension Break

Break size:
1/8"

Arc length symbol
◉ Preceding dimension text
○ Above dimension text
○ None

Radius jog dimension

Jog angle: 45

Linear jog dimension

Jog height factor:
1 1/2" * Text height

[OK] [Cancel] [Help]

Do not select the OK button yet

EXERCISE 4F....continued

11. Select the **Text** tab and change your settings to match the settings shown below.

11

Do not select the OK button yet

EXERCISE 4F....continued

12. Select the **Fit** tab and change your settings to match the settings shown below.

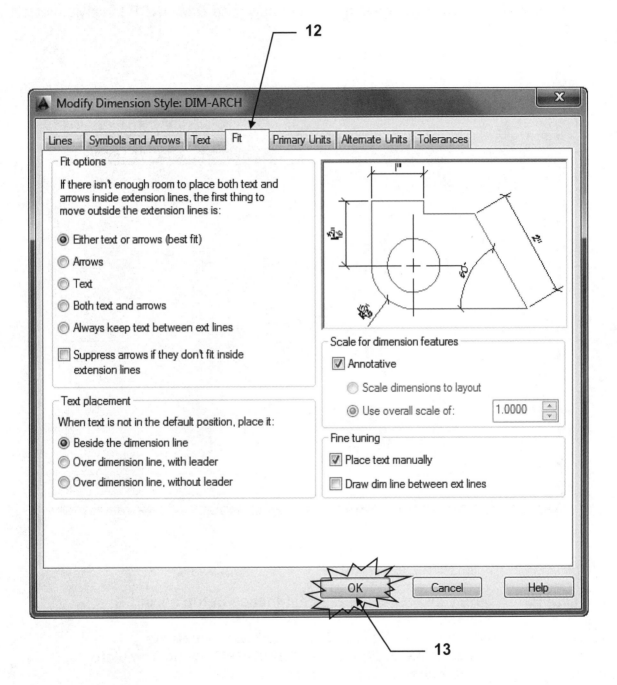

13. Now select the **OK** button.

EXERCISE 4F....continued

Your new **DIM-ARCH** dimension style should now be in the list.

13. Select the **Set Current** button to make your new style **DIM-ARCH** the style that will be used.

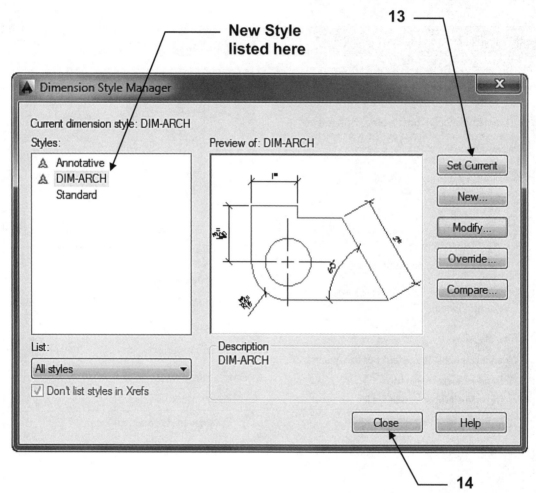

14. Select the **Close** button.

15. **Important:** Save your drawing as **My Feet-Inches Setup** again.

16. You are almost done. Now Save all of this work as a **Template.**
 a. Select **Application Menu / Save As / AutoCAD Drawing Template**
 b. Type: **My Feet-Inches Setup**
 c. Select **Save** button.

LEARNING OBJECTIVES

After completing this lesson, you will be able to:

1. Create a Table
2. Insert a Table
3. Modify an existing Table
4. Insert a Block into a Table Cell
5. Insert a Formula into a Table Cell
6. Create a Field
7. Update a Field
8. Edit an existing Field
9. Break a table

LESSON 5

TABLES

A Table is an object that contains data organized within columns and rows. AutoCAD's Table feature allows you to modify an existing Table Style or create your own Table Style and then enter text or even a block into the table cells. This is a very simple to use feature with many options.

This is an example of a Table.

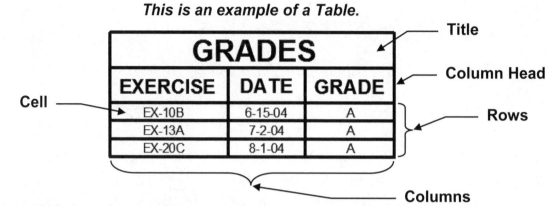

HOW TO CREATE A TABLE.

1. Select the Table Style command using one of the following:

 Ribbon = Annotate tab / Tables panel / ↘

 Keyboard = ts

 The following dialog box will appear.

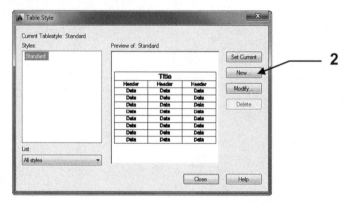

2. Select the **NEW** button. *The following dialog will appear.*

3. Enter the new Table Style name. *Note: When you create a new table style you always "Start With" an existing style and you specify the differences.*

4. Select the **Continue** button.

Tables....continued

The New Table Style dialog box appears. Customize the table by selecting options described below.

New name will appear here

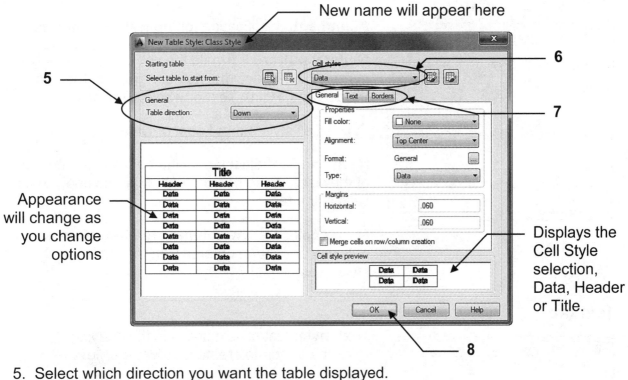

Appearance will change as you change options

Displays the Cell Style selection, Data, Header or Title.

5. Select which direction you want the table displayed.
 Up: Title and Header at the Bottom then data follows.
 Down: Title and Header at the Top then the data follows.

6. Select the Cell style that you wish to modify. (Data, Header or Title).

7. Select one of the Properties tabs after you have selected which "Cell Style" that you wish to modify.

Tables….continued

General tab

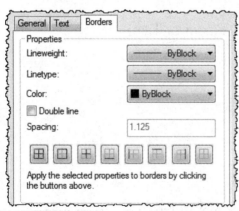

Fill Color: Background color of cell.

Alignment: Justification for the text inside the cell.

General button: Formats the cell content to: angle, currency, date, decimal number, general (default), Percentage, Point, Text or whole number.

Type: Cell style either Label or Data

Margins: Controls the spacing between the border of the cell and the cell content. Margins apply to all cells in the table.

Merge cells on row/column creation: Merges any new row or column created with the current cell style into one cell.

Text tab

Text style: List all text styles in the drawing. Click the button to create a new text style.

Text height: Sets the text height

Text color: Specifies the text color

Text angle: Specify the rotation angle of the text.

Borders

Lineweight: Selects lineweight for cell border

Linetype: Selects the linetype of the cell border.

Color: Select color for cell border.

Double line: Border lines are displayed as double lines.

Spacing: Specifies the double line spacing.

Border Buttons: Controls the appearance of the gridlines.

8. Select the **OK** button after all selections have been made.

<u>Note:</u> Tables are saved in the drawing. If you open another drawing you need to copy the previously created table using Design Center. (Refer to Lesson 10).

Tables….continued

9. Select the Table Style from the list of styles.

10. Select "**Set Current**" button.

11. Select the "**Close**" button.

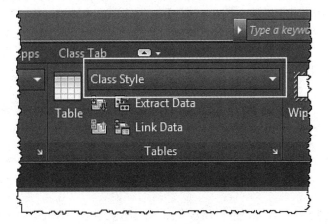

The new style name is now displayed in the Tables Panel.

How to insert a Table

1. Select **Table** from the **Table panel** or type: **table <enter>**

The Insert Table dialog box will appear.

2. Select the Table Style

3. Select the Insertion behavior.

 Specify Insertion Point: When you select the OK button you select the location to insert the table with the Columns and Rows previously selected.

 Specify window: When you select the OK button you select the location for the upper left corner of the table. Then drag the cursor to specify the Column width and number of Rows, on the screen.

4. Specify the Column and Row specifications.

5. Set cell styles: Specifies the Row settings if you haven't selected a previously created Table Style.

6. Select **OK** button.

Note:
Tables should always be inserted into Paper space or model space with a scale of 1:1. If your table does not appear, confirm you are in paper space or model space with a scale of 1:1.

How to insert a Table....continued

7. Place the Insertion Point. (The table will be attached to the cursor).

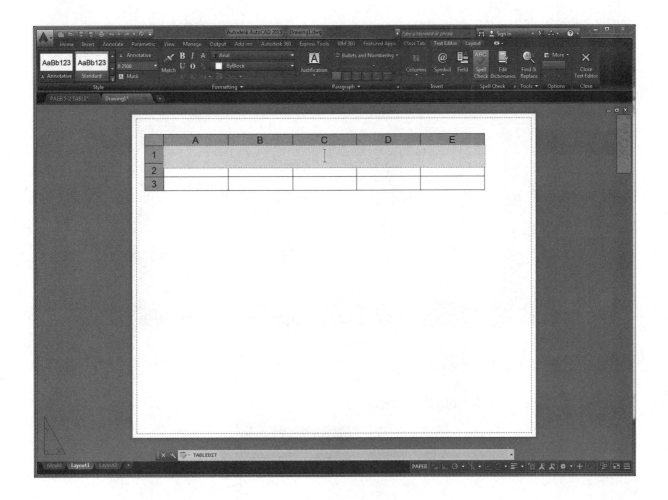

8. The Table is now on the screen waiting for you to fill in the data, header and title.

 Notice the **Text Editor** automatically appeared. This allows you to change the format of each cell as you desire.

9. When you have filled all of the cells you require, select **Close Text Editor**.

How to insert a Block into a Cell

1. Left click in the cell you wish to insert a block.

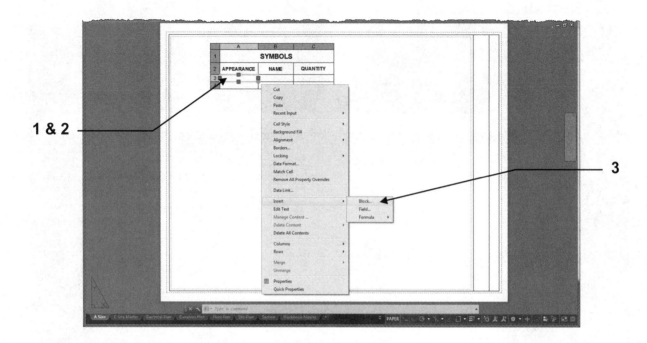

2. Right click to display the menu.

3. Select **Insert / Block** from the menu.

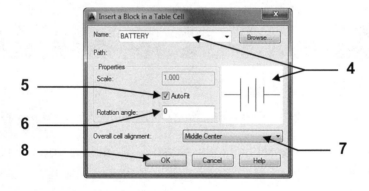

4. Select the **Block name** (a preview appears)

5. Select the **Scale**.
 Note: **AutoFit** will automatically size the block to fit within the cell.

6. Select **Rotation angle**.

7. Select the **Overall cell alignment**.

8. Select the **OK** button.

SYMBOLS		
Appearance	Name	Quantity
⊣║⊢		
⊖		

How to insert a Formula into a Cell

You may apply simple numerical operations such as Sum, Average, Count, set cells equal to other cells or even add an equation of your own. The following examples are for **Sum** and **Average** operations.

SUM

1. Click in the Cell in which you want to enter the **Sum** formula.

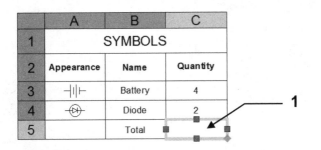

2. Right click and select: **Insert / Formula / Sum**

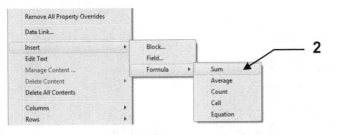

3. The following instruction appears on the Command Line:

EDITTABLECELL Select first corner of table cell range: *left-click the first corner of a window selection inside the cells you want to use for the sum* (**P1**)

4. The following instruction appears on the Command Line:

EDITTABLECELL Select second corner of table cell range: *drag the cursor to the opposite corner inside the cells you want to use for the sum, then left-click* (**P2**)

Continued on the next page...

How to insert a Formula into a Cell....continued

5. The formula appears in the cell. **Verify** the formula and select **Close Text Editor**. You may edit the formula if necessary.

	A	B	C
1		SYMBOLS	
2	Appearance	Name	Quantity
3	─┤│├─	Battery	4
4	◁▷	Diode	2
5		Total	=Sum(C3:C4)

5

Notice the formula disappears and the sum of the cells selected has been calculated. Also the value is shaded to make you aware that this cell has a formula in it.

SYMBOLS		
Appearance	Name	Quantity
─┤│├─	Battery	4
◁▷	Diode	2
	Total	6

Sum

How to insert a Formula into a Cell....continued

AVERAGE

1. Left click in the Cell that you wish to enter a formula.

	A	B	C	D
1	ROOM	TABLES	CHAIRS	COST
2	B14	2	4	100
3	F22	3	6	400
4	G7	4	8	500
5	TOTAL	9	18	1000
6	AVERAGE			

1

2. Right click and select: **Insert Formula / Average**

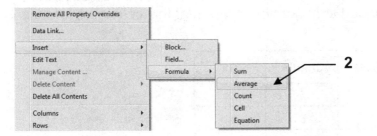

2

3. The following instruction appears on the Command Line:

EDITTABLECELL Select first corner of table cell range: *left-click the first corner of a window selection inside the cells you want to use for the average* (**P1**)

4. The following instruction appears on the Command Line:

EDITTABLECELL Select second corner of table cell range: *drag the cursor to the opposite corner inside the cells you want to use for the average, then left-click* (**P2**)

P1

	A	B	C	D
1	ROOM	TABLES	CHAIRS	COST
2	B14	2	4	100
3	F22	3	6	400
4	G7	4	8	500
5	TOTAL	9	18	1000
6	AVERAGE			

P2

Continued on the next page...

How to insert a Formula into a Cell....continued

5. The formula appears in the cell. **Verify** the formula and select **Close Text Editor**. You may edit the formula if necessary.

	A	B	C	D
1	ROOM	TABLES	CHAIRS	COST
2	B14	2	4	100
3	F22	3	6	400
4	G7	4	8	500
5	TOTAL	9	18	1000
6	AVERAGE			=Average(D2 :D4)

⟵ **5**

Notice the formula disappears and the average of the cells selected has been calculated. The value is shaded to make you aware that this cell has a formula in it.

ROOM	TABLES	CHAIRS	COST
B14	2	4	100
F22	3	6	400
G7	4	8	500
TOTAL	9	18	1000
AVERAGE			333.333333

<u>**NOTE:**</u>
You can change the amount of places after the decimal point by left-clicking in the Average formula cell and then select **Data Format** from the menu, this opens the **Table Cell Format** dialog box where you can change the decimal precision of the formula. (Refer to page 5-13)

How to change the Data Format of a Cell

1. Left click in the cell with the formula you wish to change.

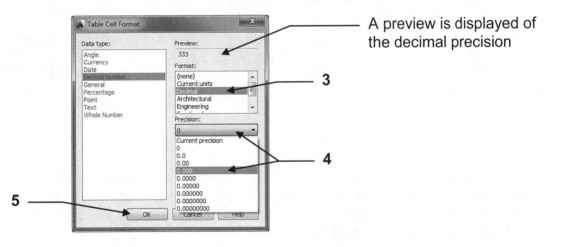

2. Right click and select **Data Format** from the menu.

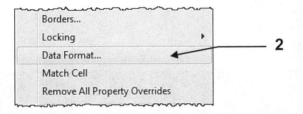

3. Select **Decimal** from the **Format** list in the **Table Cell Format** dialog box.

4. Select the required decimal precision from the **Precision** drop-down list (You can see a preview of the precision).

5. Select **OK** to close the dialog box, then press the **Esc** key to deselect the cell.

6. The formula in the cell has now changed to the required decimal precision.

Modify a Table using the Ribbon tab

So far in this lesson you have been using the right-click menus to add formulas to, or modify data in a cell, but AutoCAD also has the **Table Cell Contextual Ribbon tab**. The Table Cell tab has nearly all of the features that are available in the right-click menus.

To modify a Table or Cell using the Table Cell Ribbon tab:

1. Single left-click on any cell to enable the Table Cell Contextual Ribbon tab.

2. The Table Cell Contextual Ribbon tab will appear with various editing panels.

Table Cell Contextual Ribbon tab

It is worth experimenting with all the tools on the ribbon tab. It is also your choice on whether you use the right-click menus or the contextual ribbon tab when adding or modifying data in a table, some people prefer to use right-click menus for speed and efficiency, others prefer the contextual ribbon tab. The choice is yours.

Modify a Table using Grips

You may also modify tables using Grips. When editing with Grips, the left edge of the table remains stationary but the right edge can move. The upper left Grip is the Base Point for the table.

To use Grips, click on a table border line. The Grips should appear. Each Grip has a specific duty, shown below. To use a Grip, click on the Grip and it will change to red. Now click and drag it to the desired location.

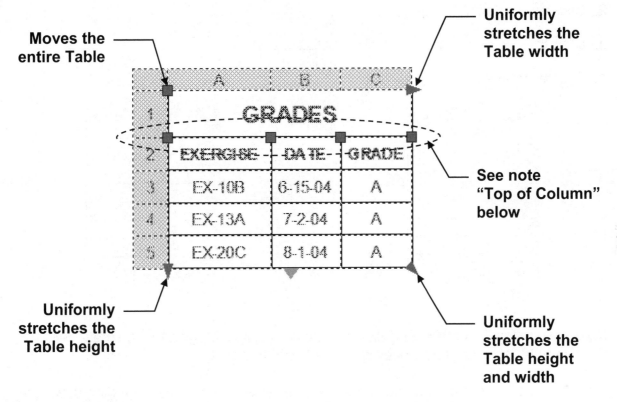

Moves the entire Table

Uniformly stretches the Table width

See note "Top of Column" below

Uniformly stretches the Table height

Uniformly stretches the Table height and width

Top of Column
There is a Grip located at the top of each column line. These Grips adjust the width of the column to the left of the Grip.

The column will change but the width of the entire Table remains unchanged.

If you hold the **CTRL** key down while moving a column Grip, the entire Table adjusts at the same time.

Achieved by holding down the Ctrl key and then dragging this grip

Achieved by dragging this grip

Autofill Grip

The AutoFill grip allows you to fill the cells automatically by increments of 1 by selecting 1 cell and dragging to the next cell.

Make sure the cell data format is set correctly. (Refer to 5-17)

1. Place data in a cell. (**Important:** Data format should be "**whole number**". Refer to page 5-17)

2. Click on the AutoFill Grip.

3. Drag the cursor down to the desired cells.

4. The cell data advances by 1 unit.

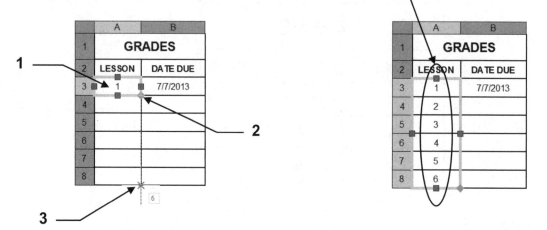

If you select 2 cells AutoFill will follow the incremental advance between the 2 cells. For example, if the date advances by 1 week rather than 1 day.

1. Fill two cells with the required dates and then select them both by holding down the **Shift** key and left-clicking each one. (Important: Set data format to "**Date**" Refer to page 5-17)

2. Select the AutoFill Grip

3. Drag the cursor down to the desired cells.

4. Cell data advances by 1 week.

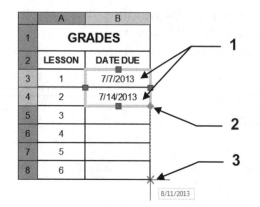
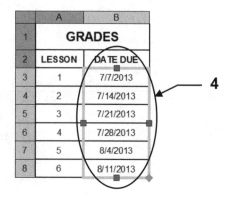

Autofill Options

You can specify how you want the cells formatted.

1. Left click on the AutoFill Grip.

2. Right click on the AutoFill Grip.

3. Select an Option from the List. (Description of each is shown below.)

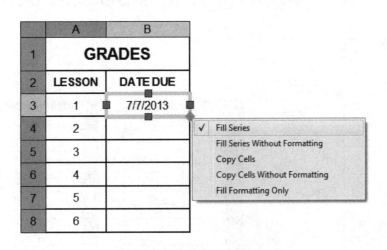

- **Fill Series**. Fills the subsequent cells with the data from the selected cell and advances at a rate of 1 unit. The format of the selected cell is maintained.
- **Fill Series Without Formatting**. Same as Fill Series except the formatting is not the same as the selected cell.
- **Copy Cells**. Duplicates the values and the formatting of the selected cells.
- **Copy Cells Without Formatting**. Same as Copy Cells except the formatting is not the same as the selected cell.
- **Fill Formatting Only**. Fills only cell formatting for the selected cells. Cell values are ignored.

To change the data formatting within a cell.

1. Left click inside the cell.

2. Right click and select **Data Format**....

3. Select from the **Data type** list.

Table Breaking

A long table can be broken into 2 or more separate tables using the Table Breaking Grip.

1. Click on the table border line.

2. Click on the Table Breaking Grip.

3. Move the cursor **up** to the cell location for the Table Break and left click.

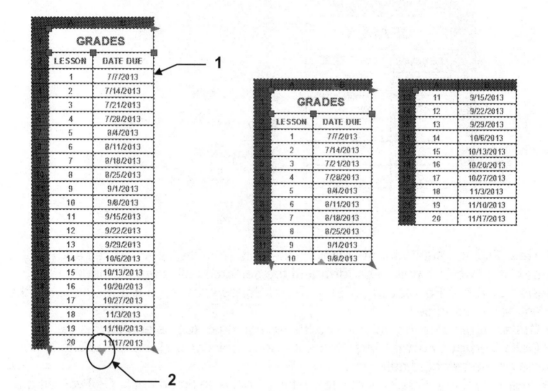

You will notice that the main and sub headings are not repeated on the second part of the broken table, you can change this in the **Properties** dialog box.

To add the headings on both tables.

1. Click on the table border line. (if it is already selected as above, skip this instruction)

2. Right click and select **Properties**.

3. Scroll down to **Table Breaks** then left click on **No** next to the **Repeat top labels** field, this will enable the drop-down list.

4. Select **Yes** from the list.

Continued on the next page...

Table Breaking....continued

5. Both tables will now have the main and sub headings included.

6. Press the **Esc** key to deselect the table. The broken table should now look similar to the image below.

GRADES	
LESSON	DATE DUE
1	7/7/2013
2	7/14/2013
3	7/21/2013
4	7/28/2013
5	8/4/2013
6	8/11/2013
7	8/18/2013
8	8/25/2013
9	9/1/2013
10	9/8/2013

GRADES	
LESSON	DATE DUE
11	9/15/2013
12	9/22/2013
13	9/29/2013
14	10/6/2013
15	10/13/2013
16	10/20/2013
17	10/27/2013
18	11/3/2013
19	11/10/2013
20	11/17/2013

You can also change the distance between the broken tables by changing the **Spacing** in the Properties dialog box. You can choose whether to have them closer together or further apart.

Select **Spacing** in the Properties dialog box to change this distance

GRADES	
LESSON	DATE DUE
1	7/7/2013
2	7/14/2013
3	7/21/2013
4	7/28/2013
5	8/4/2013
6	8/11/2013
7	8/18/2013
8	8/25/2013
9	9/1/2013
10	9/8/2013

GRADES	
LESSON	DATE DUE
11	9/15/2013
12	9/22/2013
13	9/29/2013
14	10/6/2013
15	10/13/2013
16	10/20/2013
17	10/27/2013
18	11/3/2013
19	11/10/2013
20	11/17/2013

Table Breaking....continued

There are also many other changes you can make to the broken table, a detailed description is shown below:

Enabled
If this option is set to **Yes** you can break the table, if it is set to **No** you cannot break the table.

Direction
Places the broken table to the left, right or down from the original table.

Repeat top labels
You can choose to have the top labels shown on all the broken tables or just the first part.

Repeat bottom labels
If your table has bottom labels you can choose to have the bottom labels shown on all the broken tables or just the first part.

Manual positions
This option allows you to move each segment of the broken table independently with the Move Grip on each one.

Manual heights
If **Yes** is selected on this option, a Breaking Grip will be placed on each table segment so you can additionally break them as well.

Break height
Breaks each segment into equal heights except possibly the last.

Spacing
As discussed earlier, you can change the spacing distance between each table segment.

Table Breaks	−
Enabled	Yes
Direction	Right
Repeat top labels	Yes
Repeat bottom lab...	No
Manual positions	No
Manual heights	No
Break height	2.3932
Spacing	.5940

FIELDS (Not available in the LT version)

A **Field** is a string of text that has been set up to display data that it gets from another source. For example, you may create a field that will display the Circumference of a specific Circle within your drawing. If you changed the diameter of that Circle you could "update" the field and it would display the new Circumference.

Fields can be used in many different ways. After you have read through the example below you will understand the steps required to create and update a Field. Then you should experiment with some of the other Field Categories to see if they would be useful to you. Consider adding Fields to a cell within a Table.

CREATE A FIELD

1. Draw a 2" Diameter Circle and place it anywhere in the drawing area.

2. Select the "**Insert**" tab / **Data** panel / **Field**

3. Select the Field category; **Objects**

4. Select the Field name; **Object**

5. Select the **Object Type** button.

6. Select the Circle that you just drew.

7. Select the property; **Circumference**.

8. Select the Format; **Decimal**.

9. Select **OK**.

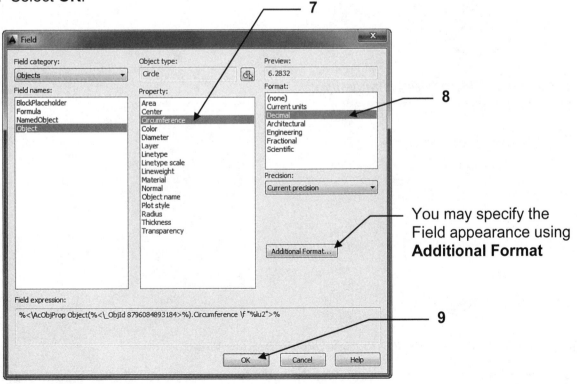

You may specify the Field appearance using **Additional Format**

Continued on the next page...

FIELDS....continued

10. Place the "Field" inside the Circle.

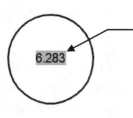

Note: Watch the command line closely. You may change the "Height" and "Justification" of the text before you place it.

*Notice that the Field appears with a gray background. This background will not plot. The background can be turned off but I find it helpful to be able to visually distinguish a Field from plain text. If you wish to turn it off use: **Options / User Preferences tab**. In the **Fields** section, uncheck the "**Display background of Fields**" box.*

UPDATE A FIELD

Now let's change the diameter of that Circle and see what happens to the Field.

1. Change the size of the Circle.
 a. Select the Circle.
 b. Right click and select Properties.
 c. Change the Diameter to 4.
 d. Close the Properties Palette.
 e. Press ESC key to clear the Grips.

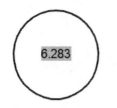

Notice that the Field has not changed yet.
In order to see the new Circumference value, you must "Update the Field".

2. Type **Regen <enter>**.

The Field has now updated to the new Circumference value.

Note: The Field will update automatically each time you Save, Plot or Regenerate the drawing.

FIELDS....continued

ADD A FIELD TO A TABLE CELL

1. Select the cell.

2. Right click.

3. Select "**Insert / Field**" from the menu.

4. Create a Field as described on page 5-21.

As an example of inserting Fields into a table, you could create a table with all the cells showing the properties of circles. The example below shows 5 circles and a table with various circle properties.

CIRCLE PROPERTIES				
CIRCLE NO.	DIAMETER	RADIUS	CIRCUMFERENCE	AREA
1	1.250	0.625	3.927	1.227
2	1.000	0.500	3.142	0.785
3	0.800	0.400	2.513	0.503
4	0.750	0.375	2.356	0.442
5	0.625	0.313	1.963	0.307

You can protect a Cell or multiple Cells by either locking the Content or by locking the Format of the Cell, or you could choose to do both.

TO LOCK A CELL

1. Select the Cell you wish to lock.

2. Right click and select **Locking**.

3. Choose from the options in the list.

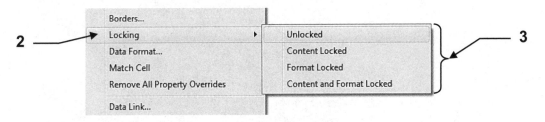

Editing Fields

Editing a Field is very easy. The process is basically the same as creating a Field.

EDIT A FIELD

1. Double click the **Field text**. The Multiline Text Editor will open.
2. Right click on the **Field text**.
3. Select **Edit Field** from the menu.
4. Make the changes.
5. Select **OK**.
6. You may also add more text to the Field text but you may not change the text within the Field.
 Example: Add the words "Circle Circumference" under the Field text on the previous pages.
7. Select **Close Text Editor** to exit the Multiline Text Editor.

Questions about Fields

1. *What happens when you Explode a Field?*

The Field will convert to normal text and will no longer update.

EXERCISE 5A

CREATE A NEW TABLE STYLE

A. Start a **New** file using **My Decimal Setup.dwt**

B. Create a New Table.

 1. Type **TS** <enter> (Refer to page 5-2)

 2. Select the **New** button.

 3. Enter the new Table Style "name" and start with "Standard".

 4. Select the **Continue** button.

Continued on the next page...

EXERCISE 5A....continued

C. Select "**Title**" from the **Cell Type** settings.

Cell styles

Title

| General | Text | Borders |

Properties

Fill color: ☐ Green

Alignment: Middle Center

Format: Text

Type: Label

Margins

Horizontal: .060

Vertical: .060

☑ Merge cells on row/column creation

Click here to select "Text" from the Format box

Cell styles

Title

| General | Text | Borders |

Properties

Text style: TEXT-CLASSIC

Text height: .250

Text color: ■ Black

Text angle: 0

Note: If you are using a Black background in the drawing area select "White"

Cell styles

Title

| General | Text | Borders |

Properties

Lineweight: ——— ByBlock

Linetype: ——— ByBlock

Color: ■ Black

☐ Double line

Spacing: .045

Apply the selected properties to borders by clicking the buttons above.

Continued on the next page...

EXERCISE 5A....continued

C. Select "**Header**" from the **Cell Type** settings.

Cell styles

Header

General | Text | Borders

Properties

Fill color: ☐ Yellow

Alignment: Middle Center

Format: Text

Type: Label

Margins

Horizontal: .060

Vertical: .060

☐ Merge cells on row/column creation

Click here to select "Text" from the Format box

Cell styles

Header

General | Text | Borders

Properties

Text style: TEXT-CLASSIC

Text height: .180

Text color: ■ Black

Text angle: 0

Note: If you are using a Black background in the drawing area select "White"

Cell styles

Header

General | Text | Borders

Properties

Lineweight: ──── ByBlock

Linetype: ──── ByBlock

Color: ■ Black

☐ Double line

Spacing: .045

Apply the selected properties to borders by clicking the buttons above.

Continued on the next page...

EXERCISE 5A....continued

C. Select "**Data**" from the **Cell Type** settings.

Cell styles

Data

General | Text | Borders

Properties
Fill color: ☐ Cyan
Alignment: Middle Center
Format: Text
Type: Data

Margins
Horizontal: .060
Vertical: .060

☐ Merge cells on row/column creation

Click here to select "Text" from the Format box

Cell styles

Data

General | Text | Borders

Properties
Text style: TEXT-CLASSIC
Text height: .125
Text color: ■ Black
Text angle: 0

Note: If you are using a Black background in the drawing area select "White"

Cell styles

Data

General | Text | Borders

Properties
Lineweight: ——— ByBlock
Linetype: ——— ByBlock
Color: ■ Black
☐ Double line
Spacing: .045

Apply the selected properties to borders by clicking the buttons above.

Continued on the next page...

EXERCISE 5A....continued

D. Select the **OK** button.

D

E. Set the new table style current.

E

F

F. Select the **Close** button.

G. Save as: **EX-5A**

EXERCISE 5B

INSERT A TABLE

1. Open **EX-5A** (If not already open)
2. Insert the Table shown below using the following Column and Width settings.

3. Enter the **Title** and **Header** text.

CIRCLE INFORMATION			
ITEM	DIA	CIR	AREA

4. Save as: **EX-5B**

EXERCISE 5C

MODIFY AN EXISTING TABLE

1. Open **EX-5B** (If not already open)

2. Modify the **Column Header** "Cir" to "Circumference" using "Properties".

 a. First change the Cell width to 2.750

 b. Edit the text

3. Add the data for column "**ITEM**"

 Try "AutoFill Grip" described on page 5-16.

 Make sure cell data is formatted as "Whole Number". See page 5-17

4. Add the diagonal guidelines if desired.

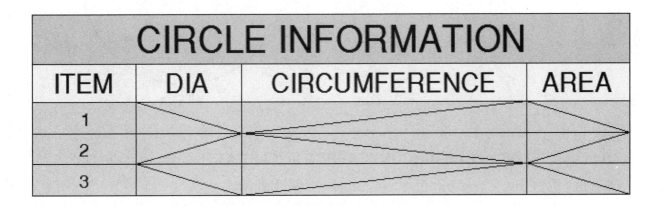

5. Save as: **EX-5C**

EXERCISE 5D

ADD FIELDS TO AN EXISTING TABLE

1. Open **EX-5C** (If not already open)

2. Draw 3 Circles and place their item number (.25 Text Height) in the middle, as shown below. (**Tip:** You could use Single-Line Text with Justify set too: Middle Centre **MC**).

| 2" Dia | 3" Dia | 4" Dia |

3. Add the <u>FIELDS</u> for **DIA, CIRCUMFERENCE** and **AREA** in the appropriate Data Cells within the "Circle Information" Table shown below.

Text Ht = .125 Justification = Middle Center

(Height and Justify are on the command line)

CIRCLE INFORMATION			
ITEM	DIA	CIRCUMFERENCE	AREA
1	2.000	6.283	3.142
2	3.000	9.425	7.069
3	4.000	12.566	12.566

4. Save as: **EX-5D**

EXERCISE 5E

UPDATE A FIELD

1. Open **EX-5D** (If not already open)

2. Modify the Diameters of the 3 Circles using **Properties**.

1" Dia **2" Dia** **3" Dia**

3. Update the Fields: Type: **Regen** <enter> (Refer to page 5-22)

CIRCLE INFORMATION			
ITEM	DIA	CIRCUMFERENCE	AREA
1	1.000	3.142	0.785
2	2.000	6.283	3.142
3	3.000	9.425	7.069

4. Save as: **EX-5E**

EXERCISE 5F

USING AUTOFILL GRIP

1. Open **EX-5A** (If not already open)

 You are using 5A because it has the "Circle Information" table style saved in it.

2. Draw the table shown below using table style "Circle Information".

3. Specify Columns and Rows as shown here.

4. Try **AutoFill Grip** to fill the cells. It is really not difficult and may save you time.

 (Refer to page 5-16)

Format: Whole Number

Format: Date

GRADES	
LESSON 1	LESSON 2
1	3/7/2013
2	3/8/2013
3	3/9/2013
4	3/10/2013
5	3/11/2013
6	3/12/2013
7	3/13/2013
8	3/14/2013
9	3/15/2013
10	3/16/2013
11	3/17/2013
12	3/18/2013

Note:
If this box appears select "Cancel". AutoCAD thinks the date is a fraction and wants you to specify if you want the fraction stacked.

4. Save as: **EX-5F**

EXERCISE 5G

BREAKING A TABLE

1. Open **EX-5F** (If not already open)

2. Break the table as shown below. (Refer to page 5-18)

GRADES	
LESSON 1	LESSON 2
1	3/7/2013
2	3/8/2013
3	3/9/2013
4	3/10/2013
5	3/11/2013

6	3/12/2013
7	3/13/2013
8	3/14/2013
9	3/15/2013
10	3/16/2013
11	3/17/2013
12	3/18/2013

3. Now change the broken table Direction to **"Down"** using **Properties.**

GRADES	
LESSON 1	LESSON 2
1	3/7/2013
2	3/8/2013
3	3/9/2013
4	3/10/2013
5	3/11/2013

6	3/12/2013
7	3/13/2013
8	3/14/2013
9	3/15/2013
10	3/16/2013
11	3/17/2013
12	3/18/2013

Position 2	.0000
Table Breaks	—
Enabled	Yes
Direction	Down
Repeat top labels	No
Repeat bottom lab...	No
Manual positions	No
Manual heights	No
Break height	2.2470
Spacing	.6880

PROPERTIES

4. Save as: **EX-5G**

Notes:

LEARNING OBJECTIVES

After completing this lesson, you will be able to:

1. Create an Isometric object
2. Create an Ellipse on an Isometric plane

LESSON 6

ISOMETRIC DRAWING

An ISOMETRIC drawing is a pictorial drawing. It is primarily used to aid in visualizing an object. There are 3 faces shown in one view. They are: Top, Right and Left. Auto-CAD provides you with some help constructing an isometric drawing but you will be doing most of the work. The following is a description of the isometric assistance that AutoCAD provides.

Note: This is not 3D. Refer the "Introduction to 3D" section in this workbook.

ISOMETRIC SNAP and GRID

1. Select **DRAFTING SETTINGS** by typing **DS <enter>**

 or

2. Right click on the **SnapMode** Status bar button then select **Snap Settings** from the short cut menu.

The following dialog box should appear.

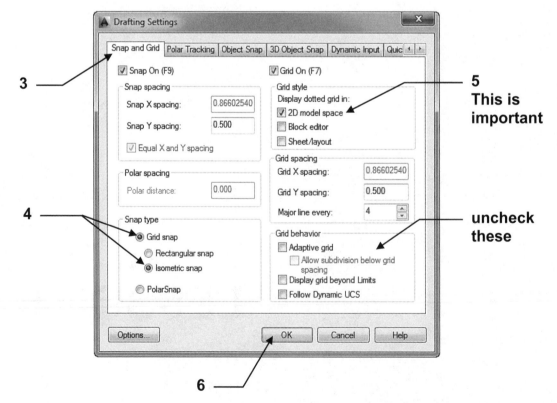

Continued on the next page...

ISOMETRIC DRAWING....continued

3. Select the "**Snap and Grid**" tab.
4. Select **"Grid snap"** and **"Isometric snap"**.
5. Select "Display dotted grid in: **2D model space**" (Important)
6. Select **OK.**

NOTE:
*The Grid pattern and Cursor should have changed. The grid lines are now dots and on a 30 degree angle. The cursor's horizontal crosshair is now on a 30 degree angle also. This indicates that the **ISOPLANE LEFT** is displayed.*

You may also turn the **Isometric Snap** on or off by selecting the **ISODRAFT** status bar button.

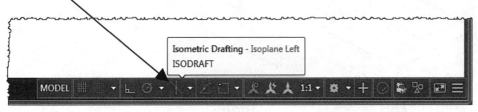

The **ISODRAFT** button should be displayed on the status bar by default. You can choose to display the button or remove it from the status bar.

To add or remove ISODRAFT from the Status Bar.

1. Select and click on the **Customization** button.

2. Check or uncheck **Isometric Drafting** on the menu.

3. Left click in the main drawing area to close the menu.

ISOPLANES

ISOPLANES

There are 3 isoplanes, **Left, Top** and **Right**. You can toggle to each one by pressing the **F5** key. You may also toggle Isoplanes by Right clicking on the **ISODRAFT** status bar button and selecting from the menu.

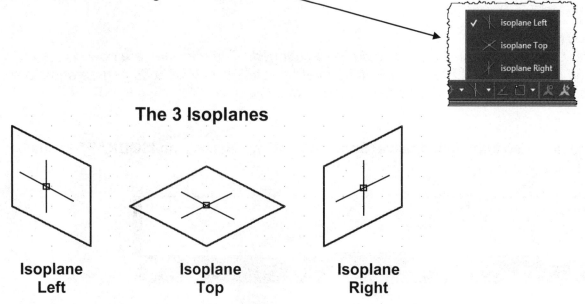

The 3 Isoplanes

Isoplane **Left**	Isoplane **Top**	Isoplane **Right**

Important: Grid, Snap and Ortho should be ON when using isoplanes.

Try drawing the 3 x 3 x 3 cube shown below using the "Line" command.

1. Start with the Left Isoplane.
 (Ortho ON and type 3 <enter>)
 for each line.

2. Next change to the Top Isoplane
 (Press F5 once) and draw the top.

3. Next change to the Right Isoplane
 (Press F5 once) and draw the Right side.

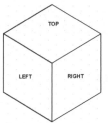

ISOMETRIC ELLIPSE

ISOMETRIC ELLIPSE

An isometric ellipse is a very helpful option when drawing an isometric drawing. AutoCAD calls an isometric ellipse an **ISOCIRCLE**. This option is located in the Ellipse command.

IMPORTANT:
The ISOCIRCLE option will only appear if you have selected the Isometric Grid and Snap shown on page 6-2 item 4. The Isocircle option will not appear if you select the Rectangular Grid and Snap.

CREATE AN ISOMETRIC ELLIPSE

1. Change to the Left Isoplane. (Isometric Grid and Snap must be ON.)

2. Select the **Ellipse** "**Axis End**" command. *(Do not select "Ellipse, Center")*

 Command: _ellipse
 Specify axis endpoint of ellipse or [Arc/Center/Isocircle]: *type "I" <enter>*
 Specify center of isocircle: *specify the center location for the new isocircle*
 Specify radius of isocircle or [Diameter]: *type the radius <enter>*

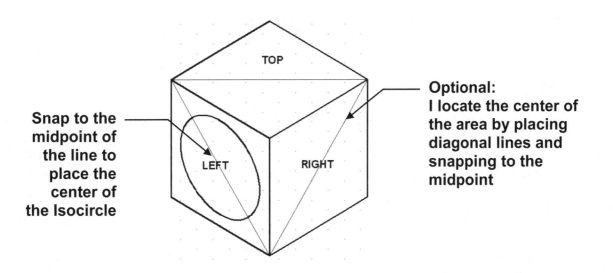

Snap to the midpoint of the line to place the center of the Isocircle

Optional:
I locate the center of the area by placing diagonal lines and snapping to the midpoint

3. Now try drawing an Isocircle on the top and right, using the method above. Don't forget to change the "Isoplane" to match the isoplane of the isocircle.

EXERCISE 6A

ISOMETRIC ASSEMBLY

1. Start a **New** file using **My Decimal Setup.dwt**.
2. Select the **Model** tab (do not select ASize tab)
3. Set the **"Snap type and Grid"** as shown on page 6-2)
4. Change to isoplane "**Top**"
5. Draw the objects below. Do not dimension
6. Save as: **EX-6A**

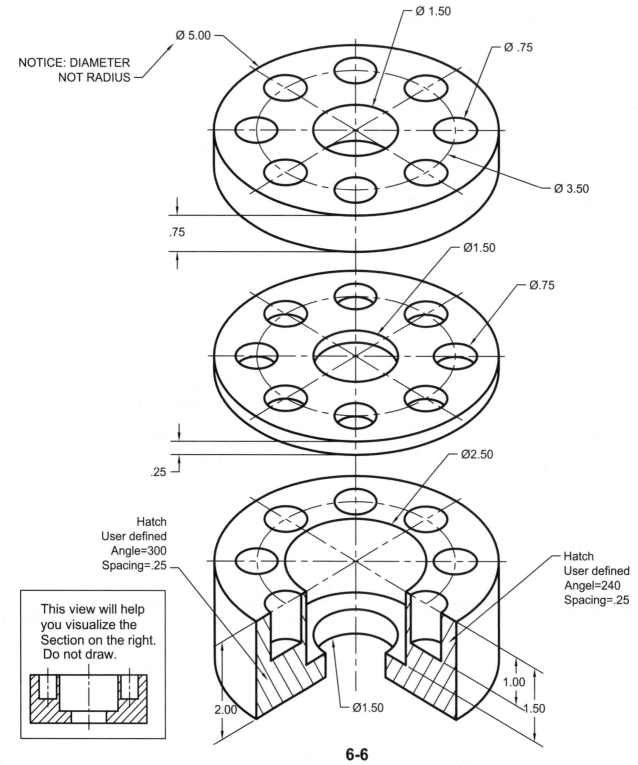

NOTICE: DIAMETER
NOTICE: NOT RADIUS

Ø 5.00
Ø 1.50
Ø .75
Ø 3.50
.75

Ø1.50
Ø.75
.25

Ø2.50
Hatch
User defined
Angle=300
Spacing=.25

Hatch
User defined
Angel=240
Spacing=.25

This view will help
you visualize the
Section on the right.
Do not draw.

2.00
Ø1.50
1.00
1.50

EXERCISE 6B

ISOMETRIC OBJECT

1. Start a **New** file using **My Decimal Setup.dwt**.
2. Select the **Model** tab (not the ASize tab)
3. Set the **"Snap type and Grid"** as shown on page 6-2)
4. Change to isoplane with F5 when necessary.
5. Draw the objects below. Do not dimension
6. Save as: **EX-6B**

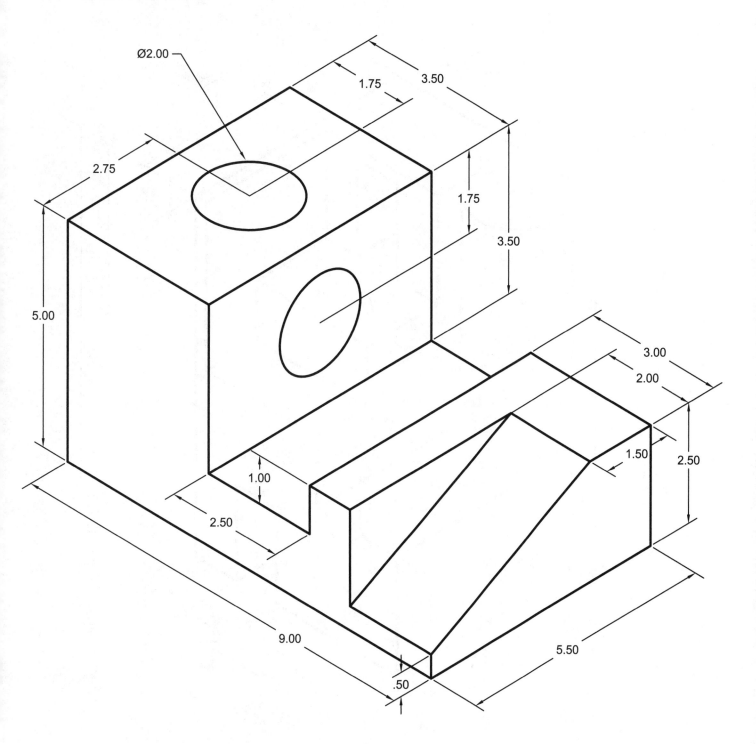

EXERCISE 6C

ABSTRACT HOUSE

1. Start a **New** file using **My Feet-Inches Setup.dwt**.
2. Select the **Model** tab (not the 'A' Size tab)
3. Set the **"Snap type and Grid"** as shown on page 6-2)
4. Change to isoplane with F5 when necessary.
5. Draw the Abstract House shown below. Do not dimension
6. Save as: **EX-6C**

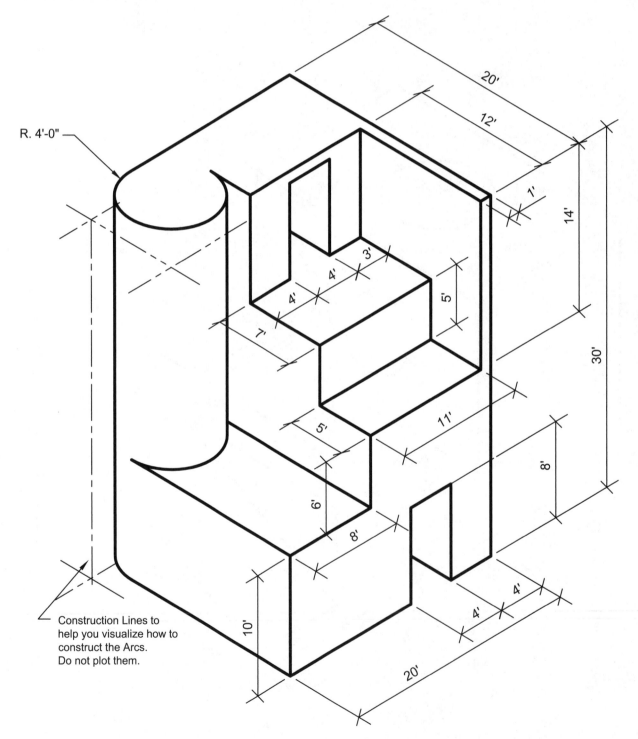

R. 4'-0"

Construction Lines to
help you visualize how to
construct the Arcs.
Do not plot them.

LEARNING OBJECTIVES

After completing this lesson, you will be able to:

1. Copy, Cut and Paste
2. Dimension an Isometric object
3. Create Isometric Text

LESSON 7

COPY CLIP and CUT

AutoCAD allows you to **Copy** or **Cut** objects from one drawing and **Paste** them into another drawing or document.

Copy Clip (copies the selected objects to clipboard, base point defaults to 0,0)

1. Select the object(s) to be copied.
2. Select the command using one of the following:

 Ribbon = Home tab / Clipboard panel /
 Short cut Menu (right click) = Clipboard / Copy
 Keyboard = Ctrl + C

3. The selected objects will be copied to the clipboard (Computers memory)
 Refer to **"Paste"** on the next page.

Copy with Base point (allows you to select a base point and copies the selected objects to clipboard)

1. Select the object(s) to be copied.
2. Select the command using one of the following:

 Ribbon = None
 Short cut Menu (right click) = Clipboard / Copy with Base Point
 Keyboard = Ctrl + Shift + C

2. Select the base point

3. The selected object(s) will be copied to the clipboard (Computers memory)
 Refer to **"Paste"** on the next page.

Cut (copies the selected objects to the clipboard and deletes them from drawing)

1. Select the objects you wish to Copy and Delete (at the same time)
2. Select the command using one of the following:

 Ribbon = Home tab / Clipboard panel /
 Short cut Menu (right click) = Clipboard / Cut
 Keyboard = Ctrl + X

3. The selected objects will be copied to the clipboard and then deleted from the drawing.
 Refer to **"Paste"** on the next page.

PASTE

After you have used one of the copy commands, on the previous page, you may **paste** the previously selected objects into the current drawing, another drawing or a document created with another software such as MS Word or MS Excel.

1. Select the command using one of the following:

 Ribbon = Home tab / Clipboard panel / **(See other options below)**

 Short cut Menu (right click) = Clipboard / Paste

 Keyboard = Ctrl + V

2. Place the objects in the location desired.

__Refer to the next page for step by step instructions for Copy and Paste.__

ADDITIONAL PASTE OPTIONS:

PASTE as BLOCK or PASTEBLOCK
Copies objects into the same or different drawing as a BLOCK.

PASTE as a Hyperlink

PASTE to ORIGINAL COORDINATES or PASTEORIG
Pastes objects into the new drawing at the same coordinate position as the original drawing. You will not be prompted for an insertion point.

PASTE SPECIAL or PASTESPEC
Use when pasting from other applications into AutoCAD.

How to Copy and Paste from one drawing to another.

To copy selected objects from one drawing and Paste them into another drawing is very easy. There are just a few new things you have to learn.

How to copy objects from one drawing to another drawing.

Step 1. Copy the objects to the clipboard.
1. Make sure that **File Tabs** is enabled. (Refer to page 1-2)
2. Open 2 or more drawings.
3. Click on the drawing tab from which you will copy objects to make the drawing **Active**.

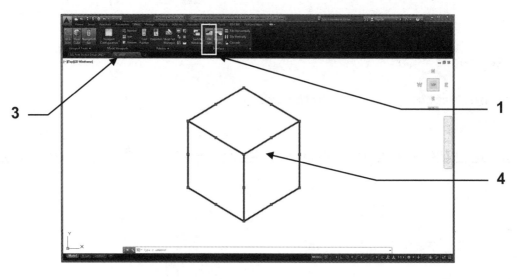

4. Select the objects to copy to the clip board
5. Select the **Copy Clip** command. (Refer to page 7-2)

Step 2. Paste the Objects into another drawing.
1. Click on the drawing tab in which you will paste the previously copied objects to make the drawing **Active**.
2. Select the **Paste** command. (Refer to page 7-3)
3. Place the previously copied objects in the desired location.

Notice the drawing may appear a different size. It depends on the scale of the viewport or Zoom. But the actual size has not changed.

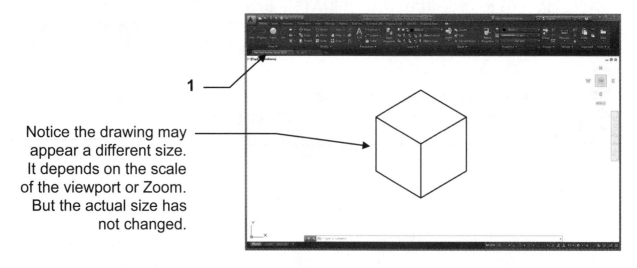

CHANGE SPACE

The **Change Space** command moves objects between Model Space and Paper Space. The object is automatically scaled to maintain visual appearance.

This is a very handy command. It is very easy to draw an object or place text in the wrong space. Especially if the viewport scale is 1:1. This command allows you to quickly transfer the object from one space to the other. *Previous to this command you would CUT the object from the space and PASTE it to the new space.*

How to use the Change Space command.

1. Select a layout tab. (This command cannot be used in the Model tab)

2. Select the **Change Space** command using one of the following:

 Ribbon = Home tab / Modify panel ▼ /
 or
 Keyboard = chspace

3. Select objects: *select the object to move*

4. Select objects: *select more objects or <enter> to stop*

5. Select the SOURCE viewport active and press ENTER to continue: *click inside the target viewport and press <enter>*

The objects will change from their original space to the other space. Objects will be scaled to maintain visual appearance.

ISOMETRIC TEXT

AutoCAD doesn't really have an Isometric Text. But by using both **Rotation** and **Oblique angle**, you can make text appear to be laying on the surface of an Isometric object.

1. First create two new text styles. One with an <u>oblique angle</u> of **30** and the other with an <u>oblique angle</u> of **minus 30**.

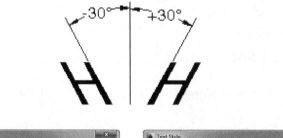

2. Next select the appropriate text style and rotation as follows:

 a. Select the text style with an obliquing angle of 30 or minus 30. (Set Current)
 b. Select **SINGLE LINE TEXT**
 c. Place the START POINT or Justify.
 d. Type the Height.
 e. Type the Rotation angle.
 f. Type the text.

Example:

The text appears to be on the top and side surfaces.

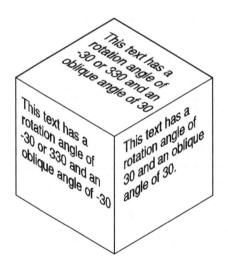

Dimensioning an Isometric Drawing

Dimensioning an isometric drawing in AutoCAD is a two-step process.
First you dimension it with the dimension command **ALIGNED**.
Then you adjust the angle of the extension line with the dimension command
OBLIQUE.

Step 1. Dimension the object using the dimension command **Aligned.**

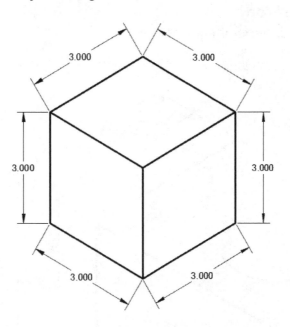

Step 2. Adjust the angle of the **extension lines** using the dimension command
Oblique. (Do each dimension individually)

1. Select dimension command **Oblique**

2. Select the dimension you wish to adjust.
3. Enter the oblique angle for the extension line. (30, 150, 210 or 330)

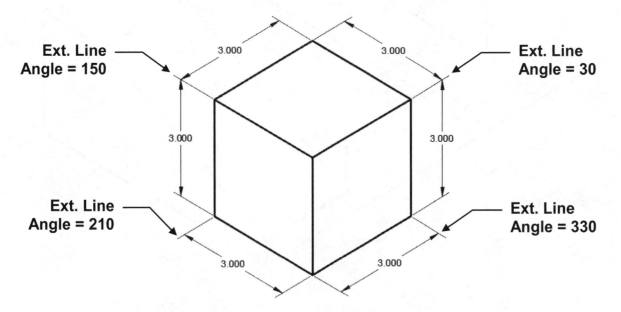

EXERCISE 7A

OBLIQUE DIMENSIONING

1. Open drawing **EX-6B**
2. Dimension the isometric object shown below. (Refer to page 7-7)
3. Use "Aligned" and then "Oblique".
4. Change to isoplane "**Top**"
5. Use grips to move dimensions if necessary.
6. Save as: **EX-7A**

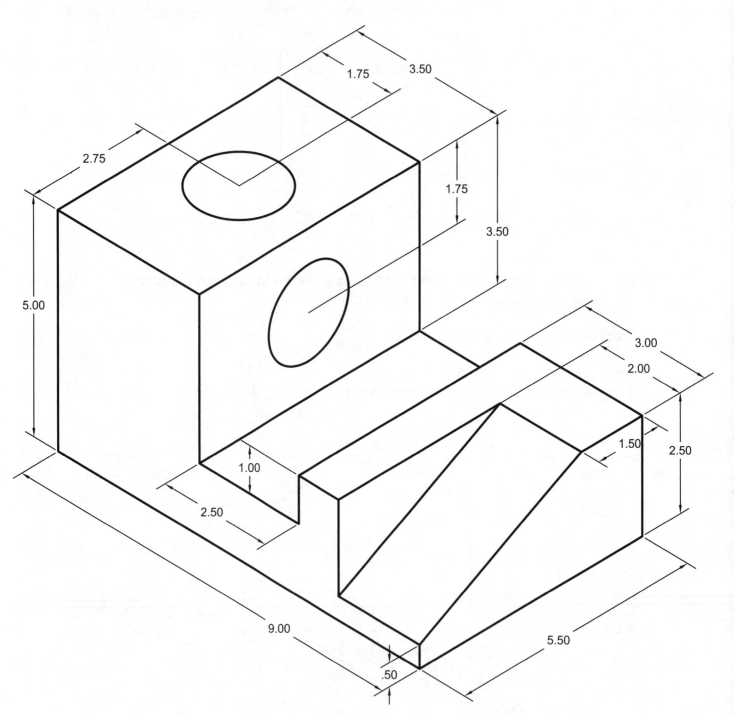

EXERCISE 7B

OBLIQUE DIMENSIONING

1. Open drawing **EX-6C**
2. Dimension the house.
3. Save as: **EX-7B**

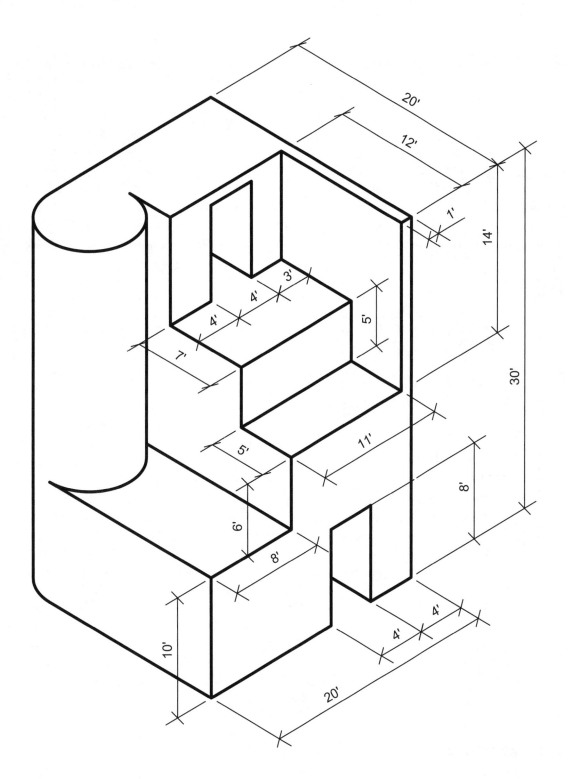

EXERCISE 7C

ISOMETRIC TEXT

1. Start a **New** file using **My Decimal Setup.dwt**
2. Select the Model tab.
3. First create two new text styles. One with an oblique angle of 30 and the other with an oblique angle of minus 30.

30 **MINUS 30**

4. Draw a 4 inch cube.

5. Next select the appropriate text style and rotation to create the text on the cube shown below.

 a. Select the text style with an oblique angle of 30 or minus 30.
 b. Select **SINGLE LINE TEXT**.
 c. Place the START POINT (Lower left corner) approximately as shown.
 d. Type the Height = .25
 e. Type the Rotation angle.
 f. Type the text.

6. Save as: **EX-7C**

LEARNING OBJECTIVES

After completing this lesson, you will be able to:

1. Review Creating a Block
2. Review inserting a Block
3. Assign and use Attributes

LESSON 8

BLOCKS

A **BLOCK** is a group of objects that have been converted into ONE object. A Symbol, such as a transistor, bathroom fixture, window, screw or tree, is a typical application for the block command. First a BLOCK must be created. Then it can be INSERTED into the drawing. An inserted Block uses less file space than a set of objects copied.

CREATING A BLOCK

1. First draw the objects that will be converted into a Block.

 For this example a circle and 2 lines are drawn.

2. Select the **CREATE BLOCK** command using one of the following:

 **Ribbon = Insert tab / Block definition panel /
 or
 Keyboard = B <enter>**

3. Enter the New Block name in the **Name** box.

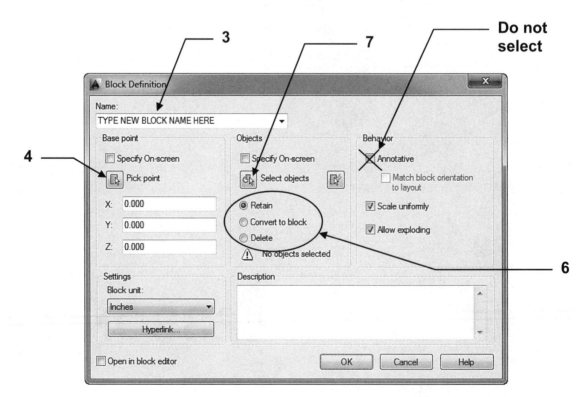

Continued on the next page...

BLOCKS....continued

4. Select the **Pick Point** button. (Or you may type the X, Y and Z coordinates.)
 The Block Definition box will disappear and you will return temporarily to the drawing.

5. Select the location where you would like the insertion point for the Block.
 Later when you insert this block, the block will appear on the screen attached to the cursor at this insertion point. Usually this point is the CENTER, MIDPOINT or ENDPOINT of an object.

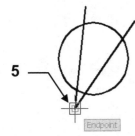

Notice the coordinates for the base point are now displayed. (Don't worry about this. Use Pick Point and you will be fine)

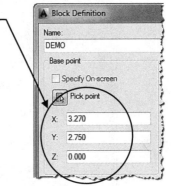

6. Select one of the options described below.

 It is important that you select one and understand the options below.

 Retain
 If this option is selected, the original objects will stay visible on the screen after the block has been created.

 Convert to block
 If this option is selected, the original objects will disappear after the block has been created, but will immediately reappear as a block. It happens so fast you won't even notice the original objects disappeared.

 Delete
 If this option is selected, the original objects will disappear from the screen after the block has been created. (This is the one I use most of the time)

7. Select the **Select Objects** button.

 The Block Definition box will disappear and you will return temporarily to the drawing.

8. Select the objects you want in the block, then press <enter>.

Selection Window

Continued on the next page...

BLOCKS....continued

The Block Definition box will reappear and the objects you selected should be displayed in the Preview Icon area.

10 ⎯⎯⎯ ⎯⎯ **Preview**

9. Select the **OK** button.
 The new block is now stored in the drawing's block definition table.

10. To verify the creation of this Block, select [icon] **Create Block** again, and select

 the Name (▼). A list of all the blocks, in this drawing, will appear.
 (Refer to page 8-6 for inserting instructions)

Continued on the next page...

ANNOTATIVE BLOCKS

If you want the appearance and size of the a Block to remain consistent, no matter what the scale of the viewport, you may make it <u>annotative</u>. Normally Blocks are not Annotative. For example, a Bathtub would not be annotative. You would want the Bathtub appearance to increase or decrease in size as you change the viewport scale. But the size of a Page or Section designator, as shown below, may be required to remain a consistent size no matter where it is displayed. To achieve this, you would make it Annotative.

Example:

1. Make a block such as the example below.

2. Insert the block into your drawing in modelspace.

3. Add an **annotative object scale** such as: 1:2 or 1:4 to the block.
 (Refer to the Beginning workbook lesson 28 to review how to add multiple annotative scales)

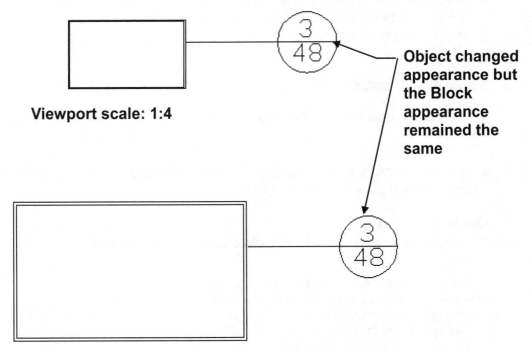

Viewport scale: 1:4

Object changed appearance but the Block appearance remained the same

Viewport scale: 1:2

INSERTING BLOCKS

A **BLOCK** can be inserted at any location within the drawing. When inserting a Block you can **SCALE** or **ROTATE** it.

1. Select the **INSERT** command using one of the following:

 Ribbon = Insert tab / Block panel /
 or
 Keyboard = Insert <enter>

2. Select the **BLOCK** name.
 a. If the block is already in the drawing that is open on the screen, you may select the block from the drop down list shown above
 b. If you want to insert an entire drawing, select the Browse button to locate the drawing file.

3. Select the **OK** button.

 This returns you to the drawing and the selected block should be attached to the cursor.

4. Select the insertion location for the block by moving the cursor and pressing the left mouse button or typing coordinates.

 Command: _insert
 Specify insertion point or **[Basepoint/Scale/X/Y/Z/Rotate]:**

 NOTE: If you want to change the **basepoint, scale** or
 rotate the block before you actually place the block,
 press the right hand mouse button and you may
 select an option from the menu or select an option
 from the command line menu shown above.

 You may also "**preset**" the insertion point, scale or
 rotation. This is discussed on the next page.

Continued on the next page...

INSERTING BLOCKS….continued

PRESETTING THE <u>INSERTION POINT</u>, <u>SCALE</u> or <u>ROTATION</u>

You may preset the **Insertion point, Scale or Rotation** in the <u>**INSERT**</u> box instead of at the command line.

1. Remove the check mark from any of the **"Specify On-screen"** boxes.

2. Fill in the appropriate information describe below:

 Insertion point
 Type the X and Y coordinates <u>from the Origin</u>. The Z is for 3D only.
 The example below indicates the block's insertion location will be 5 inches in the X direction and 3 inches in the Y direction, <u>from the Origin</u>.

 Scale
 You may scale the block proportionately by typing the scale factor in the X box and then check the <u>Uniform Scale box</u>. If you selected "Scale uniformly" box when creating the block this option is unnecessary and not available.
 If the block is to be scaled non-proportionately, type the different scale factors in both X and Y boxes.
 The example below indicates that the block will be scale proportionate at a factor of 2.

 Rotation
 Type the desired rotation angle relative to its current rotation angle.
 The example below indicates the block will be rotated 45 degrees from its originally created angle orientation.

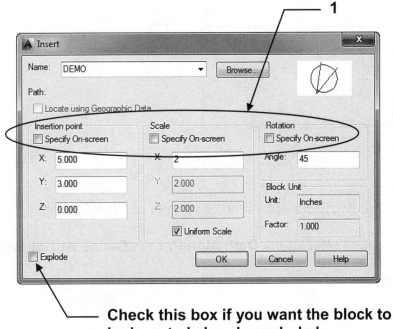

Check this box if you want the block to be inserted already exploded

ATTRIBUTES

The **ATTRIBUTE** command allows you to add text data to a block. You define the attribute and attach it to a block. Every time you insert the block, the attribute text is also inserted.

For example, if you had a block in the shape of a tree, you could assign information (attributes) about this tree, such as name, size, cost, etc.
Each time you insert the block, AutoCAD will pause and prompt you for "What kind of tree is this?" You respond by entering the tree name.
Then another prompt will appear, "What size is this tree? You respond by entering the size.
Then another prompt will appear, "What is the cost"? You respond by entering the cost.
The tree symbol will then appear in the drawing with the name, size and cost displayed.

Another example could be a title block. If you assign attributes to the text in the title block, when you insert the title block it will pause and prompt you for "What is the name of the drawing?" or "What is the drawing Number?". You respond by entering the information. The title block will then appear in the drawing with the information already filled in.

You will understand better after completing the following example.

CREATING BLOCK ATTRIBUTES

1. Draw a rectangle 2 " X 1"

1

2

2. Select the **Define Attribute** command using one of the following:

Ribbon = Insert tab / Block Definition Panel / Define Attributes

Keyboard = attdef

Continued on the next page...

ATTRIBUTES....continued

The Attribute definition box will appear.

Definitions on page 8-12

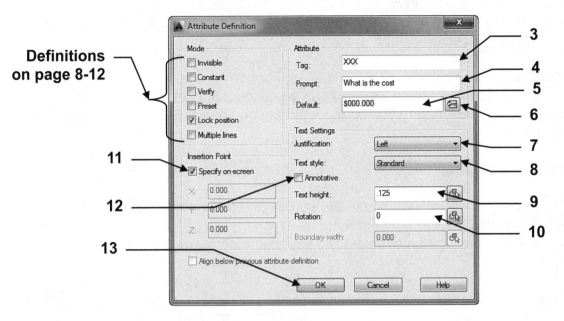

3. **Enter the Attribute tag**.
 A "Tag" is only a place saver. The "XXX's" will be replaced with your response to the prompt when the block is inserted. No spaces allowed.

4. **Enter the Attribute prompt**.
 This is the prompt that will appear when AutoCAD pauses and prompts you for information. (You create the prompt) If you select Mode "constant" (page. 8-12) the prompt will not appear.

5. **Enter a "default" value if necessary**.
 The value will appear beside the prompt, in brackets, indicating what format the prompt is requesting. Example: What is the cost? <$0.00> The $0.00 inside the brackets is the "Value".

6. **Insert Field Button**
 Displays the Field dialog box. You can insert a field as all or part of the value for an attribute. Fields were discussed previously in Lesson 5.

7. **Select the Justification for the text.**
 This will be used to place the Attribute text.

8. **Select a Text Style**.
 Select a non-annotative style such as "Standard".

9. **Enter the text Height**.
 This will be the height of the Attribute text.

10. **Enter the Rotation angle**.
 This will be the rotation angle of the Attribute text. Such as: 90, 270 etc.

Continued on the next page...

ATTRIBUTES....continued

11. **Insertion Point**.
 You may uncheck the "Specify on Screen" box and enter the X, Y and Z coordinates if you know the specific coordinates or select the "Specify on Screen" box to place the insertion point manually.

12. **Annotative**
 If your block is an object such as a bathtub you should not select Annotative.
 If your block is a designator such as the example on page 8-5 you should select Annotative.

13. Select the **OK** button.

14. The "**tag**" (item 3) will be attached to the cursor. Place it somewhere on the drawing to establish the insertion point.
 In this example, the tag has been placed approximately in the center of the rectangle.

15. Select **Create Block** command to create a block. (Refer to page 8-2)
 Make a block of the rectangle and the attribute text.
 Name = abc
 Pick Point = upper right corner of rectangle
 Select Objects = Select rectangle and attribute text with a crossing window.
 Annotative = Do not make it annotative

16. Select **OK** button.

17. Select **INSERT** command (Refer to page 8-6)
 a. Select block name **abc** and then **OK** button.
 b. Place the block somewhere on the screen and press the left mouse button.
 The "Enter Attributes" prompt will appear on the command line or in the Dynamic Input box.
 c. Type: **$300.00 <enter>**

Continued on the next page...

ATTRIBUTES....continued

18. Select **INSERT** command **again.**
 a. Select block name **abc** and then **OK** button.
 b. Place the block somewhere on the screen and press the left mouse button.
 c. Type: **$450.00 <enter>**

$450.00

19. Select **INSERT** command **again.**
 a. Select block name **abc** and then **OK** button.
 b. Place the block somewhere on the screen and press the left mouse button.
 c. Type: **$75.00 <enter>**

$75.00

You should now have 3 identical rectangles with the exception of the attribute text .
You inserted the same block but the text is different in each.
Think how this could be useful in other applications.

EDIT ATTRIBUTES DIALOG BOX

When you insert a block with attributes the **Edit Attributes** dialog box appears where you can enter the attribute information. If you would prefer to have the attribute prompts appear on the command line or in the dynamic input box, follow the instructions below.

1. **Type: Attdia <enter>**
2. **Enter 0 or 1 <enter>**

If the variable **ATTDIA** is set to **0**, the prompt will appear on the command line or in the Dynamic Input box.

By default the variable **ATTDIA** is set to **1**, the dialog box shown here will appear.

Continued on the next page...

ATTRIBUTES....continued

ATTRIBUTE MODES

Invisible
If this box is checked, the attribute will be invisible. You can make it visible later by typing the ATTDISP command and selecting ON.

Constant
The attribute stays constant. It never changes and you will not be prompted for the value when the block is inserted.

Verify
After you are prompted and type the input, you will be prompted to verify that input. This is a way to double check your input before it is entered on the screen. This option does not work when ATTDIA is set to 1 and the dialog box appears.

Preset
You will not be prompted for input. When the block is inserted it will appear with the default value. You can edit it later with **ATTEDIT**. (See Editing Attributes page 9-2.)

Lock Position
Locks the location of the attribute within the block reference. When unlocked, the attribute can be moved relative to the rest of the block using grip editing, and multiline attributes can be resized.

Multiple Lines
Specifies that the attribute value can contain multiple lines of text. When this option is selected, you can specify a boundary width for the attribute.

EXERCISE 8A

Assigning Attributes to a Block

The following exercise will instruct you to draw a Box, Assign Attributes, create a block of the Box including attributes, then insert the new block and answer the prompts when they appear on the screen.

1. Start a NEW file using **My Decimal Setup.dwt** and select the **MODEL** tab.

2. Draw the isometric Box shown on the next page using the following dims.
 L = 3.75 W = 2.25 H = 3.00

3. Assign Attributes for **Length**
 a. Tag = LENGTH
 b. Prompt = What is the Length?
 c. Default = inches
 d. Justification = Middle
 e. Text Style = Standard
 f. Height = .250
 g. Rotation = 30
 h. Annotation = off
 i. Select OK and place as shown on 8-14.

4. Assign Attributes for **Width**.
 a. Tag = WIDTH
 b. Prompt = What is Width of the Box?
 c. Default = inches
 d. Justification = Middle
 e. Text Style = Standard
 f. Height = .250
 g. Rotation = 330
 h. Annotation = off
 i. Select OK and place as shown on 8-14.

5. Assign Attributes for **Height**.
 a. Tag = HEIGHT
 b. Prompt = What is Height ?
 c. Default = inches
 d. Justification = Middle
 e. Text Style = Standard
 f. Height = .250
 g. Rotation = 90
 h. Annotation = off
 i. Select OK and place as shown on 8-14

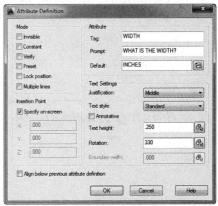

Continued on the next page...

EXERCISE 8A....continued

6. Assign Attributes for **Manufacturer**
 a. Tag = MANUFACTURER
 b. Prompt = What is the MFR?
 c. Default = (leave blank)
 d. Justification = Left
 e. Text Style = Standard
 f. Height = .250
 g. Rotation = 30
 h. Annotation = off
 i. Select OK and place as shown below.

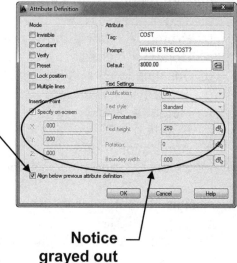

7. Assign Attributes for **Cost**.
 a. Tag = Cost
 b. Prompt = What is Cost?
 c. Default = $000.00
 d. Select
 "Align below previous attribute definition box"
 e. Select OK.
 Notice you do not have to place the tag. It automatically "Aligned below previous attribute tag". (Manufacturer)

Notice
grayed out

Your drawing should appear approximately as shown below.

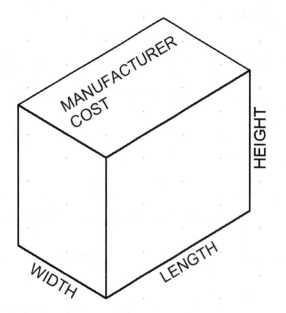

Continued on the next page...

EXERCISE 8A....continued

8. When you have finished assigning all of the attributes, create a **BLOCK**.
 a. Enter Name "Box"
 b. Select "Pick point"
 c. Select "Delete" or "Retain" (Not Convert to Block)
 d. Select Box and text
 e. Select OK

8d

8a

Not Annotative

8b

8c

8e

Block Definition dialog box:

Name: BOX

Base point
- Specify On-screen
- Pick point
- X: .000
- Y: .000
- Z: .000

Objects
- Specify On-screen
- Select objects
- Retain
- Convert to block
- Delete
- 14 objects selected

Behavior
- Annotative
- Match block orientation to layout
- Scale uniformly
- Allow exploding

Settings
- Block unit: Inches
- Hyperlink...

Description

Open in block editor

OK Cancel Help

9. Now **Insert** the new block anywhere on the screen using
 a. Select **INSERT**
 b. Select the block from the drop down list.
 c. Select OK

9b

9c

Insert dialog box:

Name: BOX Browse...

Path:

Locate using Geographic Data

Insertion point
- Specify On-screen
- X: .000
- Y: .000
- Z: .000

Scale
- Specify On-screen
- X: 1.000
- Y: 1.000
- Z: 1.000
- Uniform Scale

Rotation
- Specify On-screen
- Angle: 0

Block Unit
- Unit: Inches
- Factor: 1.000

Explode

OK Cancel Help

Continued on the next page...

EXERCISE 8A....continued

10. Type the answers in the box beside the attribute prompts as shown below.

Note:
If the dialog box shown below does not appear,
refer to page 8-11

Edit Attributes

Block name: BOX

WHAT IS THE COST?	$10.00
WHO IS THE MFR?	MILLER
WHAT IS THE HEIGHT?	3.00
WHAT IS THE WIDTH?	2.25
WHAT IS THE LENGTH?	3.75

10

11

OK Cancel Previous Next Help

11. Select the **OK** button.

Notice that the prompts may not be in any specific order. You can control the initial order of the prompts, when creating the block, by selecting the attribute text one by one with the cursor instead of using a window to select all objects at once.

In Lesson 9 you will learn how to rearrange the order after the block has been created.

Does your box look like the example below?

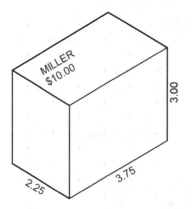

12. Save as **EX-8A**

EXERCISE 8B

Create a floor plan with Blocks and Attributes

A. Start a NEW file using **My Feet-Inches Setup .dwt**

B. Select the **A Size** tab.

C. Unlock the Viewport.

D. Set the Viewport scale to **3/16" = 1'**

E. Lock the Viewport

F. Draw the Floor Plan shown on the next page.
 1. The exterior walls are 6" thick
 2. The interior walls are 4" thick
 3. Use Layer Walls
 4. Leave spaces for the Windows and Doors OR use trim or break.

G. DOORS
 1. Use Layer DOORS
 2. Door Size = 30" (4" space behind door)

H. FURNITURE
 1. Use Layer FURNITURE
 2. Place approximately as shown.
 3. Sizes:
 Credenza's = 18" x 5'
 Lamp Table = 2' Sq.
 Copier = 2' x 3'

J. ELECTRICAL
 1. Use Layer ELECTRICAL for switches and fixtures.
 2. Use Layer **WIRING** for the wire from switches to fixtures.
 3. Sizes:
 Wall Outlet = 8" dia. Overhead Lights = 16" dia. Switches = Text ("S" ht = 1/8")

K. AREA TITLES (Office, Lobby and Reception) in PAPERSPACE.
 1. Use Layer = Text-Hvy Text Style = Text-Arch Height = 3/16" in Modelspace.

L. DIMENSION in Modelspace.
 1. Use Dimension Style "Dim-Arch"
 2. Annotation scale = same as Viewport scale

M. Save as: **EX-8B**

EXERCISE 8B....continued

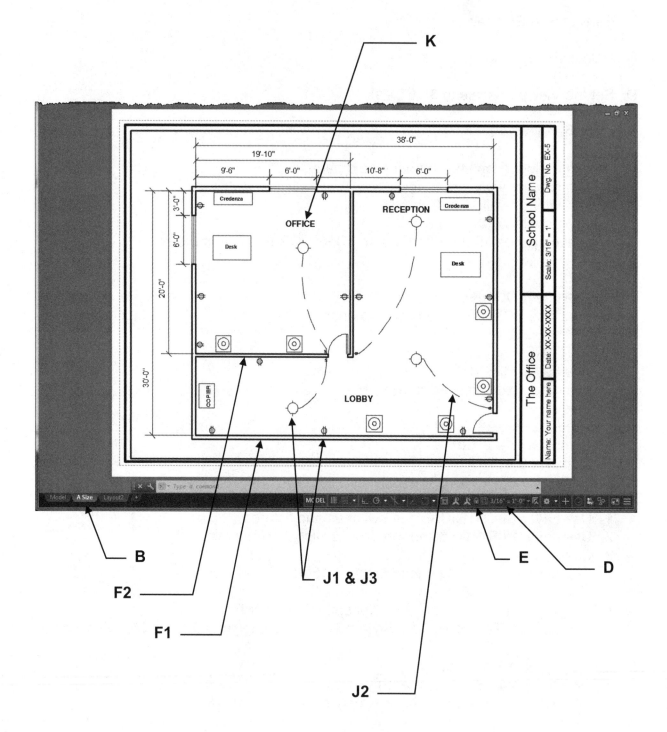

EXERCISE 8C

Assigning multiple Attributes to multiple Blocks

The following exercise will help you learn how to assign multiple attributes to 3 different objects. This drawing will be used in lesson 9 to extract the information and place it in a spreadsheet such as Excel.

A. Open **EX-8B**

B. Draw the additional furniture shown below. (Chair, sofa and file cabinet)

Chair = 2' square

Sofa = 6' X 3'

File cabinet = 24" X 15"

C. Assign Attributes to each and create blocks using Step 1 and Step 2 on the following pages.

EXERCISE 8C....continued

Start with the Sofa

This is what the sofa should look like after you have completed the Attribute definitions shown below.

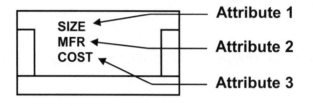

SIZE	← —— Attribute 1
MFR	← —— Attribute 2
COST	↘ —— Attribute 3

STEP 1.

1. Select **Define Attributes**
2. Fill in the boxes for Attribute 1, 2 and 3 as shown below.
3. Select the OK button and place the Tags approximately as shown above.

STEP 2

4. Now **create a block**.
 a. Select **Create**
 b. Name = Sofa
 c. Select objects = select the sofa and the attribute text.
 d. Pick Point = Any corner of the sofa.

Attribute 1

Attribute Definition

Mode
- Invisible
- Constant
- Verify
- Preset
- Lock position
- Multiple lines

Attribute
- Tag: SIZE
- Prompt: WHAT IS THE SIZE?
- Default: WIDTH x LENGTH

Insertion Point
- ☑ Specify on-screen
- X: 0"
- Y: 0"
- Z: 0"

Text Settings
- Justification: Left
- Text style: Standard
- Annotative
- Text height: 3"
- Rotation: 0
- Boundary width: 0"

☐ Align below previous attribute definition

OK Cancel Help

Attribute 2

Attribute Definition

Mode
- Invisible
- Constant
- Verify
- Preset
- Lock position
- Multiple lines

Attribute
- Tag: MFR
- Prompt: WHAT IS THE MFR'S NAME?
- Default: NAME

Insertion Point
- ☑ Specify on-screen
- X: 0"
- Y: 0"
- Z: 0"

Text Settings
- Justification: Left
- Text style: Standard
- Annotative
- Text height: 3"
- Rotation: 0
- Boundary width: 0"

☑ Align below previous attribute definition

OK Cancel Help

Attribute 3

Attribute Definition

Mode
- Invisible
- Constant
- Verify
- Preset
- Lock position
- Multiple lines

Attribute
- Tag: COST
- Prompt: WHAT IS THE COST?
- Default: $000.00

Insertion Point
- ☑ Specify on-screen
- X: 0"
- Y: 0"
- Z: 0"

Text Settings
- Justification: Left
- Text style: Standard
- Annotative
- Text height: 3"
- Rotation: 0
- Boundary width: 0"

☑ Align below previous attribute definition

OK Cancel Help

EXERCISE 8C....continued

Now do the Chair

This is what the chair should look like after you have completed the Attribute definitions shown below.

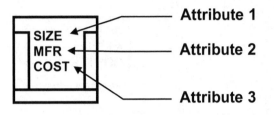

SIZE — Attribute 1
MFR — Attribute 2
COST — Attribute 3

STEP 1.

1. Select **Define Attributes**
2. Fill in the boxes for Attribute 1, 2 and 3 as shown below.
3. Select the OK button and place the Tags approximately as shown above.

STEP 2

4. Now **create a block**.
 a. Select **Create**
 b. Name = Chair
 c. Select objects = select the chair and the attribute text.
 d. Pick Point = Any corner of the chair.

Attribute 1

Attribute Definition

Mode
- Invisible
- Constant
- Verify
- Preset
- Lock position
- Multiple lines

Insertion Point
- ☑ Specify on-screen
- X: 0"
- Y: 0"
- Z: 0"

Attribute
- Tag: SIZE
- Prompt: WHAT IS THE SIZE?
- Default: WIDTH x LENGTH

Text Settings
- Justification: Left
- Text style: Standard
- Annotative
- Text height: 3"
- Rotation: 0
- Boundary width: 0"

- Align below previous attribute definition

[OK] [Cancel] [Help]

Attribute 2

Attribute Definition

Mode
- Invisible
- Constant
- Verify
- Preset
- Lock position
- Multiple lines

Insertion Point
- ☑ Specify on-screen
- X: 0"
- Y: 0"
- Z: 0"

Attribute
- Tag: MFR
- Prompt: WHAT IS THE MFR'S NAME?
- Default: NAME

Text Settings
- Justification: Left
- Text style: Standard
- Annotative
- Text height: 3"
- Rotation: 0
- Boundary width: 0"

- ☑ Align below previous attribute definition

[OK] [Cancel] [Help]

Attribute 3

Attribute Definition

Mode
- Invisible
- Constant
- Verify
- Preset
- Lock position
- Multiple lines

Insertion Point
- ☑ Specify on-screen
- X: 0"
- Y: 0"
- Z: 0"

Attribute
- Tag: COST
- Prompt: WHAT IS THE COST?
- Default: $000.00

Text Settings
- Justification: Left
- Text style: Standard
- Annotative
- Text height: 3"
- Rotation: 0
- Boundary width: 0"

- ☑ Align below previous attribute definition

[OK] [Cancel] [Help]

EXERCISE 8C....continued

Now do the File Cabinet

This is what the File Cabinet should look like after you have completed the Attribute definitions shown below.

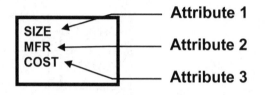

SIZE ← Attribute 1
MFR ← Attribute 2
COST ← Attribute 3

STEP 1.

1. Select **Define Attributes**
2. Fill in the boxes for Attribute 1, 2 and 3 as shown below.
3. Select the OK button and place the Tags approximately as shown above.

STEP 2

4. Now **create a block**.
 a. Select **Create**
 b. Name = File Cabinet
 c. Select objects = select the File Cabinet and the attribute text.
 d. Pick Point = Any corner of the File Cabinet.

Attribute 1

Attribute Definition

Mode
- [] Invisible
- [] Constant
- [] Verify
- [] Preset
- [] Lock position
- [] Multiple lines

Attribute
Tag: SIZE
Prompt: WHAT IS THE SIZE?
Default: WIDTH x LENGTH

Text Settings
Justification: Left
Text style: Standard
- [] Annotative

Insertion Point
- [x] Specify on-screen
- X: 0"
- Y: 0"
- Z: 0"

Text height: 3"
Rotation: 0
Boundary width: 0"

- [] Align below previous attribute definition

OK Cancel Help

Attribute 2

Attribute Definition

Mode
- [] Invisible
- [] Constant
- [] Verify
- [] Preset
- [] Lock position
- [] Multiple lines

Attribute
Tag: MFR
Prompt: WHAT IS THE MFR'S NAME?
Default: NAME

Text Settings
Justification: Left
Text style: Standard
- [] Annotative

Insertion Point
- [x] Specify on-screen
- X: 0"
- Y: 0"
- Z: 0"

Text height: 3"
Rotation: 0
Boundary width: 0"

- [x] Align below previous attribute definition

OK Cancel Help

Attribute 3

Attribute Definition

Mode
- [] Invisible
- [] Constant
- [] Verify
- [] Preset
- [] Lock position
- [] Multiple lines

Attribute
Tag: MFR
Prompt: WHAT IS THE MFR'S NAME?
Default: NAME

Text Settings
Justification: Left
Text style: Standard
- [] Annotative

Insertion Point
- [x] Specify on-screen
- X: 0"
- Y: 0"
- Z: 0"

Text height: 3"
Rotation: 0
Boundary width: 0"

- [x] Align below previous attribute definition

OK Cancel Help

EXERCISE 8C....continued

1. INSERT the **Sofa block** as shown on page 8-24

 a. Select **INSERT**
 b. Select the **SOFA** block from the drop down list.
 c. Select **OK**
 d. Answer the Attribute prompts:

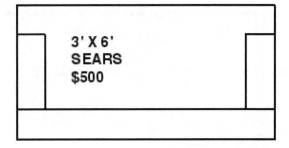

 What is the SIZE? 3' X 6'
 Who is the Manufacturer? Sears
 What is the Cost? $500.00

 e. Select **OK**.

2. INSERT the **Chair block** as shown on page 8-24

 a. Select **INSERT**
 b. Select the **CHAIR** block from the drop down list.
 c. Select **OK**
 d. Answer the Attribute prompts:

 What is the SIZE? 2' X 2'
 Who is the Manufacturer? LAZYBOY
 What is the Cost? $200.00

 e. Select **OK**.

3. INSERT the **File cabinet block** as shown on page 8-24

 a. Select **INSERT / BLOCK**
 b. Select the **File Cabinet** block from the drop down list.
 c. Select **OK**
 d. Answer the Attribute prompts:

 What is the SIZE? 15" X 24"
 Who is the Manufacturer? HON
 What is the Cost? $40.00

 e. Select **OK**.

EXERCISE 8C....continued

Your drawing should appear approximately as shown below.

Save as **EX-8C**

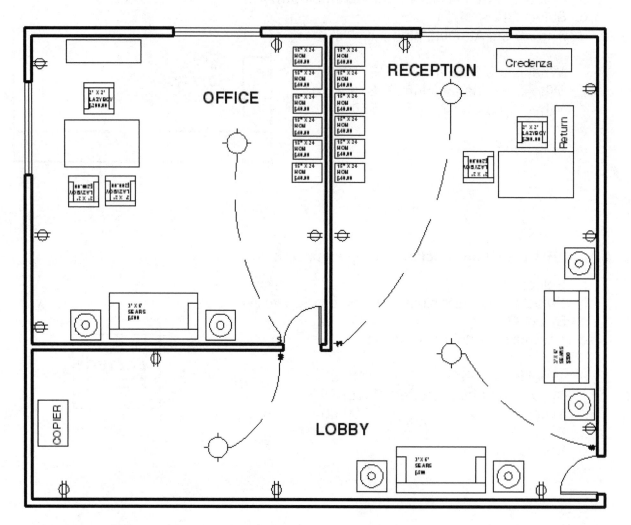

LEARNING OBJECTIVES

After completing this lesson, you will be able to:

1. Edit Attributes
2. Extract Attributes
3. Extract data to an AutoCAD table.
4. Extract data to an External file.

LESSON 9

EDITING ATTRIBUTES

After a block with attributes has been inserted into a drawing you may want to edit it. AutoCAD has many ways to edit these attributes.

1. Select the **Block Attribute Manager** using one of the following:

 Ribbon = Insert tab / Block Definition panel /
 or
 Keyboard = battman

 The following dialog box will appear.

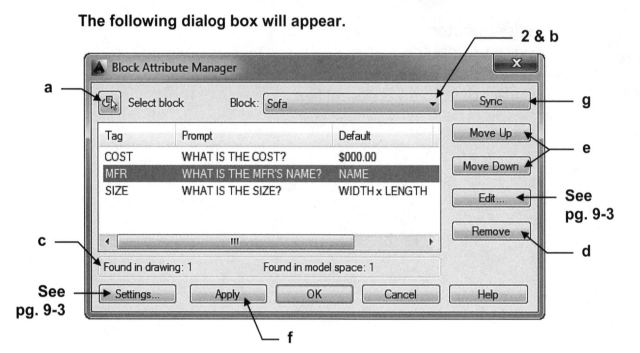

2. Select the block that you want to edit from the drop down list.

 a. **Select Block** – Allows you to select another block – takes you back to the drawing so you can select another block to edit.

 b. **Block down arrow** – Allows you to select another block –from a list.

 c. **Found** – lists how many of the selected block were found in the drawing and how many are in the space you are currently in. (You must select the model "tab" or Layout "tab". It will not find model space attributes if you are not in model space.)

 d. **Remove** - Allows you to remove an Attribute from a block. (See "Apply and Sync" below)

 e. **Move Up and Down** - Allows you to put the prompts in the order you prefer.

 f. **Apply** – After you have made all the changes, select the Apply button to update the attributes. (The Apply button will be gray if you have not made a change.)

 g. **Sync** – If you explode a block, make a change and redefine the block, Sync allows you to update all the previous blocks with the same name.

EDITING ATTRIBUTES....CONTINUED

SETTINGS [Settings...]

The Settings dialog box controls which attributes are displayed. On the previous page TAG, PROMPT, DEFAULT and MODE are displayed.
TAG values are always displayed.

a. Emphasize duplicate tags
If this option is ON, any duplicate tags will display RED.

b. Apply changes to existing refs
If this option is ON, the changes will affect all the blocks that are in the drawing and all the blocks inserted in the future.

Note, very important: If you only want the changes to affect **future** blocks, do not select "**Apply changes to existing ref**".
If you want all blocks changed, select the **Sync** button. (see page 9-2)

EDIT ATTRIBUTE [Edit...]

The Edit Attribute dialog box has 3 additional tabs, ATTRIBUTE, TEXT OPTIONS and PROPERTIES.

ATTRIBUTE tab
Allows you to change the MODE, TAG, PROMPT and DEFAULT.

TEXT OPTIONS tab
Allows you to make changes to the Text.

PROPERTIES tab
Allows you to make change to the properties.

If you select the **Auto preview changes** you can view the changes as you make them.

EDITING ATTRIBUTES....CONTINUED

WHAT IF YOU JUST WANT TO EDIT <u>ONE ATTRIBUTE</u> IN <u>ONE BLOCK?</u>

The following three commands allow you to edit the attributes in only one Block at a time and the changes will not affect any other blocks.

To change the <u>Attribute value</u>:

1. Type **ATTEDIT <enter>**
2. Select the Block you wish to edit.
3. Make change then select **OK** button.

This command allows you to edit the attribute value for <u>only one block.</u>

This command will not affect other blocks.

To change the <u>Attribute structure</u>:

1. Type **EATTEDIT <enter>**
 or double click on the block
2. Select the Block you wish to edit.
3. Make change then select **OK** button.

This command allows you to edit the Attributes, Text Options, Properties and the Values of <u>only one block</u>.

This command will not affect other blocks.

To <u>Display or Hide Attributes</u>
You may control the display of the Attributes. This command affects all blocks.

1. Type **ATTMODE <enter>**
2. Enter **0, 1 or 2**

0 = Off Makes all attributes invisible
1 = Normal Retains current visibility of each attribute. Visible attributes are displayed, invisible attributes are not.
2 = On Makes all attributes visible

EDIT OBJECTS IN A BLOCK

The following tool allows you to make a change to an existing block, saves the changes to the current drawing and updates all previously inserted blocks with the same name. The changes will only affect the current drawing.

1. Select the Block editing command using one of the following:

Ribbon = **Insert tab / Block Definition panel /**
or
Keyboard = **bedit**

The Edit Block Definition dialog box appears.

2. Select the block you wish to edit.

3. Select the **OK** button.

*The **Block Editor** panels will appear and the block selected will be displayed very large on the screen.*

Block Editor panels

Continued on the next page...

EDIT OBJECTS IN A BLOCK....CONTINUED

4. Make any changes to the block. You may even select different tabs, such as **Home** and add lines etc.

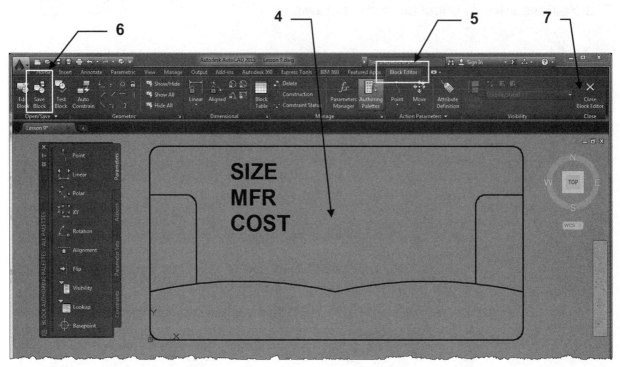

5. After all changes are complete select the **Block Editor** tab, if not already selected.

6. Select **Save Block** tool.

7. Select **Close Block Editor** tool.

The block has been redefined and all of the existing blocks with the same name have been updated to reflect the changes you made.
(These changes affect the current drawing only)

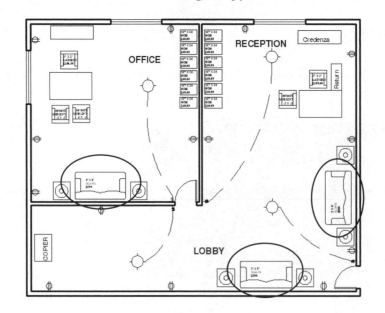

EXTRACT DATA FROM BLOCK ATTRIBUTES

Your blocks can now contain attribute information (data) such as size, manufacturer, cost or maybe even a bill of materials. The next step is to learn how to **extract** that **data** and save it to a table or to an external file such as a Microsoft Excel spread sheet.

This is a very simple process using the **Data Extraction Wizard**.

First I will show you how to Extract Data into a drawing in the form of a table.

1. Open **EX8C** and select the **A Size** tab. Make sure you are in Paperspace. (Data should always be placed in paperspace)

2. Select the **Data Extraction Wizard** using one of the following:

 Ribbon = Insert tab / Linking & Extraction panel / Extract Data
 or
 Keyboard = DX

 The "Data Extraction – Begin (Page 1 of 8)" dialog box should appear.

3. Select one of the following:

 ⊙ **Create a new data extraction:**
 ☐ Use previous extraction as a
 template (Select only if you have
 already created a template.)

 ○ **Edit an existing data extraction**

4. Select **Next >**

 The "Save Data Extraction As" dialog box should appear.

5. Select a saving location and enter the new file name. Notice the extension will be **.dxe**

6. Select the **Save** button.

Continued on the next page...

DATA EXTRACTION into a drawing....CONTINUED

The Define Data Source (Page 2 of 8) dialog box should appear.

7. Select to extract data from the current drawing or selected objects only.

8. Select **Next**

7

This panel displays the ────── path of the current drawing.

8

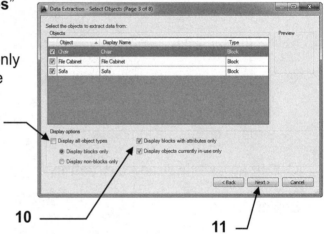

The Select Objects (Page 3 of 8) dialog box should appear.

9. Uncheck the "**Display all Object types**"

10. Select:
 ☑ Display blocks with attributes only
 ☑ Display objects currently in-use only

11. Select **Next >.**

9

10

11

The Select Properties (Page 4 of 8) dialog box should appear.

12. Uncheck all categories except "Attribute"

13. Select **Next>.**

12

13

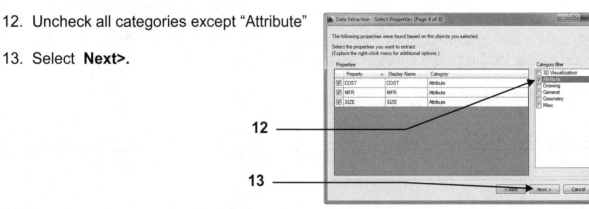

Continued on the next page...

DATA EXTRACTION into a drawing....CONTINUED

The Refine Data (Page 5 of 8) dialog box should appear

14. The display is controlled by the 3 options in the lower left corner.

15. Select **Next >**

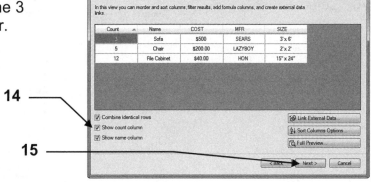

14

15

The Choose Output (Page 6 of 8) dialog box should appear

16. Select "**Insert data extraction table into drawing**".

Note: First you will experience extracting the data into a drawing. Refer to page 9-11 to "<u>Output data </u>to external file".

17. Select **Next >**

17

16

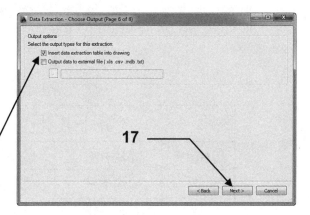

The Table Style (Page 7 of 8) dialog box should appear

18. Enter a "Title" for the table.

Note: Refer to lesson 5 to create a table.

19. Select **Next >**

18

19

Continued on the next page...

DATA EXTRACTION into a drawing....CONTINUED

The Finish (Page 8 of 8) dialog box should appear

20. Select Finish

Read this

20

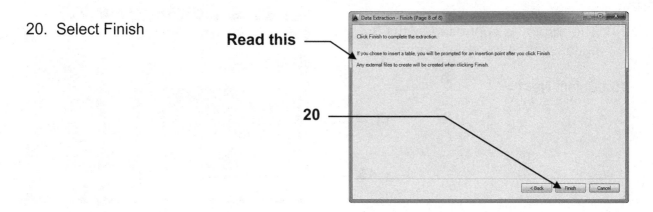

21. The Extracted Attribute data table should be attached to the cursor.
 You select the insertion location.
 You should insert the table into Paper space.
 The table will be inserted on the current layer.

OFFICE FURNITURE				
Count	Name	COST	MFR	SIZE
3	SOFA	$500	SEARS	3' X 6'
5	CHAIR	$200.00	LAZYBOY	2' X 2'
12	FILE CAB	$40.00	HON	15" X 24

To extract the attribute data to an External Spread sheet such as Microsoft Excel, refer to the next page.

DATA EXTRACTION into external file

1. Follow instructions 1 through 15 on the previous pages.

2. This time select "**Output data to external file**".

3. Select the [...] button.

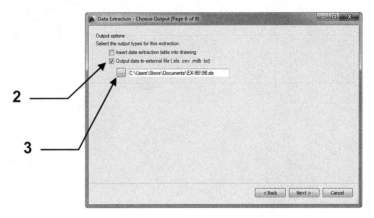

4. Locate where you wish to save the file.

5. Change **File of Type** to:

 .xls for Microsoft Excel
 or
 .txt for Word Processing Program
 or
 Notepad.

6. Enter a name for the file.

7. Select **Save** button.

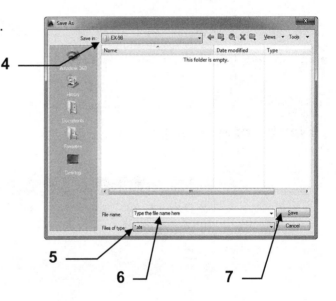

8. Select **Next >**

Continued on the next page...

DATA EXTRACTION into external file....CONTINUED

9. Select **Finish**.

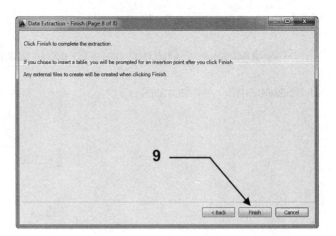

10. Open the External Program software that you selected in #5 on the previous page.

11. Select **File / Open**

12. Locate the data file that you created.

Example of Microsoft Excel

	A	B	C	D	E	F
1	Count	Name	COST	MFR	SIZE	
2	3	SOFA	$500	SEARS	3' X 6'	
3	5	CHAIR	$200.00	LAZYBOY	2' X 2'	
4	12	FILE CAB	$40.00	HON	15" X 24	
5						
6						

EXERCISE 9A

Extracting Attributes to an AutoCAD table.

The following exercise will take you through extracting attributes. You will open an existing drawing and extract the attribute data to an AutoCAD table.

1. Open **EX-8B**.

2. Select the **A Size** layout tab.

3. Make sure you are in **Paper space**.

4. Follow the instructions on pages 9-7 through 9-10 to create the Table shown below and insert it into the drawing in paper space.

Note:
You may have to use the "Scale" command to reduce the size to fit in the drawing.

OFFICE FURNITURE				
Count	Name	COST	MFR	SIZE
3	SOFA	$500	SEARS	3' X 6'
5	CHAIR	$200.00	LAZYBOY	2' X 2'
12	FILE CAB	$40.00	HON	15" X 24

EXERCISE 9B

Extracting Attributes to an External File.

The following exercise will take you through extracting attributes. You will open an existing drawing and extract the attribute data to an external program.

1. Open **EX-8B**.

2. Select the **A Size** layout tab.

3. Follow the instructions on page 9-11 through 9-12 to create the external data file shown below.

Note: you may reformat, such as center the text in the cell, if you desire.

	A	B	C	D	E	F
	Microsoft Excel - 9B.xls					
	File Edit View Insert Format Tools Data Window Help Acrobat					
	F13		=			
1	Count	Name	COST	MFR	SIZE	
2	3	SOFA	$500	SEARS	3' X 6'	
3	5	CHAIR	$200.00	LAZYBOY	2' X 2'	
4	12	FILE CAB	$40.00	HON	15" X 24	
5						
6						

LEARNING OBJECTIVES

After completing this lesson, you will be able to:

1. Navigate in the DesignCenter Palette
2. Open a drawing from the DesignCenter Palette
3. Insert a block from the DesignCenter Palette
4. Drag and drop hatch patterns.
5. Drag and drop Symbols from the Internet

LESSON 10

DesignCenter

The AutoCAD **DesignCenter** allows you to find, preview and drag and drop Blocks, Dimstyles, Textstyles, Layers, Layouts and more, from the DesignCenter to an open drawing. You can actually get into a previously saved drawing file and copy any of the items listed above into an open drawing. This is a wonderful tool and easy to use.

Opening the DesignCenter palette

To open the **DesignCenter** palette select one of the following:

Ribbon = Insert tab / Content Panel /
or
Keyboard = DC

The DesignCenter palette appears

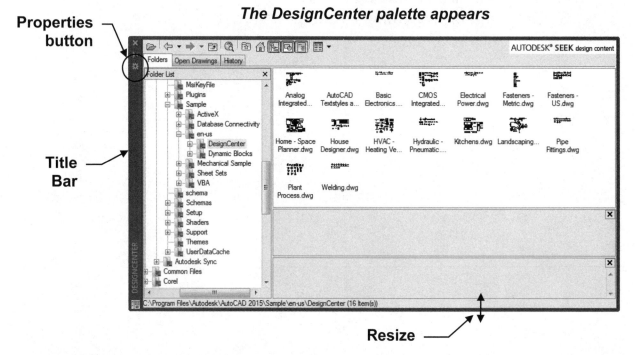

1. How to Resize the palette
If you would like to change the width or height of the palette rest the cursor on an edge until the pointer changes to a double ended arrow. Click and drag to desired size.

2. How to Dock the palette
If would like to dock the palette on the left or right sides of the screen, click the title bar, then drag it to either side of the drawing window and release.

3. How to Hide the palette
You can hide the DesignCenter palette using the Auto-hide option. Click on the "properties" button and select "Auto-hide". When Auto-hide is ON, the palette is hidden, only the title bar is visible. The palette reappears when you place the cursor on the title bar.

Continued on the next page...

DesignCenter....continued

VIEWING TABS
At the top of the palette there are 3 tabs that allow you to change the view.
They are: **Folders, Open Drawings,** and **History**.

Folders tab – Displays the Directories and files similar to Windows Explorer. You can navigate and locate content anywhere on your system.

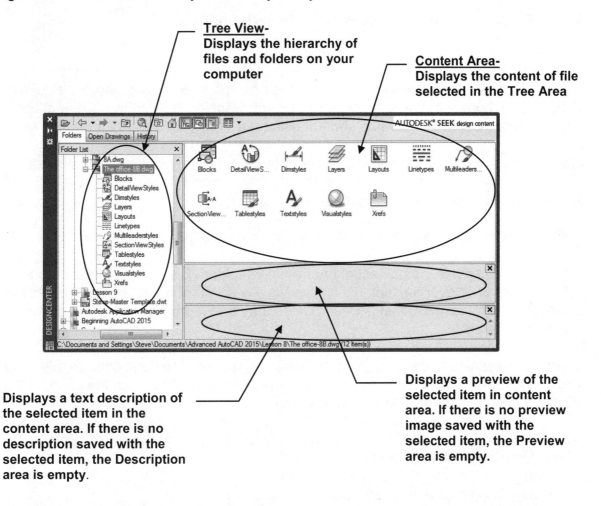

Tree View-
Displays the hierarchy of files and folders on your computer

Content Area-
Displays the content of file selected in the Tree Area

Displays a text description of the selected item in the content area. If there is no description saved with the selected item, the Description area is empty.

Displays a preview of the selected item in content area. If there is no preview image saved with the selected item, the Preview area is empty.

Open Drawings tab – Displays all open drawings. Allows you to select content from an open drawing and insert it into another open drawing. (Note: the target drawing must be the "active" drawing)

History tab – Displays the last 20 file locations accessed with DesignCenter. Allows you to double click on the path to load it into the "Content" area.

Continued on the next page...

DesignCenter....continued

BUTTONS
At the top of the DesignCenter palette, there is a row of buttons. (Descriptions below) To select a button, just click once on it.

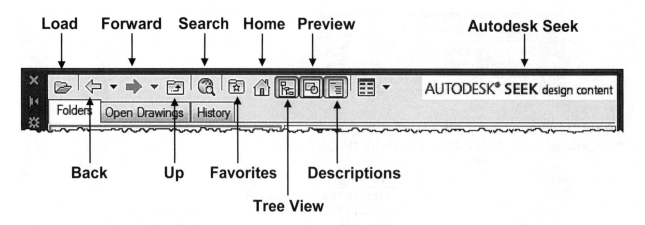

Load – This button displays the "Load" dialog box. (It is identical to the "Select File" dialog box.) Locate the drawing content that you want loaded into the "Content" area. You may also locate the drawing content using the Tree view and Folders tab.

Back and Forward – Allows you to cycle through previously selected file content.

Up – Moves up one folder from the current folder.

Search – Allows you to search for drawings by specifying various criteria.

Favorites – Displays the content of the Favorites folder. Content can be added to this folder. Right click over an item in the Tree View or Content areas then select "Add to Favorites" from the menu that appears. (You may add a drive letter, folder, drawing, layers, blocks etc.)

Home – Takes you to the DesignCenter folder by default. You can change this. Right click on an item in the Tree view area and select "Set as Home" from the menu. (You may select a drive letter, folder, drawing etc.)

Tree View – Toggles the Tree View On and OFF. Only works when the "Folders" or "Open Drawings" tab is current.

Preview – Toggles the "Preview" area On and OFF.

Description – Toggles the "Description" area On and OFF. (A description must have been given at the time the block was created.)

Autodesk Seek – Opens a web browser and displays the Autodesk Seek home page. Product design information available on Autodesk Seek depends on what content providers, both corporate partners and individual contributors, publish to Autodesk Seek. Such content could include 3D models, 2D drawings, specifications, brochures, or descriptions of products or components. (See page 10-7)

How to insert a Block using DesignCenter

There are two methods of inserting a block using DesignCenter.

Method 1: **Drag and Drop**
 a. Select "Blocks" from a specified drawing within the "Tree" area.
 b. Locate the Block desired in the Content area
 c. Drag and drop the block into the drawing area of an open drawing.
 You will not be prompted for the insertion point.

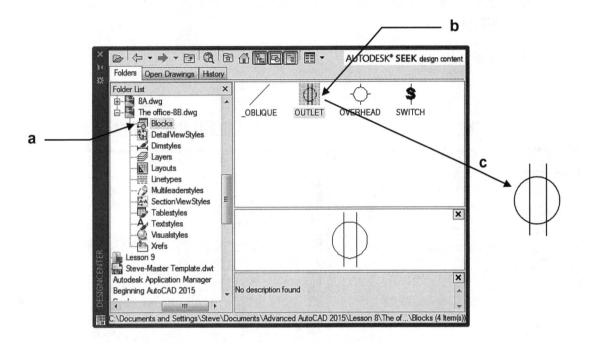

Method 2: **Specify the Coordinates, Scale or Rotation**
 a. Double click on the block in the Contents area.
 The Insert dialog box will appear.
 b. Specify on-screen or enter coordinates for insertion point.
 c. Specify scale factor.
 d. Specify rotation angle.
 e. Select **OK** button
 f. Place block

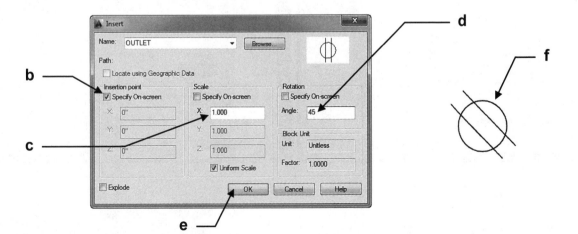

Drag and Drop Layouts, Layers, Text Styles, etc.

You can drag and drop just about anything from an existing file, listed in the Tree view "Folder List", to an open drawing file. This is a significant time saver. Just locate the source file in the tree area and drag and drop into an open drawing.

Think about this. *You could start a new file and drag previously created Layouts, Dimension styles, Text styles, Blocks etc. that were created in other drawings. They would instantly appear in the new file. As a result you can rapidly build a new file. You will never have to create Dimension styles, Text styles, Layers etc. again. You just copy them from a previous file.*

Some examples are shown below.

BLOCKS **DIMENSION STYLES**

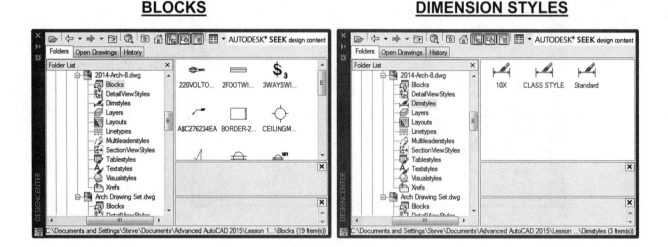

LAYERS **LAYOUTS**

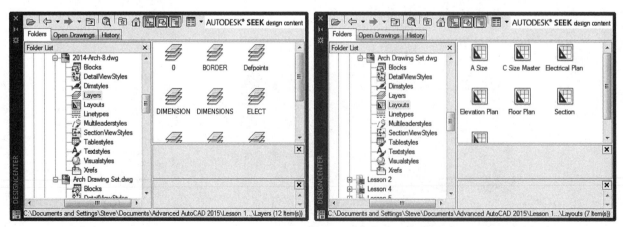

Autodesk Seek

Autodesk Seek connects you to the Internet and gives you access to thousands of symbols and manufacturer's product information.

Note: You must have an Internet connection to use this feature.

Just click on "Autodesk Seek" and AutoCAD automatically opens your Internet connection to the correct Internet address.

Experiment with Autodesk Seek. You may download various drawings, symbols and tools from the architecture, engineering and construction markets.

Autodesk Content Explorer

Autodesk Content Explorer is a search device to instantly find design content based on file objects or text attributes. It creates an index of your data based on where you instruct it to look. You may explore, or browse into, DWG files to access and insert blocks, layers, linetypes, styles and more. Unlike Design Center, Content Explorer is built on a Google-like index, so you can quickly search for design objects across folders containing thousands of files.

How to select **Autodesk Content Explorer**.

1. Select **Add-ins tab / Content panel /**

You may experiment with this new search device but no further instructions will be given at this time.

EXERCISE 10A

Inserting Blocks from the DesignCenter.

Step 1.

1. Start a **NEW** file using **My Feet-Inches Setup.dwt**

2. Draw the simple floorplan shown below.

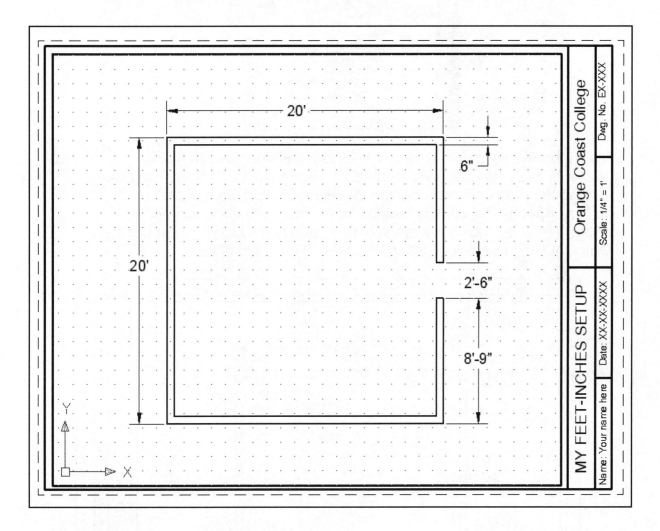

3. Save this drawing as: **EX-10A step 1**

4. Step 2 is on the next page.

Step 2.

5. **Open** the **DesignCenter** (Refer to page 10-2 if necessary.)

6. **Find** your drawing **EX-8C** in Tree View (left side.)

7. Select the **plus box** beside the file to display the contents of **EX-8C**.

8. Select "**Blocks**" to display the blocks in the Content area (right side).

9. **Insert** the Blocks from the Content area to create the drawing below.
 (Refer to page 10-4, How to Insert a Block using DesignCenter, if necessary.)
 a. Use the **drag and drop** method for the blocks that are not rotated.
 b. Use **Specify Coordinate** method for the blocks that are rotated.
 (Note: The Sofa and Chairs are at a 45 degree angle but you must use the AutoCAD degree clock to determine the rotation of the block.)

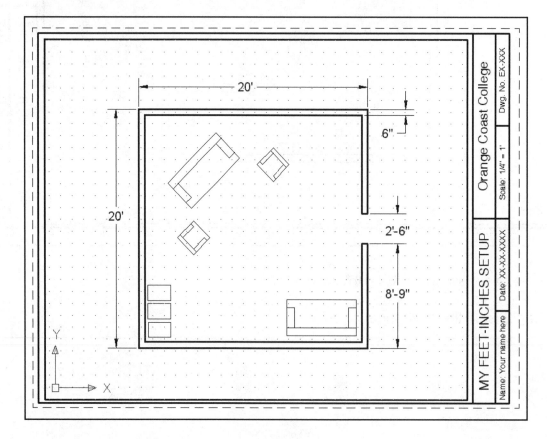

10. Save as: **EX-10A step 2**

EXERCISE 10B

Borrowing settings from another drawing

The following exercise is to demonstrate how quick and easy it is to borrow settings, text styles, dimension styles, layers, layouts, etc. from a previously created drawing file.

1. Using **New** select **acad.dwt**
 Notice this drawing has no layers, layouts, dimension styles, text styles etc.

2. Select the **DesignCenter**

3. Find **My Decimal Setup** in the Tree area.

4. Select the **[+]** beside the file to display Blocks, dimension styles, layouts etc. list.

5. Select **Layers**

6. Select all of the Layers in the Content area.

7. Click, Drag and drop all of them into the drawing area.
 Now look at your Layers. You should now have more layers than you had previously.

8. Now select **Layouts**.

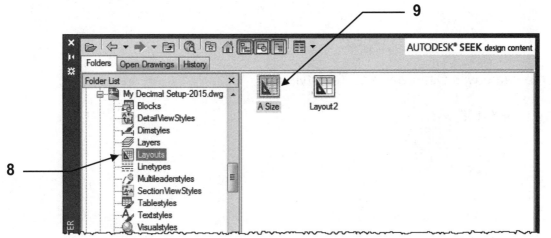

9. Select **A Size**

10. Click, drag and drop **A Size** into Paper space.
 Notice the **A Size** layout tab appears.
 Select it and see what is displayed.
 It should have your Border, Title Block and Viewport.

10

11. Do the same with Dimstyles and Textstyles.

12. Save as **EX-10B**

LEARNING OBJECTIVES

After completing this lesson, you will be able to:

1. Understand the use of Externally Referenced drawings.
2. Insert an Xref drawing.
3. Use the Xref Manager.
4. Bind an Xref to a drawing.
5. Clip an Xref drawing.
6. Edit an Xref drawing.
7. Convert an object to a Viewport.
8. Create multiple Viewports and multiple xrefs.
9. Create multiple viewports quick and easy.
10. Xref and Autodesk 360 Connectivity.

LESSON 11

External Reference drawing (Xref)

The **XREF** command is used to insert an <u>image</u> of another drawing into the current drawing. AutoCAD calls the host drawing the "Parent" and the Xref dwg the "Child". This command is very similar to the INSERT command. But when you externally reference (XREF) the Child dwg into the Parent dwg, the image of the Child dwg appears but only the **path** to where the original Child dwg is stored is loaded into the Parent dwg. The Child dwg does not become a permanent part of the Parent dwg.

Each time you open the Parent dwg, it will look for the Child dwg (via the path) and will load the image of the **current version** of the Child dwg. If the Child dwg has been changed, the new changed version will be displayed. So the Parent dwg will always display the most current version of the Child dwg.

Since only the path information of the Child dwg is stored in the Parent dwg, the amount of data in the Parent dwg does not increase. This is a great advantage.

If you want the Child dwg to actually become part of the Parent dwg, you can **BIND** the Child to the Parent. (Refer to page 11-7)

If you want the image of the Child dwg to disappear temporarily, you can **UNLOAD** it. To make it reappear simply **RELOAD** it. (Refer to page 11-7)

If you want to delete the image and the path to the Child dwg, you can **DETACH** it. (Refer to page 11-7)

Examples of how the XREF command could be useful?

If you need to draw an elevation. You could externally reference a floor plan and use it basically as a template for the wall, window and door locations. You can get all of the dimensions directly from the floor plan by snapping to the objects. It will not be necessary to refer back and forth between drawings for measurements. If there are any changes to the floor plan at a later date, when you re-open the elevation drawing, the latest floor plan design will appear automatically. To make the floor plan drawing become invisible, simply UNLOAD it. When you need it again, RELOAD it.

If you want to plot multiple drawings on one sheet of paper. Many projects require "standards" or "detail" drawings that are included in every set of drawings you produce. Currently you probably drew each detail on the original drawing package, or created those transparent "sticky backs".
Now, using the external reference command, you would do the following:
1. Make individual drawings of each standard or detail.
2. XREF the standard or detail drawing into the original drawing package. This would not only decrease the size of your file but if you made a change to the standard or detail, the latest revision would automatically be loaded each time you opened the drawing package.

How to insert an External Reference drawing

1. Open the Parent drawing. (For example, open My Decimal Setup)

2. Select Layer **Xref**.

3. Select the **Model** tab
 Note: You should always insert an Xref into Model Space not Paper Space.
 The viewport can be locked or unlocked, it does not matter.

4. Select the XREF command using one of the following:

 Ribbon = Insert tab / Reference panel /
 or
 Keyboard = xattach

 The following "Select Reference File" dialog box should appear.

5. Select the **File type**: (such as Drawing (*.dwg)

6. Select the file you wish to **externally reference**

7. Select the **Open** button.

Continued on the next page...

Insert an External Reference drawing...continued

*The following "**External Reference**" dialog box should appear.*

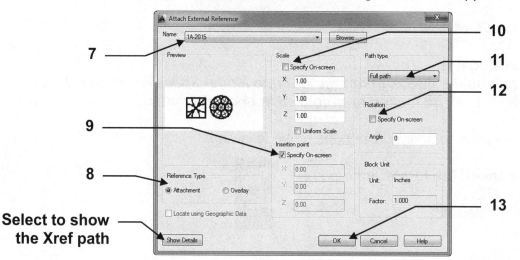

Select to show the Xref path

7. The name of the file you selected should appear in the Name box.

8. Select **"Reference Type"**.

 Attachment - This option attaches one drawing to another. If you attach the child to the Parent then attach the Parent to a Grandparent, the **Child remains attached**. (Daisy Chain of Child, Parent and Grandparent)

 Overlay - This option is exactly like Attachment except, if you Overlay a Child to a Parent, then attach a Parent to a Grandparent, **only Parent remains attached**. The Child is not. (Parent and Grandparent only)

9. **Insertion Point -** Specify the X, Y and Z insertion coordinates in advance or check the box "Specify on-Screen" to locate the insertion point with the cursor.

10. **Scale -** Specify the X, Y and Z scale factors in advance or check the box "Specify on-screen" to type the scale factors on the command line. You may select the **Uniform Scale** box if the scale is the same for X, Y and Z.

11. **Path -** Select the Path type to save with the xref. (To see path select "Show Details" button)

12. **Rotation -** Specify the Angle or check the box "Specify on-screen" to type the scale factors on the command line.

13. Select the **OK** button. (Xref will be **faded**. Refer to page 11-5 for fade control.)

14. Place the insertion point with your cursor if you have not preset the insertion point.

Note: If the externally referenced drawing does not appear, try any of the following:
1. Verify that you externally ref. the drawing into Model space, not paper space.
2. Unlock the viewport, use View / Zoom / Extents to find the drawing and re-lock the viewport.
3. Verify that the externally ref. drawing was drawn in model space. Objects drawn in paper space will not externally reference.
4. Verify the externally referenced layers are not frozen.

Control the External Reference image fade

When you insert an externally referenced drawing the image appears faded. This is merely an aid to easily identify the xref inserted from the parent drawing.

You can control the percentage of fade.

1. Select the Fade control tool using the following:

 Ribbon = Insert tab / Reference panel / Reference ▼

2. Move the **Slider** left to reduce fade or right to increase fade.

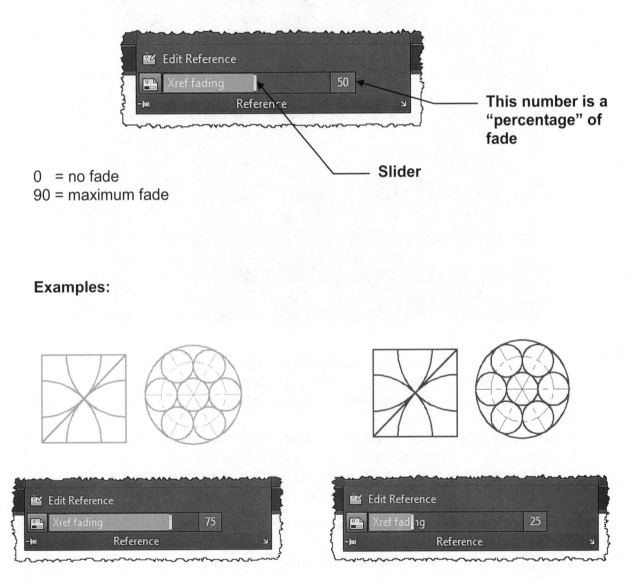

This number is a "percentage" of fade

Slider

0 = no fade
90 = maximum fade

Examples:

Note:

Fade control is saved to your computer. It is not saved with the individual file.
If you open the parent drawing on another computer the fade may appear differently.

External Reference Palette

The **External Reference Palette** allows you to view and manage the xref drawing information in the current drawing.

Select the External Reference Palette using one of the following:

> **Ribbon = Insert tab / Reference panel / ↘**
> **or**
> **Keyboard = XR**

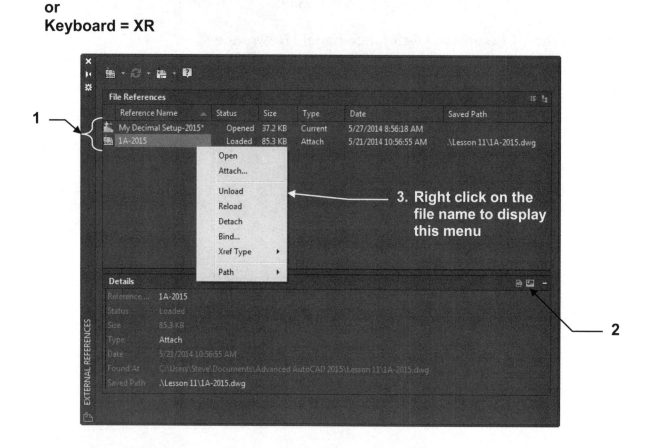

1. **Title Area** - This describes each drawing in the current drawing.
 Reference Name = The original drawing file name of the drawing
 Status = Lists whether the drawing was opened, loaded, not found or unloaded.
 Size = Indicates the size of the drawing.
 Type = Lists whether the xref drawing is an Attachment or Overlay.
 Date = Lists when the xref drawing was originally referenced.
 Saved Path = This is the path the computer will follow to find the xref drawing listed and load it each time you open the current drawing.

2. **Preview button:** - Displays a preview of the drawing selected.

3. **MENU (Right click on the file name to display a menu)**

 Open - Opens the selected xref for editing in a new window. The new window is displayed after the External Reference Palette is closed.

Continued on the next page...

External Reference Palette....continued

Attach - Takes you back to the External Reference dialog box so you can select another drawing to xref.

Unload - <u>Unload is not the same as Detach</u>. An unloaded xref drawing is not visible but the information about it remains and it can be reloaded at any time.

Reload - This option will reload an unloaded xref drawing or update it.
If another team member is working on the drawing and you would like the latest version, select the Reload option and the latest version will load into the current drawing.

Detach - This will remove all information about the selected xref drawing from the current file. The xref drawing will disappear immediately. <u>Not the same as Unload</u>.

Bind – When you bind an xref drawing, it becomes a permanent part of the current base drawing. All information in the Xref manager concerning the xref drawing selected will disappear. When you open the base drawing it will not search for the latest version of the previously inserted xref drawing.

Xref Type - Allows you to switch between **Attach** or **Overlay** (Refer to page 11-4).

Path - *Removes* the file path from the name of the reference, for referenced files stored in the same location as the drawing file. Changes the full path of an Xref to a ***relative*** path.

When a drawing is Externally referenced, its Blocks, Layers, Linetypes, Dimension Styles and Text Styles are kept separate from the current drawing. The name of the externally referenced drawing and a pipe (I) symbol is automatically inserted as a prefix to the newly inserted xref layers. This assures that there will be no duplicate layer names.

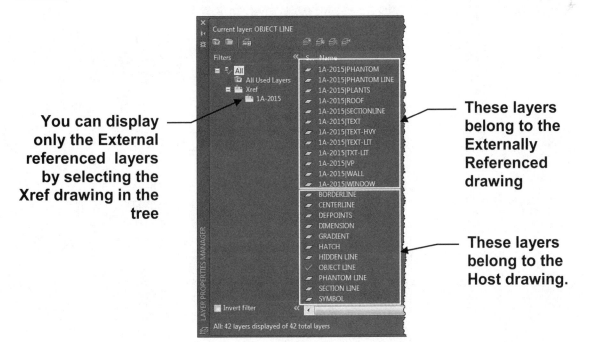

You can display only the External referenced layers by selecting the Xref drawing in the tree

These layers belong to the Externally Referenced drawing

These layers belong to the Host drawing.

Continued on the next page...

XBIND

It is important to understand that these new layer names are listed but they cannot be used. Not unless you bind the entire xref drawing or use the Xbind command to bind individual objects.

The following is an example of the Xbind command with an individual layer. You may also use this command for Blocks, Linetypes, Dimension Styles and Text Styles.

1. Type **XBIND** <enter>

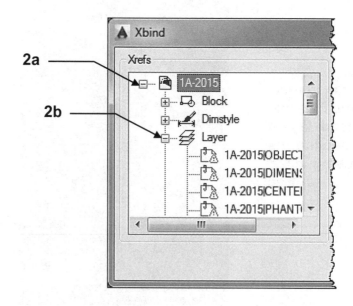

2. Expand the Xref file information list
 a. Select the **+** sign beside the Xref drawing file name.
 b. Select the **+** sign beside "Layer".

 (The + signs will then change to a - sign, as shown below.)

Continued on the next page...

External Reference Palette....continued

3. Select the layer name to bind.

3

4. Select the **ADD** button.
 (The xref layer will appear in the "Definitions to Bind" window.)

5. Select the **OK** button.

6. Now select the **Layer Properties Manager** and look at the xref layer.
 The Pipe (I) symbol between the xref name and the layer name has now changed to
 0. This layer is now usable.

Clipping External Referenced Objects

When you Externally Reference a drawing, sometimes you do not want the entire drawing visible. You may only want a portion of the drawing visible.
For example, you may Externally Reference an entire floor plan but actually only want the kitchen area visible within the viewport.

This can easily be accomplished with the Xclip command. After you have inserted an External Referenced drawing, select the Xclip command. You will be prompted to specify the area to clip by placing a window around the area. (**All objects outside of the window will disappear unless you select "Invert Clip" in 2b below.**)

1. Select the **Xclip** command using one of the following:

> **Ribbon = Insert tab / Reference panel /**
> **or**
> **Keyboard = XC**

2. _clip Select objects to clip: *select the xref you want to clip <enter>*

 a. Enter clipping option
 [ON/OFF/Clipdepth/Delete/generate Polyline/New boundary] <New>: *N <enter>*

 b. Outside mode - Objects outside boundary will be hidden.
 Specify clipping boundary or select Invert option:
 [Select polyline/Polygonal/Rectangular/Invert clip] <Rectangular>: *R <enter>*

 c. Specify first corner: *select the location for the first corner of the*
 "Rectangular" clipping boundary.

 d. Specify opposite corner: *select the location for the opposite corner of the*
 "Rectangular" clipping boundary.

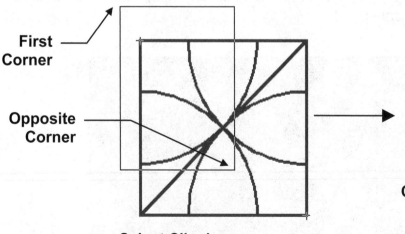

First Corner

Opposite Corner

Select Clipping Boundary using Window

Clipping Results

Continued on the next page...

Clipping Options

1. Select the XCLIP command.
2. Click on the clipped image.

Enter clipping option
[ON/OFF/Clipdepth/Delete/generate Polyline/New boundary] <New>:

The description for each option is described below:

ON / OFF – If you have "clipped" a drawing, you can make the clipped area visible again using the "OFF" option. To make the clipped area invisible again, select the "ON" option.

CLIPDEPTH – This option allows you to select a front and back clipping plane to be defined on a 3D model.

DELETE – To remove a clipping boundary completely.

GENERATE POLYLINE – Automatically draws a polyline coincident with the clipping boundary. The polyline assumes the current layer, linetype, lineweight, and color settings. Use this option when you want to modify the current clipping boundary using **PEDIT** and then redefine the clipping boundary with the new polyline. To see the entire xref while redefining the boundary, use the Off option.

NEW BOUNDARY – Allows you to select a new boundary.

If you select New Boundary option the following prompt appears because you can not create a new boundary unless the old boundary is deleted.

Delete old boundaries, yes or no: <yes>:

The descriptions for the options are shown below:

SELECT POLYLINE – Allows you to select an existing polyline as a boundary.

POLYGONAL –Allows you to draw and irregular polygon, with unlimited corners, as a boundary.

RECTANGULAR – Allows a rectangular shape, with only 2 corners, for the boundary.
INVERT CLIP - Inverts the mode of the clipping boundary: either the objects outside the boundary (default) or inside the boundary are hidden.

Edit an External Referenced Drawing

An Xref drawing can be edited very easily using the open command in the External References palette. The open command opens the Externally Referenced drawing (the child) in a separate window, you make the changes and save those changes to the original of the External Referenced (Child) drawing.

You will then "Reload" the revised version to view the changes within the Parent drawing.

1. Open the drawing that contains the External Referenced drawing.

2. Type **XR <enter>**

3. Right click on the Xref drawing to be changed.

4. Select **Open** from the short cut menu.

The selected Xref original drawing will open in a separate tab.

5. Close the File Ref. palette

6. Make the necessary changes.

7. Save the drawing. *(Note: you must use the same name.)*

8. Close the drawing.

The Parent drawing will reappear <u>unchanged</u>. A "balloon message" will appear in the lower right corner of the screen notifying you that the Xref drawing has been changed and it needs to be "Reloaded".

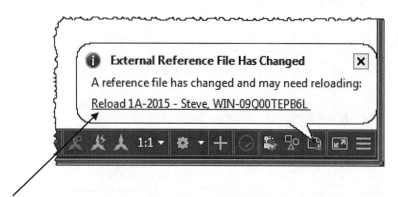

9. Click on the drawing name (underlined and blue)

Now the drawing should appear with the changes.
Note: If the Change Balloon does not appear refer to the next page.

Reloading an edited External Reference drawing

If the "Changed notification" balloon did not appear you must Reload the drawing as follows:

1. Type **XR <enter>**

2. Right Click on the drawing to **Reload**

3. Select **Reload** from the menu.

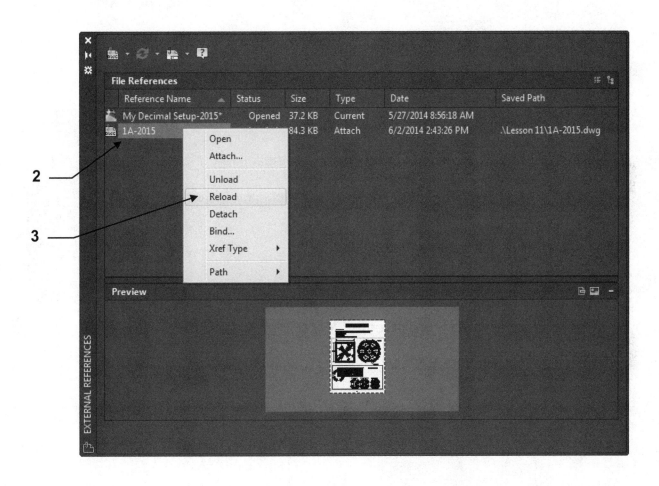

Convert an Object to a Viewport

You may wish to have a viewport with a shape other than rectangular. AutoCAD allows you to convert Circles, Rectangles, Polygons, Ellipse and Closed Polylines to a Viewport.

1. You must be in Paperspace. (a layout tab)

2. Draw the shape of the viewport using one of the objects listed above.

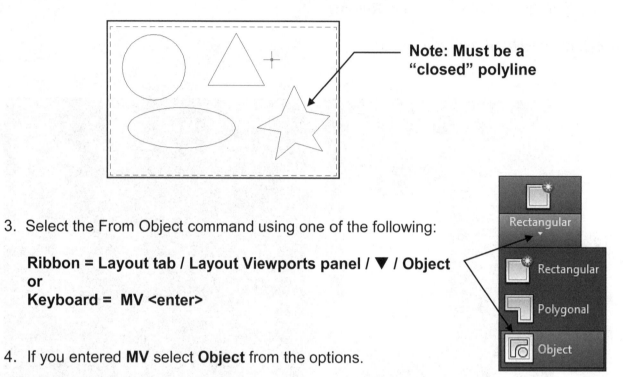

Note: Must be a "closed" polyline

3. Select the From Object command using one of the following:

 Ribbon = Layout tab / Layout Viewports panel / ▼ / Object
 or
 Keyboard = MV <enter>

4. If you entered **MV** select **Object** from the options.

5. Select object to clip viewport: *select object to convert*

 Select object to clip viewport: Regenerating model.

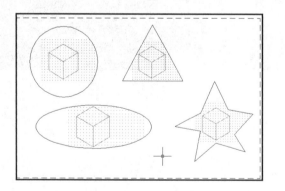

Now you can see through to model space. This is like looking out all the windows in your living room and seeing the same tree growing in your front yard.

Creating Multiple Viewports with Multiple Xrefs

When using Xrefs you may want to XREF more than one drawing. So you will require multiple viewports. Multiple viewports are easy but you will have to think a little about multiple Externally Referenced drawings.

The following is an example of how to control the viewing of multiple xrefs. The actual exercise, with step-by-step instructions, is EX-11A

1. Start a NEW file using **My Decimal Setup**

2. Select the **A Size** layout tab.

3. Delete any viewports that already exist. (Click on each frame then select Erase)

4. Select the viewport layer.

5. Create 2 viewports approximately as shown on the right.
 First one, then the other.
 Simple so far, right?

6. Double click inside the Viewport A

7. Select the XREF layer.

8. Xref a drawing into Viewport A.
 (EX-7C would be a good one to use)

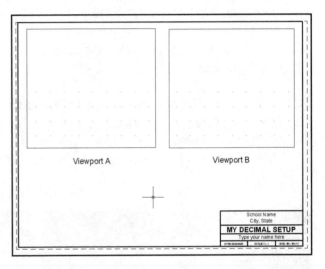

9. Select Zoom / Extents
 (You should see the entire drawing inside Viewport A)

10. Now activate Viewport B (double click inside Viewport B)

11. Select Zoom / Extents
 (You should see the same Xref drawing inside Viewport B also)

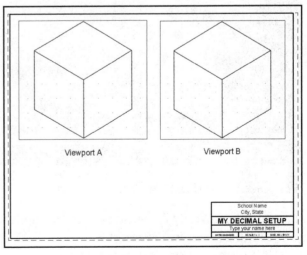

Now take a minute to think about this. This is an important concept to understand. Pretend that the Viewport frames are 2 windows in your living room and the xref drawing is a tree in your front yard. If you stand in front of one of the windows you can see the tree. Then if you walk to the other window you see the same tree. It is the same tree, right?
In the example above you are seeing the same EX-7C drawing.

Multiple Viewports with Multiple Xrefs....continued

Now make the image of the xref drawing in Viewport B <u>disappear.</u>

If you **do not** want to see the xref drawing in Viewport B you <u>must "**Freeze in Current Viewport**" the layers of the xrefed drawing inside Viewport B.</u>
This is easier than is sounds.

12. Activate Viewport B. (double click in it)

13. Select the **Layer Properties Manager**
(Type: **LA <enter>**)

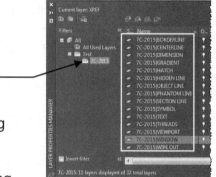

14

14. To view only the layers that belong to the Xref drawing select the xref drawing name in the **Filters** Tree area.

15. Select all of the layers that belong to the XREF drawing. (highlight them)

16. Select the "**Freeze in Current Viewport**" box.
Now this is very important: **Do not select "Freeze"** or **"New VP Freeze".**
Slide all the way over to the right hand side of the list of layers and select the
"**VP Freeze**" (This is Freeze in current Viewport)

Do not select ——— **Select**

17. Close the dialogue box.

18

18. The Externally Referenced drawing should have disappeared in Viewport B.
If it didn't, read #16 again carefully.

Now think about this. If you were to Xref another different drawing into Viewport B, it would also be visible in Viewport A (just another tree in your front yard). So you would have to activate Viewport A, select the layers that belong to the newly Xrefed drawing and select "VP Freeze". Then only one drawing would be visible in each viewport.

Multiple Viewports with Multiple Xrefs....continued

Another method to Freeze layers within Viewports

Here is another method to quickly freeze the Xref layers in **All viewports except the Current Viewport.**

1. Select the Viewport that you wish to display the Xref drawing. This is called the **Current** Viewport.

2. Select the **Layer Properties Manager**
 (Type: **LA <enter>**)

3. To view only the layers that belong to the Xref drawing select the xref drawing name in the **Filters** Tree area.

4. Select all of the layers that belong to the XREF drawing. (highlight them)

5. Right click within the Layer Properties Manager

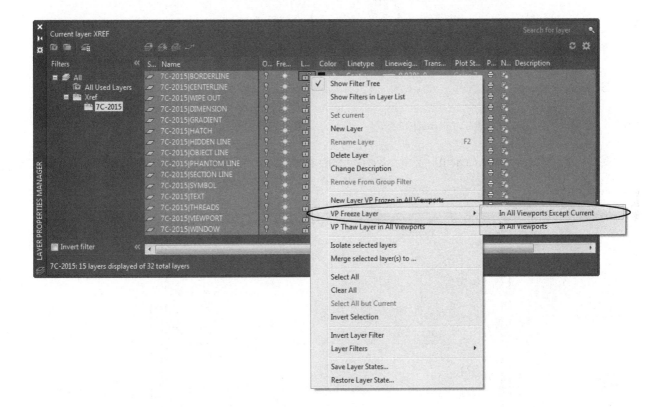

6. Select **Freeze Layer / In all viewports except Current**

7. Close the dialogue box.

Creating Multiple Viewports - A Quick Method

1. Select **Layout tab / Layout Viewports panel /** 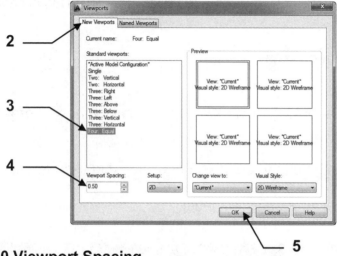 Named

2. Select the **New Viewports** tab.

3. Select **Four: Equal** from the column on the left.
 This will divide the paperspace into 4 equal viewports

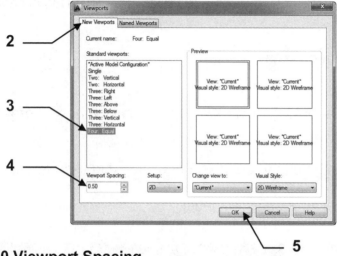

4. Enter **.50 Viewport Spacing**
 This the spacing between each of the new viewports.

5. Select the **OK** button.

6. The following prompt will appear:

 Specify first corner or [Fit] <Fit>: *Enter the location of the <u>first corner</u> of the area to divide and then the <u>opposite corner</u>.*

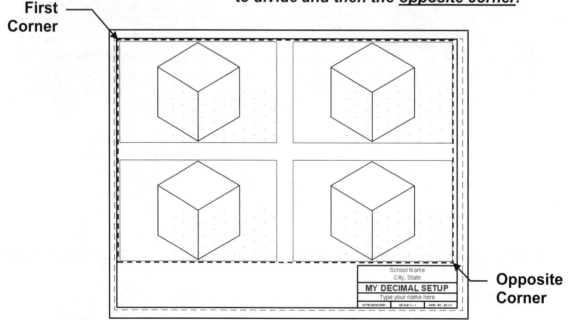

Note: If you have objects in Modelspace, they will appear in each viewport.

Missing External Reference Drawings

When you Xref a drawing AutoCAD saves the path to that drawing. So every time you open the master drawing AutoCAD looks for the Xref using that path.

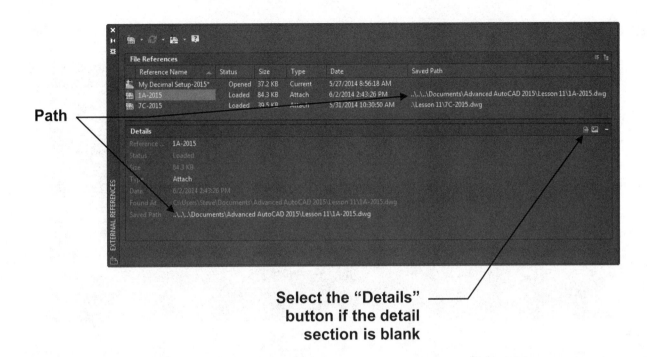

Path

Select the "Details" button if the detail section is blank

If you move the drawing and you <u>do not change</u> the path, in the External Reference palette, AutoCAD will not be able to find it. If AutoCAD can't find the Xref it will display the "old path" and a box will appear asking "**What do you want to do?**".

Example:

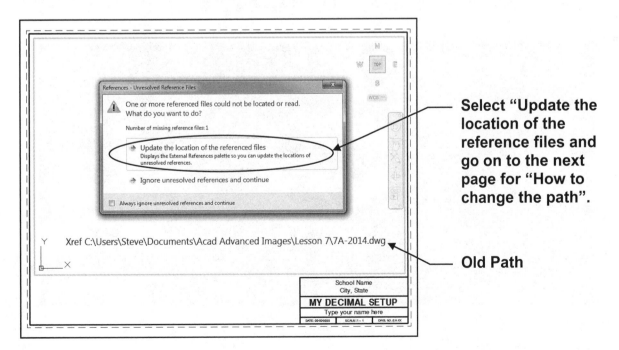

Select "Update the location of the reference files and go on to the next page for "How to change the path".

Old Path

How to change the path

1. If the **File References** palette isn't already open, type **XR <enter>**

2. Select the file.

2

3. Select the "**Details**" button

4. Select the "**Saved Path**" box.

5. Select the **Browse** button.

6. Locate the file and select **Open**.
 The Path will update and the drawing file will automatically load.

Updated Path

EXERCISE 11A

XREF MULTIPLE DRAWINGS

1. Start a **NEW** file using **My Decimal Set Up.dwt**

2. Select the "model" tab and **draw** a Rectangle
 (3.50" L X 2" W)

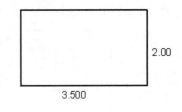

3. Save as: **RECT**

4. **Close** the drawing.

5. Start another **NEW** file using **My Decimal Set Up.dwt** **again**.

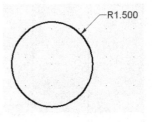

6. Select the "model" tab and **Draw** a Circle
 (1.50" Radius)

7. Save as: **CIRCLE**

8. **Close** the drawing.

9. Start another **NEW** file using **My Decimal Setup.dwt again.**

10. Select the **A Size** tab.

11. Erase the existing Viewport frame. (Click on it, select erase and <enter>)

12. Select layer **Viewport**.

13. Create 2 new Viewports as follows:
 a. Draw 2 circles, **R2.50**, as shown below.
 b. **Convert the Circles to Viewports**. (Refer to page 11-14)

Continued on the next page...

EXERCISE 11A....continued

14. **Add Viewport Titles** as shown below. (**In paper space**)
 a. Layer = Text
 b. Use "Single Line Text"
 c. Style = Text Classic
 d. Height = .35

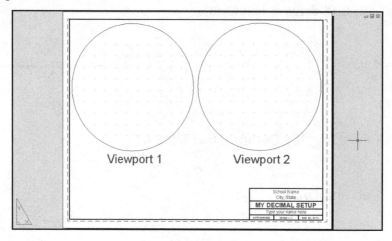

15. Double click inside of Viewport 1 to **activate Model space**.

16. Change to the XREF layer.

17. **Externally Reference** the **Rect** drawing, you made previously, as follows:
 a. Select the **Attach** command
 b. Find and Select **Rect** drawing.
 c. Select the **OPEN** button.
 d. Select the **OK** button.
 e. Click inside Viewport 1.

18. Use **Zoom / All** or **Extents** inside each viewport if necessary.

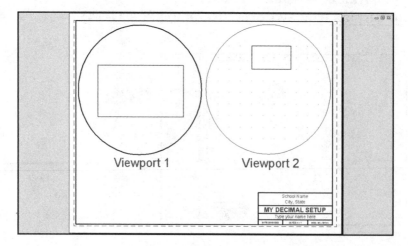

Continued on the next page...

EXERCISE 11A....continued

19. **Adjust the scale** in <u>Viewport 1</u> to **1:1.**

20. **"Pan"** the **Rect** drawing inside of Viewport 1 to display it as shown.
 (Do not use the Zoom commands or you will have to re-adjust the scale)

**Now you are going to make the Rect drawing disappear in Viewport 2.**

21. Freeze all the layers that belong to **Rect** drawing in Viewport 2 as follows:
 a. **Activate** the Viewport 2.
 b. Select **LAYER Properties Manager** (type: LA<enter>)
 c. Select **Rect** in the Filter tree.
 d. Select all the layers that begin with **Rect.**

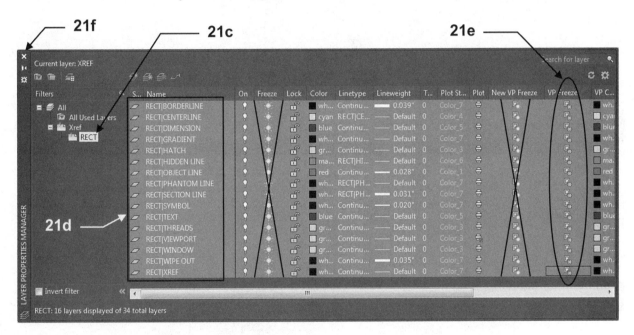

e. Select the **"VP Freeze"** column.
f. Close the Layer Properties Manager.

**The Rect drawing inside Viewport 2 should have disappeared.**

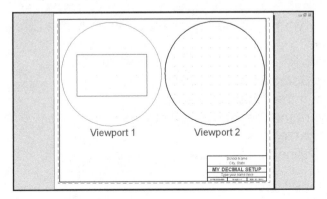

Continued on the next page...

EXERCISE 11A....continued

The next step is to XREF a second drawing into the other viewport.
Then you will make the newly xref-ed drawing disappear in Viewport 1.
When you have completed step 26 you should see only the Rectangle in
Viewport 1 and only the Circle in Viewport 2.

22. **Xref** drawing **Circle** into the **Viewport 2** as follows:
 a. Activate Viewport 2
 b. Select the **XREF** layer.
 c. Select the **Attach** command. (See page 11-3)
 d. Find and Select the **Circle** drawing.
 e. Select the **OPEN** button.
 f. Select the **OK** button.
 g. Click inside Viewport 2.

23. Use **Zoom / All** or **Extents** inside Viewport 2 if you can't see the Circle drawing.

24. **Adjust the scale** in Viewport 2 to **1 : 1. (Do not Lock)**

25. **"Pan"** the **Circle** drawing inside of Viewport 2 to display it as shown below.
 (Do not use the Zoom commands or you will have to re-adjust the scale)

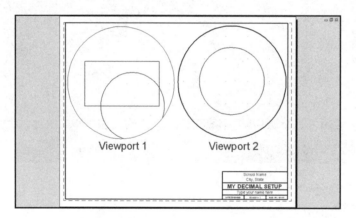

Now you will make the Circle drawing disappear in Viewport 1.

26. "Freeze in Current Viewport" all the layers that belong to the Circle drawing
 Viewport 1 as follows:
 a. **Activate** Viewport 1.
 b. Select **LAYER Properties Manager (Type LA)**
 c. Select the **Circle** in the **Filter tree** area.
 d. Select all the layers that begin with **Circle**.
 e. Select the "**VP Freeze**" column.
 f. Close the Layer Properties Manager.

Continued on the next page...

EXERCISE 11A....continued

The Xref drawing, Circle, should have disappeared in Viewport 1.

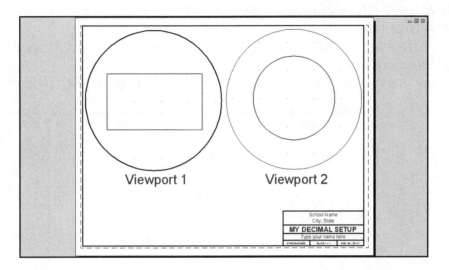

27. Save as **EX-11A.**

28. **Plot** using Plot Page Set up **Plot Setup A.**

EXERCISE 11B

Creating Multi-scaled Views

1. Start a **NEW** file using **My Decimal Setup.dwt**
2. Select the **A Size** tab.
3. **Important:** Erase the existing Viewport frame. (Click on it, select erase and <enter>)
4. Select the Viewport layer.
5. Create 3 new Viewports as shown below using the **Three: Right** (see page 11-18).

6. Add Viewport Titles as shown below. (In paperspace)
 a. Layer = Text
 b. Use "Single Line Text"
 c. Style = Text-Classic
 d. Height = .25

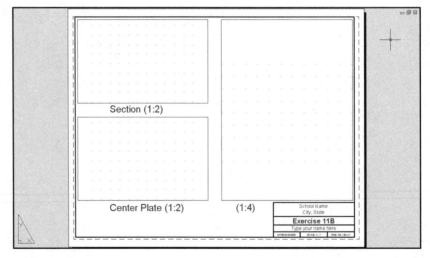

Continued on the next page...

EXERCISE 11B....continued

7. Double click inside one of the Viewports to **activate Model space**.

8. **Xref** drawing 6A as follows:
 a. Select the Xref layer
 b. Select the **Attach** command
 c. Find and Select 6A
 d. Select the **OPEN** button.
 e. Select the **OK** button.

9. **Adjust the scale** in each Viewport to the scale listed under each viewport as shown below.

10. **"Pan"** the drawing inside each viewport to display the correct area.
 (Do not use the Zoom commands or you will have to re-adjust the scale)

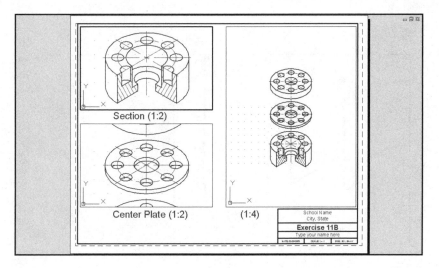

11. Save as **EX-11B**

12. **Plot** using Plot Page Set up **Plot Setup A**

EXERCISE 11C

CLIPPING AN EXTERNAL REFERENCE

1. Open **EX-11B.**
2. Select the **Model** tab.

Note:
**If the drawing does not appear when you select the Model tab,
type: Regen <enter> and it will appear.**

3. Select **XCLIP** command. (Ref to page 11-10)
4. Clip the lower section to appear as **shown below**:
 a. Select objects.
 b. Select <u>New Boundary</u> and <u>Rectangular</u>

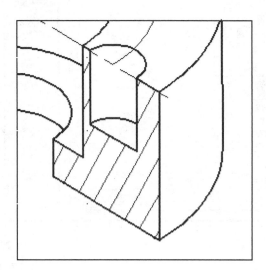

5. **Save as EX-11C**

6. Select the **XCLIP** command <u>again</u>.
 a. Select Objects.
 b. Select **OFF**

 The entire drawing should reappear.

External Reference and Autodesk 360 Connectivity

There are a few restrictions that you need to know when using Autodesk 360 Connectivity for saving or uploading documents that include externally referenced drawings.

Refer to *Exercise Workbook for Beginning AutoCAD 2015* page 30-10 for more detailed information on the Autodesk 360 Connectivity.

Saving to the Autodesk 360

If you **Save** a document to the Autodesk 360 using the **Save** or **Save As** commands AutoCAD will save the document **including the Xref's and the paths**.

Uploading to the Autodesk 360

If you **upload** a document to the Autodesk 360 the document uploaded **will not include the Xref's.**

Notes:

LEARNING OBJECTIVES

After completing this lesson, you will be able to:

1. Dimension using Datum dimensioning.
2. Use alternate dimensioning for inches and Millimeters.
3. Assign Tolerances to a part.
4. Use Geometric tolerances.
5. Type in Geometric Symbols.

LESSON 12

ORDINATE Dimensioning

Ordinate dimensioning is primarily used by the sheet metal industry. But many others are realizing the speed and tidiness this dimensioning process allows.

Ordinate dimensioning is used when the X and the Y coordinates, from one location, are the only dimensions necessary. Usually the part has a uniform thickness, such as a flat plate with holes drilled into it. The dimensions to each feature, such as a hole, originate from one "datum" location. This is similar to "baseline" dimensioning. Ordinate dimensions have only one datum. The datum location is usually the lower left corner of the object.

Ordinate dimensions appearance is also different. Each dimension has only one leader line and a numerical value. Ordinate dimensions do not have extension lines or arrows.

Example of Ordinate dimensioning:

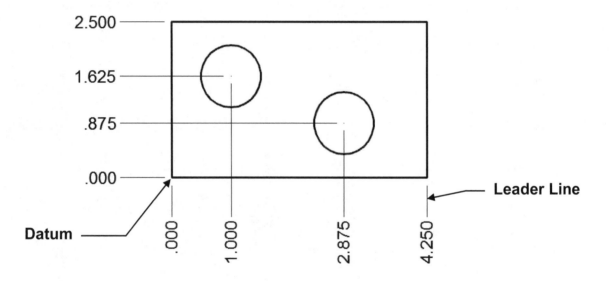

Note:
Ordinate dimensions can be Associative and are Trans-spatial. Which means that you can dimension in paperspace and the ordinate dimensions will remain associated to the object they dimension. (Except for Qdim ordinate)

Refer to the next page for step by step instructions to create Ordinate dimensions.

Creating Ordinate dimensions

1. Move the "Origin" to the desired "datum" location.
 Note: This must be done in Model Space.

2. Select the Ordinate command using one of the following:

 Ribbon = Annotate tab / Dimension panel /

 Keyboard = dimordinate

3. Select the first feature, using object snap.

4. Drag the leader line horizontally or vertically away from the feature.

5. Select the location of the "leader endpoint".
 (The dimension text will align with the leader line)

Use "Ortho" to keep the leader lines straight.

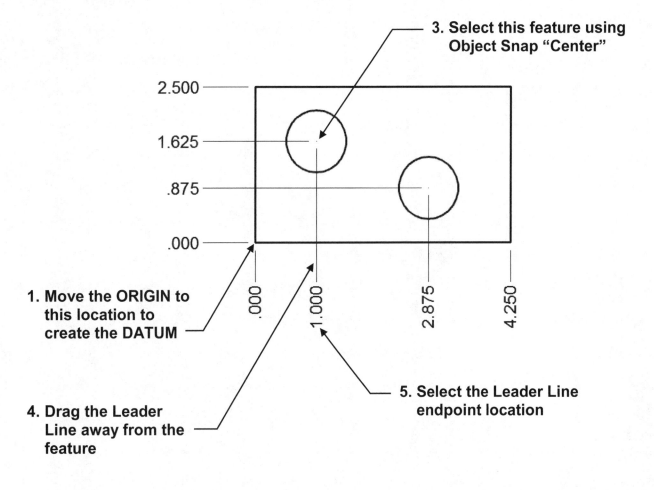

3. Select this feature using Object Snap "Center"

2.500
1.625
.875
.000

.000 1.000 2.875 4.250

1. Move the ORIGIN to this location to create the DATUM

4. Drag the Leader Line away from the feature

5. Select the Leader Line endpoint location

JOG an Ordinate dimension

If there is insufficient room for a dimension you may want to jog the dimension. To **"jog"** the dimension, as shown below, turn **"Ortho" off** before placing the Leader Line endpoint location. The leader line will automatically jog. With Ortho off, you can only indicate the feature location and the leader line endpoint location, the leader line will jog the way it wants to.

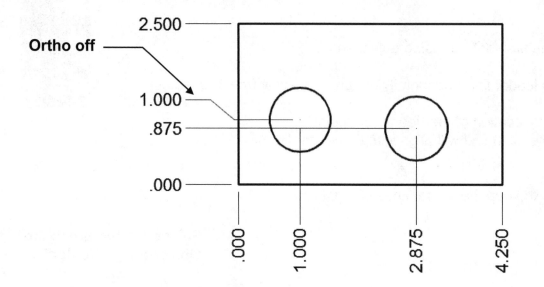

Quick Dimension with Ordinate dimensioning

(Not available in version LT)

1. Select **DIMENSION / Quick Dimension** (Refer to Beginning Workbook, lesson 20)
2. Select the geometry to dimension <enter>
3. Type **"O"** <enter> to select Ordinate
4. Type **"P"** <enter> to select the **datumPoint** option.
5. Select the datum location on the object. (use Object snap)
6. Drag the dimensions to the desired distance away from the object.

> **Note: Qdim can be associative but is not trans-spatial.**
> **If the object is in Model Space, you must dimension in Model Space.**

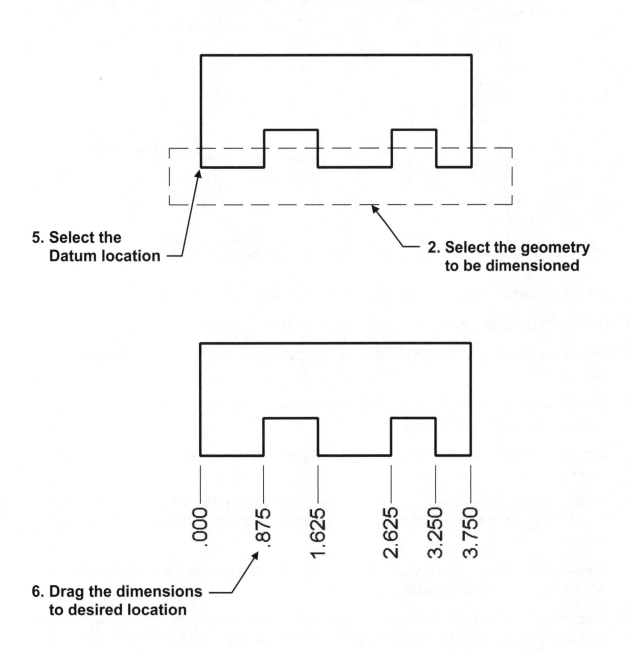

5. Select the Datum location

2. Select the geometry to be dimensioned

6. Drag the dimensions to desired location

ALTERNATE UNITS

The options in this tab allow you to display inches as the primary units and the millimeter equivalent as alternate units. The millimeter value will be displayed inside brackets immediately following the inch dimension. Example: 1.00 [25.40]

1. Select a **DIMENSION STYLE** then **Modify** button.

2. Select the **ALTERNATE UNITS** tab.

3. **Display alternate units**. Check this box to turn ON alternate units

4. **Unit format**. Select the Units for the alternate units.

5. **Precision**. Select the Precision of the alternate units. This is independent of the Primary Units.

6. **Multiplier for all units**. The primary units will be multiplied by this number to display the alternate unit value.

7. **Round distance to**. Enter the desired increment to round off the alternate units value.

8. **Prefix / Suffix**. This allows you to include a Prefix or Suffix to the alternate units. Such as: type mm to the Suffix box to display **mm** (for millimeters) after the alternate units.

9. **Zero Suppression**. If you check one or both of these boxes, it means that the zero will not be drawn. It will be suppressed.

10. **Placement**. Select the desired placement of the alternate units. Do you want them to follow immediately after the Primary units or do you want the Alternate units to be below the primary units?

TOLERANCES

When you design and dimension a widget, it would be nice if when that widget was made, all of the dimensions were exactly as you had asked. But in reality this is very difficult and or expensive. So you have to decide what actual dimensions you could live with. Could the widget be just a little bit bigger or smaller and still work? This is why tolerances are used.

A **Tolerance** is a way to communicate, to the person making the widget, how much larger or smaller this widget can be and still be acceptable. In other words each dimension can be given a maximum and minimum size. But the widget must stay within that **"tolerance"** to be correct. For example: a hole that is dimensioned 1.00 +.06 -.00 means the hole is nominally 1.00 but it can be as large as 1.06 but can not be smaller than 1.00.

1. Select **DIMENSION STYLE / MODIFY**.
2. Select the **TOLERANCES UNITS** tab.

> *Note: If the dimensions in the display look strange, Make sure "Alternate Units" are turned off.*

3. **Method**
The options allows you to select how you would like the tolerances displayed. There are 5 methods: None, Symmetrical, Deviation, Limits. (Basic is used in geometric tolerancing and will not be discussed at this time)

Refer to the next page for descriptions of the methods.

4. **Scaling the height.** This controls the height of the tolerance text. The entered value is a percentage of the primary text height. If .50 is entered, the tolerance text height will be 50% of the primary text height.

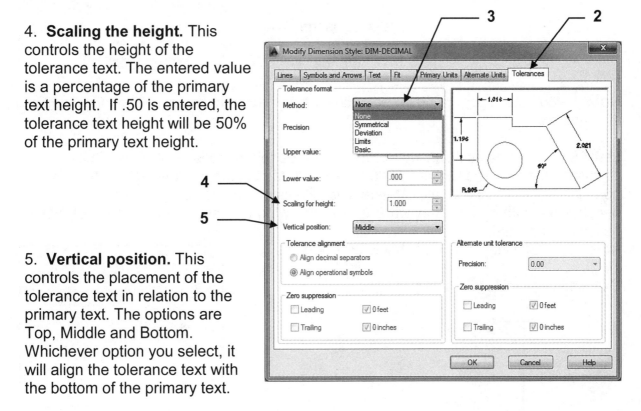

5. **Vertical position.** This controls the placement of the tolerance text in relation to the primary text. The options are Top, Middle and Bottom. Whichever option you select, it will align the tolerance text with the bottom of the primary text.

TOLERANCES....continued

SYMMETRICAL is an equal bilateral tolerance. It can vary as much in the plus as in the negative. Because it is equal in the plus and minus direction, only the "Upper value" box is used. The "Lower value" box is grayed out.

Example of a Symmetrical tolerance:

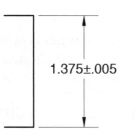

1.375±.005

Tolerance format	
Method:	Symmetrical ▼
Precision	0.000 ▼
Upper value:	.005
Lower value:	.005

DEVIATION is an unequal bilateral tolerance. The variation in size can be different in both the plus and minus directions. Because it is different in the plus and the minus the "Upper" and "Lower" value boxes can be used.

Example of a Deviation tolerance:

$1.375^{+0.005}_{-0.010}$

This controls the appearance of the tolerance.

Tolerance format	
Method:	Deviation ▼
Precision	0.000 ▼
Upper value:	.005
Lower value:	.010
Scaling for height:	1.000
Vertical position:	Middle ▼
Tolerance alignment	
⦿ Align decimal separators	
○ Align operational symbols	

Note: If you set the upper and lower values the same, the tolerance will be displayed as symmetrical.

LIMITS is the same as deviation except in how the tolerance is displayed. Limits calculates the plus and minus by adding and subtracting the tolerances from the nominal dimension and displays the results. Some companies prefer this method because no math is necessary when making the widget. Both "Upper and Lower" value boxes can be used.
Note: The "Scaling for height" should be set to "1".

Example of a Limits tolerance:

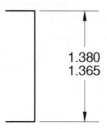

1.380
1.365

Tolerance format	
Method:	Limits ▼
Precision	0.000 ▼
Upper value:	.005
Lower value:	.010
Scaling for height:	1.000
Vertical position:	Middle ▼

GEOMETRIC TOLERANCING

Geometric tolerancing is a general term that refers to tolerances used to control the form, profile, orientation, runout, and location of features on an object. Geometric tolerancing is primarily used for mechanical design and manufacturing. The instructions below will cover the Tolerance command for creating geometric tolerancing symbols and feature control frames.

If you are not familiar with geometric tolerancing, you may choose to skip this lesson.

1. Select the **TOLERANCE** command using one of the following:

 Ribbon = Annotate tab / Dimension panel ▼ /

 Keyboard = tol

 The Geometric Tolerance dialog box, shown below, should appear.

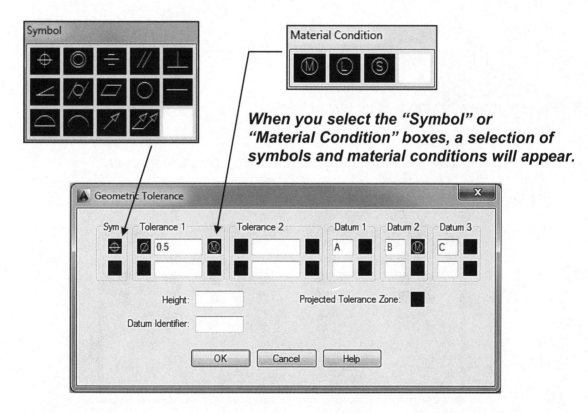

When you select the "Symbol" or "Material Condition" boxes, a selection of symbols and material conditions will appear.

2. Make your selections and fill in the tolerance and datum boxes.
3. Select the OK box.
4. The tolerance should appear attached to your cursor. Move the cursor to the desired location and press the left mouse button.

Note: the size of the Feature Control Frame above, is determined by the height of the dimension text.

GEOMETRIC TOLERANCES and QLEADER

The **Qleader** command allows you to draw leader lines and access the dialog boxes used to create feature control frames in one operation. **Do not use Multileader**

1. Type **qleader <enter>**

2. Select **"Settings"**

3. Select the **Annotation** tab

4. Select the **Tolerance** option

5. Select **OK** button

6. Place the first leader point **P1**

7. Place the next point **P2**

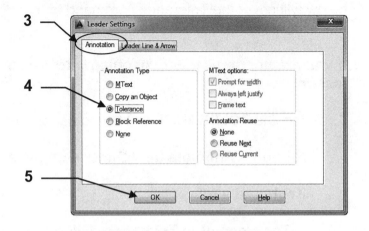

8. Press **<enter>** to stop placing leader lines.

The Geometric Tolerance dialog box will appear.

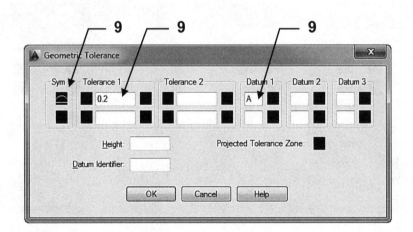

9. Make your selections and fill in the tolerance and datum boxes.

10. Select the **OK** button.

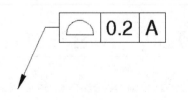

DATUM FEATURE SYMBOL

A datum in a drawing is identified by a **"datum feature symbol"**.

To create a *datum feature symbol*:

1. Select **Annotate** tab / **Dimension panel** ▼/
2. Type the "**datum reference letter**" in the "**Datum Identifier**" box.
3. Select the **OK** button.

Note: the size is determined by the text height setting within the current "dimension style".

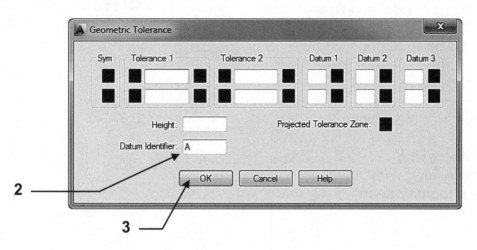

To create a *datum feature symbol* combined with a *feature control frame*:

1. Select **Annotate** tab / **Dimension panel** ▼/
2. Make your selections and fill in the tolerance.
3. Type the "**datum reference letter**" in the "**Datum Identifier**" box.
4. Select the **OK** button.

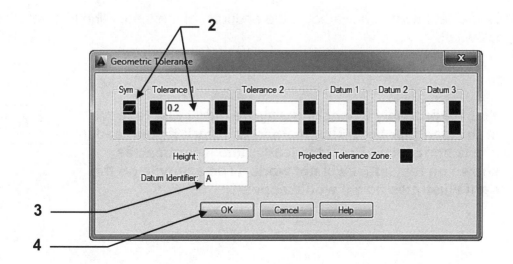

DATUM TRIANGLE

A datum feature symbol, in accordance with ASME Y14.5-2009, includes a leader line and a datum triangle filled. You can create a block or you can use the two step method below using Dimension / Tolerance and Leader.

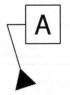

1. Select **Dimension Style** and then **_Override_**

2. Change the Leader Arrow to **Datum triangle filled**

3. Select **Set Current** and **close**.

4. Type **qleader <enter>**

5. Place the 1st point (the triangle endpoint)

6. Place the 2nd point (Ortho ON)

7. Press **<enter> twice**.

8. Select **None** from the options.

If you were successful,
a __datum triangle filled__ with
a __leader line__ should appear.

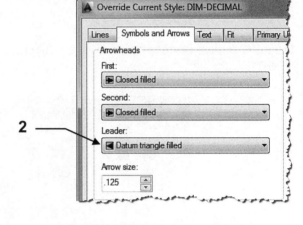

2

6

5

9. Next create a datum feature symbol. (Follow the instructions on the previous page.) A

10. Now move the datum feature symbol to the endpoint of the leader line to create the symbol below left.

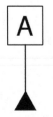

You are probably wondering why we didn't just type "A" in the identifier box. That method will work if your leader line is horizontal. But if the leader line is vertical, as shown on the left, it will not work. (The example on the right illustrates how it would appear)

A

TYPING GEOMETRIC SYMBOLS

If you want geometric symbols in the notes that you place on the drawing, you can easily accomplish this using a font named **GDT.SHX**. This font will allow you to type normal letters and geometric symbols, in the same sentence, by merely pressing the SHIFT key when you want a symbol. Note: the CAPS lock must be ON.

1. First you must create a new text style using the **GDT.SHX** font.

2. **CAPS LOCK** must be **ON**.

3. Select **Single Line** or **Multiline text**

4. Now type the sentence shown below. When you want to type a symbol, press the **SHIFT** key and type the letter that corresponds to the symbol. For example: If you want the diameter symbol, press the shift key and the "N" key. (Refer to the alphabet of letters and symbols shown above.)

Can you decipher what it says?

(Drill (3) .44 diameter holes with a 1.06 counterbore diameter .06 deep)

EXERCISE 12A

INSTRUCTIONS:

1. Start a NEW file using **My Decimal Setup.dwt** and select the **A Size** layout tab.
2. **Draw** the objects shown below.
3. Dimension using **Ordinate** dimensioning.
4. Viewport scale is **1:1**
5. **Save** the drawing as: **EX12A**
6. Plot using Plot Page Setup **Plot Setup A**

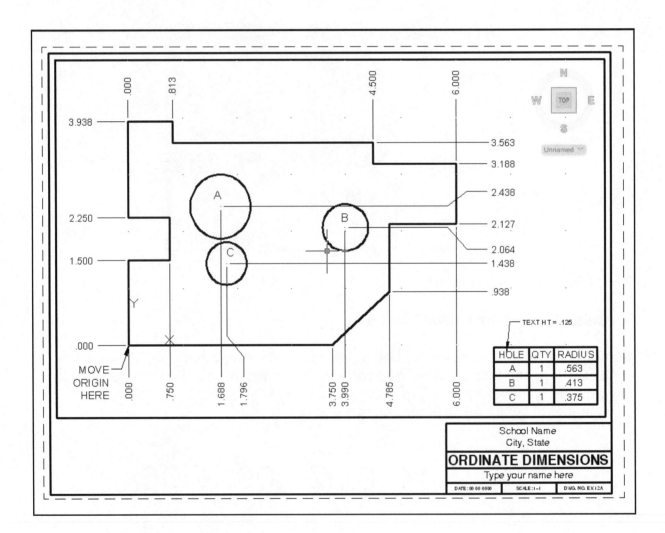

EXERCISE 12B

INSTRUCTIONS:

1. Start a NEW file using **My Decimal Setup.dwt** and select the **A Size** layout tab.
2. **Draw** the objects shown below.
3. Dimension using **Alternate Units**
4. Viewport scale is **1:1**
5. **Save** the drawing as: **EX12B**
6. Plot using Plot Page Setup **Plot Setup A**

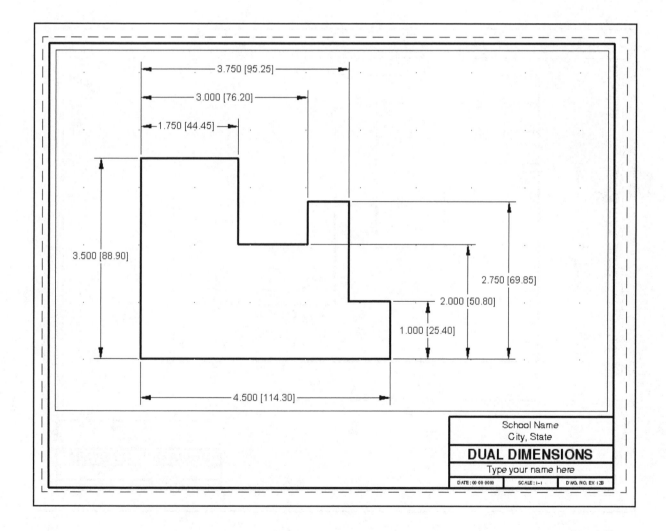

EXERCISE 12C

INSTRUCTIONS:

1. Open **EX-12B** and save immediately as **EX-12C**.

2. Change the dimensions to **Deviation or Symmetrical**. (Use **Properties**)

Note: The Upper and Lower values must be set for each dimension. Or you may use Properties to edit each dimension. It does get a little tedious.

3. **Save** the drawing as: **EX12C**

4. Plot using Plot Page Setup **Plot Setup A**

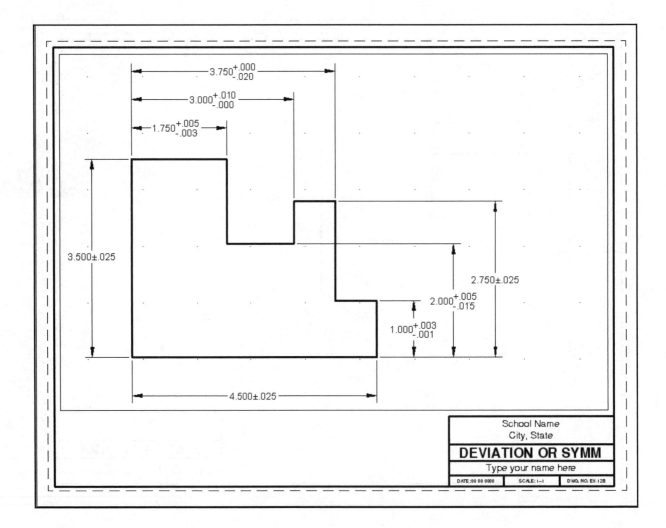

EXERCISE 12D

INSTRUCTIONS:

1. Open **EX-12C** and save immediately as **EX-12D**.

2. Turn off **Alternate Units**

3. Change the dimensions to **Limits**. (Use **Properties**)

Note: The Upper and Lower values must be set for each dimension. Or you may use Properties to edit each dimension. It does get a little tedious.

4. **Save** the drawing as: **EX12D**

5. Plot using Plot Page Setup **Plot Setup A**

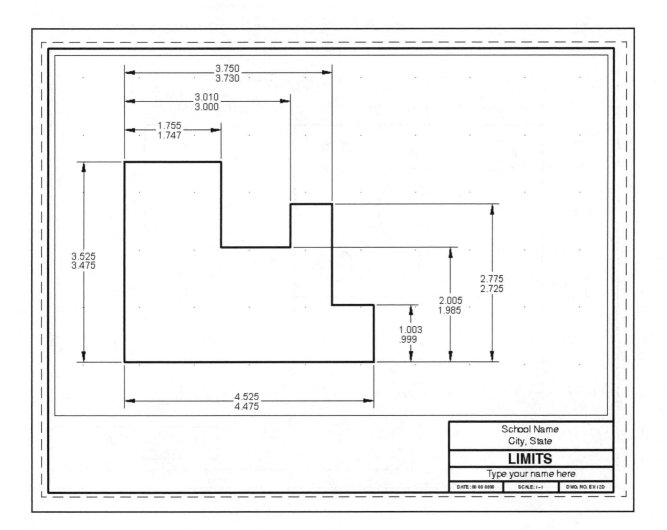

EXERCISE 12E

INSTRUCTIONS:

1. Start a NEW file using **My Decimal Setup.dwt** and select the **A Size** layout tab.

2. **Draw** the objects shown below.

3. Dimension using **Geometric Tolerances** dimensioning

4. Viewport scale is **1:1**

5. **Save** the drawing as: **EX12E**

6. Plot using Plot Page Setup **Plot Setup A**

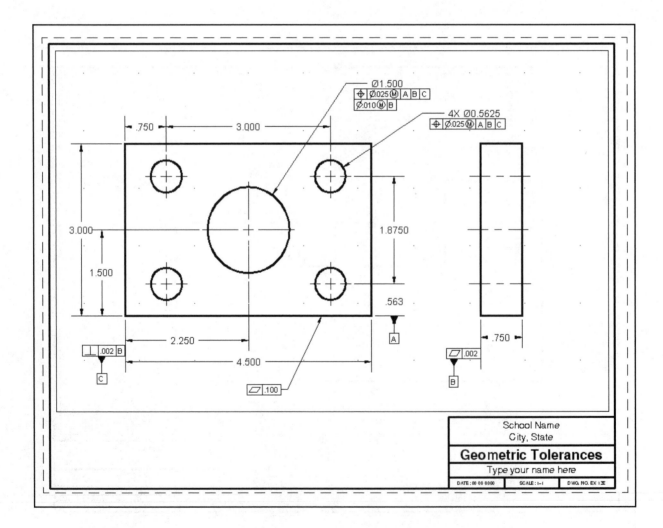

LEARNING OBJECTIVES

After completing this lesson, you will be able to:

1. Understand Parametric drawing
2. Apply Geometric and Dimensional constraints
3. Control the display of constraints
4. Plot Dimensional constraints

LESSON 13

Parametric Drawing

Parametric drawing is a method of assigning a constraint to an object that is controlled by another object. For example, you could put a constraint on line #1 to always be parallel to line #2. Or you could put a constraint on diameter #1 to always be the same size as diameter #2. If you make a change to #1 AutoCAD automatically makes the change to #2 depending on which constraint has been assigned.

<u>There are two general types of constraints:</u>

<u>Geometric</u>: Controls the relationship of objects with respect to each other. The Geometric constraints that will be discussed in this workbook are coincident, collinear, concentric, fix, parallel, perpendicular, horizontal, vertical, tangent, symmetrical and equal.

Example:

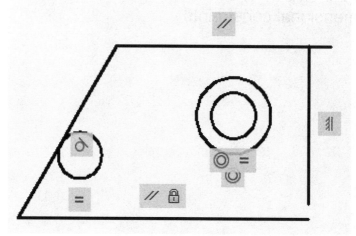

<u>Dimensional</u>: Dimensional constraints control the size and proportions of objects. They can constrain:
 A. Distances between objects or between points on objects
 B. Angles between objects or between points on objects
 C. Sizes of arcs and circles.

Example:

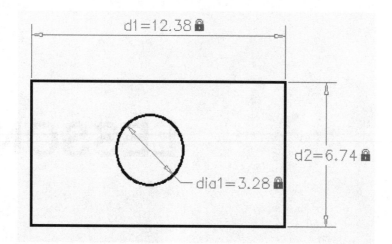

Geometric Constraints

Overview of Geometric Constraints.

Geometric constraints control the relationship of objects with respect to each other. For example, you could assign the parallel constraint to 2 individual lines to assure that they would always remain parallel.

The following is a list of Geometric Constraints available and their icons:

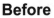

```
Constraint bar display settings
⋋  ☑ Perpendicular      //  ☑ Parallel        [ Select All ]
⇶  ☑ Horizontal         ⧼|  ☑ Vertical         [ Clear All ]
⟳  ☑ Tangent            ⤙  ☑ Smooth (G2)
⋎  ☑ Collinear          ◎  ☑ Concentric
[⫶] ☑ Symmetric         =  ☑ Equal
⥮  ☑ Coincident         🔒  ☑ Fix
☐ Only display constraint bars for objects in the current plane
```

You can apply geometric constraints to 2D geometric objects only. Objects cannot be constrained between model space and paper space.

When you apply a constraint, two things happen:
1. The object that you select adjusts automatically to conform to the specified constraint.
2. A gray constraint icon displays near the constrained object.

Example:

If you apply the **Parallel** constraint to lines A and B you can insure that line B will always be parallel to line A.

Before

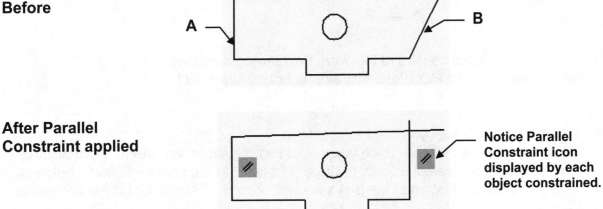

After Parallel Constraint applied

Notice Parallel Constraint icon displayed by each object constrained.

Line A rotated and Line B rotates also to remain parallel

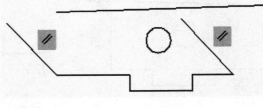

Geometric Constraints....continued

How to apply Geometric Constraints

The following is an example of how to apply the Geometric Constraint **Parallel** to 2D objects.

The remaining Geometric Constraints are described on the following pages.

1. Draw the objects.
 Geometric constraints must be applied to <u>existing</u> geometric objects.

<u>Note:</u>

The color of the ribbon has been changed to the light theme for clarity.

2. Select the **Parametric** tab.

3. Select a Geometric constraint tool from the Geometric panel.
 *(In this example the **Parallel** constraint has been selected.)*

4. Select the objects that you want to constrain.
 In most cases the order in which you select two objects is important. Normally the second object you select adjusts to the first object. In the example shown below Line A is selected first and Line B is selected second. As a result Line B adjusts to Line A.

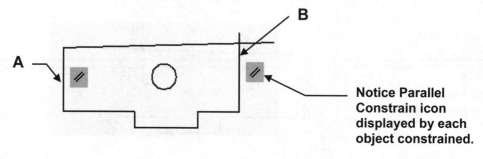

Notice Parallel Constrain icon displayed by each object constrained.

Geometric Constraints....continued

Coincident Constraint
A coincident constraint forces two points to coincide.

1. Draw the objects.

2. Select the Coincident tool from the Geometric panel.

3. Select the first Point.
 (Remember it is important to select the points in the correct order. The first point will
 be the base location for the second point)

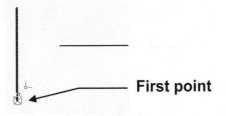

First point

4. Select the second Point.
 (Remember it is important to select the points in the correct order. The second point
 will move to the first point)

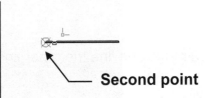

Second point

The points are now locked together. If you move one object the other object will move
also and the points will remain together.

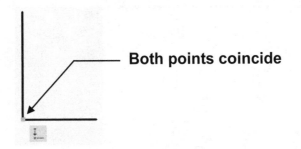

Both points coincide

Geometric Constraints....continued

Collinear Constraint
A collinear constraint forces two lines to follow the same infinite line.

1. Draw the objects.

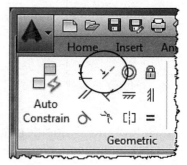

2. Select the Collinear tool from the Geometric panel.

3. Select the first line.
 (The first line selected will be the base and the second line will move.)

4. Select the second line.
 (The second line will move in line with the first line selected)

The two lines are now locked in line. If you move one line the other line will move also and they will remain collinear.

Geometric Constraints....continued

Concentric Constraint
A concentric constraint forces selected circles, arcs, or ellipses to maintain the same center point.

1. Draw the objects.

2. Select the Concentric tool from the Geometric panel.

3. Select the first circle.
 (The first circle selected will be the base and the second circle will move.)

4. Select the second circle.

The second circle moves to have the same center point as the first object.

Geometric Constraints....continued

Fixed Constraint

A Fixed constraint fixes a point or curve to a specified location and orientation relative to the Origin (World Coordinate System, WCS).

1. Draw the object.

2. Select the Fixed tool from the Geometric panel.

3. Select the Fixed location.

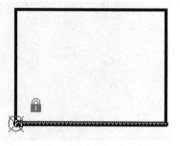

The bottom left corner is now fixed to the specified location but the other three corners can move. (Note: the "lock" symbol may appear in a slightly different location)

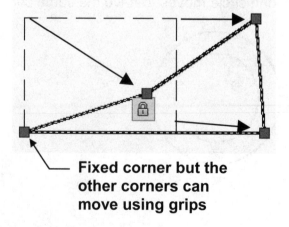

Fixed corner but the other corners can move using grips

Geometric Constraints....continued

Perpendicular Constraint

A Perpendicular constraint forces two lines or polyline segments to maintain a 90 degree angle to each other.

1. Draw the objects.

2. Select the Perpendicular tool from the Geometric panel.

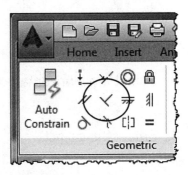

3. Select the First object.
 (The first object will be the base angle and the second will rotate to become perpendicular to the first)

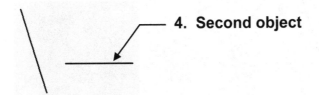

3. **First object**

4. Select the Second object.

4. **Second object**

The second object rotated to become perpendicular to the first object.

Geometric Constraints....continued

Horizontal Constraint

The Horizontal constraint forces a line to remain <u>parallel to the **X-axis**</u> of the current UCS.

1. Draw the objects.

2. Select the Horizontal tool from the Geometric panel.

3. Select the <u>object</u> .

select object

The object selected becomes <u>horizontal to the X-Axis of the current UCS</u>.

Note: If the object is a Polyline or Polygon use the "2 point" option. The first point will be the pivot point.

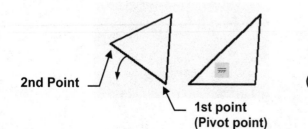

2nd Point

1st point (Pivot point)

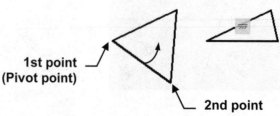

1st point (Pivot point)

2nd point

Geometric Constraints....continued

Vertical Constraint

The Vertical constraint forces a line to remain <u>parallel to the **Y-axis**</u> of the current UCS.

1. Draw the objects.

2. Select the Vertical tool from the Geometric panel.

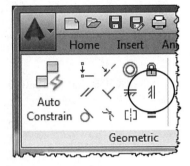

3. Select the <u>object</u> .

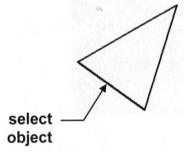

select object

The object selected becomes <u>vertical to the Y-Axis of the current UCS</u>.

Note: If the object is a Polyline or Polygon use the "2 point" option. The first point will define the pivot point.

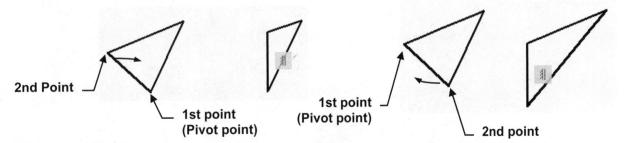

2nd Point

1st point (Pivot point)

1st point (Pivot point)

2nd point

Geometric Constraints....continued

Tangent Constraint
The Tangent constraint forces two objects to maintain <u>a point of tangency</u> to each other.

1. Draw the objects.

2. Select the Tangent tool from the Geometric panel.

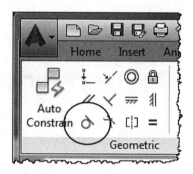

3. Select the base object (Large Circle) and then the object (Line) to be tangent.

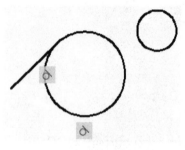

4. Select the base object (Large Circle) and then the object (Small Circle) to be tangent.

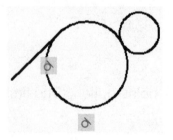

Geometric Constraints....continued

Symmetric Constraint

The Symmetric constraint forces two objects on a object to maintain <u>symmetry about a selected line</u>.

1. Draw the objects.

2. Select the Symmetric tool from the Geometric panel.

3. Select the base line (1) then the Line (2) to be symmetrical and then the line (3) to be symmetrical about.

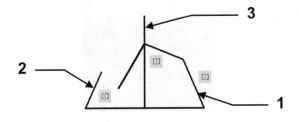

4. Select the base line (1) then the Line (2) to be symmetrical and then the line (3) to be symmetrical about.

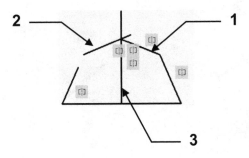

Geometric Constraints....continued

Equal Constraint
The Equal constraint forces two objects to be <u>equal in size</u>. (Properties are not changed)

1. Draw the objects.

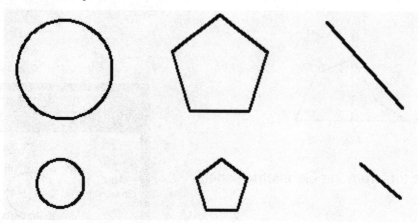

2. Select the Equals tool from the Geometric panel.

3. Select the base object (A) then select the object (B) to equal the selected base object.

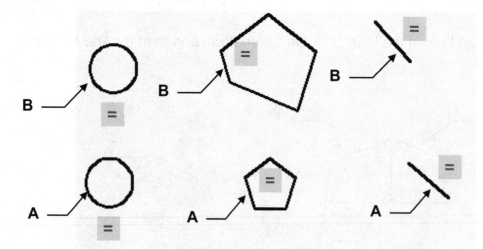

Geometric Constraints....continued

Controlling the display of Geometric constraint icons

You may temporarily Hide the Geometric constraints or you may show individually selected constraints using the Show and Hide tools.

Show All

This tool displays all geometric constraints.
Click on the tool and the constraints appear.

Hide All

This tool hides all geometric constraints.
Click on the tool and the constraints disappear.

Show / Hide

After you have selected the **Hide All** tool to make the constraints disappear, you may display individually selected geometric constraints.

1. Select the **Show/Hide** tool

2. Select the object

3. Press **<enter>**

4. Press **<enter>**

The geometric constraints for only the selected objects will appear.

Dimensional Constraints

Overview of Dimensional Constraints
Dimensional constraints determine the distances or angles between objects, points on objects, or the size of objects.

Dimensional constraints include both a name and a value.

Dynamic constraints have the following characteristics:
 A. Remain the same size when zooming in or out
 B. Can easily be turned on or off
 C. Display using a fixed dimension style
 D. Provide limited grip capabilities
 E. Do not display on a plot

There are 7 types of dimensional constraints. (They are similar to dimensions)
 1. Linear
 2. Aligned
 3. Horizontal
 4. Vertical
 5. Angular
 6. Radial
 7. Diameter

The following is an example of a drawing with dimensional constraints. The following pages will show you how to add dimensional constraints and how to edit them.

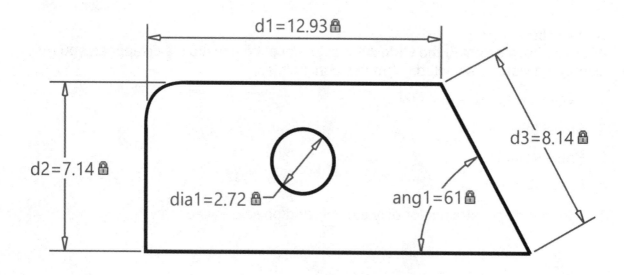

Dimensional Constraints....continued

How to apply Dimensional Constraints

The following is an example of how to apply the dimensional constraint Linear to a 2D object.

1. Draw the objects.

2. Select the Parametric tab.

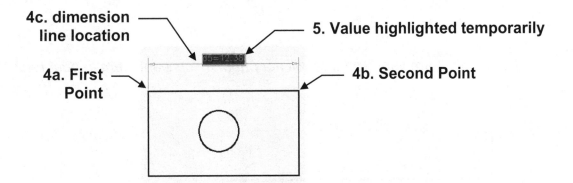

3. Select a Dimensional Constraint tool from the Dimensional panel.
 (In this example the Linear tool has been selected)

4. Apply the "Linear" dimensional constraint as you would place a linear dimension.
 a. Place the first point
 b. Place the second point
 c. Place the dimension line location

5. Enter the desired value or <enter> to accept the displayed value.
 (Notice the constraint is highlighted until you entered the value)

4c. dimension line location　　　　**5. Value highlighted temporarily**

4a. First Point　　　　**4b. Second Point**

6. The Dimensional constraint is then displayed with Name (d1) and Value (12.38).

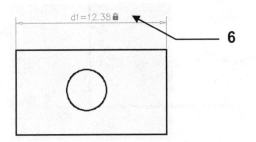

Dimensional Constraints....continued

How to use Dimensional Constraints

The following is an example of how to use dimensional constraint to change the dimensions of a 2D object.

1. Draw the objects.
 (Size is not important. The size will be changed using the dimensional constraints.)

2. Apply Dimensional constraints
 Linear and Diameter.

Note:
Dimensional constraints are very faint and will not print. If you want them to print refer to page 13-24

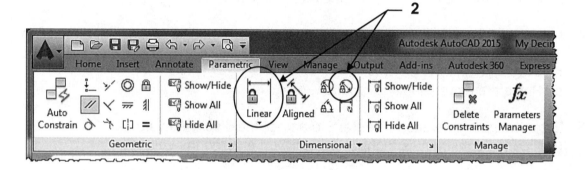

Dimensional Constraints....continued

Now adjust the length and width using the dimensional constraints.

1. Double click on the d1 dimensional constraint.

2. Enter the new value for the length then **\<enter\>**

Note: The length increased automatically in the direction of the "2nd endpoint". If you want the length to change in the other direction you must apply the "geometric constraint Fixed" to the right hand corners. (See page 13-8)

3. Double click on the d2 dimensional constraint and enter the new value for the width then **\<enter\>**

Dimensional Constraints....continued

Parameter Manager

The Parameter Manager enables you to manage dimensional parameters. You can change the name, assign a numeric value or add a formula as its expression.

1. Select the Parameter Manager from the Parametric tab / Manage Panel

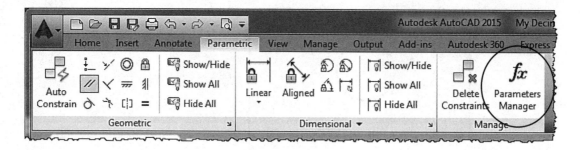

Column descriptions:

Name: Lists all of the dimensional constraints. The order can be changed to ascending or descending by clicking on the up or down arrow.

Expression: Displays the numeric value or formula for the dimension.

Value: Displays the current numeric value.

Dimensional Constraints....continued

Parameter Manager Name cell

You may change the name of the dimension to something more meaningful. For example you might change the name to Length and width rather than d1 and d2.

1. Double click in the name cell that you want to change.

2. Type the new name and **\<enter\>**

Example:

The names in the Parameter Manager shown below have been changed. Notice the dimensional constraints in the drawing changed also.

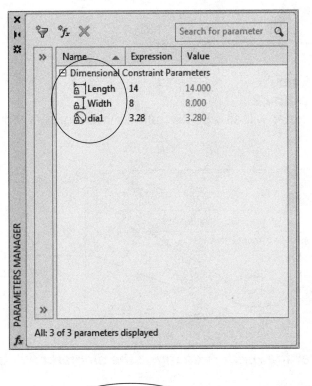

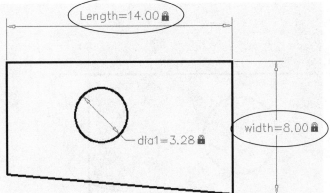

Dimensional Constraints....continued

Parameter Manager Expression cell

You may change the value of a dimensional constraint by clicking on the Expression cell and entering a new value or formula.

1. Open the Parameter Manager.

2. Double click in the Expression cell to change (dia1 in this example)

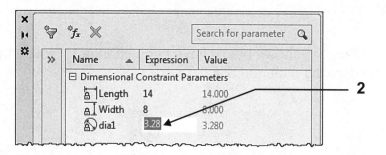

3. Enter new value or formula.
 For this example: **width / 2**
 This means the diameter will always be half the value of d2 (width)

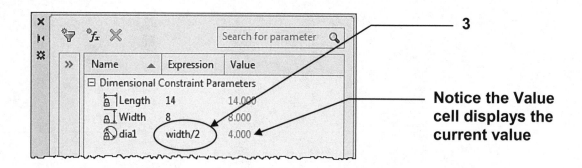

Notice the Value cell displays the current value

Now whenever the width is changed the diameter will adjust also.

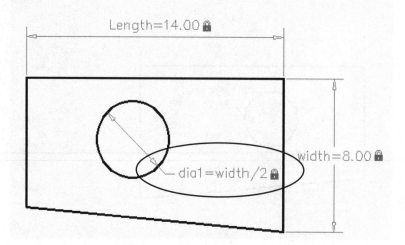

Dimensional Constraints....continued

Adding User-defined parameters

You may create and manage parameters that you define.

1. Open the Parameter Manager

2. Select the "New user parameter" button.
 A "**User Parameters**" will appear.

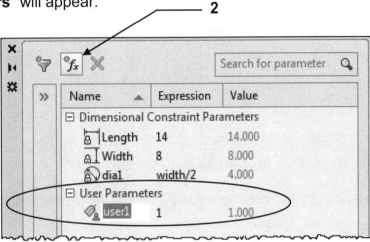

3. Enter a desired **Name** for the expression.

4. Enter an **Expression**.

The <u>Value cell</u> updates to display the current value.

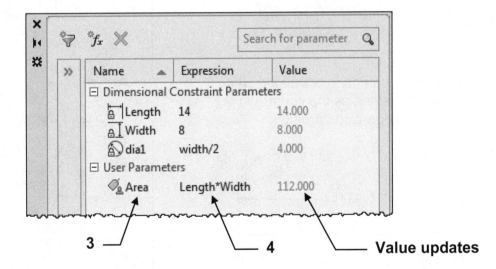

Note: With Imperial Units, the parameter manager interprets a minus or a dash (-) as a unit separator rather than a subtraction operation. To specify subtraction, include at least one space before or after the minus sign. For example: to subtract 9" from 5', enter **5' -9"** rather than **5'-9"**

Dimensional Constraints....continued

Convert a Dimensional constraint to an Annotational constraint

Geometric and Dimensional constraints do not plot. If you would like to plot them you must convert them to an Annotational constraint.

1. Select the constraint to convert. (Click on it once)

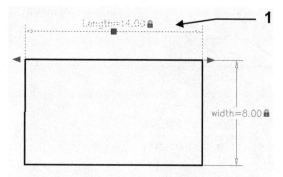

2. Right click and select **properties** from the list.

3. Select the Constraint Form down arrow and select Annotational

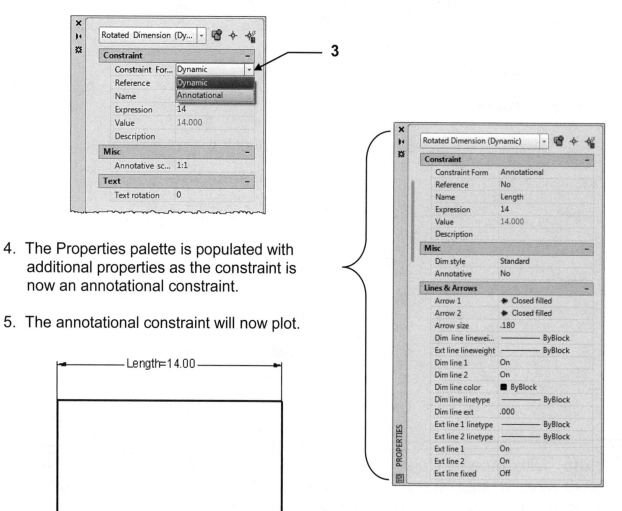

4. The Properties palette is populated with additional properties as the constraint is now an annotational constraint.

5. The annotational constraint will now plot.

Dimensional Constraints....continued

Control the Display of Dimensional constraints

You may turn off the display of Dimensional constraints using the **Show** and **Hide** tools.
(Refer to page 13-15).

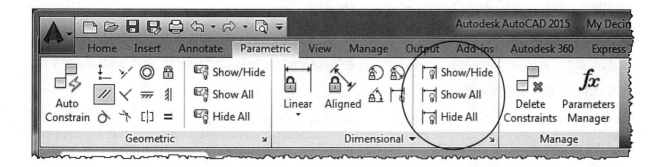

Delete a Dimensional constraint.

To permanently delete a dimensional constraint select the **Delete Constraints** button
and then select the constraint to delete.

EXERCISE 13A

INSTRUCTIONS:

1. Start a **NEW** file using **My Decimal Setup.**

2. **Draw** the Lines shown below on the left using random lengths and angles.

3. Create the shape on the right using the lines on the left and Geometric constraints.

4. Add the two Dimensional constraints.

5. Change the Dimensional constraints name as shown.

6. Create an Expression formula for the Width.
 (pg 13-22)

7. Add a <u>User defined parameter</u> **Area**

8. Change the Dimensional Constraints to Annotational. (pg. 13-24)

9. **Save** the drawing as: **EX13A**

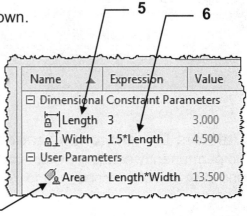

Name	Expression	Value
⊟ Dimensional Constraint Parameters		
🔒⊢Length	3	3.000
🔒⊤Width	1.5*Length	4.500
⊟ User Parameters		
🔩 Area	Length*Width	13.500

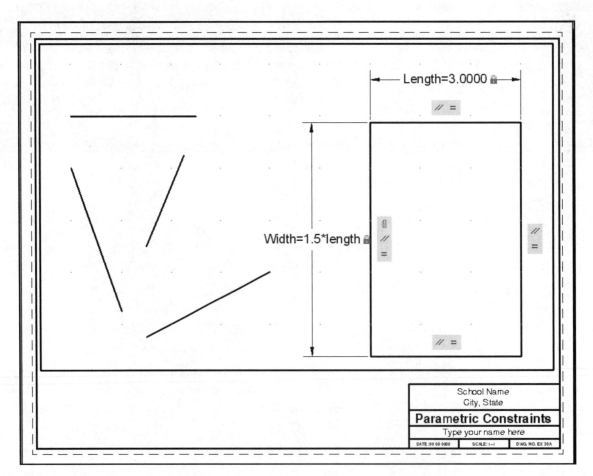

Length=3.0000 🔒

Width=1.5*length 🔒

School Name
City, State
Parametric Constraints
Type your name here

| DATE :00 00 0000 | SCALE: I-I | DWG. NO. EX 30A |

EXERCISE 13B

INSTRUCTIONS:

Step 1

1. Draw the Floor plan shown below.

2. Do not dimension.

3. **Save** the drawing as: **EX13B**

Continue on to Step 2 on the next page

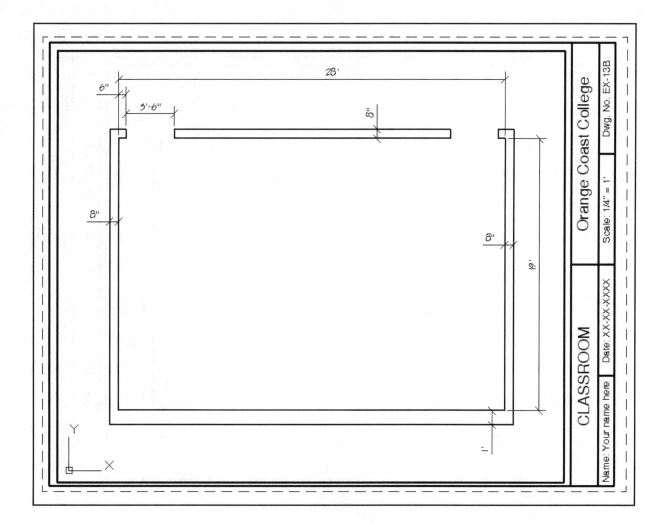

EXERCISE 13B....continued

INSTRUCTIONS:

Step 2

1. Using the **Polyedit / Join** command, join the lines that form the walls into 2 sets of polylines.
2. **Save** the drawing again as: **EX13B**

Continue on to Step 3 on the next page

EXERCISE 13B....continued

INSTRUCTIONS:

Step 3

1. Using Geometric constraints, make **all** inside lines **Parallel** to the outside lines.

 (Refer to page 13-3)

Note:

Your geometric icons may appear in different locations than the illustration below.

2. **Save** the drawing as: **EX13B**

Continue on to Step 4 on the next page

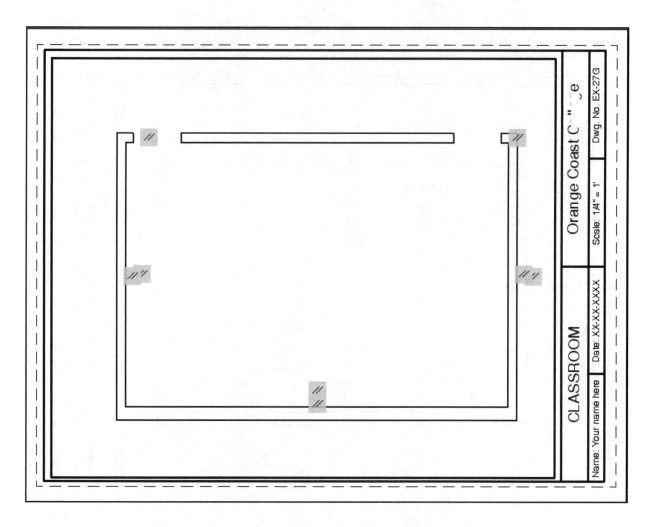

EXERCISE 13B....continued

INSTRUCTIONS:

Step 4.

1. Apply Dimensional constraints as shown below.

Note:

Notice where the 1st point is located. When placing the Length and Width dimensional constraints, it is important to select the 1st and 2nd points in the correct order. The objects will change size in the direction of the 2nd point.

2. **Save** the drawing as: **EX13B**

Continue on to Step 5 on the next page

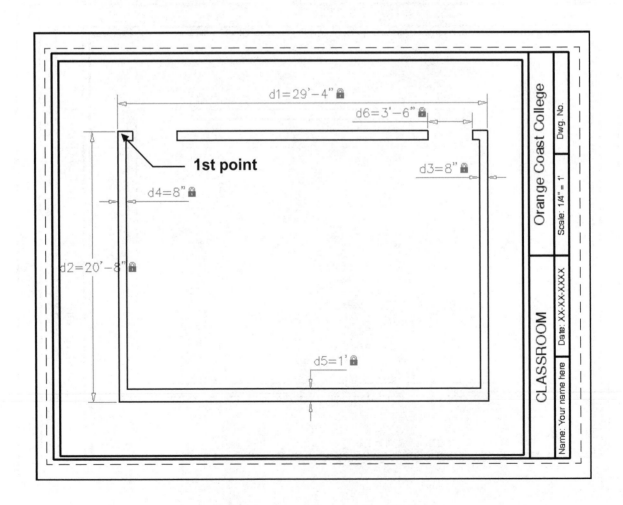

EXERCISE 13B....continued

INSTRUCTIONS:

Step 5.

1. Change d1 to 31' -4" (refer to page 13-19)

2. Change d2 to 22'

Note:

If you placed everything correctly d1 should have increased to the right and d2 down. Do not be surprise if it does not work correctly the first time. If it did not, try to figure out what you did wrong. You may not have made all of the lines parallel to each other or maybe you did not place the 1st points of the dimensional constraints in the correct location. If you master Geometric and Dimensional constraints it could be very helpful in the future.

3. **Save** the drawing as: **EX13B**

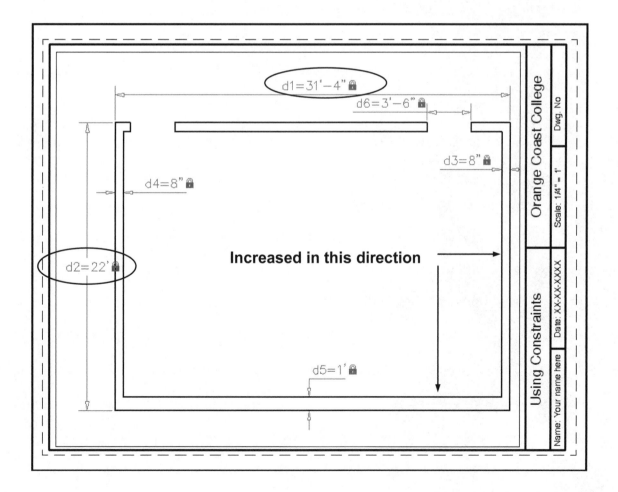

Notes:

LEARNING OBJECTIVES

After completing this lesson, you will be able to:

1. Set a Geographic Location on a Map.
2. Set a Geographic Location using Latitude and Longitude.
3. Edit an existing Geographic Location.
4. Change the display of the Map.
5. Understand Position Markers.
6. Place a Position Marker on the Map.
7. Edit an existing Position Marker.
8. Capture Map Data.

LESSON 14

GEOGRAPHIC LOCATION Overview

AutoCAD allows you to set a **Geographical Location** in your drawing, this means you can set a location of your position, or a landmark, or perhaps a building, at the exact location it is in the world. You can import geolocated data into a geolocated drawing and AutoCAD automatically places it in the correct world location.

AutoCAD now includes the same Coordinate System Library as AutoCAD® Map 3D and Autodesk® Live Maps . You can have a map showing the geographic location displayed in your drawing, this is a very useful feature if you want to show the plans of say your house, in the correct position on the map.

The Geographic Location information that you set in your drawing is built around a **Geographic Marker**, the Geographic Marker that you place, points to a reference point in Model Space which corresponds to a location on Earth of known Latitude and Longitude. And don't worry if you have no idea what your latitude or longitude is of the position you want to enter, you can simply type in the name of the road you want, or you can type in the name of a town, or the name of a landmark, AutoCAD searches for those locations. You can then zoom in on the map and place your Geographic Marker. It really is a lot easier than it sounds.

> **Important:** The only requirement to use the online maps service is that you must have an Autodesk® 360 account set up, and be signed in. If you do not already have an account, refer to **Appendix-B2** for creating an Autodesk® 360 account.

The example below shows the Statue of Liberty on a section of map with a geographic marker placed on it, the X and Y coordinates are set at 0,0. If you find that the UCS icon is difficult to see, you may change its color. The geographic marker will be Red in color.

Geographic Marker

The Geographic Marker would appear like this if you were in 3 Dimensional Space, with the point of the cone in the ground

Enlarged plan view of the Geographic Marker in 2D.

Set a Geographic Location on a Map

Note: You must be signed in to Autodesk 360 to use this feature.

1. Select the **GEOGRAPHICLOCATION** command using one of the following:

 Ribbon = Insert tab / Location panel / Set Location ▼ / From Map
 or
 Keyboard = Geo <enter> / Map

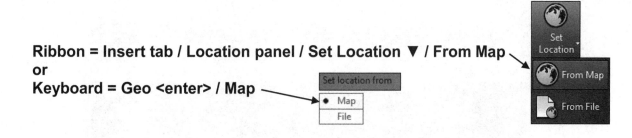

2. If the **Geolocation - Live Map Data** dialog box appears, select **YES**.

3. If you have not signed into Autodesk 360 the **Autodesk - Sign In** dialog box will appear, enter your Autodesk account information then click on **Sign In**.

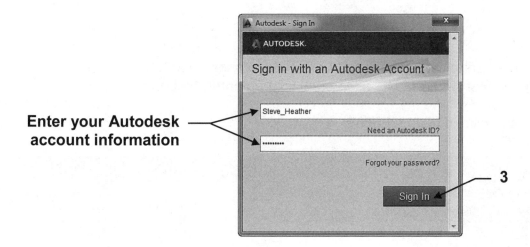

Continued on the next page...

Set a Geographic Location on a Map....continued

The **Geographic Location** dialog box is displayed.

4

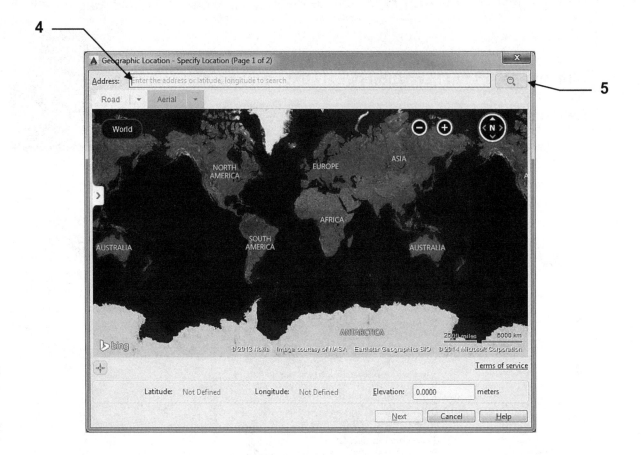

5

4. Enter an **Address**, **Place Name** or **Latitude** & **Longitude** into the search box.

5. Select the **SEARCH** button.

> ### Note:
>
> When entering the Latitude and Longitude into the search box, enter the Latitude first separated by a 'comma' (,) then enter the Longitude.
>
> For example: **51.2713,1.0639**

Continued on the next page...

Set a Geographic Location on a Map....continued

6. The numbered search results will be displayed in the left-hand window, with the corresponding number displayed on the map.

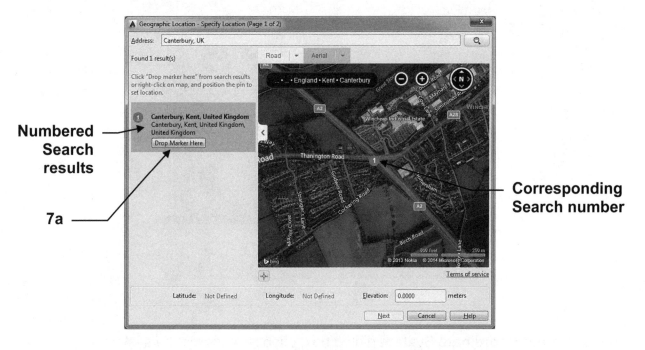

Numbered Search results

7a

Corresponding Search number

There are several options you can use to set the **Geographic Marker** into position.

7. (a) If you are happy with the location of the search number on the map, select: **Drop Marker Here**.

7. (b) Zoom in closer on the map then right-click and select: **Drop Marker Here**.

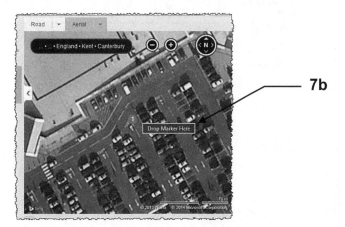

7b

Once you have selected **Drop Marker Here**, the Geographic Marker will be displayed on the map in the Geographic Location dialog box. Don't worry if you have placed the marker in the wrong position as there are many ways you can edit the location.

Continued on the next page...

Set a Geographic Location on a Map....continued

8. Select the **Next** button.

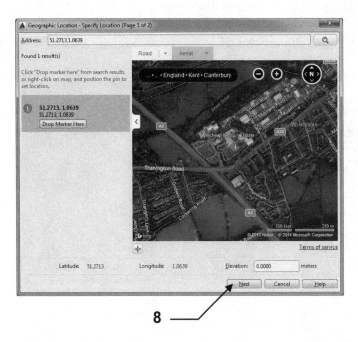

8

9. In the **Set Coordinate System** dialog box, choose a coordinate system that is suitable for your location. (For this example I have chosen **BritishNatGrid**)

10. Choose the most suitable **Time Zone** for your location. (I have chosen **GMT**)

11. Choose the **Drawing Units** for the map.

12. Select the **Next** button.

Continued on the next page...

Set a Geographic Location on a Map....continued

The **Geographic Location** dialog box will close and the following will appear on the command line and in the dynamic input box:

13. Enter the **X,Y,Z** coordinates you require and press **<enter>** or just press **<enter>** to accept the default **0,0,0**

Note: The '**Z**' axis is used if you know the **Elevation** (Height) of the location you are entering. Just enter '**0**' (zero) if you don't know it.

The following will appear on the command line and in the dynamic input box:

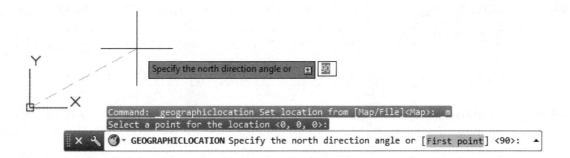

14. Turn on **OrthoMode (F8)** and move you mouse upwards (**Y+**), then press **<enter>** or type in **90** then press **<enter>**

Note: It is normally best to have the North direction at the top of your drawing (**Y+**), but you can have it any angle you require.

15. The map showing the **Geographic Marker** will now be visible in the drawing area and look similar to the example on page 14-2.

Continued on the next page...

Edit an existing Geographic Location

When you insert a Geographic Marker into your drawing, the **Geolocation** contextual ribbon tab will appear with various commands and options, including the **Edit Location** command where you can edit an existing geographic location.

How to edit an existing Geographic Location:

1. Select the **EDIT LOCATION** command using one of the following:

 Ribbon = Geolocation tab / Location panel / Edit Location ▼ / From Map
 or
 Keyboard = Geo <enter> / Map

2. The **Geographic Location** dialog appears where you can make any changes that are necessary.

Note: You can zoom in on the map to get a closer view, you can then hold down the left mouse button and drag the Geographic Marker to a new location. When you are satisfied with the new position, release the left mouse button to set the new location.

3. Select the **Next** button in the Geographic Location dialog box.

4. Complete steps **9** & **15** to finish the location editing. (refer to pages 14-6 to 14-7)

How to remove an existing Geographic Location:

It is very easy to remove a Geographic Location and any associated information from your drawing. Just follow the two simple steps below:

1. Select the **"Remove Location"** command on the **Location** panel of the Geolocation ribbon tab.

2. Select **Yes** in the **Geographic Location - Remove** dialog box.

Changing the Map display

You can choose how the map is displayed in the current viewport from four options, these are: **Map Aerial**, **Map Road**, **Map Hybrid**, and **Map Off**.

To change the display of the Map in the current viewport:

1. Select the **Map Aerial** drop-down menu from the **Tools** panel on the **Geolocation** ribbon tab.

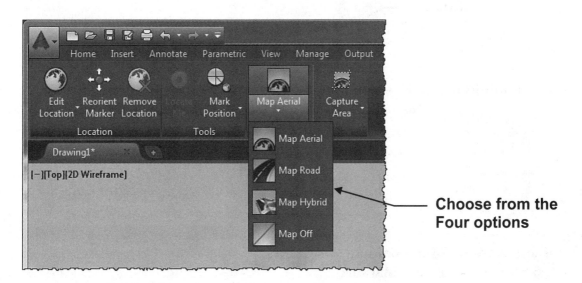

2. Select from the four options available.

 A. **Map Aerial** - Displays the map using satellite images.
 B. **Map Road** - Displays the map using vector images.
 C. **Map Hybrid** - Displays the map using satellite images overlaid with roads.
 D. **Map Off** - Turns off the display of the map. (the geographic marker is displayed)

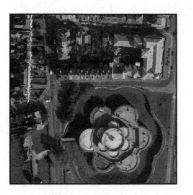 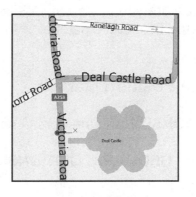 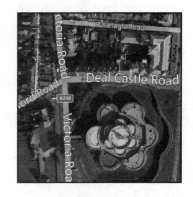

Map Aerial **Map Road** **Map Hybrid**

POSITION MARKERS

A **Position Marker** is used to mark and label a location on the map in Model Space. It consists of a **Leader Line**, a **Point**, and **Multiline Text**. You can place as many Position Markers in the drawing as you like. You can use the multi-functional grips to lengthen the leader line, change the position of the marker point, or you can use the grips to change the position of the multiline text.

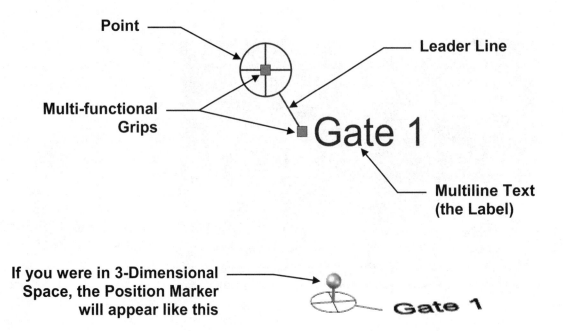

When you first place a Position Marker on to the drawing, its default size is **1** drawing unit, this means, if you have your map measurements set to **"Inches"**, the point radius will be **1 inch** and the text height will be **1 inch**. So you can imagine placing a position marker with its text height at **1 inch**, you would not be able to see it on the map. I prefer to set my markers at **100 inches** before I place them on to the drawing.

The size of the Position Marker is controlled by the **GEOMARKPOSITIONSIZE** system variable, you can set the size before you place any Position Markers, or if you have existing Position Markers use the Properties palette.

To change the size of the Position Marker:

1. Type in **GEOMARKPOSITIONSIZE** and then press **<enter>**

2. At the **"Enter new value for GEOMARKPOSITIONSIZE"** prompt, type in **100** and then press **<enter>**

Note: The size you enter for the Position Marker is controlled by the map drawing units you set on page 14-6. So the setting I have just changed makes the text height 100 inches and the Point radius 100 inches.

Place a Position Marker on the Map

<u>You will first need to set your Geographic Location as described on pages 14-3 to 14-7</u>

1. Select the **POINT** command using one of the following:

 Ribbon = Geolocation tab / Map Tools panel / Mark Position ▼ / Point
 or
 Keyboard = Geomarkpoint <enter>

2. Specify a point: *move the cursor to the location you require and then left mouse click, or type in the X and Y coordinates and press <enter>.*

3. Enter the text you want for the position marker. (you will notice that the **Text Editor** ribbon has appeared, you can change the text style, size, color or any other attributes you require).

4. Left click outside the text area, or select **Close Text Editor** to finish the command.

5. The **Position Marker** with it's Label will now be visible on the map.

<u>Note:</u> The Position Marker is fully editable by selecting it first, then right-click and select **Properties** from the menu. In the example below I have changed the **Size** of the marker to 250 inches and the color to Yellow, to make it more visible.

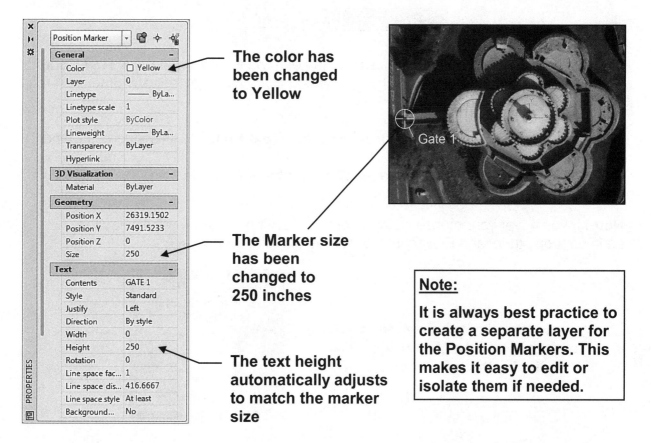

The color has been changed to Yellow

The Marker size has been changed to 250 inches

The text height automatically adjusts to match the marker size

Note:

It is always best practice to create a separate layer for the Position Markers. This makes it easy to edit or isolate them if needed.

Place a Position Marker using Latitude and Longitude

You can also place a **Position Marker** on the Map by using Latitude and Longitude coordinates.

You will first need to set your Geographic Location as described on pages 14-3 to 14-7

1. Select the **LAT-LONG** command using one of the following:

 Ribbon = Geolocation tab / Tools panel / Mark Position ▼ / Lat-Long
 or
 Keyboard = Geomarklatlong <enter>

2. Specify Latitude: *type in the Latitude coordinate and then press <enter>*

 Specify latitude <eXit>: 40.7488

3. Specify Longitude: *type in the Longitude coordinate and then press <enter>*

 Specify longitude <eXit>: -73.9860

4. Enter the text you want for the position marker. (you will notice that the **Text Editor** ribbon has appeared, you can change the text style, size, color or any other attributes you require).

5. Left click outside the text area, or select **Close Text Editor** to finish the command.

6. The **Position Marker** with it's Label will now be visible on the map.

Note: If you hover your mouse cursor over any Position Marker it will display the Latitude, Longitude, and Elevation coordinates and also the Layer.

Hover the mouse cursor over the Position Marker to display the information —

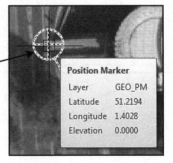

Position Marker

Layer	GEO_PM
Latitude	51.2194
Longitude	1.4028
Elevation	0.0000

Edit an existing Position Marker

There are various ways you can edit an existing Position Marker, you can right-click on a Marker and select the Properties palette as shown on page 14-11. You can also left-click a position Marker to enable the Multi-functional Grips.

Edit a Position Marker using Grips:

1. Left-click on a Marker to enable the grips.

2. a) Left-click on the **Point Grip**, then drag to move the Markers position. (**Note:** Only the Marker will move, the Text and Leader-Line will remain in the same position)

Point Grip

Gate 1

Original

Gate 1

New Marker position

2. b) Left-click on the **Leader and Text Grip**, then drag to move the Leader-Line and Text position. (**Note:** Only the Leader-Line and Text will move, the Marker will remain in the same position)

Leader and Text Grip

Gate 1

Original

Gate 1

New Leader-Line and Text position

3. Press the **Esc** key to disable the Multi-functional Grips.

Capture Map Data

AutoCAD allows you to capture and print out map data. You can capture an area or viewport of any part of the map. This capture can then be saved with the drawing. The capture is embedded into the drawing and can be used even if you have no internet access.

How to capture an area of the map:

1. Complete the steps for setting up a Geographic Location on pages 14-3 through to 14-7

2. Select the **CAPTURE AREA** command using one of the following:

 Ribbon = Geolocation tab / Online Map panel / Capture Area ▼ / Capture Area
 or
 Keyboard = Geomapimage <enter>

3. Specify first corner: *move the cursor to the location you require then left mouse click*.

4. Specify opposite corner: *move the cursor to the opposite corner you require then left mouse click*.

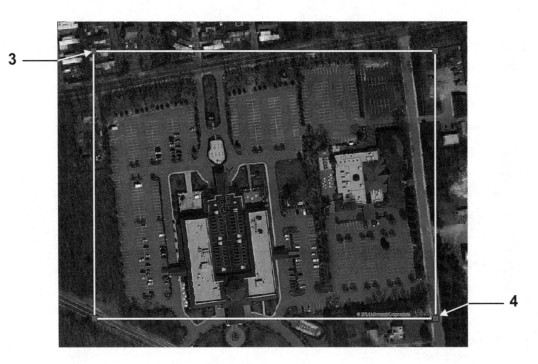

Note: The line color of the capture area has been changed to white for clarity purposes.

The area of the map you captured will now be embedded into the drawing when you save it. You may also plot the captured area of the map using your printer.

Continued on the next page...

Capture Map Data....continued

You may choose to display only the captured area of the map on your screen and hide the rest of the map by using the **MAP OFF** command. You may also choose to display the captured area as **Map road** or **Map Hybrid**. (Refer to page 14-9)

Only the captured area of the map is now displayed.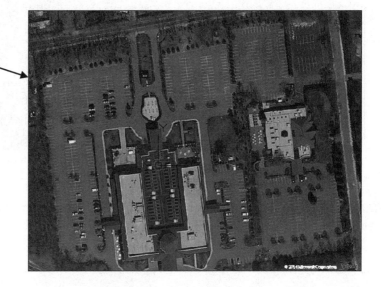

You can **resize**, **move** or **rotate** the captured area by selecting the image to enable the grips. Only the captured area will change, the map position and orientation will remain in the same place.

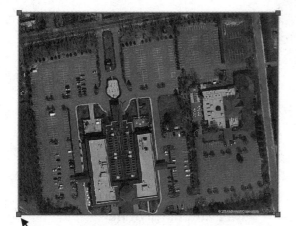

The grips have been selected by clicking on the captured area.

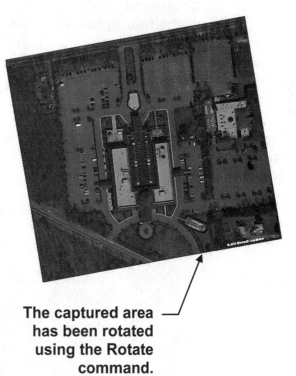

The captured area has been rotated using the Rotate command.

Continued on the next page...

Capture Map Data....continued

When you enable the grips by selecting the captured area, the **Map Image** contextual ribbon tab will open giving you further options and commands to adjust the captured area.

You can change the map image resolution by selecting the **Optimal** drop-down menu and selecting from the four options, Optimal is the default.

Choose from any of the four options.

You may also change the **Brightness** and **Contrast** of the map image, or you may choose to **Fade** the image if you want to draw any geometry on the image, as shown below.

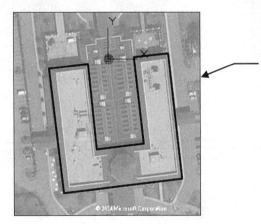

The Fade control has been used to enhance the geometry on the image.

The higher the number the more fade you will have.

EXERCISE 14A

INSTRUCTIONS:

1. Start a **NEW** drawing using **Acad.dwt.**

2. Sign in to your **Autodesk 360** account.

3. Set a Geographic Location for the "**Empire State Building in the USA**".

> **Note:** It is your choice how you set the location, you could type in the search box:
>
> ### "Empire State Building, New York, USA"
>
> Or you could type in the Latitude and Longitude coordinates, I used:
>
> ### Latitude: 40.749 Longitude: -73.986
>
> (Depending on where you are in the world, you might not need the minus (-) sign)

4. Try to place the Geographic Location at the top of the buildings Spire. (See image below. This is just for fun as the location won't really be at the top).

5. **Save** the drawing as: **EX-14A**

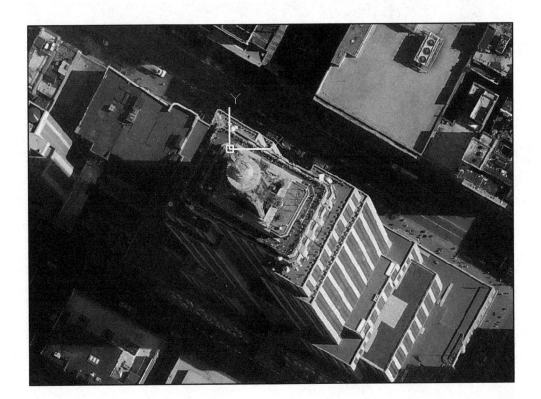

EXERCISE 14B

INSTRUCTIONS:

1. Start a **NEW** drawing using **Acad.dwt.**

2. Sign in to your **Autodesk 360** account.

3. Set a Geographic Location for "**Deal Castle, Deal, United Kingdom**".

Note: It is your choice how you set the location, you could type in the search box:

"**Deal Castle, Deal, UK**"

Or you could type in the Latitude and Longitude coordinates, I used:

Latitude: 51.219 Longitude: 1.404

4. Try to place the Geographic Location at the center of the Castle. (See image below)

5. Place a **Position Marker** called "**Gate 1**" roughly in the position shown in the image.

6. **Save** the drawing as: **EX-14B**

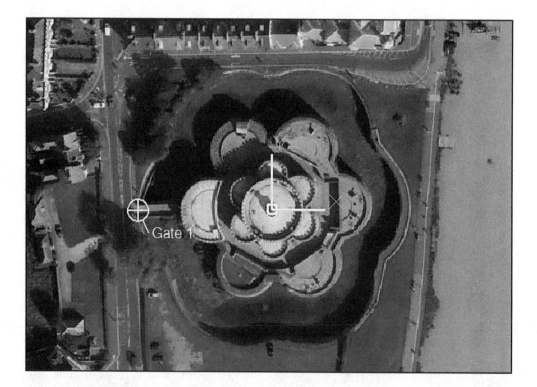

EXERCISE 14C

INSTRUCTIONS:

1. Open **EX-14A**

2. **Capture an Area** of the map as shown below. (It doesn't have to be exact)

3. **Rotate the captured Area** by **5°** (Degrees) using the **Rotate** command.

4. **Save** the drawing as: **EX-14C**

EXERCISE 14D

INSTRUCTIONS:

1. Open **EX-14B**

2. **Capture an Area** of the map as shown below. (It doesn't have to be exact)

3. **Turn Off** the map and **Fade** the captured image to **50%**.

4. **Save** the drawing as: **EX-14D**

2 —

3 —

LEARNING OBJECTIVES

After completing this lesson, you will be able to:

1. Understand the concept of 3D
2. Enter the 3D Workspace
3. Manipulate and rotate the 3D Model
4. Understand the difference between:
 Wireframe, Surface and Solid Modeling

The following lessons are an introduction to 3D. These lessons will give you a good understanding of the basics of AutoCAD's 3D program.

LESSON 15

INTRODUCTION TO 3D

We live in a three-dimensional world, yet most of our drawings represent only two dimensions. In Lesson 6 you made an isometric drawing that appeared three-dimensional. In reality, it was merely two-dimensional lines drawn on angles to give the appearance of depth.

In the following lessons you will be presented with a basic introduction to AutoCAD's 3D techniques for constructing and manipulating objects. These lessons are designed to give you a good start into the environment of 3D and encourage you to continue your education in the world of CAD.

DIFFERENCES BETWEEN 2D AND 3D

Axes
In 2D drawings you see only one plane. This plane has two axes, X for horizontal and Y for vertical. In 3D drawings an additional plane is added. This third plane is defined by an additional axis named Z. The direction of the positive Z-axis basically comes out of the screen toward you and gives the object height. To draw a 3D object you must input all three, X, Y and Z axes coordinates.

A simple way to visualize these axes is to consider the X and Y axes as the ground and the Z axis as a Tree growing up (positive Z) from the ground or the roots growing down (negative Z) into the ground.

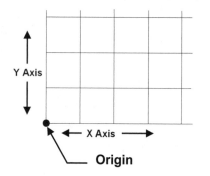

2D Coordinate System

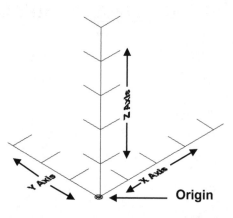

3D Axes Coordinate System

BASIC TYPES OF 3D MODELS

There are 3 basic types of 3D models.

1. Wireframe models
2. Surface models
3. Solid models

A description of each starts on page 15-15.

ENTER AutoCAD 3D WORKSPACE

AutoCAD has two 3D workspaces, <u>3D Basics</u> and <u>3D Modeling</u>. The following Lessons will require the use of "<u>3D Modeling</u>" only.

1. Select the "**3D Modeling**" **Workspace.**

 A. Selecting a Workspace is easy.
 Select the ▼ on the **Workspace Switching** icon located on the <u>Status Bar</u> at the bottom right corner of the screen.

 B. Select the **3D Modeling** workspace.

2. The Ribbon tabs and panels have changed as shown below.

<u>(Note:I have changed my background to white for clarity throughout the workbook.)</u>

Remember you can place the command line top, bottom or floating. Mine is floating as shown here.

Continued on the next page...

ENTER AutoCAD 3D WORKSPACE....continued

4. Select **NEW** (to start a new file) and select one of the following **3D** templates from the list of templates:

 acad3D.dwt (for Imperial units)
 or
 Acadiso3D.dwt (for metric)

 Now your screen should appear approximately as shown below.

 (Note:I have changed my background to white for clarity throughout the workbook.)

Notice the appearance of the Origin and the Cursor have changed.
They now display the Z axis.

Viewing a 3D Model

Viewpoint

It is very important for you to be able to control how you view the 3D Model.
The process of changing the view is called **selecting the Viewpoint**.
(Note: View**point**; not view**port.**)

The **Viewpoint** is the location where "**YOU**" are standing. *This is a very important concept to understand*. The Model does not actually move; you move around the model. For example, if you want to look at the South East corner of your house, you need to walk to the South East corner of your lot and look at the corner of your house. Your house did not move, but you are seeing the South East corner of your house. If you want to see the Top or Plan View of your house, you would have to climb up on the roof and look down on the house. The house did not move, you did. So in other words, the Viewpoint is **your "Point of View"**.

Remember when you select a Viewpoint you are selecting where you are standing. The view that appears on the screen is what you would see when you move to the viewpoint and looked at the model.

How to change the Viewpoint
There are 3 methods to change the viewpoint of your model.
 ViewCube, **Orbit**, **3D Views**.

Each of these methods are described on the pages noted below.

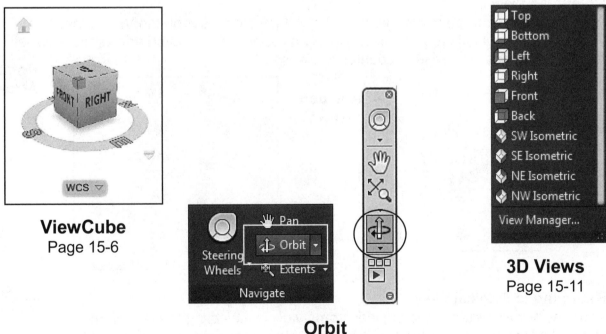

ViewCube
Page 15-6

Orbit
Page 15-9

3D Views
Page 15-11

ViewCube

The following is a description of the ViewCube tool and how to use it to view your model. But the best way to understand the ViewCube is to use it. So I would like you to **_OPEN_** the **_2015-3D Demo.dwg_** that you downloaded from our website. Refer to Intro-1 if you have not downloaded this file.

ViewCube Location
The ViewCube is located in the upper right corner of the drawing area. But you can change it's location. (Refer to ViewCube settings on page 15-8.)

Selecting a View
The ViewCube allows you to manipulate the model in order to see and work on all sides. I have added text to the model so you can see how clicking on the ViewCube, such as Top, automatically shows you the view of the top.

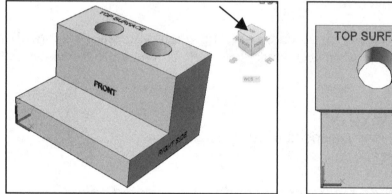
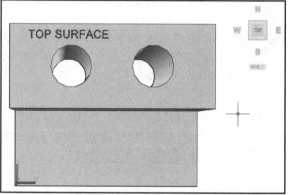

Rotating a View
After you have selected a view, such as Top, place the cursor on the ViewCube. Rotation arrows should appear. If you click on either of the rotation arrows the view will rotate 90 degrees clockwise or counter clockwise.

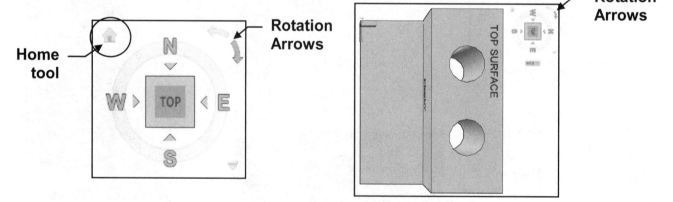

Returning to Original View
You may always return to the original **Home** view by selecting the little Home tool.
Note: The **Home** tool only appears when you place the cursor near the ViewCube.
You may also select a new view to become the **Home** view.
1. Orient the model to the preferred **view**.
2. Right click on the ViewCube and select **Set current view as Home.**

ViewCube....continued

ViewCube Menu

If you right-click on the ViewCube the ViewCube menu will appear.

Home
Parallel
✓ Perspective
Perspective with Ortho Faces
Set Current View as Home
ViewCube Settings...
Help

Home
This will return you to the original view that you specified as the Home View. This is the same as selecting the Home tool.

Parallel and Perspective
Displays the View as Parallel or Perspective.

Parallel

Perspective

Perspective with Ortho Faces
If the current view is a face view it will appear as parallel.

Set Current View as Home
Selects the current view as the Home view.
When you select Home this view will be displayed.

ViewCube Setting...
Displays the ViewCube Settings dialog box shown on the next page.

Help
Takes you directly to the ViewCube content in the Help Menu

ViewCube....continued

ViewCube Settings

To change the ViewCube settings, and you will want to, <u>right click on the ViewCube</u> and select **ViewCube Settings...** from the list.

Most of these settings are personal preference. But I suggest that you uncheck the two boxes that I have shown. I think it will make the manipulation of the views smoother and less confusing. But again, it is your personal preference.

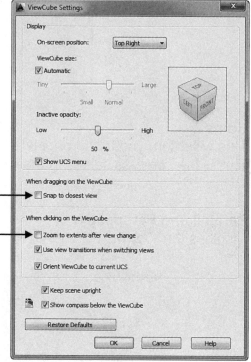

On-screen position:
Controls which corner the ViewCube is displayed.

ViewCube size:
Controls the size of the ViewCube display.

Inactive opacity:
Controls how visible the ViewCube is <u>when inactive only</u>. It will display dark automatically when you pass the cursor over it.

Show UCS menu:
Controls the display of the UCS drop-down menu below the ViewCube.

Snap to closest view:
When using Click and Drag to rotate the View you have a choice of it automatically snapping to the closest View or smoothly rotating to the desired View. ***This is one that I prefer to uncheck in order to have a smooth rotation.***

Zoom to extents after view change:
Each time you select a new View it also will Zoom to Extents if you select this option.
I prefer to control when Zoom is activated.

Use View transitions when switching views:
Controls how smooth the transition appears when rotating.

Orient ViewCube to current UCS: (Important)
You definitely want this one ON. Every time you move the Origin, the Cube orients itself to match the new UCS. You will understand this one better in later lessons.

Keep scene upright:
Controls whether or not the view can be turned upside down. This reduces confusion.

Show compass below the ViewCube:
Controls the display of the compass, N, S, E, W.

> *Note: The settings stay with the computer not the drawing file.*

Orbit

The **Orbit** tool allows you to rotate around the model using the click-drag method. This used to be the only way to freely rotate until ViewCube was added.

1. The Orbit tool can be selected using one of the following:

 (**Note:** The **Navigate panel** is **off** by default. Select the **View tab** then right click on any panel and select **Show Panels**, then select **Navigate** from the menu.)

 Ribbon = View tab / Navigate panel
 or
 Navigation Bar / Orbit tool
 or
 Keyboard = 3do

Ribbon Tool **Navigation Bar Tool**

2. Click and drag the cursor to rotate the model.

3. To stop press the **Esc** or **Enter** key

4. Select the **Home tool** to return to the original view orientation. (See page 15-6)

Orbit
Constrains 3D Orbit along the **XY** plane or the **Z** axis

Free Orbit
Orbits in any direction without reference to the planes.
The point of view is not constrained along the **XY** plane of the **Z** axis.

Continuous Orbit
Orbits continuously. Click and drag in the direction you want the continuous orbit to move, and then release the mouse button. The orbit continues to move in that direction.

Rotate the Model quickly

You may also quickly rotate the model around a pivot point.

1. Place the cursor on the ViewCube

2. Press and hold down the left mouse button and drag the cursor.

The cursor will change to 2 circular arrows.

When the model is positioned as you wish, just release the left mouse button.

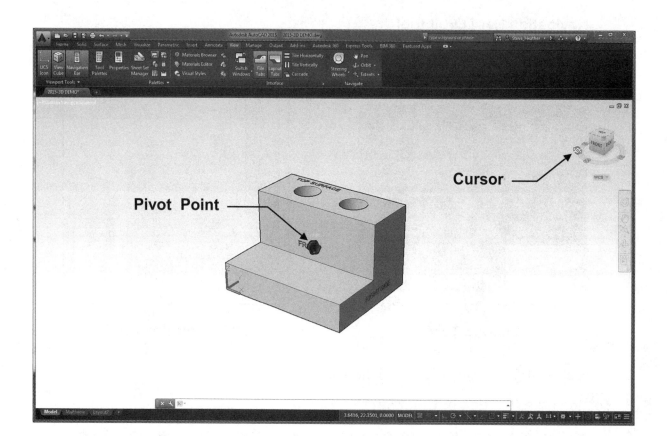

3D Views

You may prefer to rotate your model using fixed views such as Top or South West Isometric.

1. Select **3D Views** as follows:

 Ribbon = Visualize tab / Views panel / ▼

2. Select a View from the list.

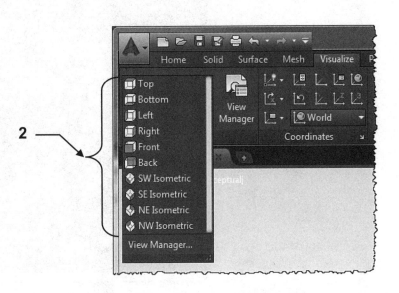

The list of view options are the same as the ViewCube.

Selecting from this list or using ViewCube is the users personal preference

Visual Styles

Description of Visual Styles

There are 12 visual styles supplied with AutoCAD.

A visual style is a collection of customizable settings that control the display of the 3D model in the current viewport.

1. Select the **Visual Styles tools** as follows:

 Ribbon = Visualize tab / Visual Styles panel / ▼

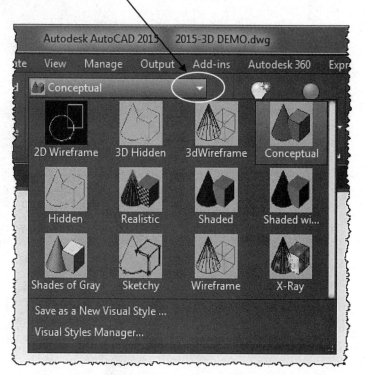

2. Click on any box to select it.

3. Place the cursor on each of the styles and watch the model change to give you a preview before actually selecting the style.

Visual Styles descriptions:

2D Wireframe: All lines and curves shown in Parallel
Conceptual: Shades the object with cool and warm using Gooch face style.
Hidden: Wireframe representation and hides lines
Realistic: Shades the object with dark to light.
Shaded: Smooth shading
Shaded w/ Edges: Smooth shading and visible edges
Shades of Gray: Smooth shading and monochromatic shades of gray
Sketchy: Hand-sketched effect .
Wireframe: Lines and curves to represent the boundaries
X-Ray: Partial transparency

Visual Styles Manager

The **Visual Styles Manager** palette allows you to modify the existing visual styles or create new.

1. Select the **Visual Styles Manager** as follows:

 Ribbon = Visualize tab / Visual Styles panel / ↘

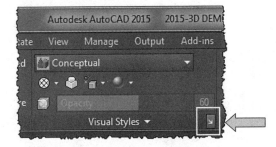

The **Visual Styles Manager** Palette will appear on the left side of the drawing area.

The next page will describe the **Face Settings and Lighting**. The remainder of the selections will not be discussed but may be reviewed in the Help menu.

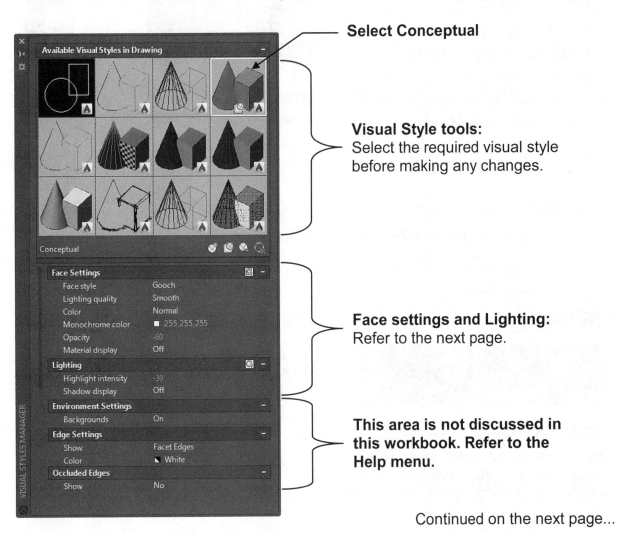

Select Conceptual

Visual Style tools:
Select the required visual style before making any changes.

Face settings and Lighting:
Refer to the next page.

This area is not discussed in this workbook. Refer to the Help menu.

Continued on the next page...

Visual Styles Manager....continued

Face Settings
Controls the appearance of faces.

> **The Following is merely a sample of the controls that AutoCAD offers.**

Face Settings	
Face style	Gooch
Lighting quality	Smooth
Color	Normal
Monochrome color	■ 255,255,255
Opacity	-60
Material display	Off

Face Style
There are 3 Face Styles.

None **Realistic** **Gooch**

Lighting Quality

There are 3 Lighting Qualities.

Faceted: faceted appearance.

Smooth: regular quality smooth appearance. (This is the default level)

Smoothest: High quality smooth appearance.

faceted smooth smoothest

Opacity
The opacity property controls the transparency of an object.

Opacity: off Opacity: 20

Lighting

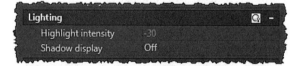

Lighting	
Highlight intensity	-30
Shadow display	Off

Highlight Intensity
The size of the highlights on an object affects the perception of shininess. A smaller, more intense highlight makes objects look shinier.

Highlight
Intensity: off size: 10 size: 30

Wire Frame Model

A wireframe model of a box is basically 12 pieces of wire (lines). Each wire represents an **edge** of the object. You can see through the object because there are no surfaces to obscure your view. This type of model does not aid in the visualization of the 3D object. Wireframe models have no volume or mass.

How to draw a Wireframe Box

1. Start a **NEW** file using **acad3D.dwt**
2. Draw a **Rectangle,** just like you would in 2D. (Select from Home tab / Draw panel)
 First corner: 0,0 Second corner: 6,4
3. *Zoom in closer* if the rectangle seems too small.

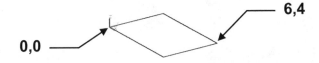

4. Copy the Rectangle 5" **above** the original rectangle as follows:
 a. Select the **Copy** command from the Modify panel.
 b. Select the Rectangle then <enter>.
 c. Select the **basepoint** as shown below.
 d. Type the **X, Y, Z** coordinates for the new location: **@ 0, 0, 5 <enter> <enter>**

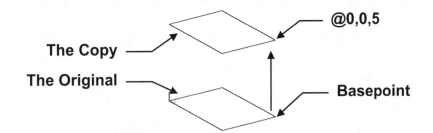

*Now think about the coordinates entered. The coordinates @0, 0, 5 mean that you **do not** want the new rectangle location to move in the **X** or **Y** axis. But you **do** want the new rectangle location to move **5"** in the **positive "Z"** axis.*

5. Now using **Line** command, draw lines from the corners of the lower rectangle to the upper rectangle.

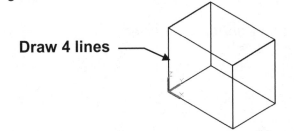

Draw 4 lines

Note: This wireframe is displayed as Parallel, SE Isometric.

That is all there is to it. You have now completed a Wireframe Box. This Wireframe can now be used as the structure for a Surface Model described on the next page.

Surface Model

A **Surface Model** is like an <u>empty cardboard box</u>. All surfaces and edges are defined but there is nothing inside. The model appears to be solid but it is actually an empty shell. The hidden line removal command can be used because the front surfaces obscure the back surfaces from view. A surface model makes a good visual <u>representation</u> of a 3D object.

How to add a 3D Surface to a Wireframe structure

1. Create a Wireframe Model as shown on the previous page.

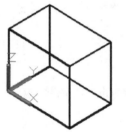

2. Type: **3dface <enter>**

3. Draw a 3D Surface by snapping to the 4 corners as shown below and **<enter>**.
 (The Shape will **Close** automatically.)
 Note: Each surface must be created as a separate object.

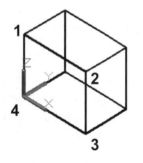 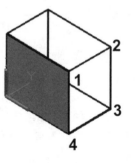

First Surface **Second Surface**

Your 3D Wireframe model now has 2 surfaces attached.
Now you may even use a "Visual Style".

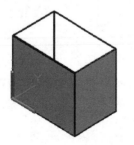

Solid Models

(Refer to Lesson 16 for more detailed instructions)

It is important that you understand both **Wireframe** and **Surface** Modeling **but** you will not be using either very often. **Solid Modeling** is the most useful and <u>the most fun</u>.

Solid models have **edges**, **surfaces** and **mass**.

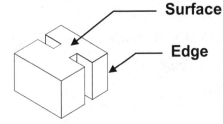

Surface

Edge

Solid Models can be modified using many **Solid Editing** features such as the ones described below.

Use Boolean operations:
such as **Union, Subtract and Intersect** to create a solid form.

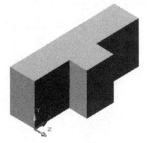

Union

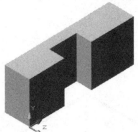

Subtract

Intersect

A simple shape can be:

Revolved

Extruded & Shelled

EXERCISE 15A

INSTRUCTIONS:

1. Start a **NEW** file using **acad3D.dwt** .
2. Create the **Wireframe** Model shown below. (Refer to page 15-15)
3. Display the Model as follows:

 SE Isometric (Refer to page 15-11)

 Or

 click on the corner of the ViewCube ——————→

Note:

The rectangle may appear small. Zoom in. Also,

change the color if the default color is too light. Use "Properties".

4. Display the Model as **Parallel** not perspective. (Refer to page 15-7)
5. Do not dimension.
6. **Save** the drawing as: **EX15A**

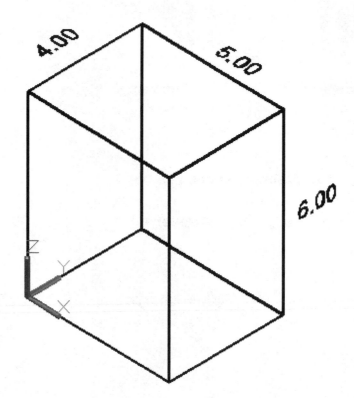

EXERCISE 15B

INSTRUCTIONS:

1. Open **EX15A** (If not already open)

2. Add surfaces to all 6 sides. (Refer to page 15-16)

 (Use ViewCube or Orbit to rotate the model to access each side.)

3. Display as

 a. **SE Isometric**

 b. Visual Style = Conceptual (Refer to page 15-12)

 c. **Parallel** (Refer to page 15-7)

4. **Save** the drawing as: **EX15B**

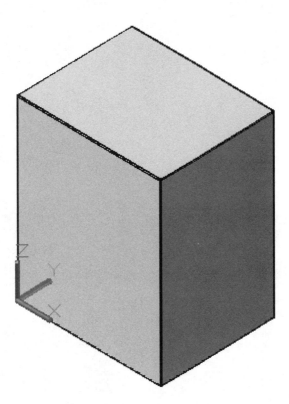

Notes:

LEARNING OBJECTIVES

After completing this lesson, you will be able to:

1. Construct 7 Solid model Primitives:
 Box, Sphere, Cylinder, Cone, Wedge, Torus and Pyramid

LESSON 16

Drawing Basic Geometric Shapes

In this lesson you will learn the required steps to construct each of AutoCAD's basic geometric shapes. Each one requires different input information and some have multiple methods of construction.

AutoCAD has <u>7 Solid shapes</u>.
<u>Box, Cylinder, Cone, Sphere, Pyramid, Wedge and Torus.</u>

To select a solid primitive use one of the following:

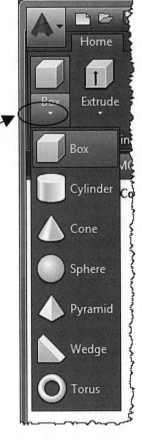

 Ribbon = Home tab / Modeling panel / ▼
 or
 Keyboard = Type the name such as: Box

3D input direction
When drawing in 3D and prompted for Length, Width or Height, each input corresponds to an axis direction as follows:

> **Length = X Axis**
> **Width = Y Axis**
> **Height = Z Axis**

| *I always write this on a little post-it and stick it to my monitor. It comes in handy as a reminder.* |

For example, if you are prompted for the <u>Length</u>, the dimension that you enter will be drawn on the <u>X axis</u>. <u>So keep your eye on the Origin icon in order to draw the objects in the correct orientation.</u> Although it should be easy to visualize because you will actually see the shape constructed as you draw.

Consider starting the primitives on the Origin. It is useful to know where the primitive is located so it can be moved or manipulated easily.

In Lesson 17 you will learn more about moving the UCS around to fit your construction needs. But just relax and let's take it one step at a time.

BOX

There are <u>4 methods</u> to draw a **Solid Box**. Which one you will use will depend on what information you know. For example, if you know where the corners of the base are located and the height, then you could use method 1 or 2.

Start a new file and select <u>Acad3d.dwt</u>

Method 1

(You will enter the location for: base corner, diagonal corner and height)

1. Select the **SE Isometric** view (15-11) and **Parallel**. (15-7)

2. Select the **Box** command. (See page 16-2)

3. Specify first corner [Center]: **type coordinates or pick location with cursor (P1).**

4. Specify other corner or [Cube/Length]: **type coordinates for the diagonal corner or pick location with the cursor (P2).**

5. Specify height or [2Point]: **type or use cursor.**

<u>Note: This model is displayed as Wireframe for clarity</u>

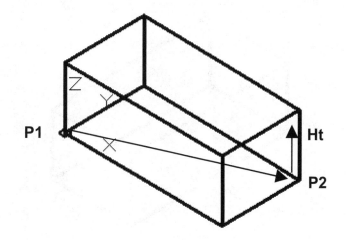

BOX....continued

Method 2

(You will enter the dimension for L, W, and Ht)

1. Select the **SE Isometric** view (15-11) and **Parallel** (15-7).

2. Select the **Box** command.

3. Specify first corner or [Center]: *type coordinates or pick location with cursor. (P1)*

4. Specify other corner or [Cube/Length]: *type "L" <enter>.*

(Note: when entering L, W and H, <u>Ortho should be</u> "ON".)

5. Specify length: *enter the Length (X axis).*

6. Specify width: *enter the Width (Y axis).*

7. Specify height: *enter the Height (Z axis).*

Note: This model is displayed as Wireframe for clarity

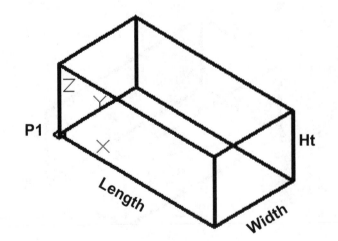

BOX....continued

Method 3

(If Length, Width & Height have the same dimension)

1. Select the **SE Isometric** view (15-11) and **Parallel** (15-7).

2. Select the **Box** command.

3. Specify first corner or [Center] : *type coordinates or*
 pick location with cursor. (P1)

4. Specify corner or [Cube/Length]: *type "C" <enter>.*

5. Specify length: *enter the dimension.*

Note: This model is displayed as Wireframe for clarity

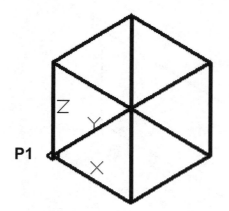

BOX....continued

Method 4

(You will enter the location for the center, a corner and the height)

1. Select the **SE Isometric** view (15-11) and **Parallel** (15-7).

2. Select the **Box** command.

3. Specify corner of box or [Center] : *type "C"<enter>.*

4. Specify center of box : *type coordinates or pick location with cursor. (P1)*

5. Specify corner or [Cube/Length]: *type coordinates for a corner or pick location with the cursor. (P2)*

6. Specify height: *type the height.*

Note: This model is displayed as Wireframe for clarity

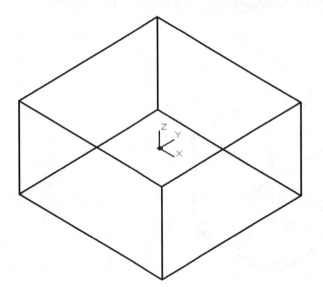

(Note: The total Length, Width and Height straddles the centerpoint.
Use Orbit to view)

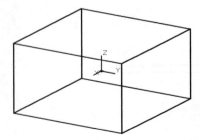

CYLINDER

Cylinder creates a cylindrical solid. You will define the center location for the base, define the radius or diameter and then the height or location for the other end.

The two methods below are the most commonly used.

Method 1

The default orientation of the cylinder locates the base on the X,Y plane and the height is in the Z direction. When you enter the height, the cylinder grows in the Z axis direction. You may enter a positive or negative number. It depends upon which direction you want the cylinder to grow. The Z-axis origin icon line points to the positive direction. So remember, keep an eye on the 3D Origin icon.

1. Select the **SE Isometric** view (15-11) and **Parallel** (15-7).

2. Select the **Cylinder** command.

3. Specify center point for base or [3P/2P/Ttr/Elliptical] : *type coordinates or pick location with cursor (P1)*

 (This base will be located on the X,Y plane)

4. Specify radius for base of cylinder or [Diameter]: *enter radius or D. (P2)*

5. Specify height of cylinder or [Center of other end]: *enter the height (Ht). (P3)*

Note: This model is displayed as Shades of Gray

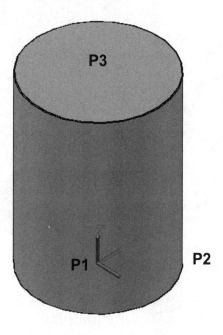

CYLINDER....continued

Method 2

The orientation of the Cylinder base depends on the placement of the <u>Center of the other End</u>. This method allows you to tilt the cylinder. Define the center of the base and radius then select the "Axis Endpoint" option. Define the "Axis Endpoint" entering relative coordinates or snapping to an object. (Soon you will learn how to rotate the Origin)

1. Select the **SE Isometric** view (15-11) and **Parallel** (15-7).

2. Select the **Cylinder** command.

3. Specify center point of base or [3P/2P/Ttr/Elliptical] <0,0,0>: *type coordinates or pick location with cursor (P1).*

4. Specify base radius or [Diameter]: *enter radius or D. (P2)*

5. Specify height or [2 point/Axis endpoint]: *A <enter>.*

6. Specify axis endpoint: *type coordinates or snap to an object. (P3)*

In the example below the radius is 3" and the "center of the other end" is 0,6,0 (P3) This means the "center of the other end" was placed on the same axes as X and Z but 6" in the Y axis.

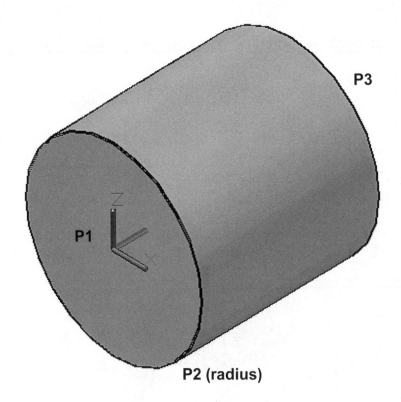

P3

P1

P2 (radius)

CONE

Cone command creates a Conical solid. There are 2 methods to create a Cone.
You will define the center location, radius or Diameter for the base and then define the
height or location for the apex.

Method 1

When using this method the default orientation for the base is on the X, Y plane and the
height is perpendicular to the X, Y plane in the Z direction.

1. Select the **SE Isometric** view (15-11) and **Parallel** (15-7).

2. Select the **Cone** command. (16-2)

3. Specify center point of base [3P/2P/Ttr/Elliptical]: ***type coordinates or pick location with cursor (P1)***

4. Specify base radius or [Diameter]: ***enter radius or D. (P2)***

5. Specify height or [2Point/Axis endpoint/Top Radius]: ***enter the height (P3) (can be positive or negative).***

If you select "Top Radius" you may enter a radius for the top and then the height

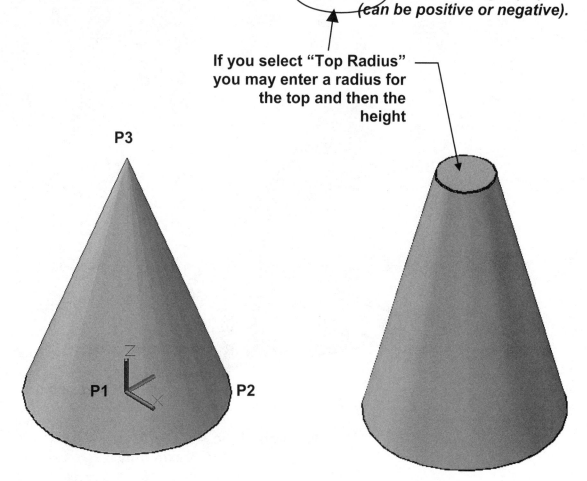

P3

P1 P2

CONE….continued

Method 2

When using this method the orientation of the Cone depends on the placement of the Apex. Define the center of the base and radius then select the "Apex" option. Define the "Apex" location using coordinates or snapping to an object.

1. Select the **SE Isometric** view (15-11) and **Parallel** (15-7).

2. Select the **Cone** command. (16-2)

3. Specify center point of base or [Elliptical]: *type coordinates or pick location with cursor (P1)*

4. Specify base radius or [Diameter]: *enter radius or D. (P2)*

5. Specify height or [2Point/Axis endpoint/Top radius]: *type "A" <enter>*

6. Specify axis endpoint: *type coordinates or snap to an object. (P3)*

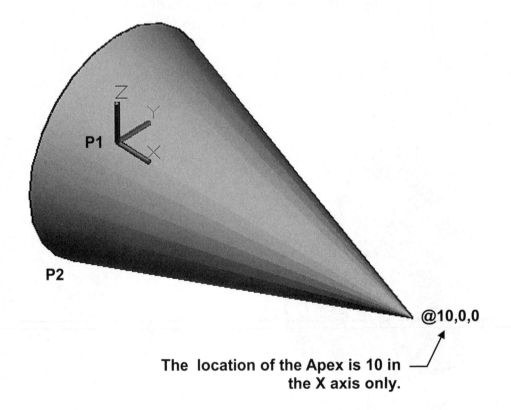

The location of the Apex is 10 in the X axis only.

SPHERE

Sphere creates a spherical solid. You define the center point and then define the size by entering either the radius or the diameter.

1. **Start a new file and select <u>Acad3d.dwt</u>.**

2. Select the **Sphere** command. (See page 16-2)

3. Specify center point or [3P/2P/Ttr]: *type coordinates or pick location with cursor.*

4. Specify radius of sphere or [Diameter]: *enter radius or D.*

You may enjoy experimenting with Visual Styles.

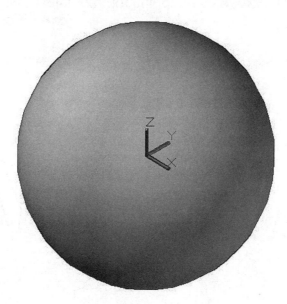

PYRAMID

The method for drawing a Pyramid is very similar to drawing a polygon for the base and a cone for the height. You specify the number of sides the base will need. It may have from 3 to 32 sides. Decide if the base radius is Inscribed or Circumscribed. Then define the height. If you select the Top radius option you can truncate it.

1. Select the **SE Isometric** view (15-11) and **Parallel** (15-7).

2. Select the **Pyramid** command.

3. Specify center point of base or [Edge/Sides]: *type "S"<enter>*

4. Enter number of sides <4>: *type number of sides <enter>*

5. Specify center point of base or [Edge/Sides]: *type coordinates or pick location with cursor for Center location*

6. Specify base radius or [Inscribed] <1.000>: *enter radius or D*

7. Specify height or [2Point/Axis endpoint/Top radius] <1.000>: *enter the height (can be positive or negative).*

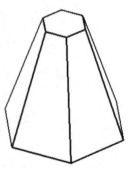

Pyramid with 6 sided base

Truncated Pyramid
Use the "Top Radius"
option. Note: Top Radius
is <u>smaller</u> than base radius

Truncated Pyramid
Use the "Top Radius"
option. Note: Top Radius
is <u>larger</u> than base radius

WEDGE

The Wedge command creates a wedge solid. There are 4 methods to create a Wedge.
The base is always parallel with the XY plane and the height is always along the Z axis.
The slope is always from the Z axis along the X axis.

Method 1

(Define the location for 2 corners of the Base and then the Height)

1. Select the **SE Isometric** view (15-11) and **Parallel** (15-7).

2. Select the **Wedge** command. (See page 16-2)

3. Specify first corner or [Center] <0,0,0>: *type coordinates or
 pick location with cursor. (P1)*

4. Specify other corner or [Cube/Length]: *type coordinates for the diagonal
 corner or pick location with the cursor. (P2)*

5. Specify height: *type the height*

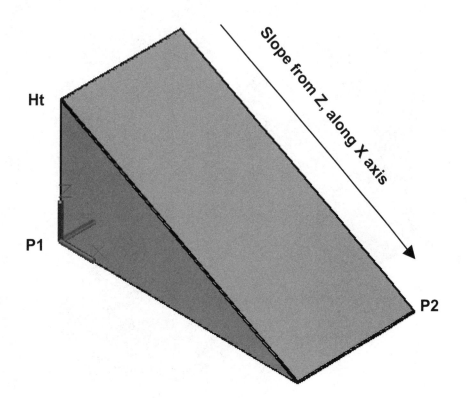

WEDGE....continued

Method 2

(Define the location for each: L, W and Ht)

1. Select the **SE Isometric** view (15-11) and **Parallel** (15-7).

2. Select the **Wedge** command. (See page 16-2)

3. Specify first corner or [Center]: *type coordinates or pick location with cursor. (P1)*

4. Specify other corner or [Cube/**Length**]: *type "L" <enter>.*

5. Specify length: *enter the Length (X axis).*

6. Specify width: *enter the Width (Y axis).*

7. Specify height: *enter the Height (Z axis).*

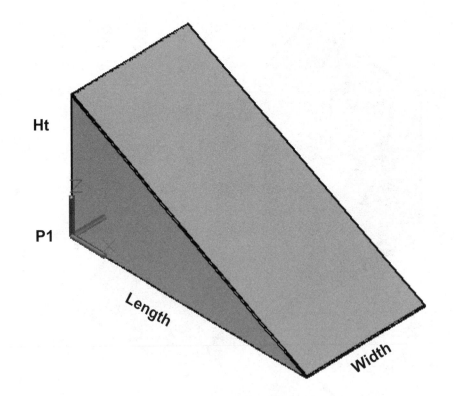

WEDGE....continued

Method 3

(Define the same dimension for Length, Width & Height)

1. Select the **SE Isometric** view (15-11) and **Parallel** (15-7).

2. Select the **Wedge** command.

3. Specify first corner or [Center] <0,0,0>: *type coordinates or pick location with cursor. (P1)*

4. Specify other corner or [**Cube**/Length]: *type "C" <enter.>*

5. Specify length: *enter the dimension.*

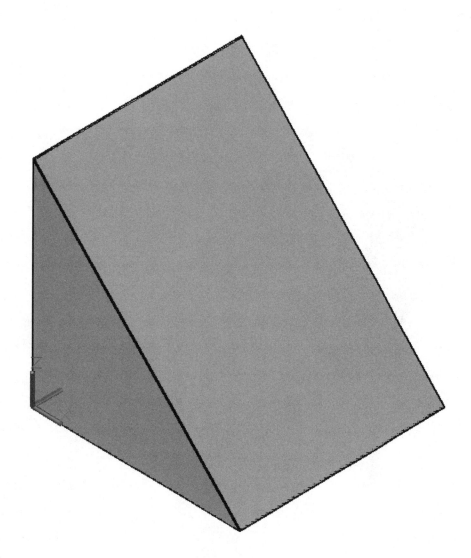

WEDGE....continued

Method 4

(Define the location for the Center and the Height)

1. Select the **SE Isometric** view (15-11) and **Parallel** (15-7).

2. Select the **Wedge** command.

3. Specify first corner or [Center] <0,0,0>: *type "C"<enter>.*

4. Specify center <0,0,0>: *type coordinates or pick location with cursor. (P1)*

5. Specify corner or [Cube/Length]: *type coordinates for a corner or pick location with the cursor. (P2)*

6. Specify height: *type the height.*

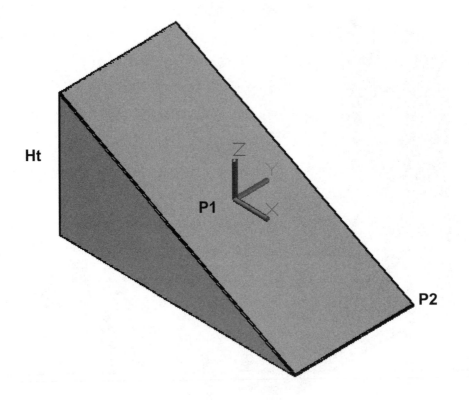

TORUS

The Torus command can be used to create 3 different solid shapes.

The 2 dimensions that are required are the radius or diameter of the **Torus** and the **Tube**.
(Pay close attention to what the Torus and Tube are defining. Example on the right)

Tube Radius

Torus Radius

Donut shaped
Note: the <u>Torus radius</u> must be <u>greater than</u> the <u>Tube radius</u>.
1. Select the **SE Isometric** view (15-11) and **Parallel** (15-7).
2. Select the **Torus** command. (See page 16-2)
3. Specify center point or [3P/2P/Ttr]: *type coordinates or pick location with cursor.*
4. Specify radius or [Diameter]: *(this dim. must be <u>greater than</u> the <u>Tube</u> radius).*
5. Specify tube radius or [2pt/Diameter]: *(this dim. must be <u>less than</u> the <u>Torus radius</u>).*

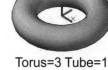

Torus=3 Tube=1

Football shaped
Note: the <u>Torus radius</u> must be <u>negative</u> and the <u>Tube radius positive</u> and <u>greater than</u> the <u>Torus radius</u>.
1. Select the **Torus** command.
2. Specify center point or [3P/2P/Ttr]: *type coordinates or pick location with cursor.*
3. Specify radius or [Diameter]: *(this dim. must be <u>negative</u>).*
4. Specify tube radius or [2pt/Diameter]: *(this dim. must be <u>positive</u> and <u>greater than the Torus radius</u>).*

Torus=-2 Tube=3

Self-Intersecting
Note: the <u>Torus radius</u> must be <u>less than</u> the <u>Tube radius</u>.
1. Select the **Torus** command.
2. Specify center point or [3P/2P/Ttr]: *type coordinates or pick location with cursor.*
3. Specify radius or [Diameter]: *(this dim. must be <u>less than</u> the <u>Tube</u> radius).*
4. Specify tube radius or [2pt/Diameter]: *(this dim. must be <u>greater than</u> the <u>Torus</u> radius).*

Torus=1 Tube=3

EXERCISE 16A

Create 4 Solid Boxes

1. Start a **NEW** file using **Acad3d.dwt**

2. Select the **SE** Isometric view

3. **Create 4 solid boxes as shown below. _You decide which method to use._**
 (Refer to page 16-3 for instructions if necessary)

4. Save as **EX-16A**

5. **Do not Dimension** _Do not add the letters B, C or D. They are for reference only._

BOX A	**BOX B**
L = 14 W = 6 HT = -1	L = 4 W = 3 HT = 2

BOX C	**BOX D**
ALL SIDES 2"	L = 2 W = 4 HT = 1 (Think, positive or negative)

Enter X, Y, Z coordinates for <u>each point</u> or Dynamic Input. If you use Dynamic Input make sure <u>Ortho</u> is ON for <u>each point</u>.

REMEMBER L = X AXIS W = Y AXIS HT = Z AXIS

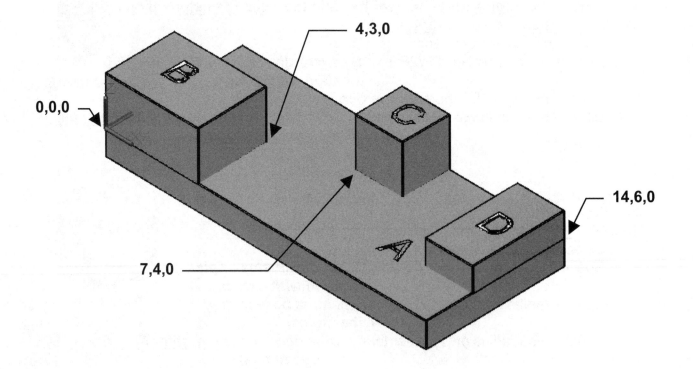

EXERCISE 16B

<u>Create 3 solid Cylinders</u>

1. Open **EX-16A** (if not already open)

2. Add the 3 Cylinders as shown below.
 Use Method 1 or 2 shown on page 16-7 and 16-8.
 The method will depend on the information you are given below.

 Read the command line prompts to make sure you are entering the correct information at the correct time.

3. Select Orbit to confirm you have placed the objects in the correct location.

4. Save as **EX-16B**

 Do not Dimension, do not add text

CYLINDER E	**CYLINDER F**	**CYLINDER G**
Radius = 1.25	6" from end to end	Radius = 1
Ht = 4"	Dia = 1 (notice "diameter")	Length = 4
	Hint: Use Axis endpoint	
	@0,6,0	

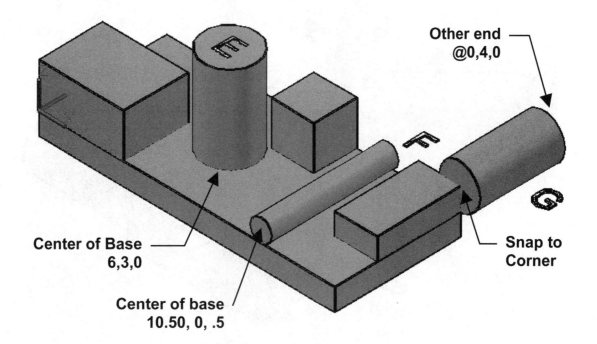

Other end
@0,4,0

Center of Base
6,3,0

Center of base
10.50, 0, .5

Snap to
Corner

EXERCISE 16C

Create 2 solid Cones

1. Open **EX-16B** (If not already open)

2. Add the 2 Cones as shown below.
 (Refer to page 16-9 for instructions if necessary)

3. Save as **EX-16C**

 Do not Dimension

CONE H	**CONE J**
Radius = 1.25	Radius = .50
Ht = 4"	Ht = 2"

Note:
Locate the Center location by snapping to the Center of the Cylinder.
Locate the Radius by snapping to the Quadrant of the Cylinder.
Remember, OrthoMode ON will help.

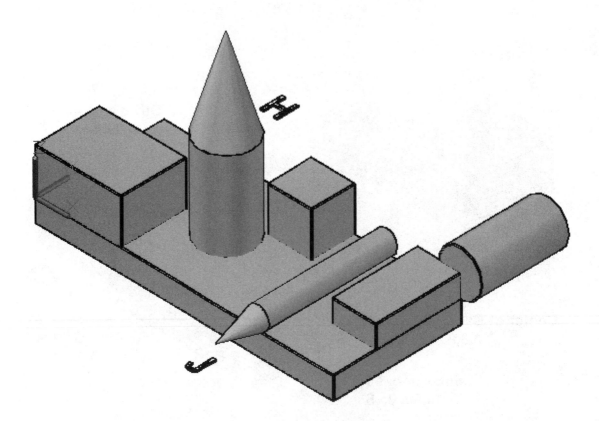

EXERCISE 16D

Create 3 solid Wedges

1. Open **EX-16C** (If not already open)

2. Add the 3 Wedges as shown below.
 (Refer to page 16-13 for instructions if necessary)

3. Save as **EX-16D**

 Do not Dimension

WEDGE K	**WEDGE L**	**WEDGE M**
Ht = 2"	L, W & H = 2	L = 1.5
		W = 2
		Ht = .5

**Turn OSNAP and 3DOSNAP OFF
after locating this corner. It may
interfere with placing the other
corner. OrthoMode should be ON.**

EXERCISE 16E

Create a solid Sphere

1. Start a **NEW** file using **Acad3d.dwt**

2. Select the **SE** Isometric view

3. Create the solid Sphere shown below.
 (Refer to page 16-11 for instructions if necessary)

4. Experiment with Visual Styles.

5. Save as **EX-16E**

 Do not Dimension

Center = 0, 0, 0
Radius = 4

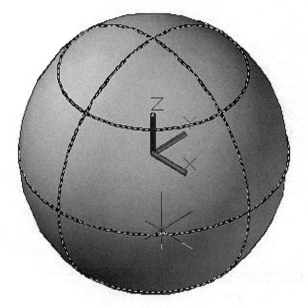

EXERCISE 16F

Create 3 solid Torus'

1. Start a **NEW** file using **Acad3d.dwt**

2. Select the **SE** Isometric View.

3. Add the 3 Torus' as shown below.
 (Refer to page 16-17 for instructions if necessary)

4. Save as **EX-16F** **Do not Dimension**

DONUT	**FOOTBALL**	**SELF-INTERSECTING**
Center = 4, 3, 0	Center = 8.5, 7, 0	Center = 10.5, 3, 0
Torus Rad = 3	Torus Rad = -3	Torus Rad = 1
Tube Rad = 1	Tube Rad = 5	Tube Rad = 1.50

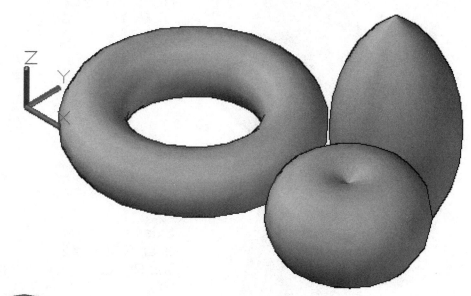

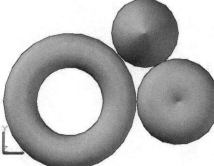

**Take a look at the Top View to see if you have
them positioned correctly.**

1. Select <u>Parallel</u> instead of <u>Perspective</u>

EXERCISE 16G

Create 2 Pyramids

1. Start a **NEW** file using **Acad3d.dwt**

2. Draw the 2 Pyramids (INSCRIBED) shown below.
 (Refer to page 16-12 for instructions if necessary)

3. Save as **EX-16G**

 Do not Dimension

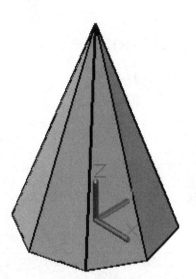

Sides = 8
Base Radius = 2
Ht = 6

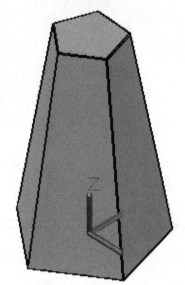

Sides = 5
Base Radius = 2
Top Radius = 1
Ht = 6

Note:
You may also create this pyramid by
changing the pyramid above using
"Properties".

LEARNING OBJECTIVES

After completing this lesson, you will be able to:

1. Move the UCS to aid in the construction of the model.
2. Understand and use Boolean operations:
 Union, Subtract and Intersect.

LESSON 17

Configuring Options for 3D

In the Intro section of this workbook you configured your system for use with this workbook. But I skipped the 3D section. Now you need to make those selections.

1. Type **Options <enter>**

2. Select the **3D Modeling** tab.

3. Change the settings to match the settings shown below.

4. Select **Apply** and **OK**

Understanding the UCS

In this Lesson you are going to learn how to manipulate the UCS Origin to make constructing 3D models easy and accurate.

World Coordinate System vs. User Coordinate System

All objects in a drawing are defined with XYZ coordinates measured from the 0,0,0 Origin. This coordinate system is **fixed** and is referred to as the **World Coordinate System (WCS)**. When you first launch AutoCAD, the WCS icon is in the lower left corner of the screen. (An easy way to return to WCS is: Type **UCS <enter> <enter>**.)

The **User Coordinate System (UCS)** allows you to move a temporary Origin to any location. (This procedure is referred to as "moving the Origin".)

Why move the UCS Origin?

Objects that are drawn will always be parallel to the XY plane. (Unless you type a Z coordinate) So it is necessary to define which plane is the XY plane. You define the plane by moving the UCS origin to a surface.

Let me give you a few examples and maybe it will become more clear.

Example 1:

This wedge was drawn using L, W, H. When you entered the L, W and H how did AutoCAD know to draw its base parallel to the XY plane? Because all objects are drawn parallel to the XY plane. Length is always in the X axis, Width is always in the Y axis and Height is in the Z axis. Notice the UCS icon displays the plane orientation.

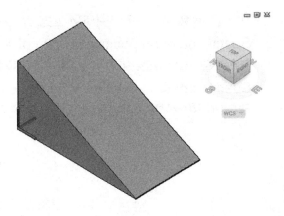

Example 2:

Now I have drawn the base of the cylinder parallel to the sloped surface. How did I do that? Notice the UCS icon. I moved it to the surface I wanted to draw on. (Remember: all objects are drawn parallel to the XY plane.) The base of the cylinder is automatically placed on the XY surface I defined and the height is always drawn in the Z axis.

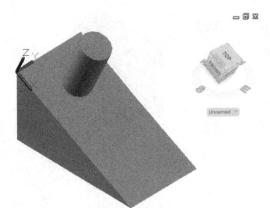

How did I move the UCS icon to the orientation shown in the example above?

I will discuss that next.

Moving the UCS

There are many options available to manipulate the UCS icon. In this Lesson the two most commonly used options will be discussed. One is to move the UCS <u>permanently</u> and one is to move the UCS <u>temporarily</u>.

HOW TO MOVE THE UCS PERMANENTLY USING "3 POINT".

Use this method if you need to add a feature to a surface "<u>in a defined location</u>".

In the example below the UCS is moved to the corner of the sloped surface. This will allow you to place a feature, such as the cylinder, using X, Y coordinates from the Origin.

1. Select the **3 point** command using one of the following:

 Ribbon = Visualize or Home tab / Coordinates Panel /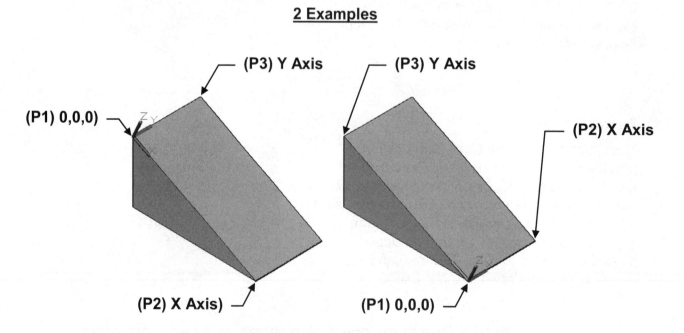
 or
 Keyboard = UCS <enter> 3 <enter>

2. Specify new origin point <0,0,0>: *Locate where you want the new 0,0,0*

 (P1-place with the cursor <u>using object snap</u> type coordinates - be accurate)

3. Specify point on positive portion of X-axis <1.000,0.000,0.000>: *define which direction is <u>positive</u> X axis by snapping to a corner (P2).*

4. Specify point on positive-Y portion of the UCS XY plane <0.000,1.000,0.000>: *define which direction is <u>positive</u> Y axis by snapping to a corner (P3)*

2 Examples

(P3) Y Axis **(P3) Y Axis**

(P1) 0,0,0

(P2) X Axis

(P2) X Axis)

(P1) 0,0,0

When the Grid is ON it will be displayed on the new X,Y plane.

Use Orbit to get a good look.

Moving the UCS....continued

You may select the **3 point** command from the UCS icon shortcut menu.

1. Click on the UCS icon.

2. Right click (press the right mouse button.)
 The shortcut menu shown below should appear.

This method of UCS command selection is quicker and you do not have to remember where the command is located on the ribbon.

Some of the other commands shown on the UCS shortcut menu will be discussed within this lesson.

Moving the UCS....continued

You may also move the UCS quickly by using the direct manipulations. Select the UCS icon and easily move the origin, and automatically align the UCS with objects.

1. Click on the UCS icon. The icon will highlight and Grips will appear at the base and at the positive end of each axis.

2. Rest the cursor at the base of the icon and a shortcut menu will appear.

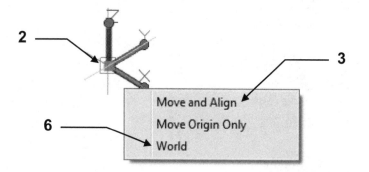

3. Select **Move and Align**

4. Move the UCS icon to any surface. The axes should align with the surface automatically.

Examples:

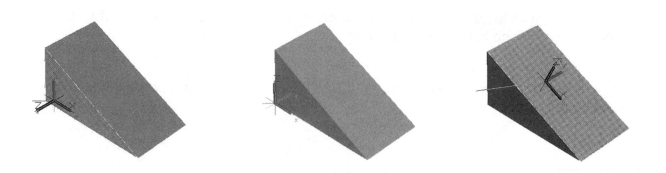

5. When the icon appears on the correct surface, press the left mouse button.

6. To return the icon to it's original position, select **World** from that same shortcut menu.

Moving the UCS Temporarily Using "Dynamic UCS"

Use this method if you are placing a feature on a surface but you are not concerned with location at this time. You may move the feature later.

In the previous example you must return the UCS Origin to its original location. This method allows you to <u>dynamically</u> change the XY Plane temporarily and then it is returned to the previous location automatically

1. You may turn this feature **ON** or **OFF** with the **DYNAMIC UCS** button on the status bar or **F6** key. (Refer to Page 2-12 for adding buttons to the Status Bar).

Cursor displays the current X,Y,Z orientation

2. <u>Start a command</u> such as Cylinder. (You **must** be in a command)

3. <u>Pass the cursor over a face</u>. (Such as the slope of a wedge)

 A faint <u>dashed border</u> appears around the selected face and the cursor displays the new X,Y and Z planes.

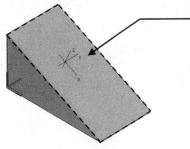

Cursor displays the selected surface X,Y,Z planes

4. <u>Continue with the command</u>. (Such as click to place the center of the cylinder, radius and height)

 Notice the UCS Origin did not actually move.

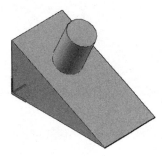

Rotating the UCS

Rotating the UCS is another option to manipulate the UCS icon. You may rotate around any one of the 3 axes. You may use the cursor to define the rotation angle or type the rotation angle.

1. Select the UCS Rotate command using one of the following:

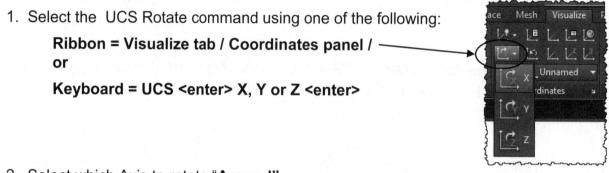

> **Ribbon = Visualize tab / Coordinates panel /**
> **or**
>
> **Keyboard = UCS <enter> X, Y or Z <enter>**

2. Select which Axis to rotate "**Around**".
 *(For Example: If you select **X**, you are rotating the Y and Z-axes around the X axis.)*

3. Specify rotation angle about X axis <90>: ***type the rotation angle or use cursor.***

Understanding the rotation angle

The easiest way to determine the rotation angle is to think of you standing in front of the point of the axis arrow, and then rotate the other 2 axes.

For example, if you are rotating around the X-axis put the point of the X-axis arrow against your chest and then grab the Z axis with your left hand and the Y axis with your right hand. Now rotate your hands Clockwise or Counterclockwise like you are holding a steering wheel vertically. The X-axis arrow, corkscrewing into your chest, is the Axis you are rotating around. **Clockwise is negative** and **Counter Clockwise is positive** just like the Polar clock you learned about in the Beginning workbook.

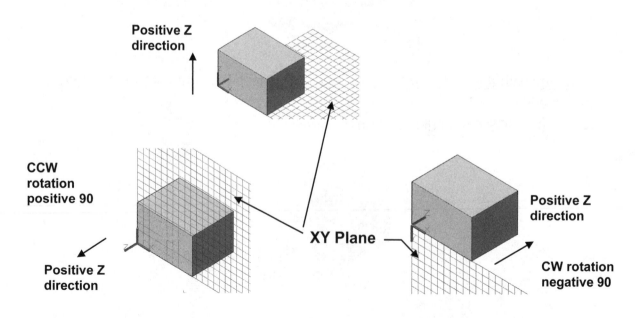

Rotating the UCS

The UCS short cut menu can be helpful for selecting the Rotate Axis direction.

1. Click on the UCS icon.

2. Right click (press the right mouse button.)

 The shortcut menu shown below should appear.

3. Select **Rotate Axis**

4. Select the Axis to rotate around.

New Direction for the Z Axis

Remember that "**Height**" is always the **positive** Z axis. Sometimes the positive Z axis is not oriented to suit your height direction need. The "**Z-axis Vector**" option allows you to change the positive direction of the Z axis. The X and Y axes will change also automatically. **(Turn OFF the <u>DYNAMIC UCS</u> function. It will be confusing to use both.)**

1. Select the **Zaxis** command using one of the following:

 Ribbon = Visualize tab / Coordinates panel /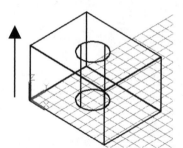
 or
 Keyboard = UCS / ZA

2. Specify new origin point or object <0,0,0>: ***Place the new Origin location***

3. Specify point on positive portion of Z-axis <0.000,0.000,1.000>: ***select the <u>positive</u> Z direction.***

EXAMPLES

Notice all 3 examples below use the same process to draw the Cylinder.

The only difference is the direction of the Z-axis.

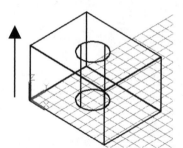

The Original
The XY drawing plane is on the <u>inside bottom</u>.
The Cylinder base is drawin on the XY plane and the height is in the positive Z axis.

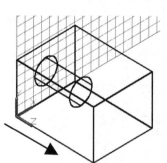

Positive Zaxis direction has been changed
The XY drawing plane is on the <u>inside of the left side</u>.
The Cylinder is base is drawn on the Xy plane and the height is in the positive Z axis.

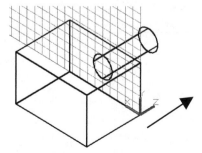

Positive Zaxis direction has been changed again
The XY drawing plane is on the <u>outside of the Back</u>.
The Cylinder is base is drawn on the Xy plane and the height is in the positive Z axis.

New Direction for the Z Axis....continued

You may select the Z-Axis command from the UCS shortcut menu.

1. Click on the UCS icon.

2. Right click (press the right mouse button.)

 The shortcut menu shown below should appear.

3. Select **Z Axis**

4. Place the new Origin location.

5. Select the **positive** **Z direction**.

Boolean Operations

Solid objects can be combined using Boolean operations to create *composite solids*. AutoCAD's **Boolean** operations are **Union, Subtract** and **Intersect.**

Boolean is a math term which means using logical functions, such as addition or subtraction on objects. George Boole (1815-1864) was an English mathematician. He developed a system of mathematical logic where all variables have the value of either one or zero. Boole's two-value logic, or binary algebra, is the basis for the mathematical calculations used by computers and is required in the construction of composite solids.

UNION

The **Union** command creates one solid object from 2 or more solid objects.

1. Select the **Union** command using one of the following:

 Ribbon = Home tab / Solid Editing /
 or
 Keyboard = uni

2. Select objects: *select the solids to be combined <enter>*

BEFORE UNION – 4 separate objects

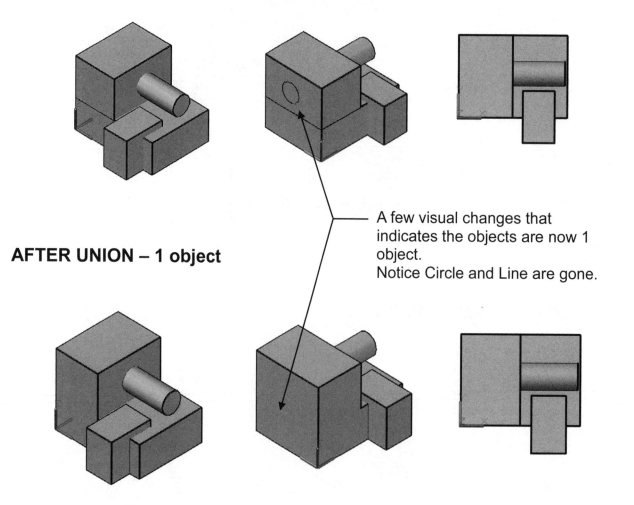

AFTER UNION – 1 object

A few visual changes that indicates the objects are now 1 object.
Notice Circle and Line are gone.

Boolean Operations....continued

SUBTRACT

The **Subtract** command subtracts one solid from another solid.

1. Select the **Subtract** command using one of the following:

 Ribbon = Home tab / Solid Editing /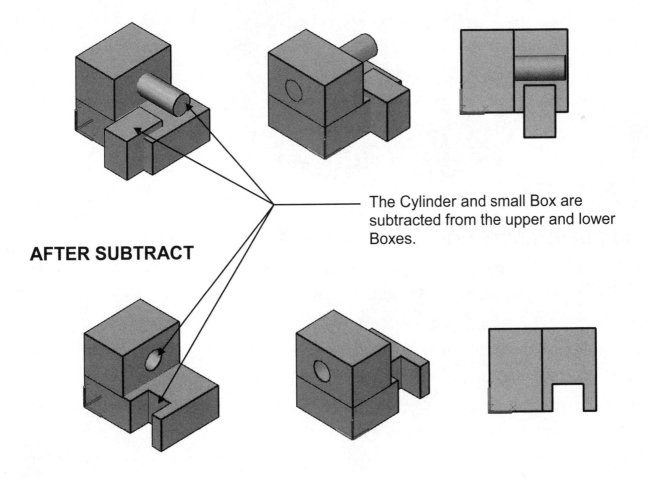
 OR
 Keyboard = su

2. Select solids and regions to subtract from...
 Select objects: **select the solid object to subtract <u>from</u>**
 Select objects: **<enter>**

3. Select solids and regions to subtract...
 Select objects: **select the solid object to subtract**
 Select objects: **<enter>**

BEFORE SUBTRACT – 5 separate objects
 Note: The objects are not Unioned.

The Cylinder and small Box are subtracted from the upper and lower Boxes.

AFTER SUBTRACT

Boolean Operations....continued

INTERSECTION

If solid objects intersect, they <u>share a space</u>. This shared space is called an Intersection. The <u>**Intersection**</u> command allows you to create a solid from this shared space.

1. Select the **Intersection** command using one of the following:

 Ribbon = Home tab / Solid Editing /
 OR
 Keyboard = in

2. Select objects: *select the solid objects that form the intersection*
 Select objects: *<enter>*

EXAMPLE 1:

BEFORE INTERSECTION

AFTER INTERSECTION

Boolean Operations....continued

INTERSECTION

EXAMPLE 2:

BEFORE INTERSECTION

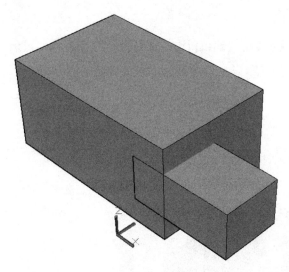

AFTER INTERSECTION

EXERCISE 17A

Subtract

1. Start a **NEW** file using **Acad3d.dwt**.

2. Select the **SE Isometric view.**

3. Draw the solid object shown below. (Step by step instructions are on the next page)

4. Save as **EX-17A.**

5. **Do not Dimension.**

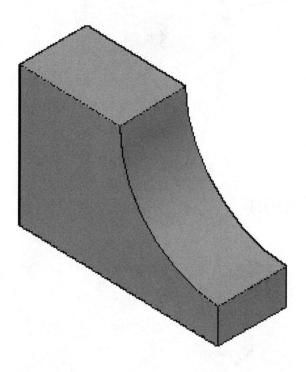

Step by step instructions and dimensions are shown on the next page.

Note: There are many different methods to create the object above.
The steps on the next page are designed to make you think about UCS
positioning, rotating and positive and negative inputs.
But you may use any method you choose.

EXERCISE 17A....CONTINUED

Step 1

1. Create a solid Box.
 Length = 6
 Width = 2
 Height = 4

 Note: Zoom in if the box appears small.

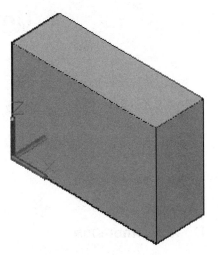

Step 2

1. Rotate the Origin around the X-Axis **negative** 90

 Remember, Height is always in the positive Z-axis

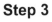

Step 3

1. Draw a 3" radius solid Cylinder.
 Radius = 3
 Height = 2
 Place center on corner of the Box.

 Snap the center of the Cylinder to the corner of Box.

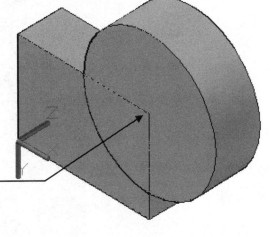

Step 4

1. Subtract Cylinder from Box.

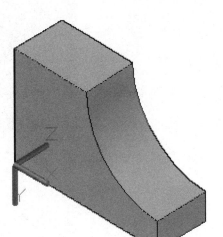

EXERCISE 17B

Union and Subtract

1. Open **EX-17A** (if not already open.)

2. Add and subtract from the existing model to form the solid object below.
 (Step by step instructions are on the next page)

3. Save as **EX-17B**

4. **Do not Dimension**

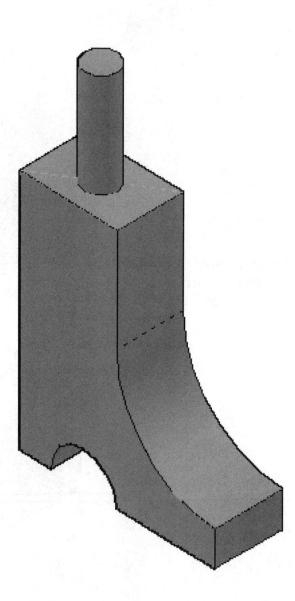

EXERCISE 17B....CONTINUED

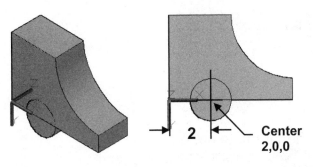

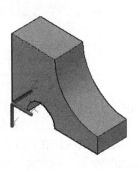

→2← **Center 2,0,0**

Step 1
1. **Add** a solid Cylinder
 Center location = 2,0,0
 Radius = 1
 Height = 2

Step 2
1. **Subtract** the Cylinder

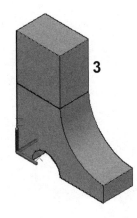

3

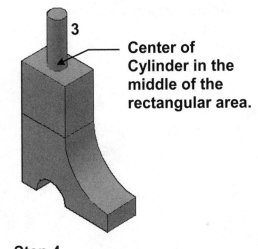

3

Center of Cylinder in the middle of the rectangular area.

Step 3
1. Rotate the Origin to original orientation. (World)
2. **Add** solid Box
 Height = 3

Step 4
1. **Add** solid Cylinder
 Radius = .50
 Height = 3

Step 5
1. **Union** all 3 parts.

EXERCISE 17C

Assembling 3D solids

1. Start a **NEW** file using **Acad3d.dwt**.

2. Change the **Units** to Architectural and the **Limits** to 60, 60 (inches).
 Reminder: Type: **Units <enter>** Type: **Limits <enter>**

3. Draw the table shown below
 (Step by step instruction on the following pages)

4. Save as **EX-17C**

5. **Do not dimension**

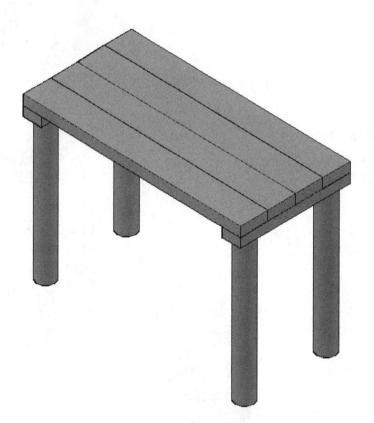

Dimensions and construction hints on the following pages.
Have some fun with this.
If you have time try to add some benches.

EXERCISE 17C....CONTINUED

Step 1

1. Draw a plank (use solid Box)
 - Length = 48
 - Width = 6
 - Height = 2

Step 2

1. Copy the Plank

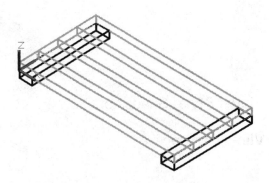

Step 3

1. Draw a plank (use solid Box)
 - Length = 4
 - Width = 24
 - Height = 2

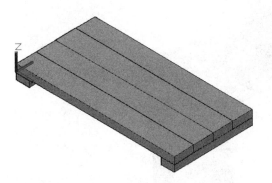

Step 4

1. Place a plank at each end

EXERCISE 17C....CONTINUED

Step 5
1. Move the Origin

Step 6
1. Draw 4 Legs (use solid Cylinder)
 Center = noted below
 Radius = 2
 Height = -30

Center location
2,21,0

Center location
46,21,0

Center location
2,3,0

Center location
46,3,0

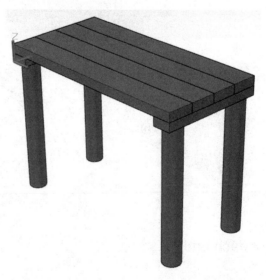

Visual Style: Shades of Gray

View: Perspective

LEARNING OBJECTIVES

After completing this lesson, you will be able to:

1. Extrude solid surfaces.
2. Create a Region.
3. Review Polyline "Join" command.
4. Use the Presspull command.
5. Add Thickness to a surface.

LESSON 18

EXTRUDE

AutoCAD's solid objects are helpful in constructing 3D solids quickly. But what if you want to create a solid object that has a more complex shape such as the one shown here.

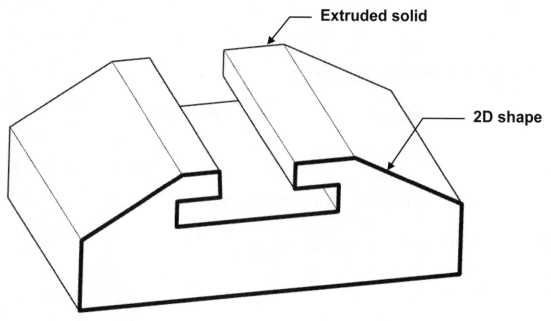

Extruded solid

2D shape

To create the solid shown above you first need to draw a **closed 2D shape** and then **EXTRUDE** it.

The **EXTRUDE** command allows you to take a 2D shape and extrude it into a solid. It extrudes <u>along the Z-Axis</u>. Extrusions can be created along a straight line or along a curved path it may also have a taper. (Refer to page 18-4)

You may **EXTRUDE** Polylines, Arcs, Circle, Polygon, Rectangle, Ellipses, Donuts, and Regions. (Splines can also be extruded but we are not discussing those in this workbook)

4 methods for extruding a 2D shape:
(Note: Step by step instructions for these methods on the pages noted below)
1. Perpendicular to the 2D shape with straight sides. (page 18-3)
2. Perpendicular to the 2D shape with tapered side. (page 18-4)
3. Along a Path (Page 18-4)
4. Extrude a Region. (Page 18-5)

HOW TO SELECT THE EXTRUDE COMMAND

Ribbon = Home tab / Modeling panel /
 or
Keyboard = Ext

EXTRUDE - <u>PERPENDICULAR WITH STRAIGHT SIDES</u>

Before drawing the 2D shape do the following:

1. Select the **Top** view.

2. Use **Polyline** to draw the closed 2D shape. (Be sure to use "close")

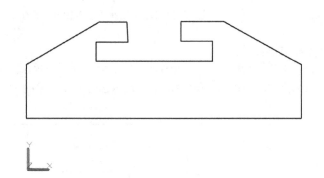

Now Extrude:

1. Select the **SE Isometric view**.

2. Select the **EXTRUDE** command (Refer to pg 18-2).

3. Select the objects: *select the objects to extrude <enter>*

4. Select the objects: *<enter>*

5. Specify height of extrusion or [Direction/Path/Taper angle]: *type the height <enter>*

 (Note: a **positive** value extrudes **above the XY plane** and **negative** extrudes **below the XY plane**, along the Z axis.)

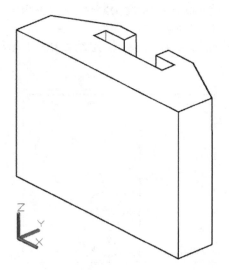

EXTRUDE - <u>PERPENDICULAR WITH TAPERED SIDES</u>

1. Draw a closed 2D shape on the XY plane.
2. Select the **EXTRUDE** command.
3. Select the objects: ***select the objects to extrude <enter>***
4. Select the objects: ***<enter>***
5. Specify height of extrusion or [Direction/Path/Taper angle]: ***T <enter>***
6. Specify angle of taper for extrusion <0>: ***enter taper angle <enter>***
7. Specify height of extrusion or [Direction/Path/Taper angle]: ***enter height <enter>***

How to control the taper direction
If you enter a <u>positive angle</u> the resulting extruded solid will <u>taper inwards</u>.
If you enter a <u>negative angle</u> the resulting extruded solid will <u>taper outwards</u>.

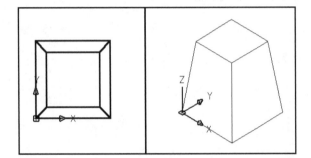
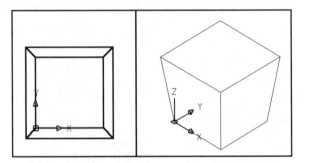

| **Positive angle** | **Negative angle** |

EXTRUDE - <u>ALONG A PATH</u>

Important: The path should be drawn perpendicular to the 2D shape to be extruded.

1. Draw a 2D shape on the XY plane.
2. Draw the path perpendicular to the shape.
 (*hint: rotate the UCS around the Y Axis negative 90 degrees*)
3. Select the **EXTRUDE** command.
4. Select the objects: ***select the objects to extrude <enter>***
5. Specify height of extrusion or [Direction/Path/Taper angle]: ***P <enter>***
6. Select extrusion path or [Taper angle]: ***select the path (object)***

**Notice the path must be drawn perpendicular to the shape to be extruded.
Draw the shape then rotate the XY plane perpendicular to the shape.**

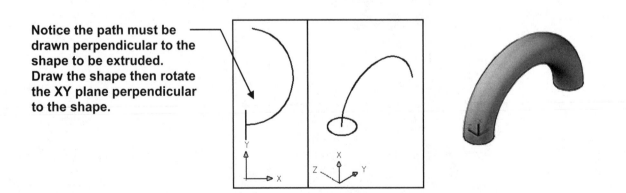

REGION

A **REGION** is a solid with no thickness. Think of a piece of paper. Thin but it is a solid. You can use all the Boolean operations, Union, Subtract and Intersect, on the region and you can extrude it.

Example:

1. You have a <u>**2D** drawing of a flat plate with circles</u> on it. You would like to extrude this plate and you want the circles to be holes.

2. Use the **REGION** command to transform these objects into a solid.

 a. Select the REGION command using one of the following:

 Ribbon = Home tab / Draw panel ▼ / 🔲
 or
 Keyboard = reg

 b. Select objects: ***select the objects <enter>***
 Select objects: ***<enter>***
 4 loops extracted.
 4 Regions created.

3. Now **subtract** the circles from the rectangle, so they are actually "holes".

4. Extrude the region.

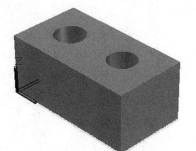

> **Which is more efficient?**
>
> 1. Draw a 2D drawing, create a region and then extrude.
> or
> 2. Draw a box and 3 cylinders then subtract cylinders from box.
>
> **Also see the PressPull command on page 18-6.**

PRESSPULL COMMAND

The **PressPull** command allows you to create a Region and Extrude a closed shape all in one operation. You may also use it to modify the height of an already extruded object. The area must be closed such as a circle, rectangle, polygon or closed polylines. You may even select an area created by two overlapping objects.

1. Draw a shape. (Note: it is not necessary to "subtract" the circles)

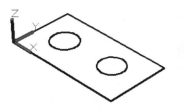

2. Move the UCS to the plane to extrude if the objects are not on the XY plane. (The plane to be extruded must be on the XY plane).

3. Select the Press/Pull command using:

 Ribbon = Home tab / Modeling panel /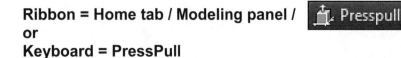
 or
 Keyboard = PressPull

4. Click in the boundary just as you would to select a hatch boundary.

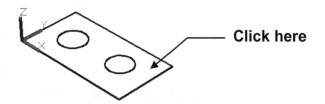

Click here

5. Move the cursor along the positive or negative Z axis to press or pull the region. You may click to determine the height or enter a value.

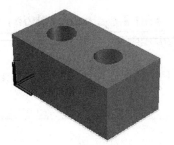

POLYSOLID

If you Extrude an open shape you will create 3D surfaces instead of a solid. These surfaces have no thickness. Sort of like a piece of paper standing on end. You may give these surfaces thickness using the **Polysolid** Surface tool.

Note: Drawing Units must be set to **Architecture** if you enter **feet** for the height. Decimal units will only accept **inches**.

1. Select the **Polysolid** using one of the following:

 Ribbon = Home tab / Modeling panel / 🍷 Polysolid
 or
 Keyboard = polysolid

2. Specify start point or [Object/Height/Width/Justify] <Object>: *Type h <enter>*

3. Specify height <8'-0">: *Type the height desired <enter>*

4. Specify start point or [Object/Height/Width/Justify] <Object>: *Type w <enter>*

5. Specify width <0'-4">: *Type the width desired <enter>*

6. Specify start point or [Object/Height/Width/Justify] <Object>: *Type j <enter>*

7. Enter justification [Left/Center/Right] <Center>: *Type r <enter>*

8. Specify start point or [Object/Height/Width/Justify] <Object>: *Place the start point*

9. Specify next point or [Arc/Undo]: *Place next point*

10. Specify next point or [Arc/Undo]: *Place next point*

11. Specify next point or [Arc/Undo]: *continue placing next points or <enter> to stop*

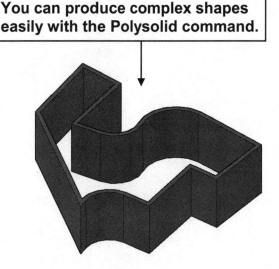

You can produce complex shapes easily with the Polysolid command.

DELOBJ SYSTEM VARIABLE

The **DELOBJ** system variable determines whether the object used when extruding, revolving, sweeping or presspulling, is retained or deleted. For example, when you extrude a circle to make a cylinder, what should happen to the original circle? Do you want to delete it or do you want to keep it?

Set the **DELOBJ** system variable before using the Modeling command.

1. To set the variable type **delobj <enter>**

2. Enter one of the options described below.

Options:

0 = Retains all source objects.

1 = Deletes profile curves. For example, if you use a circle to create a cylinder, the circle will be deleted. Cross sections and guides used with the SWEEP command are also deleted. However, if you extrude along a path, the path is not deleted.

2 = Deletes all defining objects, including paths

3 = This is the default setting.
Deletes all defining objects, including paths if the actions results in a solid object.

-1 = Just like "1" except you get a prompt to allow you to choose.

-2 = Just like "2" except you get a prompt to allow you to choose.

-3 = Just like "3" except you get a prompt to allow you to choose.

PLAN VIEW

Remember, you always draw on the XY plane. If you want to draw on a specific surface you have to move the XY plane (Origin) to the surface that you wish to work on. Then you may position the view in a 2D plan view so you may add a feature easily. You may do this easily with the PLAN command. After you move the XY Plane (Origin) to the surface type "Plan <enter>" and the view will change to a 2D plan view of the surface.

1. Move the UCS icon to the plane that you wish to draw on.
2. Type: **PLAN <enter>**
3. Enter an option [Current ucs/Ucs/World] <Current>: **<enter>**

You may now draw on the XY plane as if you were drawing a 2D drawing. Remember Height will be drawn along the Z-Axis. Use positive or negative.

> ### Very Important:
> ### "DYNAMIC UCS should be OFF" to use this method of drawing.

EXAMPLE

Step 1. Move the Origin to the surface you wish to work on.

Step 2. Type: **plan <enter> <enter>**

Step 3. Add a Cylinder (**Remember height is the Z-Axis**).

EXERCISE 18A

Extrude

1. Start a **New** file using **Acad3d.dwt**.

2. Draw the 2D drawing approximately as shown below to form a closed Polyline. (Exact size is not important.)

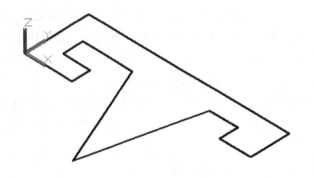

3. Use **Extrude** or **Presspull** to form the solid object.

4. Save as **EX-18A**

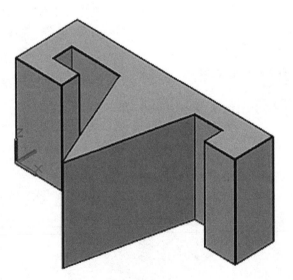

EXERCISE 18B

Extrude along a Path

1. Start a **New** file using **Acad3d.dwt.**

2. Draw a Circle with a radius of 1

3. Rotate the UCS, about the Y axis, -90. (Perpendicular to current UCS.)

4. Draw a **polyline path** perpendicular to the Polygon approximately as shown

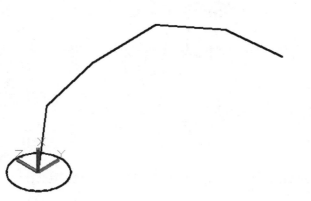

5. Extrude the Polygon along the path

6. Save as **EX-18B**

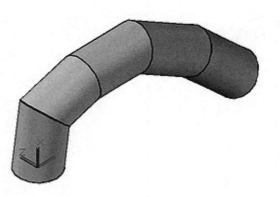

EXERCISE 18C

Extrude with Taper

1. Start a **New** file using **Acad3d.dwt.**

2. Draw a 6 sided Inscribed Polygon with a radius of 2

3. Extrude to form the solid object. Ht = 4 Taper angle = 5

4. Add the letter & Number shapes (Use polyline, **do not use text**).
 Extrude each. Ht = 1 (Fig. 3)
 Don't forget to use subtract on the shapes "4" , "6" and "B".

 Refer to the next page for construction suggestions

5. Select the **SE Isometric** view.

6. Save as **EX-18C**

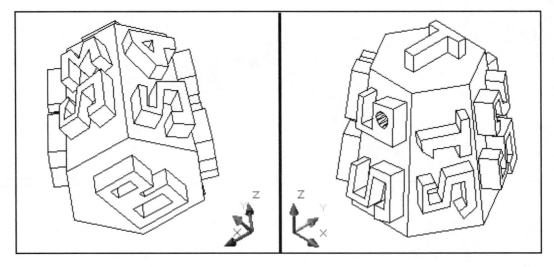

EXERCISE 18C....continued

Construction suggestion:

a. After constructing the shape shown below, move the UCS, using **3 Point** to select the correct surface to draw on.

b. View the **Plan view** to draw the text.
 (Remember, use Polyline to construct the letter. Do not use Text)

c. Extrude the polyline letter shapes.

d. Select **SE Isometric view** and then use Orbit to rotate around to the next surface to repeat the process for all 6 sides, Top and Bottom.

EXERCISE 18D

Extrude or PressPull a Region

1. Start a **New** file using **Acad3d.dwt.**

2. Draw the 2D drawing shown below.
 Note: Use **PLAN**

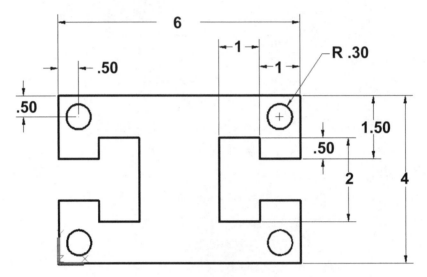

3. Create a "**Region**" and Extrude or use "**PressPull**" command to form the solid object
 Height = 4"

4. Save as **EX-18D**

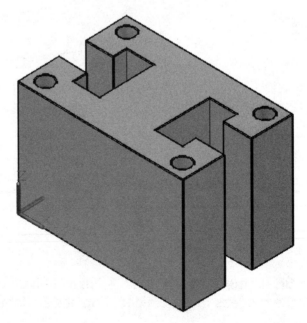

EXERCISE 18E

<u>Extrude or PressPull a Region</u>

1. Start a new file using **My Feet-Inches Setup.dwt**

2. Draw the Floor plan shown below using closed polylines.
 **Note: Use the <u>Join command</u> to join polylines into one polyline if necessary.
 Refer to Beginning Workbook if you can't remember.**

3. **Do not dimension.**

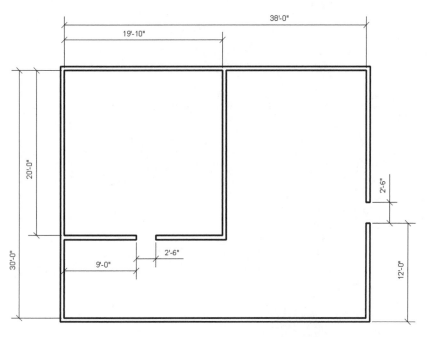

4. Select the **SE Isometric**
 View.

5. Use the **Region** command to
 create a region to Extrude.

6. Extrude or Presspull the walls
 to a height of 8 feet.

7. Save as **EX-18E**

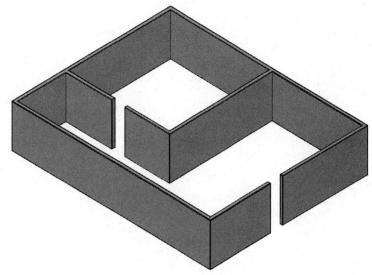

Notes:

LEARNING OBJECTIVES

After completing this lesson, you will be able to:

1. Understand 3D Operations.
 Mirror 3D, 3D Rotate, 3D Align and 3D Array

LESSON 19

3D Operations

3D Operations allow you to **3D Mirror, 3D Rotate, 3D Align** and **3D Array** a solid. The methods are almost identical to the 2D commands with the exception of defining the plane. <u>You do not have to move the UCS.</u>

Note: You may use the equivalent 2D commands but they will only work in the XY plane. <u>It may be necessary to move the UCS.</u>

THE FOLLOWING ARE EXPLANATIONS FOR THE <u>3D</u> COMMANDS.

3D MIRROR
You must define the mirror plane.

1. Select the **3D MIRROR** command using one of the following:

 Ribbon = Home tab / Modify panel /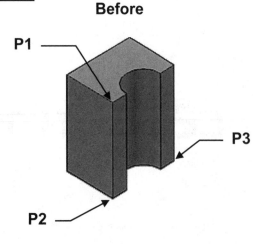
 or
 Keyboard = mirror3d

2. Select objects: *select the solid to be mirrored*

3. Select objects: *Select more or <enter> to stop*

4. Specify first point of mirror plane (3 points) or [Object/Last/Zaxis/View/XY/YZ/ZX/3points] <3points>: *3 <enter>*

5. Specify first point on mirror plane: *select first point on mirror plane (P1)*

6. Specify second point on mirror plane: *select second point on mirror plane (P2)*

7. Specify third point on mirror plane: *select third point on mirror plane (P3)*

8. Delete source objects? [Yes/No] <N>: *select Y or N <enter> (the example is NO)*

<u>EXAMPLE:</u>

Before

After

P1

P3

P2

3D Operations....continued

3D ROTATE

You must pick 2 points to define the axis of rotation and the rotation angle. To determine the rotation angle you must look down the axis from the second point.

If you use my stabbing arrow analogy (page 17-8), you will put the positive end of the second point selected in your chest and rotate the other two axes. <u>Positive input is counterclockwise and Negative input is clockwise.</u>

1. Select the **3D ROTATE** command using one of the following:

 > **Ribbon = Home tab / Modify panel /**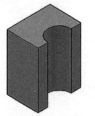
 > or
 > **Keyboard = 3drotate**

2. Current positive angle in UCS: ANGDIR=counterclockwise ANGBASE=0
 Select objects: *select the solid to be rotated*

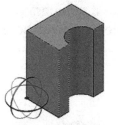

3. Select objects: *<enter> to stop*

4. Specify Base Point: *Snap to the base point of the rotation*

5. Pick a Rotation axis:
 Touch the ribbons until the correct axis line appears then click left mouse button

6. Specify angle start point or type angle: *type rotation angle <enter>*

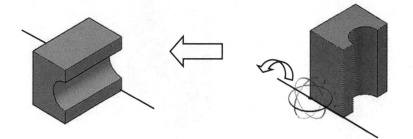

In the example on the left I have selected the Red ribbon which is the "X" axis. A Red line should appear. And I entered a positive 90.

3D Operations....continued

3D ALIGN

The **3D ALIGN** command allows you to MOVE and ROTATE an object from its existing location to a new location.

You define the two or three points on the **SOURCE** object and then the points on the **DESTINATION** location.

1. Select the **3D ALIGN** command using one of the following:

 Ribbon = Home tab / Modify panel /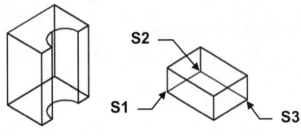
 or
 Keyboard = 3dalign

2. Select objects: *select the object to be aligned*

3. Select objects: *select more or <enter> to stop*

4. Specify source plane and orientation ...

 Specify base point or [Copy]:: *select the 1st source (S1)*

5. Specify second point or [Continue] <C>: *select the 2nd source (S2)*

6. Specify third point or [Continue] <C>: *select the 3rd source (S3)*

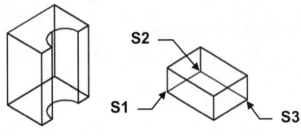

> **Note:** It will be easier to select source points if you change the **"Visual Style"** to **Wireframe**.

7. Specify destination plane and orientation ...

 Specify first destination point: *select the 1st destination point (D1)*

8. Specify second destination point or [eXit] <X>: *select the 2nd destination point (D2)*

9. Specify third destination point or [eXit] <X>: *select the 3rd destination point (D3)*

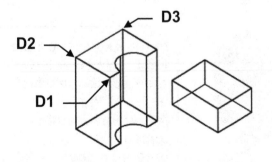

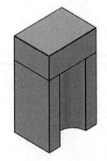

ARRAY in 3D space

The Array command can be used in 2D and 3D space. You learned how to use the Array command in 2D space in the Beginning Workbook. Now you will learn how to use the Array command in 3D space.

The Array command steps are exactly the same as in 2D and 3D except after you have created the Rows and Columns count and spacing you must specify **levels**.

How to create a RECTANGULAR ARRAY in 3D space

1. Draw a 1" cube.

2. Select the **ARRAY** command using one of the following:

 Ribbon = Home tab / Modify panel / Array ▼
 or
 Keyboard = Array <enter>

3. Select **Rectangular Array.**

4. Select Objects: *Select the Object to be Arrayed. (the cube)*

5. Select Objects: *Select more objects or <enter> to stop*

 A display of 4 X 3 appears and the **Array Creation** tab and panels appear.

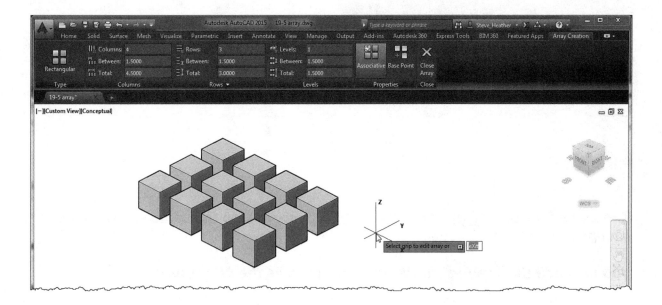

Now here is where the difference between 2D and 3D occurs.
You may specify "Levels" which will place copies in the Z-axis.

Continue on the next page

ARRAY in 3D space....continued

6. Enter the number of Levels **3**

7. Enter the distance between levels **1.5000**

8. ***Press <enter>*** to display the Array

9. Select **Close Array**

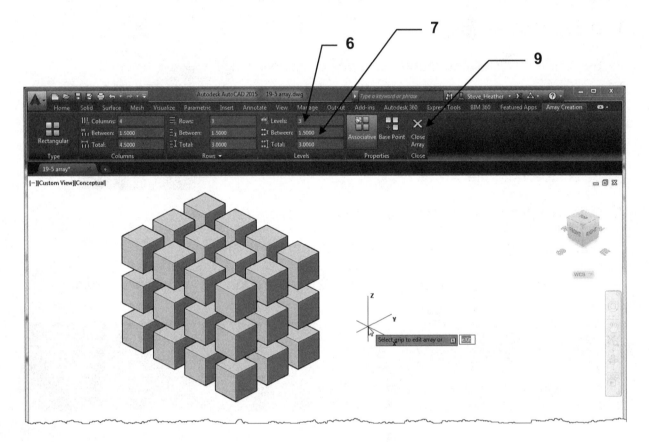

The steps for <u>Polar Array</u> and <u>Path</u>, in 3D space, is also the same as 2D space except you will specify <u>levels</u>.

You may edit the array using the same process as the 2D array.

EXERCISE 19A

3D MIRROR

1. Start a **New** file using **<u>Acad3d.dwt.</u>**
2. Draw the solid object below.
3. Dimensions and construction hints below.
4. Save as **EX-19A**

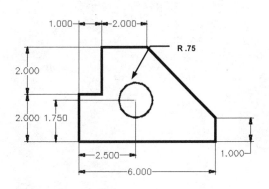

Step 1.
Draw the profile using **Plan View**

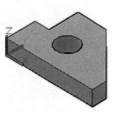

Step 2.
Presspull (height = 1.00)

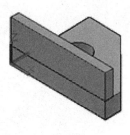

Step 3.
Add center divider
L = 6 W = .50 Ht = 1.50

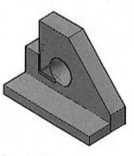

Step 4.
Rotate

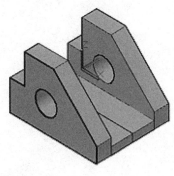

Step 5.
Mirror

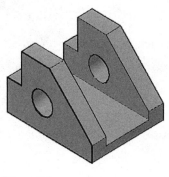

Step 6.
Union

EXERCISE 19B

3D ROTATE

1. Open **EX-19A** (If not already open)

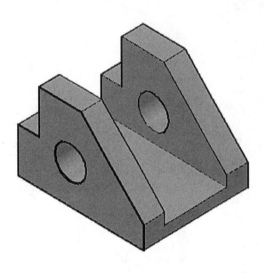

2. Rotate the solid model 180 degrees around the **Z** Axis as shown below

3. Save as **EX-19B**

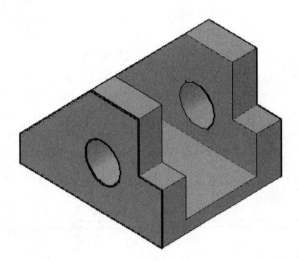

EXERCISE 19C

3D ALIGN

1. Start a **New** file using **Acad3d.dwt**.

2. Draw the 3 solid objects shown below .
 (Use the dimensions shown)

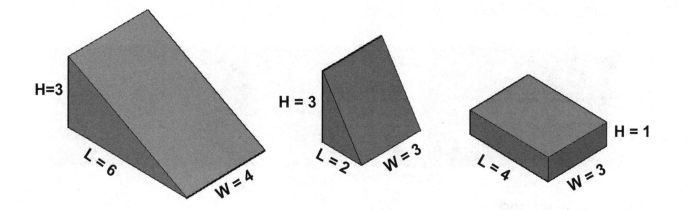

3. Using the **3D ALIGN** command, assemble the objects as below.

4. Save as **EX-19C**

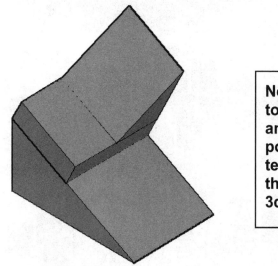

Note: It will be easier to select the source and destination points if you temporarily change the Visual Style to 3dWireframe

EXERCISE 19D

ARRAY - RECTANGULAR

1. Start a **New** file using **Acad3d.dwt**.

2. Draw the solid Cylinder
 Radius: 0.50
 Height: 1.00

3. Array Specifications:

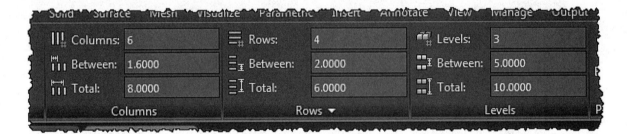

		Columns:	6		Rows:	4		Levels:	3
		Between:	1.6000		Between:	2.0000		Between:	5.0000
		Total:	8.0000		Total:	6.0000		Total:	10.0000
		Columns			Rows ▼			Levels	

4. Save as **EX-19D**

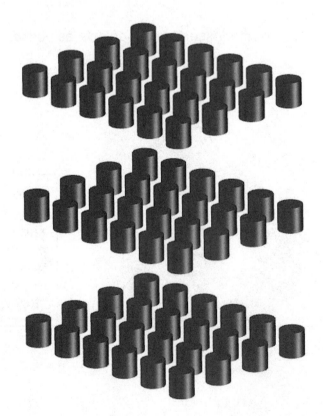

LEARNING OBJECTIVES

After completing this lesson, you will be able to:

1. Use the Gizmo tool to modify Solid objects.

LESSON 20

Using the Gizmo tool

Gizmo tools help you move, rotate, or scale an object or a set of objects along a 3D axis or plane.

There are three types of gizmos:

3D Move gizmo. Relocates selected objects along an axis or plane.

3D Rotate gizmo. Rotates selected objects about a specified axis.

3D Scale gizmo. Scales selected objects along a specified plane or axis, or uniformly along all 3 axes.

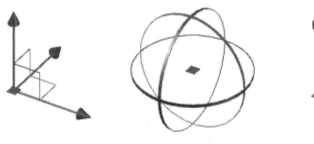

| **Move** | **Rotate** | **Scale** |

How to select the desired Gizmo tool.

1. Select the Gizmo tool before selecting the object as follows:

 Ribbon = Home tab / Selection Panel / Gizmo ▼

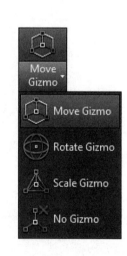

The Gizmo tool is also available on the **Status Bar**.
(Refer to page 2-12 for adding buttons to the Status Bar)

The Gizmo tool will appear after you select an object.

You may also change Gizmo tools etc. by right clicking and select from the shortcut menu.

MOVE a Sub-object using Grips

You may move a 3D solid sub-object within another 3D solid

The example below demonstrates how to move a hole within a box.

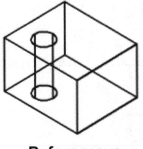

Before move

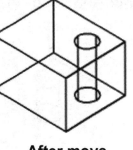

After move

1. Select the sub-object that you choose to move as follows:

 a. Hold down the **Ctrl** key while clicking inside of the hole.

2. Click on the **Move** grip.

3. Drag or enter coordinates for the new location.

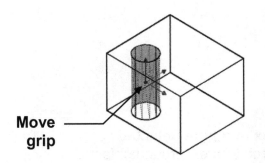

Move grip

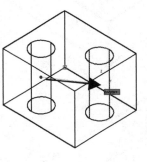

Move on Axis or free movement

After selecting the object to move, click on the axis arrow end to restrict the movement in only one axis.

For example:
If you want to move the hole in the X-axis click on the X-axis arrow end (Red).
The hole will then be restricted to only X-axis movement.
If you want free movement click on the Base grip

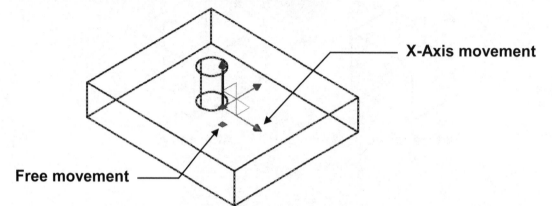

X-Axis movement

Free movement

To select a sub-object or entire object.

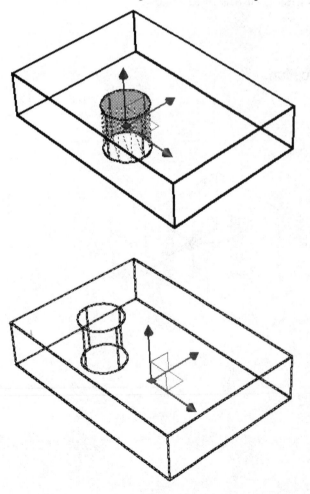

Hole Selected
Hold down the **Ctrl** key and click inside the hole.

Only the hole will move.

Box and hole Selected
Place window around objects.

The Box and the hole will move together.

STRETCH a 3D object

You may also quickly stretch an object.

1. Hold down the **CTRL** key and click on a surface . The Surface will highlight.

2. Click on the Gizmo tool arrow end.

3. Enter stretch length from existing location or place cursor and press left mouse button.

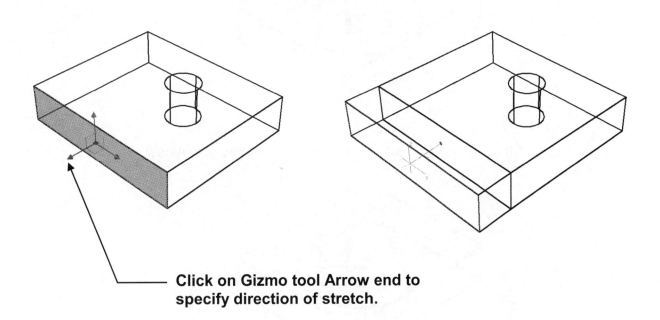

Click on Gizmo tool Arrow end to specify direction of stretch.

ROTATE a 3D object

Using the 3D Rotate Gizmo tool you can rotate selected objects and sub-objects about a selected Axis.

1. Select the objects to be rotated.

2. Select the 3D Rotate Gizmo tool using Ribbon or shortcut menu. (Refer to 20-2)

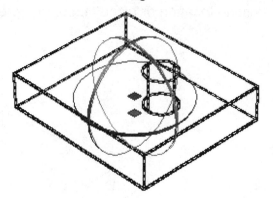

3. Select one of the Gizmo tool Axis rings. (Example below is Y-Axis)

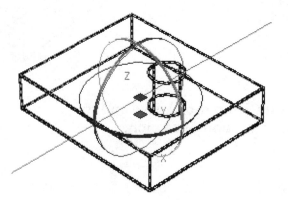

4. Enter Rotation angle or place cursor and press left mouse button.

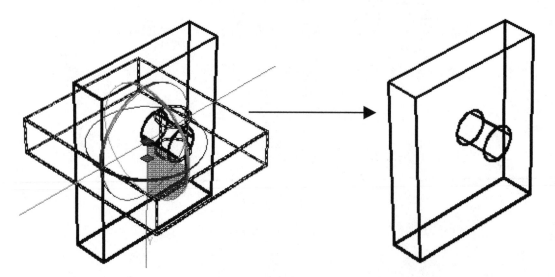

SCALE a 3D object

Using the 3D Scale Gizmo tool, you can resize selected objects and sub-objects along an axis or plane, or resize the objects uniformly.

The example shown below is scaled uniformly.

1. Select the objects to be scaled.

2. Select the 3D Scale Gizmo tool using Ribbon or shortcut menu (Refer to 20-2)

3. Select one of the Gizmo tool Axis ends.

Axis end

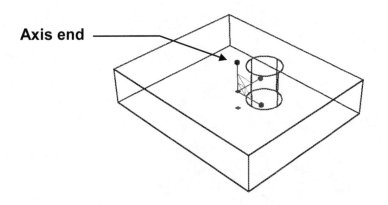

4. Enter scale factor or place cursor and press left mouse button.

Box scaled

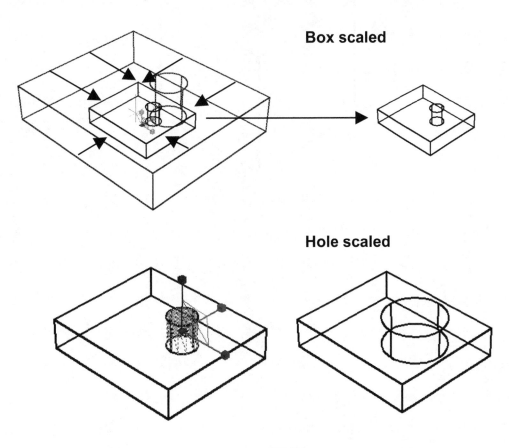

Hole scaled

EXERCISE 20A

Create a Cube

1. Start a **New** file using **Acad3d.dwt**

2. Draw a 3D Solid Cube as shown below.

3. Do not dimension

4. Save as: **EX-20A**

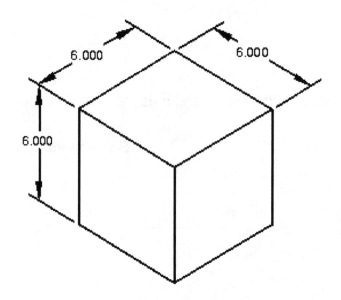

EXERCISE 20B

PressPull or Grips

1. Open EX-20A (If not already open)

2. Increase the Length and Height as shown below.

3. Do not dimension

4. Save as: **EX-20B**

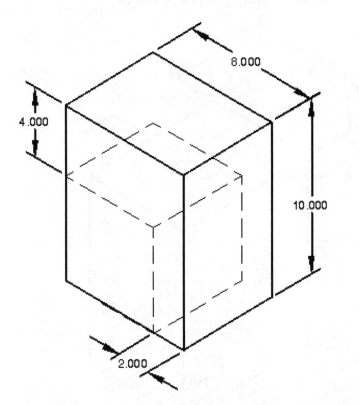

Note: The dashed cube represents the Cube previous to scaling. It will not appear on your drawing after scaling is complete.

EXERCISE 20C

Add Cylinders and Subtract

1. Open EX-20B (if not already open)

2. Add (3) 1" radius holes as shown below.

3. Subtract the Cylinders from the Box.

4. Save as: **EX-20C**

Notice:
You will have to move the Origin and change the XY plane
to accurately place the holes.

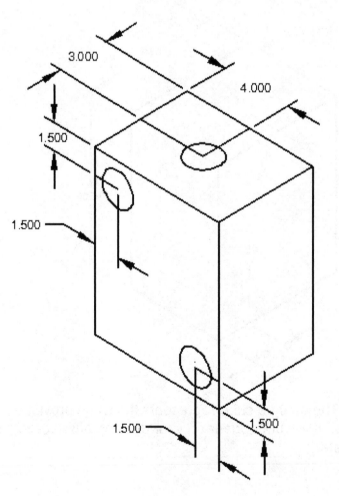

EXERCISE 20D

Move the hole

1. Open EX-20C (if not already open)

2. Move hole "A" to a new location as shown below. (Refer to page 20-4)

3. Save as: **EX-20D**

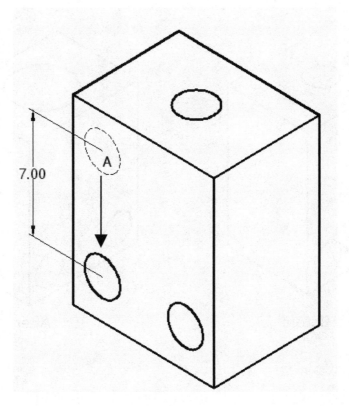

EXERCISE 20E

Scale hole

1. Open EX-20D (if not already open)

2. Increase the size of the hole "B" to 2" radius. (Factor of 2)

3. Save as: **EX-20E**

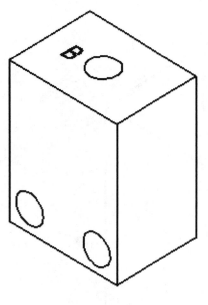

Before

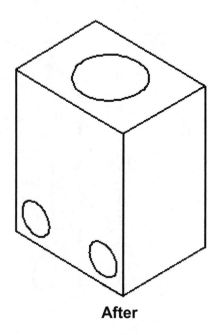

After

EXERCISE 20F

Delete

1. Open EX-20E (If not already open)

2. Delete hole "C".

3. Save as: **EX-20F**

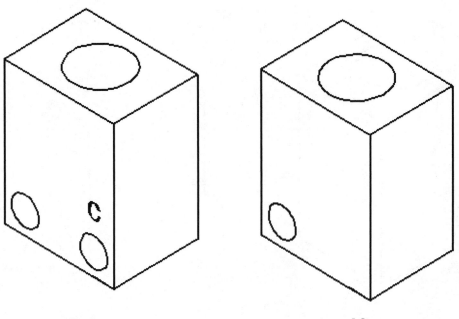

Before **After**

Remember to use Ctrl key and click inside desired hole to select.

EXERCISE 20G

Rotate

1. Open EX-20F (If not already open)

2. Rotate entire object negative 90 degrees as shown.

3. Save as: **EX-20G**

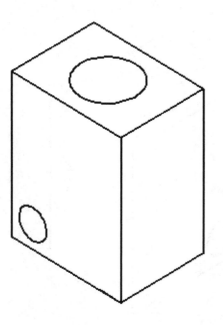

Before

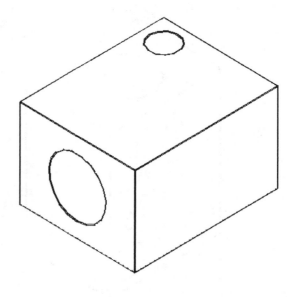

After

LEARNING OBJECTIVES

After completing this lesson, you will be able to:

1. Create a solid object by revolving a 2D shape.
2. Slice a solid object into 2 segments.
3. Create a 2D and 3D section view through a solid object.
4. Create a twisted object along a path.
5. Create a Helix.

LESSON 21

REVOLVE

The **REVOLVE** command allows you to revolve a profile around an axis. If the shape is closed it will become a solid. If the shape is open it will become a surface. The shape can be revolved from 1 to 360 degrees.

You will select the <u>axis to revolve around</u>, the <u>solid to be revolved</u> and enter the <u>angle of revolution.</u>

Selecting the axis of revolution

The axis of revolution can be the X or Y axis. It may also be an object such as a line. The axis may be located on the shape or not.

HOW TO USE THE REVOLVE COMMAND

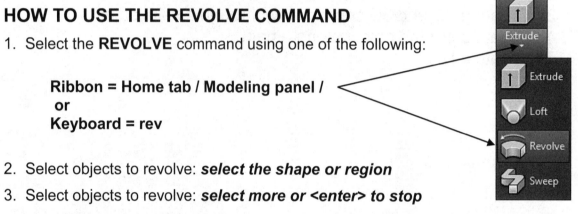

1. Select the **REVOLVE** command using one of the following:

 > **Ribbon = Home tab / Modeling panel /**
 > **or**
 > **Keyboard = rev**

2. Select objects to revolve: *select the shape or region*
3. Select objects to revolve: *select more or <enter> to stop*
4. Specify axis start point or define axis by [Object/X/Y/Z] <Object>: *Select Axis*
5. Specify angle of revolution or [STart angle] <360>: *type the angle (positive ccw or negative cw determines direction of rotation.*

Below are examples of how you can make 3 different solids by selecting different "Axis of Revolution".

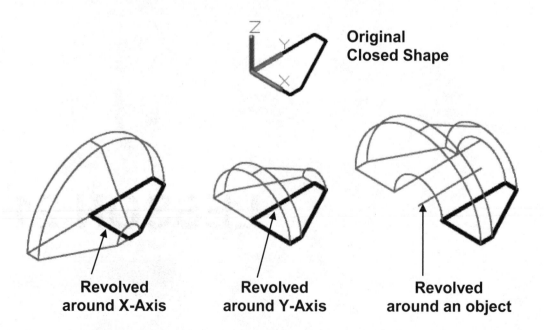

Revolved around X-Axis	**Revolved around Y-Axis**	**Revolved around an object**

SLICE

The **SLICE** command allows you to make a knife cut through a solid. You specify the location of the slice by specifying the plane. After the solid has been sliced, you determine which portion of the slice you want removed. You may also keep both portions but they are still separate.

HOW TO USE THE SLICE COMMAND

1. Select the **SLICE** command using one of the following:

 Ribbon = Home tab / Solid editing panel /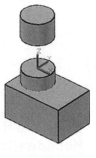
 or
 Keyboard = sl

2. Select objects: *select the solid object*
3. Select objects: *<enter> to stop*
4. Specify start point of slicing plane or [planer object/Surface/Zaxis/View/XY/YZ/ZX/
 3points <3points>: *select the option preferred. (See methods below.)*

THERE ARE 2 EASY METHODS TO SPECIFY THE CUTTING PLANE.

Method 1. (3 points)
1. Define the cutting plane by selecting 3 points on the object.
2. Click on the side you want to keep or "B" to keep both sides.

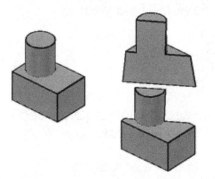

Method 2. (XY, YZ or ZX Plane)

1. Move the UCS to the desired cutting plane location.
2. Select the XY, YZ or ZX plane. (The cut will be made along the selected plane)

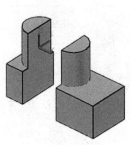
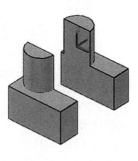

XY Plane YZ Plane ZX Plane

SECTION PLANE

The **SECTION PLANE** command creates a section "**object**" that acts as a "Cutting plane" through the 3D model. AutoCAD calls this command "**Live sectioning**". It allows you to cut a section plane through a model at any location, move the section plane to a new location and delete the section plane. The model will not be affected and will mend as you move the "section plane object" and the model will become whole again when you delete the section plane object.
This is a great tool to dynamically peek inside your model as you are creating it.

Examples:

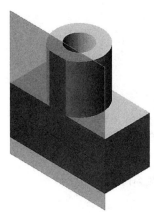
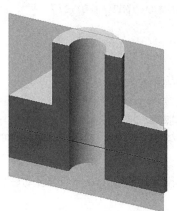

Section Plane **Section Plane Rotated** **Section Plane Deleted**

1. Select the **SECTION PLANE** command using one of the following:

 **Ribbon = Home tab / Section panel /
 Or
 Keyboard = sectionplane**

2. _Sectionplane Select Face or any point to locate section line or [Draw section Orthographic]: *place the cursor on any "face" and left click*.

3. Now you may click on the "Section Plane object" to move or rotate it.

After selecting the Section Plane you may move or rotate it using the "**Arrow Grip**" or "**Square Grip**", shown below. The Gizmo has been turned off for clarity.

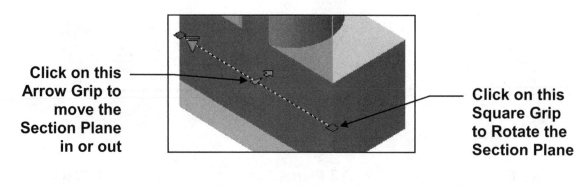

**Click on this
Arrow Grip to
move the
Section Plane
in or out**

**Click on this
Square Grip
to Rotate the
Section Plane**

Continued on the next page...

SECTION PLANE....continued

Moving the Section Plane:

1. Left click on the Section Plane to enable the Grips.

2. Left click on the "Arrow" Move Grip to enable it.

3. Move the Section Plane in or out to your desired location.

4. Left click to finish the move, then press the **Esc** key to close the grips.

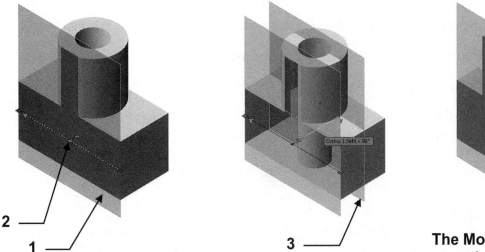
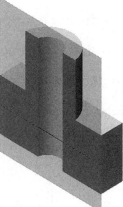

The Model now shows a sectioned view

Rotating the Section Plane:

1. Left click on the Section Plane to enable the Grips.

2. Left click on the "Square" Rotate Grip to enable it.

3. Rotate the Section Plane to your desired location.

4. Left click to finish the rotation, then press the **Esc** key to close the grips.

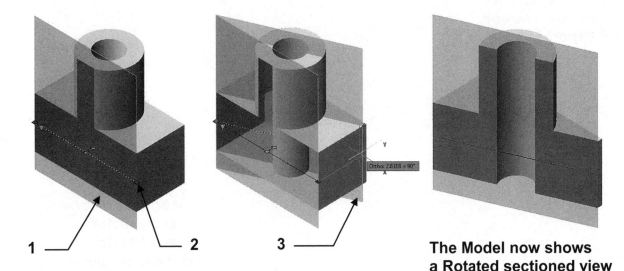

The Model now shows a Rotated sectioned view

SECTION PLANE....continued

When you have successfully placed the Section Plane object you may do the following:

Note: Left click on the Section Plane object and then Right click. A Pop up menu will appear that includes the options shown on the left.

Activate live sectioning: Activate or De-Activate the live sectioning.

Show cut-away geometry: Displays cut-away geometry.

Live section settings: Refer to the next page.

Generate 2D/3D section… This is very useful. This option will create either a 2D or 3D section from the Area that the Section Plane object defines.

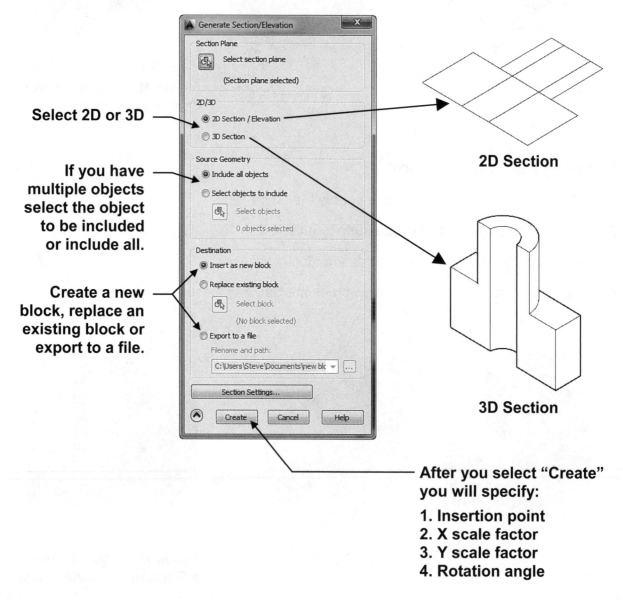

Select 2D or 3D

If you have multiple objects select the object to be included or include all.

Create a new block, replace an existing block or export to a file.

2D Section

3D Section

After you select "Create" you will specify:

1. Insertion point
2. X scale factor
3. Y scale factor
4. Rotation angle

SECTION PLANE....continued

Add Jog to a Section: Specify a location for the jog by clicking on the section line.

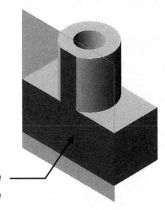

Click on the Section Line

Before Jog

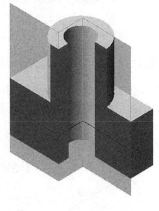

After Jog

Live section settings.... Determines how sectioned objects are displayed. You may make changes to the "Properties" of the Section Plane, 2D section or 3D section.

Section Settings	
Section Plane	
Select section plane	
(Section plane selected)	

- ● 2D section / elevation block creation settings
- ○ 3D section block creation settings
- ○ Live Section settings
 - ☑ Activate Live Section

Select what you want to change

Intersection Boundary	
Color	■ ByLayer
Layer	0
Linetype	Continuous
Linetype Scale	1.0000
Plot style	ByColor
Lineweight	———— ByLayer
Division Lines	Yes

Intersection Fill	
Show	Yes
Face Hatch	Predefined/SOLID
Angle	0
Hatch Scale	1.0000
Hatch Spacing	1.0000
Color	■ Color 8
Layer	0
Linetype	Continuous
Linetype Scale	1.0000
Plot style	ByColor
Lineweight	———— ByLayer

The list of Properties depends on what you selected above

Background Lines	
Show	Yes
Hidden Line	Yes
Color	■ ByLayer
Layer	0
Linetype	Continuous
Linetype Scale	1.0000

☐ Apply settings to all section objects

[OK] [Reset] [Cancel]

SWEEP

The SWEEP command is similar to the Extrude along a path but it does much more. You draw a path and an object to sweep along the selected path. Sweep will automatically align the object(s) perpendicular to the path and extrudes them along the path.

HOW TO USE THE SWEEP COMMAND

1. Select the Layer that you want the finished object on.
2. Draw the object and the path on the same plane.

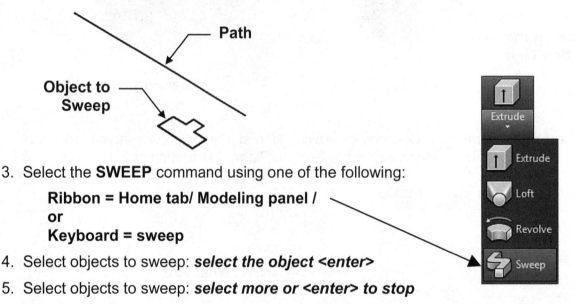

3. Select the **SWEEP** command using one of the following:

 Ribbon = Home tab/ Modeling panel /
 or
 Keyboard = sweep

4. Select objects to sweep: *select the object <enter>*
5. Select objects to sweep: *select more or <enter> to stop*
6. Select sweep path or [Alignment/Base Point/Scale/Twist]: *select the path*

Note: When selecting the Path line it is important where you click on the line. If you click at the left end, the sweep will appear as shown. If you click on the right end, the sweep will be upside down.

If you would like it to twist, when prompted for the path, select **"Twist"**. Then enter the total angle that you would like it to twist along the entire path. Then select the path.

Example of 180 degree twist from the start of the path to the end.

HELIX

The HELIX command allows you to easily construct a wireframe helix or spiral. You will specify the center of the base and top, diameters of the base and top, number of turns, turn height distance and which direction it turns. The default is counterclockwise.

HOW TO USE THE HELIX COMMAND

1. Select the Helix command using one of the following:

 Ribbon = Home tab / Draw panel ▼ /
 or
 Keyboard = helix

Command: _Helix
Number of turns = 3.000 Twist=CCW

2. Specify center point of base: *select the location for the center of the base*

3. Specify base radius or [Diameter] <1.000>: *enter base radius <enter>*

4. Specify top radius or [Diameter] <1.000>: *enter top radius <enter>*

5. Specify helix height or [Axis endpoint/Turns/turn Height/tWist] <1.000>:
 enter Axis endpoint or select one of the other options.

Options:

Axis endpoint = center of the top of the Helix.

Turns = How many turns do you want? (500 max) Then you will be prompted for distance between turns. AutoCAD will calculate the height from that information.

Turn Height = Distance between revolutions.

Twist = The default twist is CCW. You may change it to CW.

You may combine the Helix and Sweep commands to create a 3D solid.

1. Create the Helix.

2. Draw the cross-section object such as the diameter of a spring.

3. Use the cross-section as the Sweep object and the Helix as the path.

EXERCISE 21A

SLICE

1. Start a **NEW** file using **Acad3d.dwt.**

2. Draw the 3D solid shown below.

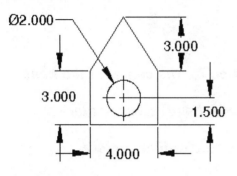

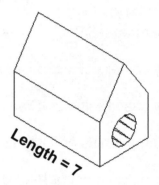

Length = 7

3. IMPORTANT: Save as **EX-21A1** before Slicing.
 This object will be used in EX-21C also.

4. **SLICE** the solid as shown below.

5. Save as **EX-21A**

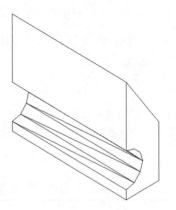

EXERCISE 21B

REVOLVE

1. Start a **NEW** file using **Acad3d.dwt.**

2. Draw the 2D shape shown below. Using a closed Polyline.

3. Create 2 additional copies (3 total)

4. Revolve in the X axis, Y axis and around an object, **as shown on the next page**.

5. Save as **EX-21B**

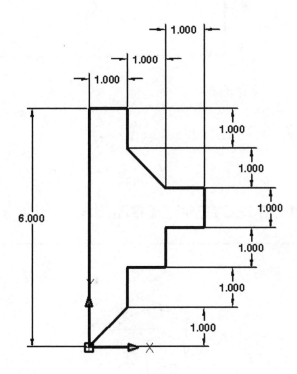

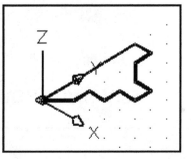

EXERCISE 21B....continued

REVOLVE AROUND X-AXIS
180 DEGREES

REVOLVE AROUND Y-AXIS
-90 DEGREES

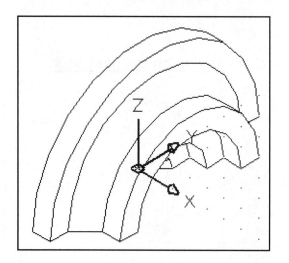

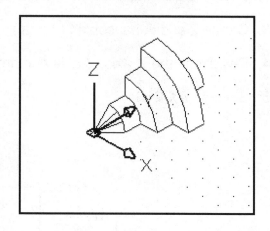

REVOLVE AROUND AN OBJECT 360 DEGREES

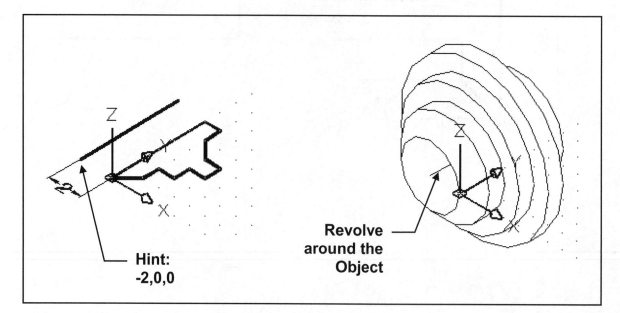

Hint:
-2,0,0

Revolve
around the
Object

EXERCISE 21C

CREATE 2D and 3D SECTION

1. Open **EX-21A1 (from exercise 21A)**

2. Create a Section Plane as shown below.

2. Using **Section Plane** command create a **2D Section**.

3. Using **Section Plane** command create a **3D Section**.

4. Save as **EX-21C**

EXERCISE 21D

SWEEP

1. Start a **NEW** file using **Acad3d.dwt.**

2. Draw the 2D shape shown below and the path on the XY plane.

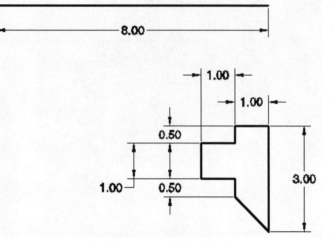

3. Make a Region of the shape.

4. Create a copy of both the Region and the Line.

5. Select the layer where you want the sweep placed.

6. First do a straight Sweep. Then do a Sweep with a twist of 180 degrees.

7. Save as **EX-21D**

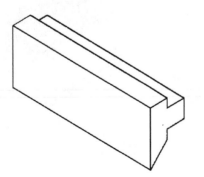

EXERCISE 21E

HELIX

1. Start a **NEW** file using **Acad3d.dwt**.

2. Draw the 2 HELIX shown below.

3. Save as: **EX-21E**

Number of turns = 10
Twist = CCW
Base radius = 3.000
Top radius = 3.000
Axis end point = 8

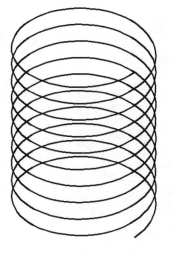

Number of turns = 5
Twist = CCW
Base radius = 6
Top radius = 2
Turns = 5
Turn Height = 1

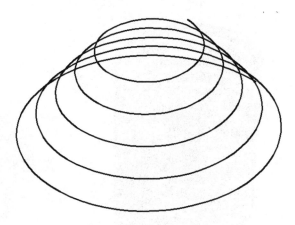

EXERCISE 21F

3D SOLID HELIX

1. **Open EX-21E**
2. Draw the 2 objects (circle & polygon) shown below each Helix, the position of each is not important.
3. Sweep the objects using the Helix as the Path.
4. Save as: **EX-21F**

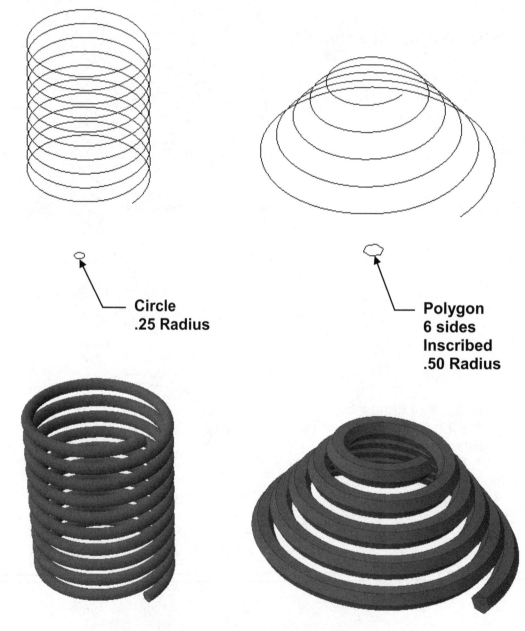

Circle
.25 Radius

Polygon
6 sides
Inscribed
.50 Radius

Both objects are shown in Perspective view

LESSON 22

Plotting Multiple Views Quickly

The following is a quick and simple method to develop a <u>multiview</u> layout to use for plotting 3D drawings. Refer to page 4 for a more specific process of creating projected views, sections and details.

STEP 1. SELECTING THE PLOTTER / PRINTER AND PAPER SIZE.

1. Open a solid model drawing. (Example: **2015-3D demo.dwg**)
2. Display the model as **Parallel**
3. Select an unused Layout tab.
4. Right click on the Layout tab and select **Page Setup Manager**. (If it didn't open)
5. Select **Modify**
6. Select "<u>your printer</u>", "<u>Plot Style: Monochrome</u>" and " <u>Paper Size-Letter</u>".
 and <u>OK</u>.
7. Select **Close**
8. Rename the Layout tab to "**Multiview**".
9. If a viewport already exists, erase it.

STEP 2. CREATE VIEWPORTS

1. Select the **Viewport** layer.
2. Type **vports** <enter>
 a. Select **FOUR EQUAL**
 b. Set **Viewport Spacing to: .50**
 c. Set **Setup to: 3D**
 d. Select **OK**
 e. Specify first corner or [Fit] <Fit>: **<enter>**

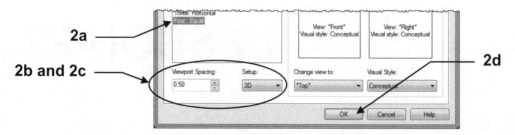

Plotting Multiple Views....continued

The 3D Model will be displayed within 4 viewports. Each display is a different view of the model.

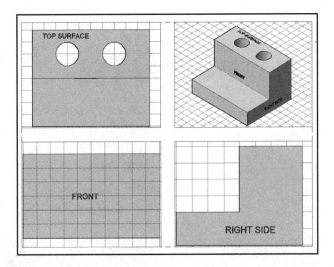

STEP 3. ADJUST VIEWPORT SCALE, PAN and LOCK
1. Adjust the scale of each Viewport to **1: 2**.
2. **LOCK** each Viewport.

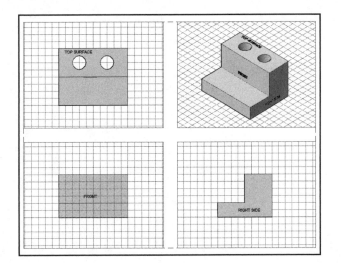

STEP 4. PLOT
1. Select **PLOT** command
2. Select **Printer / Plotter** = yours
3. Select **Paper Size** = Letter
4. Select **Plot Area** = Layout
5. Select **Plot Offset** = 0
6. Select **Scale** = 1 : 1
7. Select **Plot Style Table** = Monochrome
8. Select the **Preview** button.
9. If **OK** then plot.

Creating Projected Views

AutoCAD will automatically create top, front, side and isometric projected views of a model base that you select. It is simple and very helpful.

1. Open **2015-3D Demo. Dwg**

2. Select the **Multiview** tab.

3. Select the **Layout** tab.

4. Select **Base** from the **Create View** panel.

 4a. Select **From Model Space** in the drop-down menu.

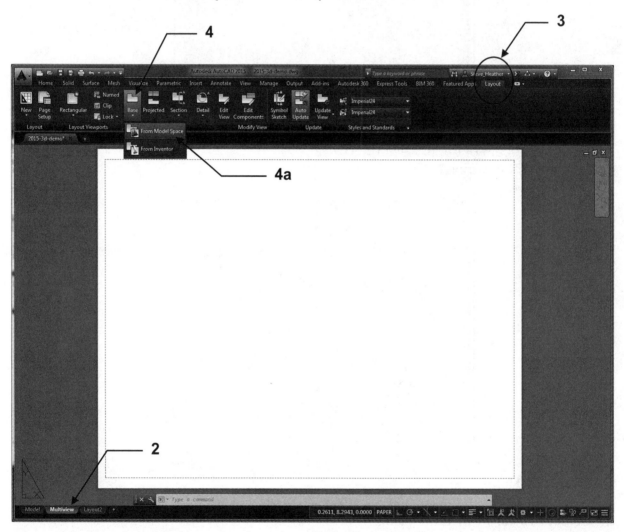

Note: If you have more than one model in your drawing you may wish to only select one of them. ***Type "E" <enter>***, AutoCAD switches back to Model space where you can select the models you require by left mouse clicking on them. Press ***<enter>*** when complete. AutoCAD will return to the Multiview tab.

Continued on the next page...

Creating Projected Views....continued

5. The **Drawing View Creation** tab has been automatically selected.

6. Select the **Orientation** for the initial view that is attached to the cursor. (*In this example I selected Front*)

7. Select **Hidden Lines** visible or not from the **Appearance** panel. (*In this example I selected Visible and hidden lines*)

8. Place the initial view by pressing the left mouse button then press **<enter>**. (*In this example I placed it in the center*)

Continued on the next page...

Creating Projected Views....continued

9. Move the cursor around the initial view to create projected views, **left mouse click** each time you place a view. Continue until you have the desired projected views.

 Note: if you place the cursor in the diagonal corners you will display an isometric view of the model.

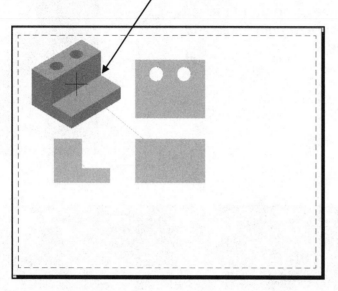

10. When you have displayed the desired projected views press **<enter>** to finalize the layout.

The projected views will now be displayed with visible and hidden lines as selected in step 7 previously.

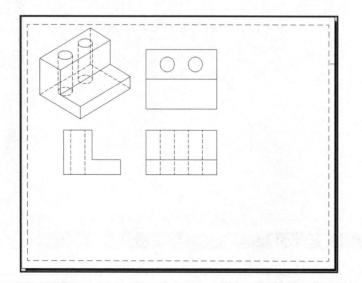

Note: Very important.....Do NOT use the undo command. The entire layout will disappear and you will have to start all over again.

Creating Section Views

After you have created Projected Views you may want a **Section** view. Again this is a very simple task.

1. Select the Section style you desire from the **Layout tab / Create View panel.** (In this example I have selected **Full**)

2. Select the View from which you will take the section.

 The **Section View Creation** tab will automatically open.

3. Place the first end of the section line.

4. Place the second end of the section line.

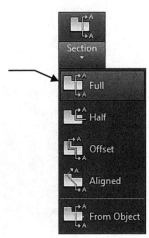

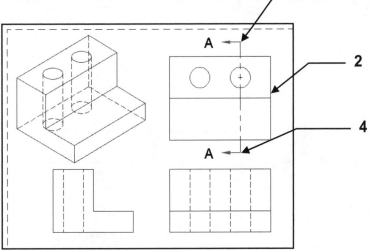

5. Move the cursor to the section views desired location and click.

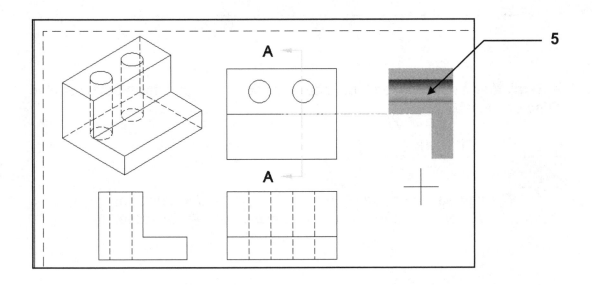

Continued on the next page...

Creating Section Views....continued

6. Select whether you desire to **Show Hatch** lines or not then press **<enter>**
 A standard hatch pattern will appear but you can edit the hatch by double clicking on the hatch.

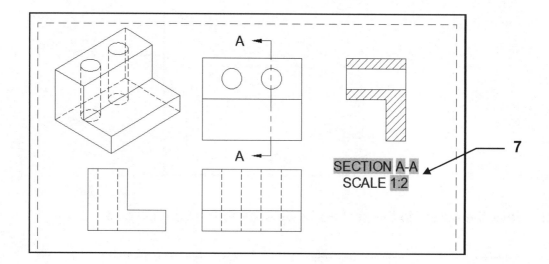

7. The Detail View Label appears automatically. (You may edit this label by double clicking on the label.)

The new sectioning function is very helpful and is full of options.
Experiment with sectioning to experience its full value.

SHELL

The SHELL command allows you to hollow out the insides of a solid, leaving a thin wall

How to Shell a solid object:

1. Draw a solid object such as a box.

2. Move the UCS origin to the top surface.

3. Select the Shell command using one of the following:

 Ribbon = Home tab / Solid Editing panel /
 or
 Keyboard = Shell

 Command: _solidedit
 Solids editing automatic checking: SOLIDCHECK=1
 Enter a solids editing option [Face/Edge/Body/Undo/eXit] <eXit>: _body
 Enter a body editing option
 [Imprint/seParate solids/Shell/cLean/Check/Undo/eXit] <eXit>: _shell

4. Select a 3D solid: *select the solid object*

5. Remove faces or [Undo/Add/ALL]:
 select the top face

6. Remove faces or [Undo/Add/ALL]:
 1 face found, 1 removed. **"confirmed"**

7. Remove faces or [Undo/Add/ALL]: *select more*
 faces or <enter> to stop

8. Enter the shell offset distance: *enter the wall*
 thickness <enter>

9. Enter a body editing option [Imprint/seParate
 solids/Shell/cLean/Check/Undo/eXit]
 <eXit>: *<enter>*
 Solids editing automatic checking:
 SOLIDCHECK=1

10. Enter a solids editing option [Face/Edge/Body/
 Undo/eXit] <eXit>: *<enter>*

EXERCISE 22A

PLOT MULTIPLE VIEWS

1. Open **EX-16D**

2. Change display to **Parallel.**

3. Set up the drawing to plot the Top, Front, Right and Isometric views as shown on pages 2 and 3.

4. Adjust viewport scale to **1:4** in each viewport pan if necessary and lock.

5. Save as **EX-22A**

6. Plot.

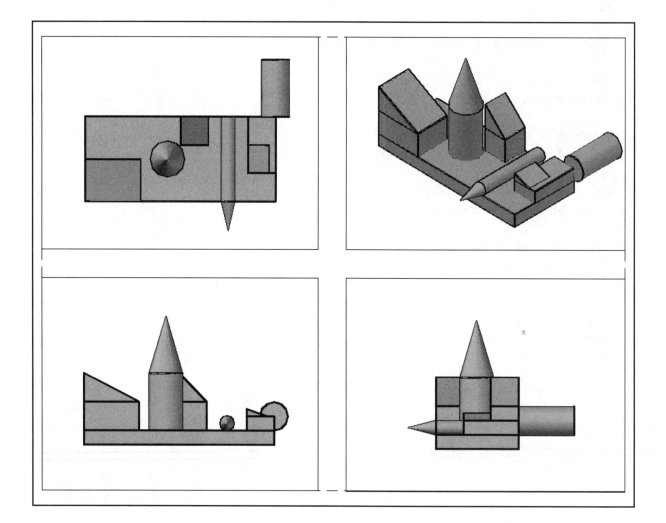

EXERCISE 22B

CREATE PROJECTED VIEWS

1. Open **2015-3D DEMO.dwg**

2. Change display to **Parallel.**

3. Set up the drawing to plot the Top, Front, Left, Isometric and section views as shown on pages 4 through 6.

4. Save as **EX-22B**

5. Plot

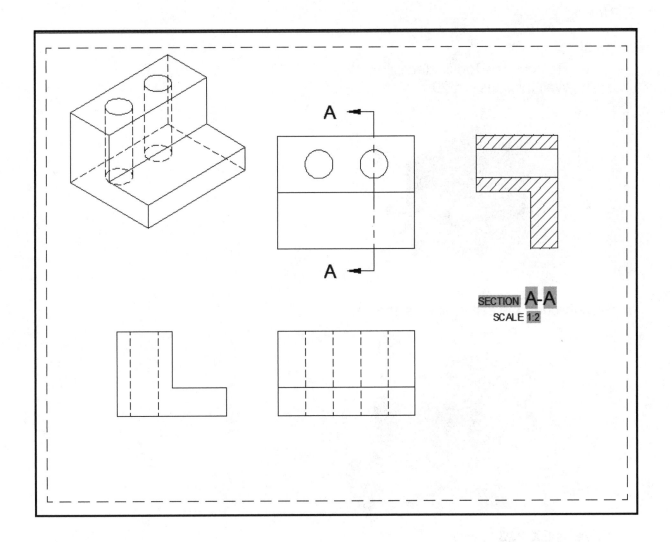

EXERCISE 22C

SHELL

1. Select a **New** file using **Acad3d.dwt**

2. Draw the Box shown below. Place a cylinder at each end.
 Box = L = 8 W = 6 Ht = 6
 Cylinder = 2 Radius L = 3

3. Union

4. Shell
 a. Remove the Top Surface
 b. Wall thickness = .20

5. Slice through the center line as shown.

6. Save as **EX-22C**

Welcome to the Architecture Project.

**Within this project you will learn one of many
ways to manage a set of drawings required to
construct a home. You will also get additional
practice drawing, scaling and plotting.**

A
R
C
H
I
T
E
C
T
U
R
E

Architecture Project

In the following pages you will practice how to handle a residential housing construction plan. There are many ways to accomplish this. Consider this just one of them.

The drawings are relatively simple and do not contain all the necessary requirements to build a house. The project is merely designed to walk you through one method of managing the project sheets.

Step 1. Create a **Library** of symbols.

Step 2. Create a new **Master Architecture Border** for 18 X 24 sheet size.

Step 3. Create a site plan.

Step 4. Create a Floor Plan.

Step 5. Add the Electrical to the Floor Plan.

Step 6. Create Elevations.

Step 7. Create a Section View.

ARCHITECTURAL SYMBOL LIBRARY

When you are using a CAD system, you should make an effort to only draw an object once. If you need to duplicate the object, use a command such as: Copy, Array, Mirror or Block. This will make drawing with CAD more efficient.

In the following exercise, you will create a file full of architectural symbols that you will use often when creating an architectural drawing. You will create them once and then merely drag and drop them, from the DesignCenter, when needed. This will save you many hours in the future.

Save this library file as **Library** so it will be easy to find when using the DesignCenter or create a Library Palette.

1. Select **Workspace: Drafting & Annotation**

2. Start a **NEW** file using; **My Feet-Inches Setup.dwt**

3. Select the **Model** tab.

4. Draw each of the Symbol objects, shown on the following pages, actual size.
 Do not scale them. Do not dimension. **Do not make them Annotative**.

5. Create an individual Block for each one using the **BLOCK** command.
 Use the number as the name. The actual name is too long.

6. Save this drawing as: **Library**

SYMBOLS

INSTRUCTIONS

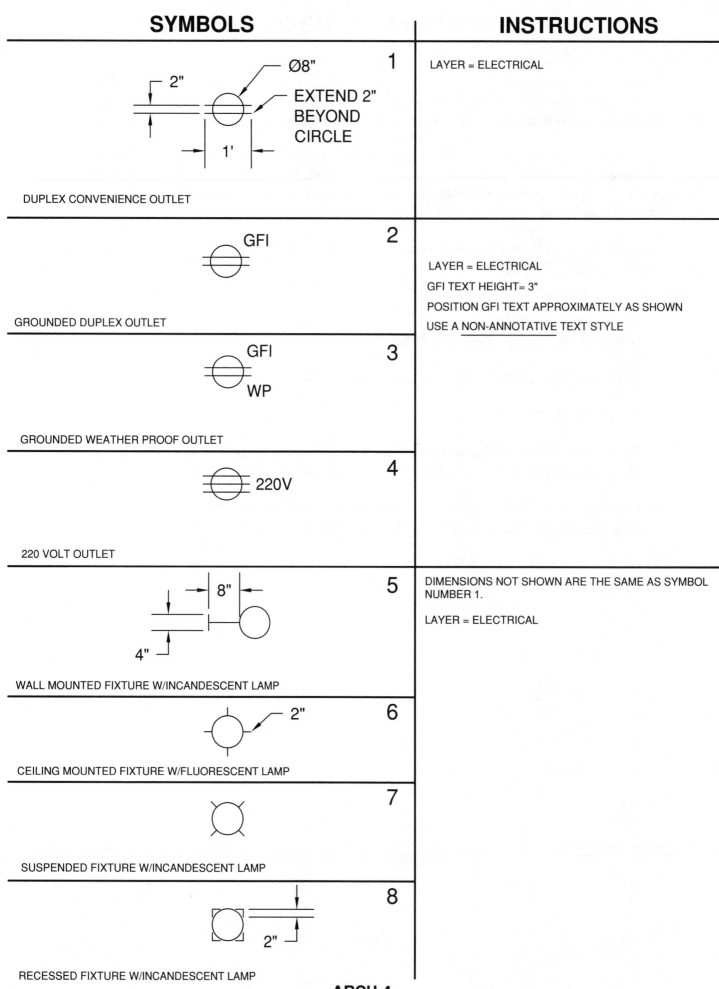

1

DUPLEX CONVENIENCE OUTLET

Ø8"
2"
EXTEND 2" BEYOND CIRCLE
1'

LAYER = ELECTRICAL

2

GFI

GROUNDED DUPLEX OUTLET

LAYER = ELECTRICAL

GFI TEXT HEIGHT= 3"

POSITION GFI TEXT APPROXIMATELY AS SHOWN

USE A NON-ANNOTATIVE TEXT STYLE

3

GFI
WP

GROUNDED WEATHER PROOF OUTLET

4

220V

220 VOLT OUTLET

5

8"
4"

WALL MOUNTED FIXTURE W/INCANDESCENT LAMP

DIMENSIONS NOT SHOWN ARE THE SAME AS SYMBOL NUMBER 1.

LAYER = ELECTRICAL

6

2"

CEILING MOUNTED FIXTURE W/FLUORESCENT LAMP

7

SUSPENDED FIXTURE W/INCANDESCENT LAMP

8

2"

RECESSED FIXTURE W/INCANDESCENT LAMP

ARCH-4

SYMBOLS	INSTRUCTIONS

9

6"

2'-6"

30" FLUORESCENT TUBE

LAYER = ELECTRICAL

10

$

SWITCH

DO NOT USE THE DOLLAR SIGN
TEXT STYLE = USE A NON-ANNOTATIVE
HEIGHT = 6"
LAYER = ELECTRICAL

11

$₃ ← HEIGHT = 3"

3 WAY SWITCH

SAME AS SYMBOL NUMBER 10

12

6"

1'-6"

BREAKER PANEL

LAYER = ELECTRICAL

13

← 8" SQUARE

METER

14

6"

1'-6"

CHIMES

15

Ø8" → (S) ← Text style = Standard
Non-annotative
HT=4"

SMOKE DETECTOR

16

8" EDGE

PHONE JACK

ARCH-5

SYMBOLS

INSTRUCTIONS

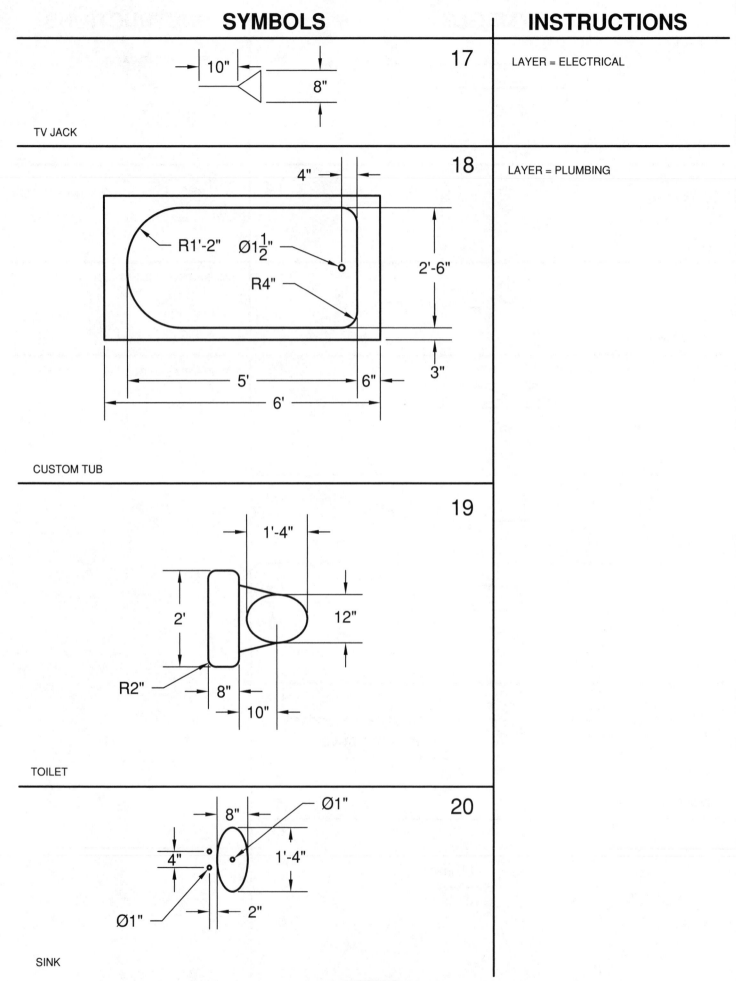

17

LAYER = ELECTRICAL

TV JACK

10"

8"

18

LAYER = PLUMBING

CUSTOM TUB

4"

R1'-2" Ø1½"

R4"

2'-6"

3"

5' 6"

6'

19

TOILET

1'-4"

2'

12"

R2" 8"

10"

20

SINK

Ø1"

8"

4"

1'-4"

Ø1"

2"

ARCH-6

SYMBOLS

INSTRUCTIONS

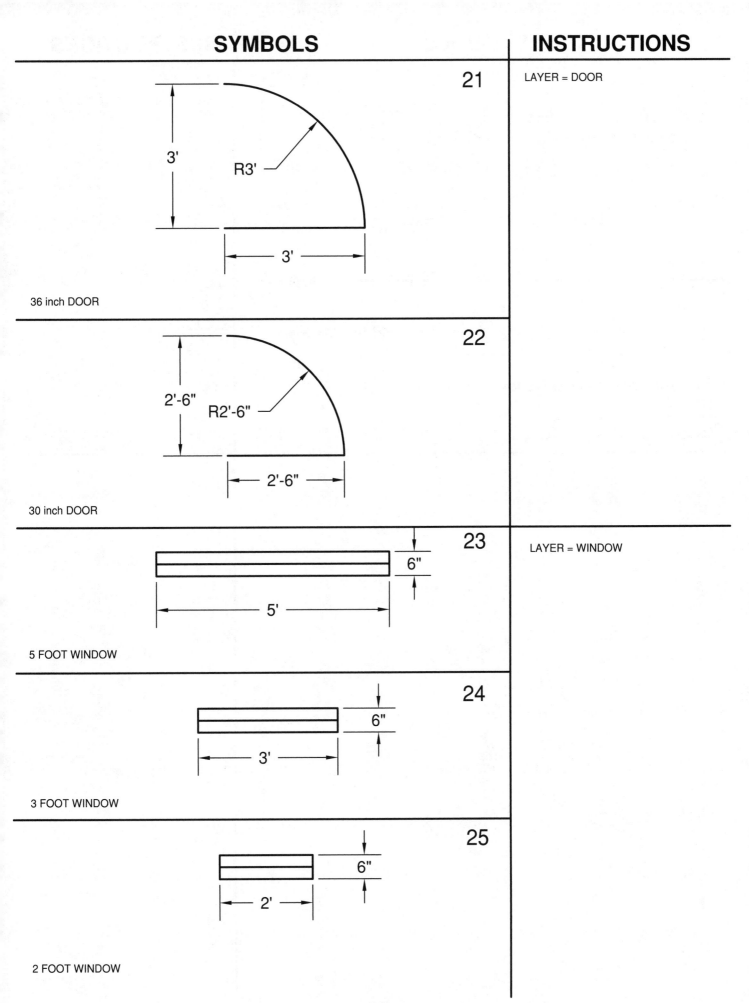

21

LAYER = DOOR

3'

R3'

3'

36 inch DOOR

22

2'-6"

R2'-6"

2'-6"

30 inch DOOR

23

LAYER = WINDOW

6"

5'

5 FOOT WINDOW

24

6"

3'

3 FOOT WINDOW

25

6"

2'

2 FOOT WINDOW

ARCH-7

SYMBOLS	INSTRUCTIONS

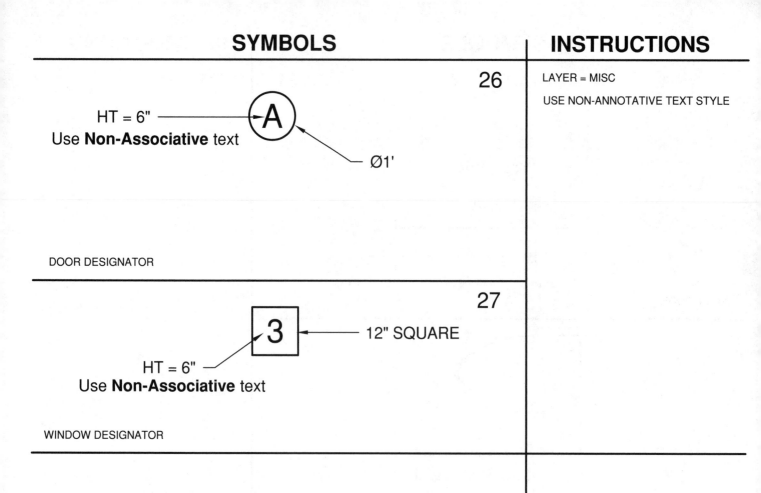

26

HT = 6" ——————
Use **Non-Associative** text

Ø1'

DOOR DESIGNATOR

27

12" SQUARE

3

HT = 6" ——
Use **Non-Associative** text

WINDOW DESIGNATOR

LAYER = MISC

USE NON-ANNOTATIVE TEXT STYLE

Create a New Border

Before you can work on the following exercises you must first create a new Page Setup and Border for a larger sheet of paper. Follow the instructions below.

PAGE SETUP

A. Start a **NEW** file using: **My Feet-Inches Setup.dwt**

B. Select the **Layout2** tab.

Note: *If the "Page Setup Manager" dialog box shown below does not appear automatically, right click on the Layout tab, then select "Page Setup Manager".*

Note: Your list may be different. That's OK

C

Yours may be different. That's OK for now

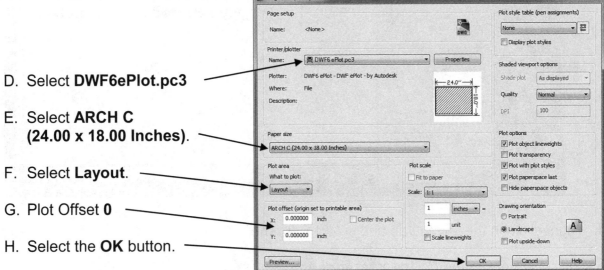

C. Select the **Modify** button.

D. Select **DWF6ePlot.pc3**

E. Select **ARCH C (24.00 x 18.00 Inches)**.

F. Select **Layout**.

G. Plot Offset **0**

H. Select the **OK** button.

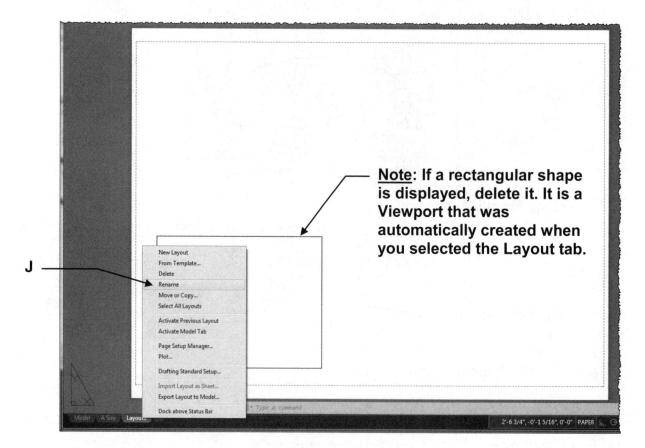

I. Select the **Close** button.

> You should now have a sheet of paper displayed on the screen.
>
> **Note: If a rectangular shape is displayed, delete it. It is a Viewport that was automatically created when you selected the Layout tab**.
>
> This sheet is the size you specified in the "**Page Setup**". (24" X 18")

J. Right click on the Layout tab and select **Rename**.

K. Type the new name: **C Size Master <enter>**

L. **Draw the Border with title block**, shown below, on the sheet of paper shown on the screen. Use layers **Border** and **Text**.

M. When you have completed the Border, shown below:
Save as: "Master Architecture Border"

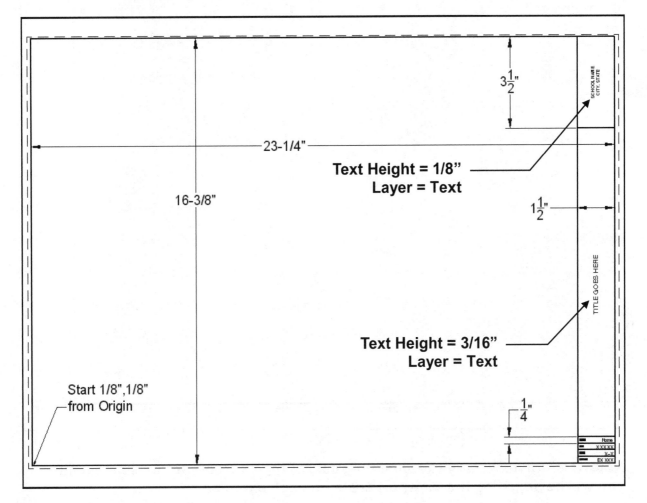

Use Text Style = Text Classic

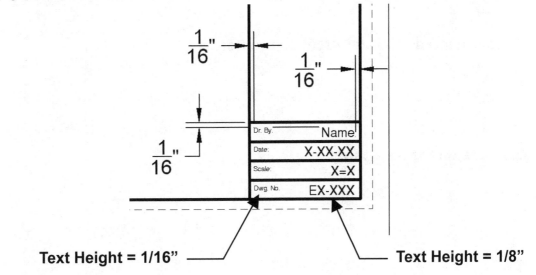

Text Height = 1/16" Text Height = 1/8"

N. **Create a Viewport** approximately as shown below.
 Use Layer **Viewport**.

Note: It is not necessary to adjust the scale of the viewport at this time because you will be adjusting the Viewport scale for each exercise.

Your Grids may appear different than the display above.

O. Save again as: **Master Architecture Border**

Continue on the next page....

P. Create a new **Plot Page Setup**

 1. Select **Plot**

 2. Change the settings to match settings shown below:

Q. **ADD** a page setup name: **Plot Setup C**

R. Select **Apply to Layout**

S. Select **Cancel** (This closes the dialog box but your settings are still saved)

T. Save again: **Master Architecture Border**

Continue on to the next page.....

Create additional Layouts

Now you are going to learn how to duplicate a layout.

1. Select the **C Size Master** layout tab. (if not already selected)

2. Right click on the **C Size Master** layout tab.

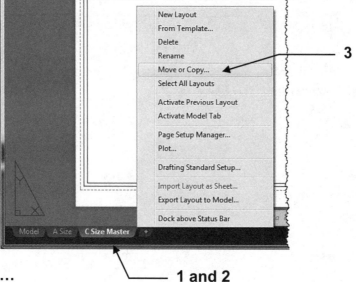

3. Select **Move or Copy…**

4. Select **Create a copy**

5. Select the **OK** button.

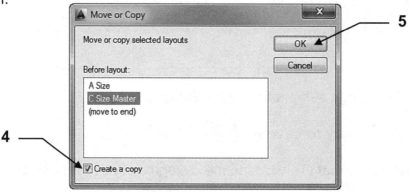

Notice the new layout tab "C Size Master (2)" has been created.

6. Select the **C Size Master (2)** Layout tab.

Now you should see an exact duplicate of your previously created "C Size Master" layout. Think about what a time saving process this is.

Now you need to make a few changes to the new layout.

7. Double click inside the Viewport until you see the **Model space Origin**. (Make sure you are in Model)

8. Change the Model space Limits: (Type: **Limits**)
 Lower left corner = **0, 0** Upper Right corner = **170', 130'** (feet)

9. **Zoom / All** (*If your grids are ON, you will be able to see what is happening*) Also, your grids may appear different than the display shown.

10. Adjust the Viewport Scale to **1/8" = 1'** and **Lock**

11. Change the Title Block to: **Site Plan**

12. Rename the Layout tab to: **Site Plan**

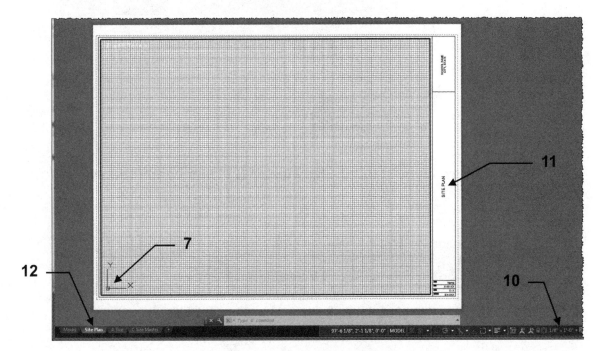

ARCH-15

**Now you have a layout tab prepared for a "Site Plan".
The Border is already there and all of the Plot settings are already set.
This process copied all of the settings and paperspace objects into the new
layout. This is a big time saver.**

Now you need to do it all again.

13. Select the **C Size Master** layout tab.

14. Right click on **C Size Master** layout tab.

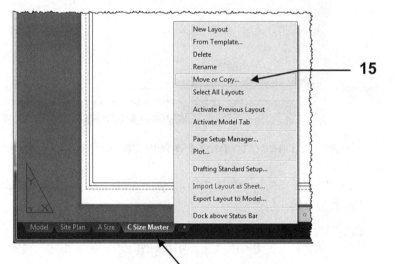

15. Select **Move or Copy…**

16. Select **Create a copy**

17. Select the **OK** button.

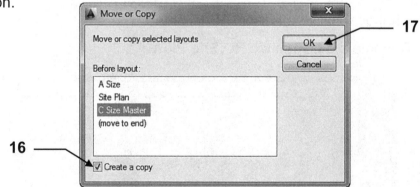

Notice the new layout tab "C Size Master (2)" has been created.

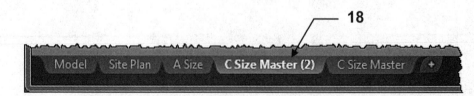

18. Select the **C Size Master (2)** Layout tab.

You should see another duplicate.

Now you need to make a few changes to the new layout.
Your grids may appear different than the display above.

19. Double Click inside the Viewport until you see the **Model space Origin**.
 Make sure you are in Model

20. **Zoom / All** (*If your grids are ON you will see what is happening*)

21. Adjust the Viewport Scale to **1/4" = 1'** and **Lock**

22. Change the Title Block to: **Floor Plan**

23. Rename the Layout tab to: **Floor Plan**

Now you have a layout tab prepared for a "Floor Plan".

Now you need to do it all again.

24. Select the **Floor Plan** layout tab this time. (**Not** C Size Master)

25. Right click on the **Floor Plan** layout tab.

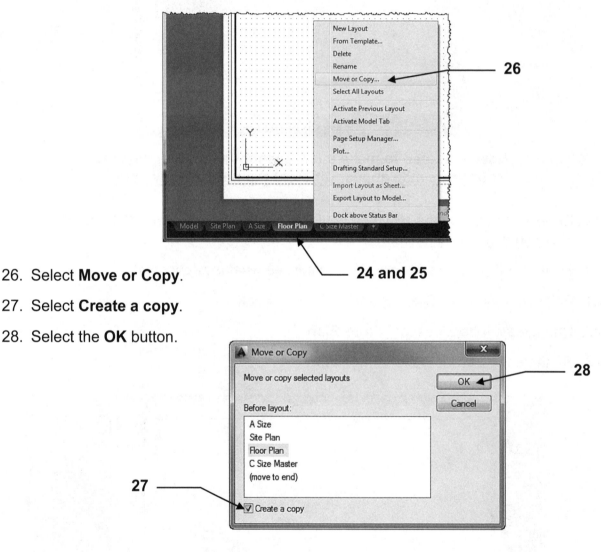

26. Select **Move or Copy**.

27. Select **Create a copy**.

28. Select the **OK** button.

Notice the new layout tab "Floor Plan (2)" has been created.

29. Select the **Floor Plan (2)** Layout tab.

You should see another duplicate.

Now you need to make a few changes to the new layout.
Your grids may appear different than the display above.

30. Change the Title Block to: **Electrical Plan**

31. Rename the Layout tab to: **Electrical Plan**

Note: The viewport scale is the same as the Floor Plan so no need to change.

30

31

Same scale
as Floor Plan
1/4" = 1'0"

Now you have another layout tab prepared for an "Electrical Plan".

Now you need to do it all again.

32. Select the **Floor** Plan layout tab again.

33. Right click on the **Floor Plan** layout tab.

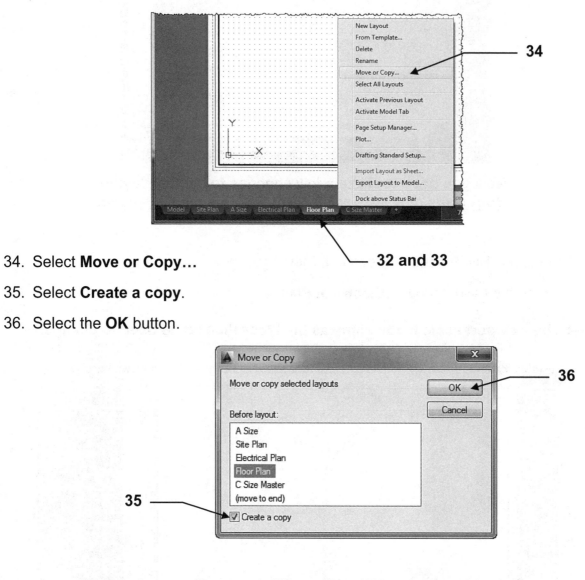

34. Select **Move or Copy…**

35. Select **Create a copy**.

36. Select the **OK** button.

Notice the new layout tab "Floor Plan (2)" has been created.

37. Select the **Floor Plan (2)** Layout tab.

You should see another duplicate.

Now you need to make a few changes to the new layout.
Your grids may appear different than the display above.

38. Unlock the viewport.

39. Adjust the Viewport Scale to: **3/8" = 1'** and **Lock**.

40. Change the Title Block to: **Elevation Plan**

41. Rename the Layout tab to: **Elevation Plan**

Now you have another layout tab prepared for an "Elevation Plan".

Now you need to do it all <u>one more time</u>.

42. Select the **Floor Plan** layout tab again.

43. Right click on the **Floor Plan** layout tab.

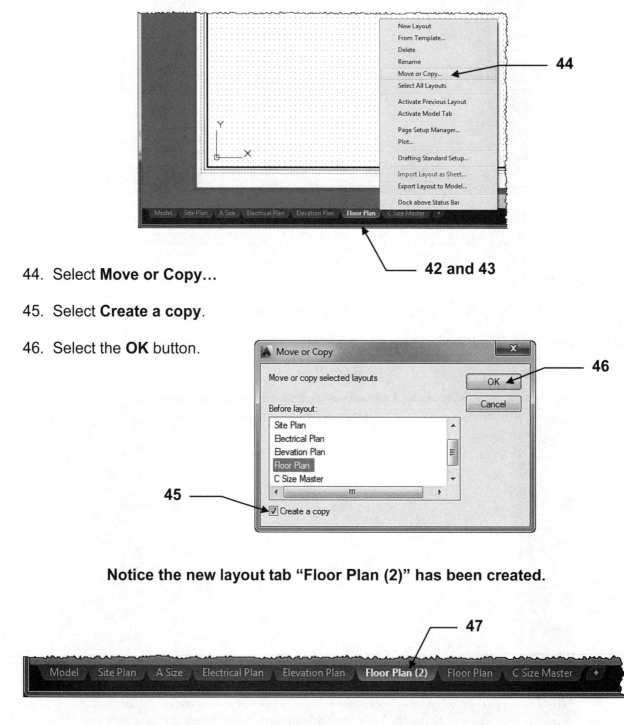

44. Select **Move or Copy...**

45. Select **Create a copy**.

46. Select the **OK** button.

Notice the new layout tab "Floor Plan (2)" has been created.

47. Select the **Floor Plan (2)** Layout tab.

You should see another duplicate.

Now you need to make a few changes to the new layout.
<u>**Your grids may appear different than the display above**</u>.

48. Double click inside the Viewport until you see the **Model space Origin**.
 (<u>Make sure you are in Model</u>)

49. Unlock the Viewport, if it is locked.

50. Adjust the Viewport Scale to **1" = 1**' and Lock (Note: this is 1 inch = 1 foot)

51. Change the Title Block to: **Section**

52. Rename the Layout tab to: **Section**

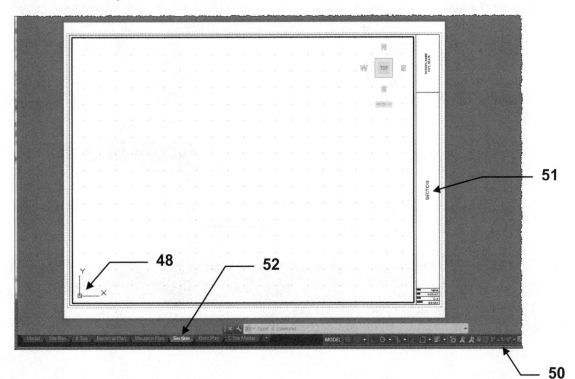

Now you should have 7 Layout tabs and 1 Model tab.

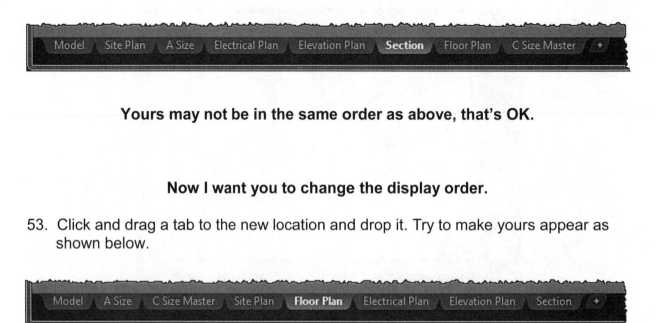

Model | Site Plan | A Size | Electrical Plan | Elevation Plan | **Section** | Floor Plan | C Size Master

Yours may not be in the same order as above, that's OK.

Now I want you to change the display order.

53. Click and drag a tab to the new location and drop it. Try to make yours appear as shown below.

Model | A Size | C Size Master | Site Plan | **Floor Plan** | Electrical Plan | Elevation Plan | Section

54. **Very important:** Save as: **Master Architecture Border**

You now have a Master Border all set up ready to use on the following exercises. If you ever need more layouts, just repeat the steps shown on the previous pages.

Notice if you rest the cursor on any of the Layout tabs a "Thumb size view" of the contents of the Layout will appear.

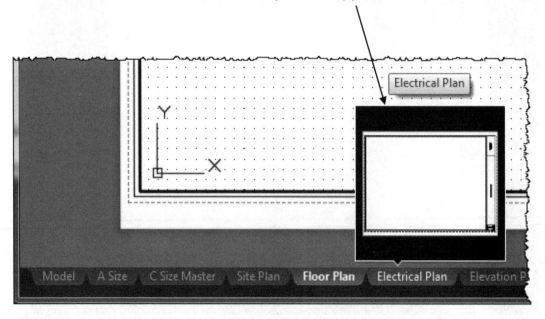

EX-ARCH-1

INSTRUCTIONS:

1. Open **Master Architecture Border**

2. Immediately save it as: **ARCH DRAWING SET** (To prevent you from saving on top of the Master Border)

3. Select the **Site Plan** layout tab

4. Draw the **SITE PLAN** shown below.

 Use Layers: Walls, Hatch, Property Line, Symbol and Dimension

5. Hatch lines are to highlight the house foot print. You choose pattern.

6. Dimension as shown using Dimension Style: **Dim-Arch**

7. Design a North Symbol in paper space and make it a block (Be creative)

 Use Layer: Symbol

8. **Save** the drawing as: **ARCH DRAWING SET**

9. Plot using Plot page Setup: **Plot Setup C** if you have a large format printer.

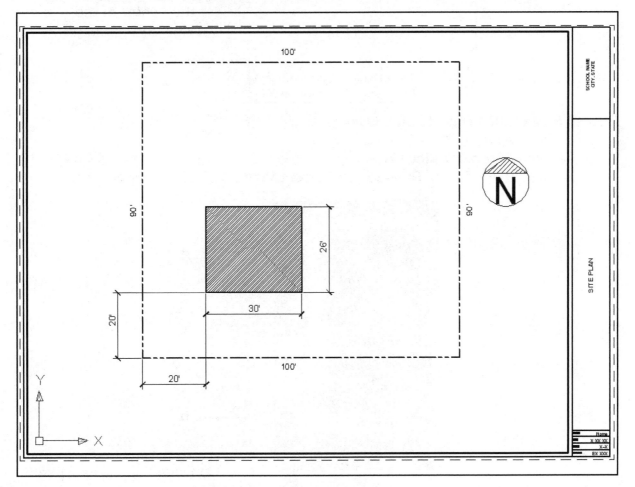

ARCH-25

EX-ARCH-2

INSTRUCTIONS:

1. Open **ARCH DRAWING SET**

2. Select the **FLOOR PLAN** layout tab

 Notice you may see some of property line and house foot print. They are in Model space and you can see Model space through the this viewport also. The hatch and dimensions are not displayed because they are a different annotative scale. Remember the Site Plan layout is 1/8"=1' and the Floor Plan layout is 1/4"=1'.

Something New

3. **Unlock** the Viewport and "**Pan**" the House foot print to the center of the viewport. You will also see part of the "Property Line". We do not want to see the "Property Line" in this layout. So you need to "**Freeze in the Current Viewport**" the Property Line layer.

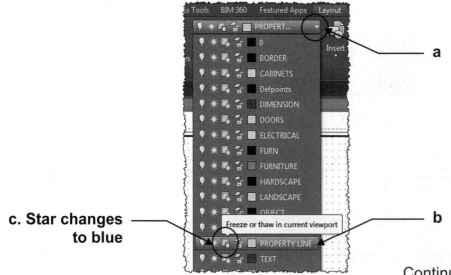

Layer: Property Line

Unlock Viewport and Pan the Floor plan to the center of the viewport

How to Freeze the Property Line layer:
 a. Select the Layer ▼
 b. Find the **"Property Line"** layer.
 c. Select the "**Freeze or Thaw in the Current Viewport**" icon. (Star changes to blue)

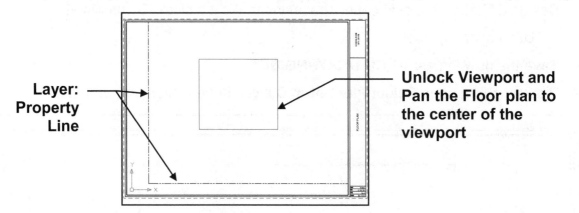

a

b

c. Star changes to blue

Freeze or thaw in current viewport

Continued on the next page...

EX-ARCH-2....continued

The "Property Line" will disappear but **only in the current layout viewport**. If you go back to the "Site Plan" layout you will see that the "Property Line" is still displayed.

Note: Do not use "ON/OFF" or "FREEZE/THAW" in the layer manager. If you do, the layers will disappear in ALL layout viewports.

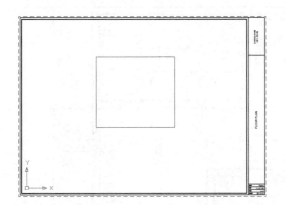

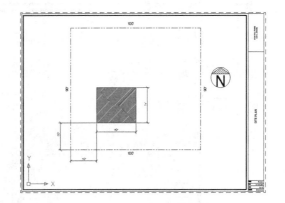

Floor Plan tab
Layer "Property Line" <u>Frozen</u>
in "Current Viewport" only

Site Plan tab
Layer Property Line still displayed
in the "Site Plan" layout

4. Draw the **Floor Plan** shown on the next page.
 Wall width = 6"
 Use Layers: Wall, Door, Window, Plumbing, Dimension and Misc.

5. Dimension as shown using dimension style "Dim-Arch".

6. Draw the Tables in Paperspace on layer Symbol (Size is your option)

7. Create the room labels (Living Room, Bath and Kitchen) using text style "Text-Classic", Height: 1"

8. **Save** the drawing as: **ARCH DRAWING SET**

9. Plot using Plot page Setup: **Plot Setup C** if you have a large format printer.

Continued on the next page...

EX-ARCH-2....continued

Note: Dimension text height is shown larger for clarity. Yours will appear smaller.

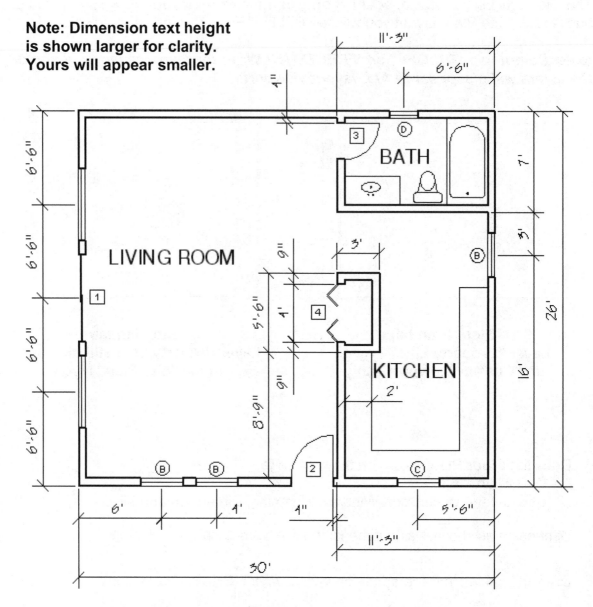

Room labels: Text style: Text-Classic Height: 1"

Place Schedules in "Paper Space". Size is your choice.

WINDOW SCHEDULE			
SYM	SIZE	TYPE	GLAZING
A	5'-0" X 4'-0"	WOOD FIXED	3/16" SHEET
B	3'-0" X 4'-0"	WOOD FIXED	3/16" SHEET
C	3'-0" X 3'-0"	WOOD FIXED	3/16" SHEET
D	2'-0" X 3'-0"	ALUMINUM SLIDER	3/16" SHEET

DOOR SCHEDULE			
SYM	SIZE	TYPE	MATERIAL
1	6'-0" X 6'-8"	WOOD SLIDER	1/4" POL PL
2	3'-0" X 6'-8"	PANEL	STAIN GRADE
3	2'-8" X 6'-8"	H.C. SLAB	STAIN GRADE
4	4'-0" X 6'-8"	H.C. SLAB	STAIN GRADE

ARCH-28

EX-ARCH-2....continued

Your completed drawing should appear as shown below.

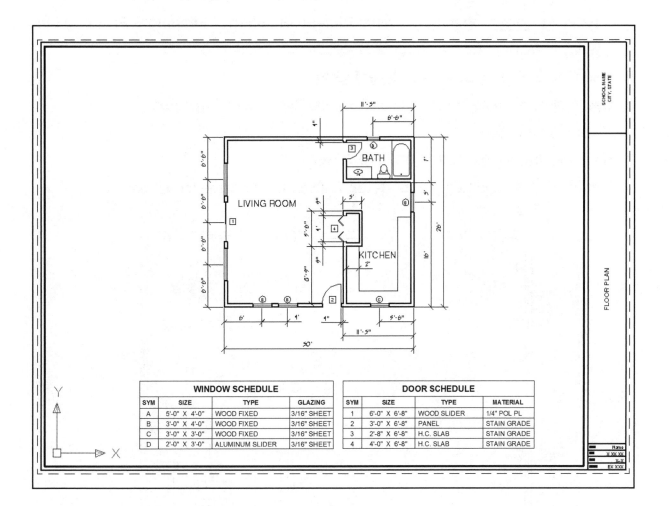

WINDOW SCHEDULE			
SYM	SIZE	TYPE	GLAZING
A	5'-0" X 4'-0"	WOOD FIXED	3/16" SHEET
B	3'-0" X 4'-0"	WOOD FIXED	3/16" SHEET
C	3'-0" X 3'-0"	WOOD FIXED	3/16" SHEET
D	2'-0" X 3'-0"	ALUMINUM SLIDER	3/16" SHEET

DOOR SCHEDULE			
SYM	SIZE	TYPE	MATERIAL
1	6'-0" X 6'-8"	WOOD SLIDER	1/4" POL PL
2	3'-0" X 6'-8"	PANEL	STAIN GRADE
3	2'-8" X 6'-8"	H.C. SLAB	STAIN GRADE
4	4'-0" X 6'-8"	H.C. SLAB	STAIN GRADE

EX-ARCH-3

INSTRUCTIONS:

1. Open **ARCH DRAWING SET**

2. Select layout tab **Electrical Plan**

3. "**Freeze in <u>Current Viewport</u>**" layers: **Dimension, Misc., Plumbing & Property Line**

4. Use layer "**Wiring**" for the wiring from switches to fixture.

5. Insert the Electrical symbols on <u>layer Electrical</u>.

6. Use Tables to create the Legend of Electrical Symbols on layer Text.

 (Size is your option)

7. **Save** the drawing as: **ARCH DRAWING SET**

8. Plot using Plot page Setup: **Plot Setup C** if you have a large format printer.

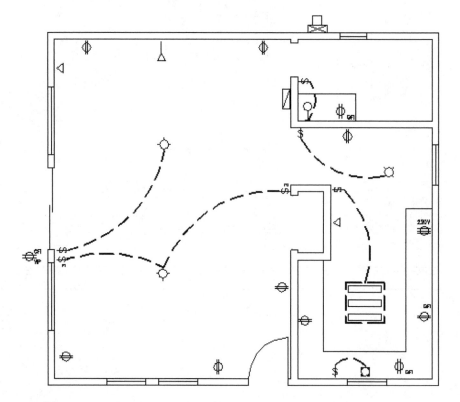

LEGEND OF ELECTRICAL SYMBOLS	
SYM	**DESCRIPTION**
⊖	DUPLEX CONVENIENCE OUTLET
⊖ GFI	GROUNDED DUPLEX OUTLET
⊖ GFI WP	GROUNDED WEATHER PROOF OUTLET
⊖ 220V	220 VOLT OUTLET
⊢◯	WALL MTD. FIXT. W / INCANDESCENT LAMP
◇	CEILING MTD. FIXT. W / FLUORESCENT LAMP
◯	SUSPENDED FIXT. W / INCANDESCENT LAMP

◯	RECESSED FIXT. W / INCANDESCENT LAMP
▭	30" FLUORESCENT TUBE
$	SWITCH
$₃	3 WAY SWITCH
⋈	BREAKER PANEL
▢	METER
◺	CHIMES
Ⓢ	SMOKE DETECTOR
◁	PHONE JACK
◁	T.V. JACK AND LEAD-IN

EX-ARCH-4

INSTRUCTIONS:

1. Open **ARCH DRAWING SET**

2. Select layout tab **Elevation**

3. "**Freeze in <u>Current Viewport</u>**" layers:

 Cabinets, Dimension, Misc., Plumbing & Property Line

4. Unlock the viewport and adjust the scale to 1/16" = 1'

5. Change **Limits** to **OFF**

 A. Type **Limits <enter>**

 B. Type **Off <enter>**

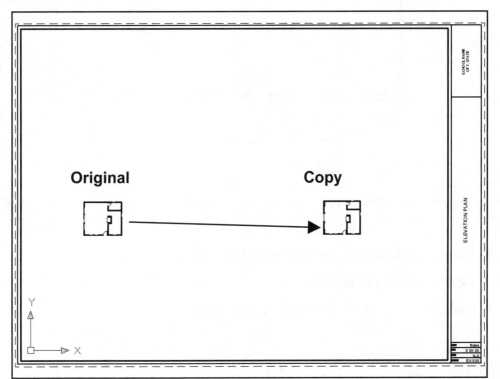

Original **Copy**

6. Copy the Floor plan that remained and place the copy on the far right side as shown below.

7. Using the "**Pan**" command, pan the Floor plan copy (located on the right) to the center of the viewport. The original will be out of view.

Continued on the next page...

EX-ARCH-4....continued

7. Adjust the scale of the Viewport to **3/8" = 1'** and **lock.**

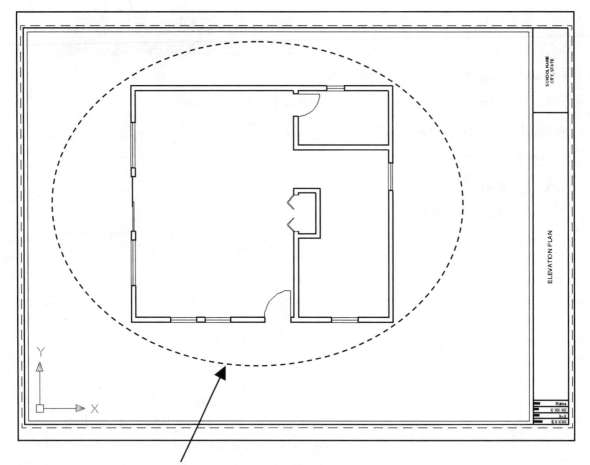

8. Select all of the floor plan and put it on layer "**0**".

 You can also change the color.

 In the example above I have used color green.

Now using the Floor plan shown above, draw the Elevation using the method shown on the next page.

Continued on the next page...

7. Use the Floor plan copy as a template to draw horizontal lines for the Walls, Windows and Door. (Refer to the Elevation shown on the next page.) Use Layer Walls. Use Object Snap to snap to the Floor Plan to define the horizon location for Walls, Windows and Doors.

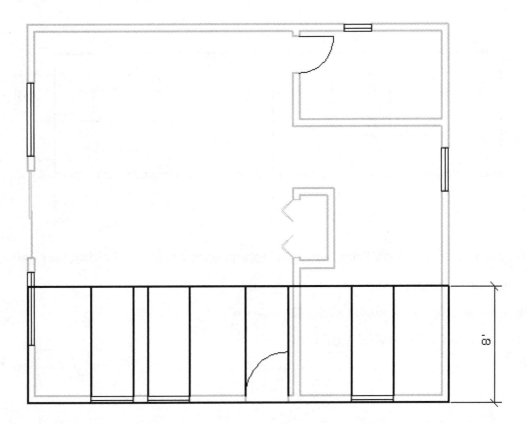

8. Now **"Freeze in current Viewport"** the layer **"0"**

 The Floor plan should have disappeared and only the Elevation Walls remain.

Continued on the next page...

EX-ARCH-4....continued

9. Using the "Offset" command define the Vertical heights for the Windows and Door.

 The Top of the Windows and Door is 6'-8".

 The Size of the Windows is defined in the Window Schedule.

 (Refer to the Floor plan layout. page Arch-28)

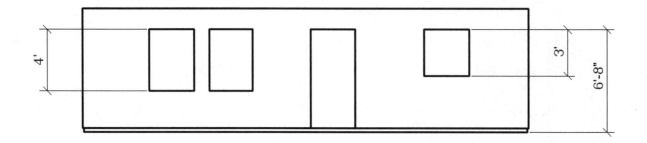

10. The design of the Roof, Windows and Door is your choice. The drawing below is merely an example.

11. Dimension using dimension style: **Dim-Arch**

12. Save as: **ARCH DRAWING SET**

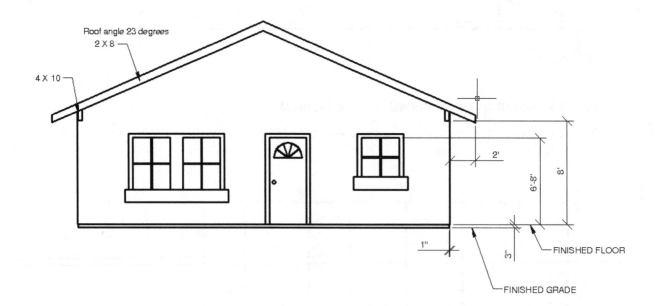

Continued on the next page...

EX-ARCH-4....continued

If you would like to draw the other 3 views:

 a. Thaw the "0" layer

 b. Rotate the Floor plan

 c. Draw the horizontal guide lines

 d. When the view is complete, **"Freeze in current Viewport"** to make the Floor Plan disappear.

Note:

You will have to unlock the viewport and use Zoom and pan while you are creating the elevation views. When they are complete, adjust the scale of the viewport and use **"Pan"** to center the drawing. You may have to use **1/4" = 1'** to fit all views within the viewport.

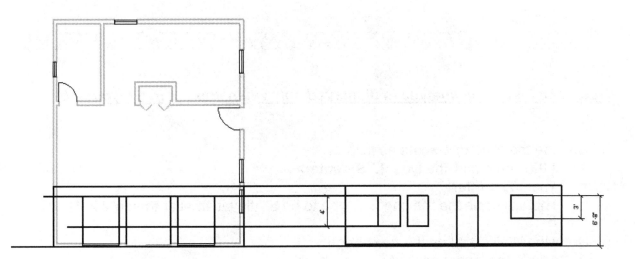

EX-ARCH-5

INSTRUCTIONS:

The following exercise requires that you create a new layer with a new linetype.

1. Open **ARCH DRAWING SET**

2. Select the **SECTION** layout tab

3. If you can see parts of the Floorplan, unlock the viewport and use "**Pan**" to pan the Floor plan out of view. Then **lock** the viewport.

4. Create a new layer
 <u>Name</u> = Insulation <u>Color</u> = magenta **Linetype = batting** <u>LWT</u> = default

Now experiment drawing the insulation as follows:
 a. You must be in a layout tab
 b. Select the Layer Insulation
 c. Draw a line

<u>*Note: The insulation linetype is displayed only when you are in a layout tab.*</u>

5. Change the **Linetype scale** as follows:
 a. At the command line type: **LTS <enter>**
 b. Type: **.35 <enter>**
 (This will scale the "batting" linetype to be a little bit smaller than a 2 X 4)

6. Draw the Wall Detail on the **next page**.
 A. Include the leader call outs.
 b. Use Hatch Pattern "**AR-CONC**" for footing Scale = .5
 c. Use **User de**fined for the Finished and Subfloor.
 Angle =**45** and **135** Spacing = **3"**
 d. Layers and colors, your choice.

7. Save as **EX-ARCH-5**

8. Plot using Plot page Setup: **Plot Setup C** if you have a large format printer.

Continued on the next page...

EX-ARCH-5....continued

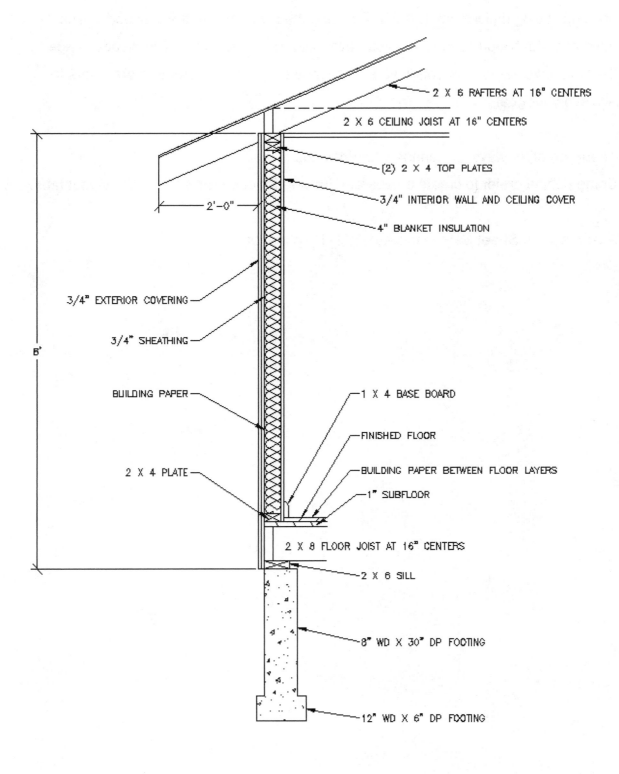

2 X 6 RAFTERS AT 16" CENTERS

2 X 6 CEILING JOIST AT 16" CENTERS

(2) 2 X 4 TOP PLATES

3/4" INTERIOR WALL AND CEILING COVER

4" BLANKET INSULATION

2'-0"

3/4" EXTERIOR COVERING

3/4" SHEATHING

8'

BUILDING PAPER

1 X 4 BASE BOARD

FINISHED FLOOR

BUILDING PAPER BETWEEN FLOOR LAYERS

2 X 4 PLATE

1" SUBFLOOR

2 X 8 FLOOR JOIST AT 16" CENTERS

2 X 6 SILL

8" WD X 30" DP FOOTING

12" WD X 6" DP FOOTING

SUMMARY

The previous exercises were examples of how you can manage a set of Architectural drawings using multiple layouts and Freezing the layers within the viewports. The advantage to this process is that you never draw anything twice. The disadvantage is that you have to manage your layers. You may even need to create more layers to achieve your goal.

There are other ways to manage your drawings.
Some people prefer to create a separate drawing for each rather than use layout tabs.

Also research **Sheet Sets** in the AutoCAD Help menu.

ELECTRO MECH

ELECTRO-MECHANICAL SYMBOL LIBRARY

When you are using a CAD system, you should make an effort to ONLY draw an object once. If you have to duplicate the object, use a command such as: Copy, Array, Mirror or Block. Remember, this will make drawing with CAD more efficient.

In the following exercise, you will create a file full of electronic symbols that you consistently use when creating an architectural drawing. You will create them once and then merely drag and drop them, from the DesignCenter, when needed. This will save you many hours in the future.

Save this library file as **Library** so it will be easy to find when using the DesignCenter or create a Library Palette.

1. Start a **NEW** file using **My Decimal Setup.dwt**

2. Add the following layers to your **MY Decimal Setup** drawing.

CIRCUIT	GREEN	CONTINUOUS
CIRCUIT2	RED	CONTINUOUS
CORNERMARK	9	CONTINUOUS
DESIGNATOR	BLUE	CONTINUOUS
MISC	CYAN	CONTINUOUS
PADS	GREEN	CONTINUOUS
PCB	WHITE	CONTINUOUS
COMPONENTS	RED	CONTINUOUS

3. Save the **My Decimal Setup**.

4. Select the **Model** tab.

5. Draw each of the Symbol objects, shown on the next page, actual size.
 <u>Do not scale the objects - Do not dimension - Do not make them Annotative.</u>

6. Create an individual Block for each one using the **BLOCK** command. Do not make them Annotative.

7. Save this drawing as: **Library**

SYMBOLS

INSTRUCTIONS

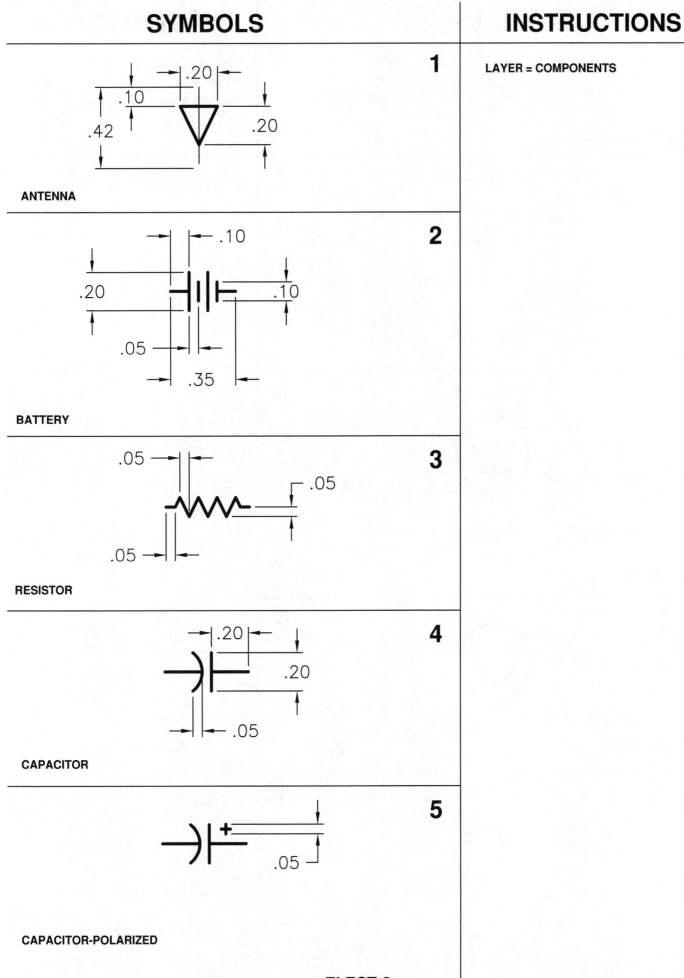

1

ANTENNA

2

BATTERY

3

RESISTOR

4

CAPACITOR

5

CAPACITOR-POLARIZED

ELECT-3

SYMBOLS

INSTRUCTIONS

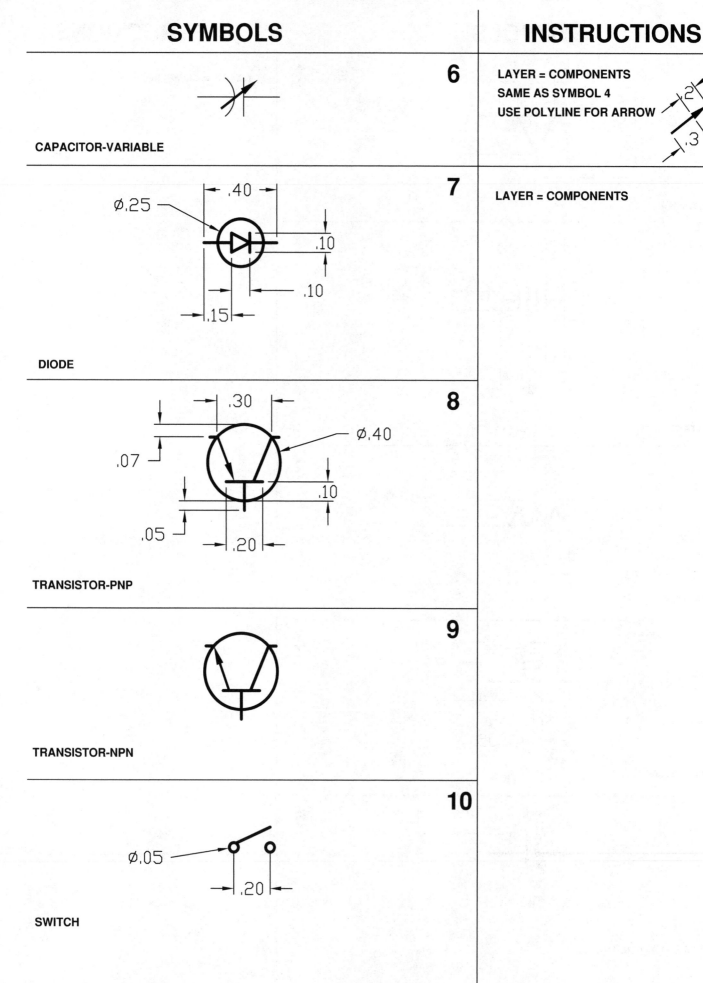

6

LAYER = COMPONENTS
SAME AS SYMBOL 4
USE POLYLINE FOR ARROW

CAPACITOR-VARIABLE

7

LAYER = COMPONENTS

Ø.25

.40

.10

.10

.15

DIODE

8

.30

Ø.40

.07

.10

.05

.20

TRANSISTOR-PNP

9

TRANSISTOR-NPN

10

Ø.05

.20

SWITCH

ELECT-4

SYMBOLS

INSTRUCTIONS

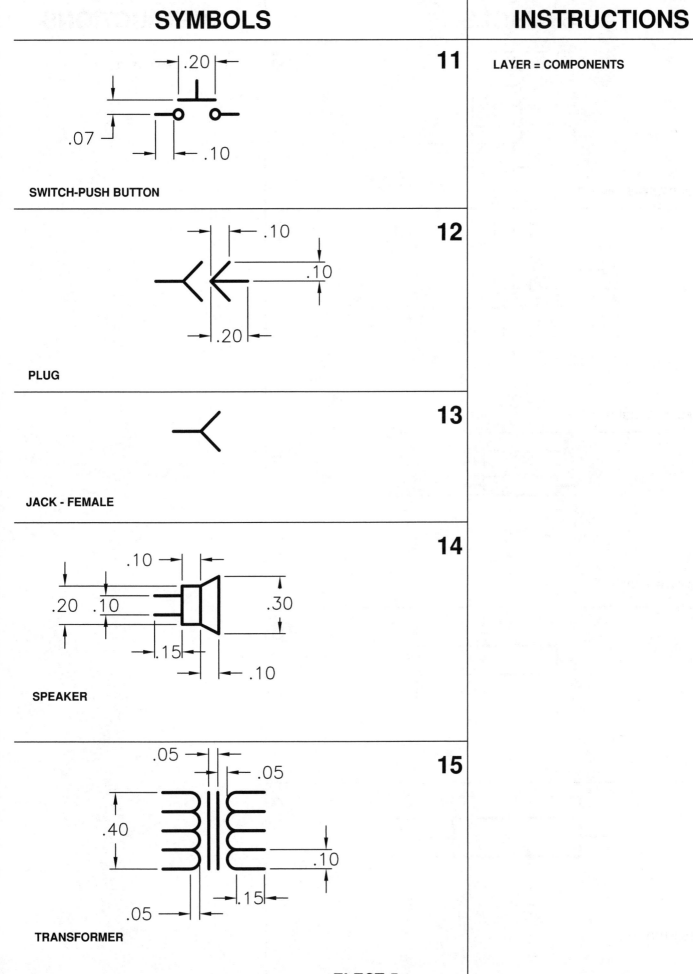

11

SWITCH-PUSH BUTTON

12

PLUG

13

JACK - FEMALE

14

SPEAKER

15

TRANSFORMER

ELECT-5

SYMBOLS

INSTRUCTIONS

16

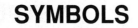
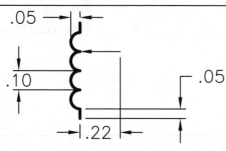

INDUCTOR - VARIABLE

17

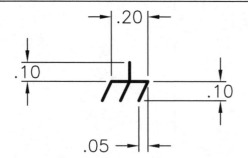

CHASSIS GROUND

18

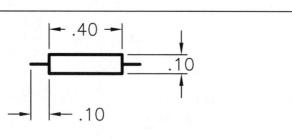

RESISTOR (1/4W)

19

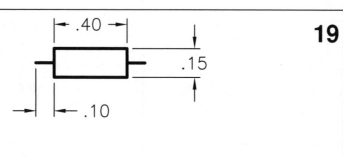

RESISTOR (1/2W)

20

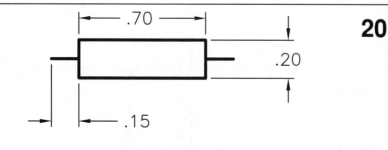

RESISTOR (2W)

ELECT-6

SYMBOLS

INSTRUCTIONS

21

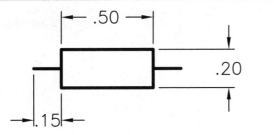

CAPACITOR (22mf)

LAYER = COMPONENTS

22

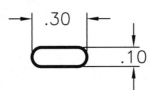

CAPACITOR (.01mf)

23

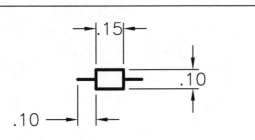

DIODE (IN914)

24

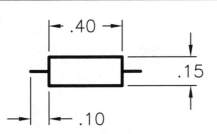

DIODE (IN4001)

25

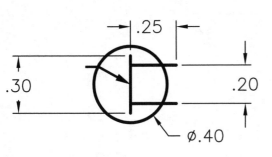

2N2646 UJT (USE FOR SCHEMATIC ONLY)

ELECT-7

SYMBOLS

INSTRUCTIONS

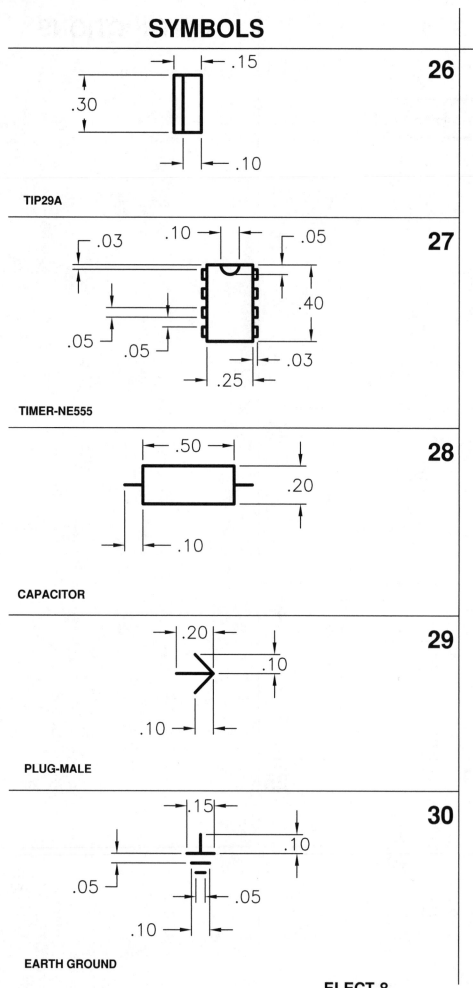

26

TIP29A

27

TIMER-NE555

28

CAPACITOR

29

PLUG-MALE

30

EARTH GROUND

LAYER = COMPONENTS

ELECT-8

SYMBOLS

INSTRUCTIONS

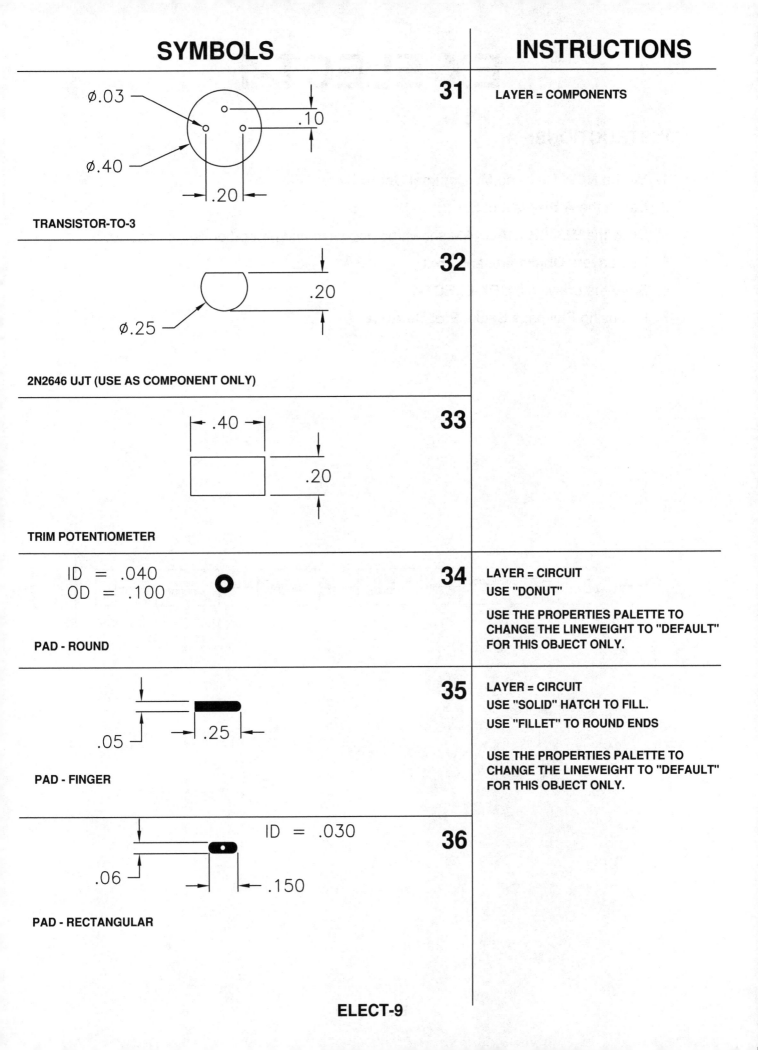

31

LAYER = COMPONENTS

Ø.03

Ø.40

.10

.20

TRANSISTOR-TO-3

32

.20

Ø.25

2N2646 UJT (USE AS COMPONENT ONLY)

33

.40

.20

TRIM POTENTIOMETER

34

ID = .040
OD = .100

LAYER = CIRCUIT
USE "DONUT"

USE THE PROPERTIES PALETTE TO
CHANGE THE LINEWEIGHT TO "DEFAULT"
FOR THIS OBJECT ONLY.

PAD - ROUND

35

.05

.25

LAYER = CIRCUIT
USE "SOLID" HATCH TO FILL.
USE "FILLET" TO ROUND ENDS

USE THE PROPERTIES PALETTE TO
CHANGE THE LINEWEIGHT TO "DEFAULT"
FOR THIS OBJECT ONLY.

PAD - FINGER

36

ID = .030

.06

.150

PAD - RECTANGULAR

ELECT-9

EX-ELECT-1

INSTRUCTIONS:

1. Start a **NEW** file using **My Decimal Setup.dwt**

2. Select the **A Size** layout tab

4. Draw the **BLOCK DIAGRAM** shown below. Size and proportion is your choice.

5. Use Layers **Object line** and **Text**.

6. **Save** the drawing as: **EX-ELECT-1**

7. Plot using Plot page Setup: **Plot Setup A**

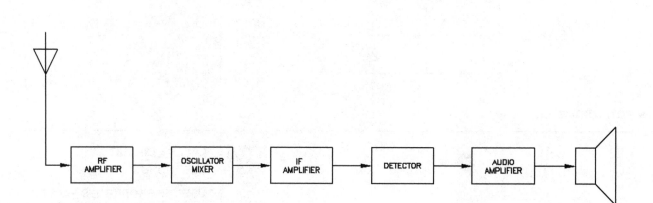

EX-ELECT-2

INSTRUCTIONS: SCHEMATIC

1. Start a **NEW** file using **My Decimal Setup.dwt**

2. Select the **A Size** layout tab

4. Set: Snap = .100 Grid = .100.

5. Draw the schematic (shown on the next page) in Model Space

 The size is not critical but maintain good proportions and drawing balance.

6. Draw the solder points using **Donuts**. .00 I.D. and .100 O. D.

 Use layer **Circuit**

7. Add the designators, use layer **Designator**

 Text Ht = .125

8. Add the Parts List (in paperspace)

 Rows = .25 Text Ht = .125 (Try tables)

9. **Save** the drawing as: **EX-ELECT-2**

10. Plot using Plot page Setup: **Plot Setup A**

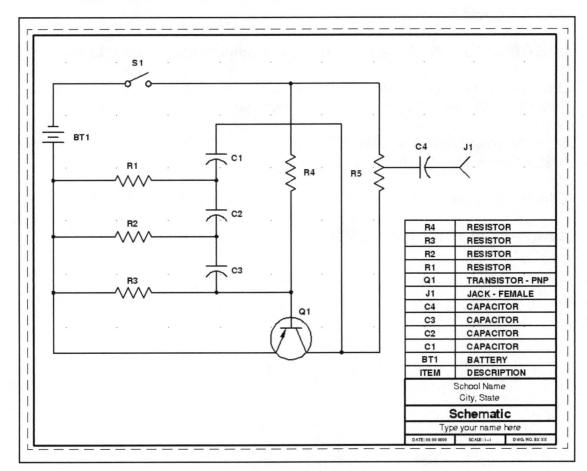

ELECT-11

EX-ELECT-3

INSTRUCTIONS: GRID LAYOUT

Refer to drawing on the next page.

This drawing is only a template. It will be used as a template for the following 4 drawings. If you follow the instructions and draw this template correctly, the next 4 drawings will be very easy.

1. Start a **NEW** file using **My Decimal Setup**

2. Select the **A Size** tab and unlock the viewport.

3. Adjust the Viewport scale to 2 : 1

4. Set: SNAP = .100 GRID = .100

5. Draw the board outline <u>shown on the next page</u> (on layer PCB) Full Scale (2.50 x 2.00).
 (Note: it will appear larger because you set the VP scale to 2 :1)
 Printed Circuit Boards are generally drawn 2, 10 or even 100 times larger than their actual size.

6. Draw the **Circuit** on layer **Circuit.**

7. **INSERT** symbols 19, 28, and 31 on Layer **Components** (Refer to Library)

8. Draw the designators on Layer **DESIGNATOR**.
 Text Ht = .125 (use an annotative text style and set)

9. Draw dimensions on Layer **DIMENSION**.
 (Use an annotative dimension style)

10. **Edit** the title block

11. Save as **EX-ELECT-3 (Do not plot)**

EX-ELECT-3....continued

GRID LAYOUT
Refer to instructions on the previous page.

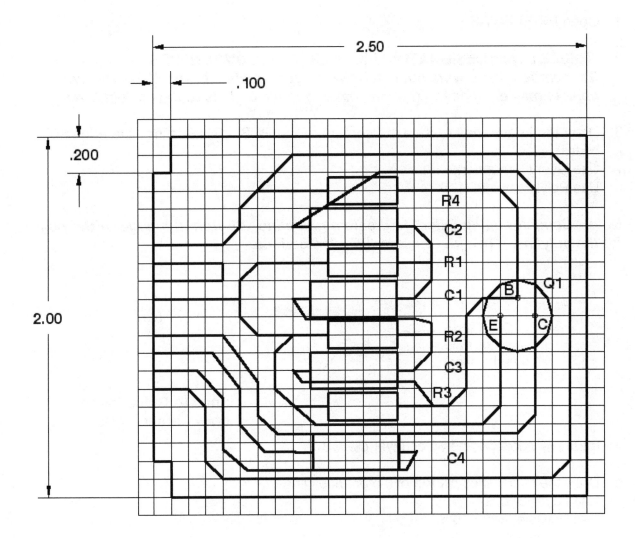

EX-ELECT-4

INSTRUCTIONS: ARTWORK

Refer to the drawing on the next page.

The following is an example of a how you might illustrate the ARTWORK for the circuit on the PCB.

1. Open **EX-ELECT-3**

2. **FREEZE** Layers **DESIGNATOR, DIMENSION** and **COMPONENTS**.
 (Remember, if you were not careful when you created EX-ELECT-3 the wrong objects may disappear. You may have to move objects to the correct layer)

3. Draw the heavy lines outside the corners of the PCB. (This defines the edges of the board)
 Use layer Cornermark.
 Use Polyline, width .100

Note: Consider using Offset to create a guideline, .05 from the edge of the board, for the polyline. Then just snap to the intersections.

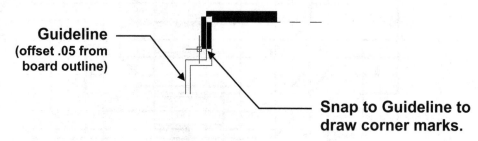

Guideline
(offset .05 from
board outline)

Snap to Guideline to
draw corner marks.

4. **Insert** symbols **34** and **35** on layer **CIRCUIT**.

5. Draw the circuit lines **on top** of the previous lines.
 Use Layer Circuit
 Use Polyline, width .025

6. Turn **OFF** Layer **PCB**.

7. Save as **EX-ELECT-4**

8. **Plot** using Page Setup: **Plot Setup A.**

EX-ELECT-4....continued

ARTWORK
Refer to instructions on the previous page.

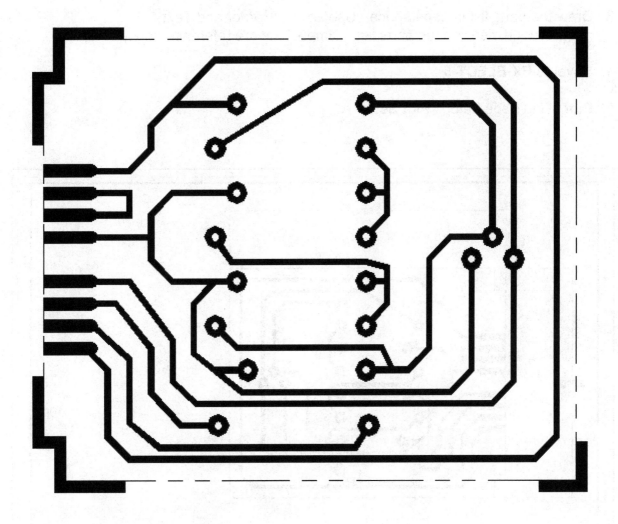

EX-ELECT-5

INSTRUCTIONS: PCB DETAIL

This exercise illustrates how you can create a drawing merely by freezing and thawing existing layers.

1. Open **EX-ELECT-4**

2. **Freeze** layer <u>Cornermark</u> and **thaw** layers <u>PCB</u> and <u>Dimension</u>

3. Draw the parts list in paperspace. Use Layers Border and Text.
 (Do not dimension the parts list. Dimensions are reference only.)

4. Save as **EX-ELECT-5**

5. **Plot** using Page Setup: **Plot Setup A.**

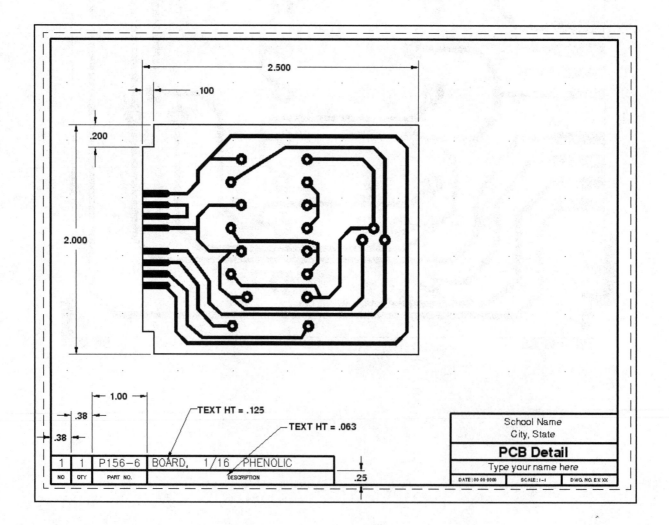

EX-ELECT-6

INSTRUCTIONS: COMPONENT ARTWORK

Refer to the drawing on the next page.

The following is an example of a how you might illustrate the **ARTWORK** for the **COMPONENTS**.

1. Open **EX-ELECT-3**

2. **Freeze** Layer **Dimension**.
 (Remember, if you were not careful when you created EX-ELECT-3 the wrong objects may disappear. You may have to move objects to the correct layer)

3. **MIRROR** the entire board and its components.

WHY? *A printed circuit board has the circuit on one side and the components on the other. We need to show the opposite side of the board to place the components..*

First, lets review the MIRRTEXT command you learned in the Beg. workbook.

 a. At the command line type: **MIRRTEXT <enter>**
 b. Type: **0 <enter>** (0 means OFF, 1 means ON)

The **MIRRTEXT** command controls whether the **TEXT** will mirror or not. It will change positions with the object but you can control the "Right Reading". In this case, we do not want the text to be shown reversed, so we set the **MIRRTEXT** command to "**0**" **OFF**.

4. **ALIGN** the designators.

5. Save as: **EX-ELECT-6**

6. **Plot** using Page Setup: **Plot Setup A.**

EX-ELECT-6....continued

COMPONENT ARTWORK

Refer to instructions on the previous page.

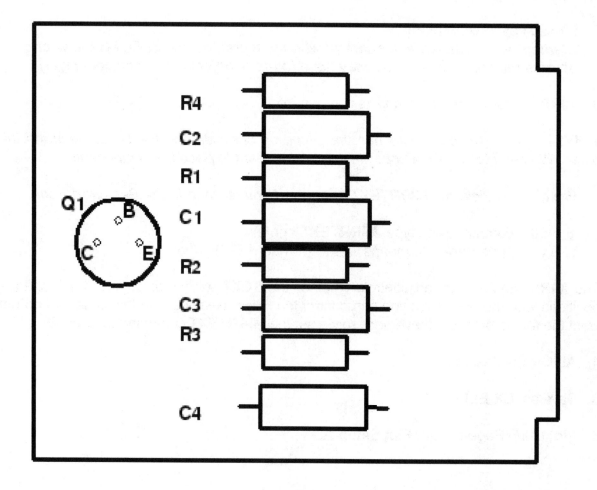

EX-ELECT-7

INSTRUCTIONS: PCB Assembly

1. Open **EX-ELECT-6**

2. Make the modifications to the drawing

3. Add the Parts List in paper space as shown.

4. Save as: **EX-ELECT-7**

5. **Plot** using Page Setup: **Plot Setup A.**

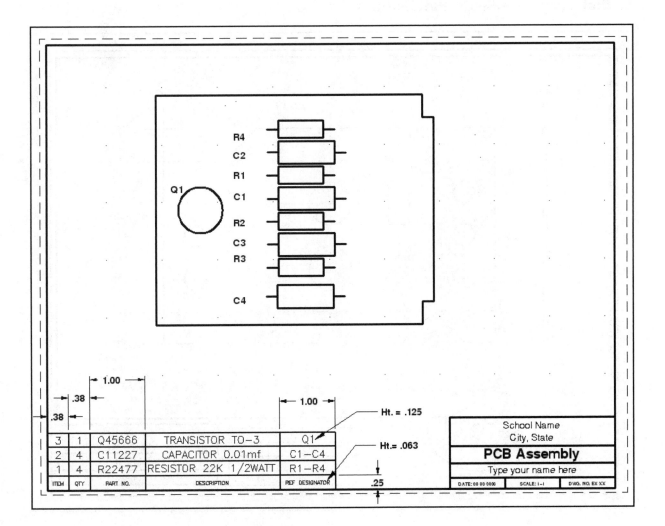

EX-ELECT-8

INSTRUCTIONS: CHASSIS

1. Start a **NEW** file using **My Decimal Setup**

2. Adjust the Viewport Scale to 1 : 1.

3. Draw the **Flat Pattern** and dimension using Ordinate dimensioning as shown.

4. Cut an elliptical Viewport and adjust the scale to 1 : 4.

5. Draw the **Isometric** view to illustrate the **After Forming** appearance.

6. Draw the **Hole Chart** in paperspace. Size is your choice. (Try Tables)

7. Save as: **EX-ELECT-8**

8. **Plot** using Page Setup: **Plot Setup A**

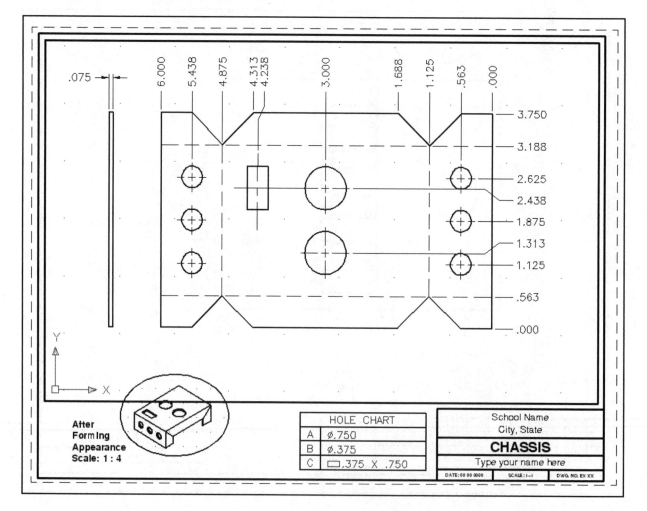

HOLE CHART	
A	⌀.750
B	⌀.375
C	☐.375 X .750

After
Forming
Appearance
Scale: 1 : 4

School Name
City, State
CHASSIS
Type your name here

DATE: 00 00 0000	SCALE: 1-1	DWG. NO. EX XX

MECHANICAL

MECHANICAL SYMBOL LIBRARY

When you are using a CAD system, you should make an effort to ONLY draw an object once. If you have to duplicate the object, use a command such as: Copy, Array, Mirror or Block. Remember, this will make drawing with CAD more efficient.

In the following exercise, you will create two mechanical symbols that you use frequently. You will create them once and then merely drag and drop them, from the DesignCenter, when needed. This will save you many hours in the future.

Save this library file as Library so it will be easy to find when using the DesignCenter or create a Library Palette.

1. Start a **New** file using **My Decimal Setup.dwt**

2. Select the **Model** tab.

3. Draw each of the Symbol objects, shown on the next page, actual size. **Do not scale.**

4. Create an individual Block for each one using the **BLOCK** command.

5. Save this drawing as: **Library**

6. Plot a drawing of your library symbols for reference. The format is your choice.

7. Plot using Page Set up: **Plot Setup A**.

FINISH MARK

NOTE IDENTIFIER

Layer = Symbol
Assign Attributes to the Text

Create a New Border

Before you can work on the following exercises you must first create a new Page Setup and Border for a larger sheet of paper. Follow the instructions below.

<u>PAGE SETUP</u>

A. Start a **NEW** file using: **My Feet-Inches Setup.dwt**

B. Select the **Layout2** tab.

Note: If the "Page Setup Manager" dialog box shown below does not appear automatically, right click on the Layout tab, then select "Page Setup Manager".

Note: Your list may be different. That's OK

C

Yours may be different. That's OK for now

C. Select the **Modify** button.

D. Select **DWF6ePlot.pc3**

E. Select **ARCH C (24.00 x 18.00 Inches)**.

F. Select **Layout**.

G. Plot Offset **0**

H. Select the **OK** button.

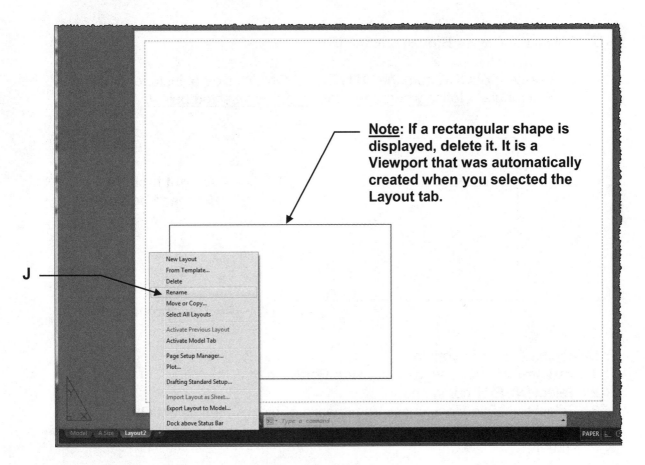

I. Select the **Close** button.

You should now have a sheet of paper displayed on the screen.
This sheet is the size you specified in the "**Page Setup**".
This sheet is in front of the drawing that is in Model Space.
The dashed line represents the printing limits for the device that you selected.

Note: If a rectangular shape is displayed, delete it. It is a Viewport that was automatically created when you selected the Layout tab.

J. Right click on the Layout tab and select **Rename**.

K. Type the new name: **C Size** then press **<enter>**

L. Now we need to draw a new larger RECTANGLE, shown below, to fit on the larger sheet of paper shown on the screen. (Use Layer = Border line)

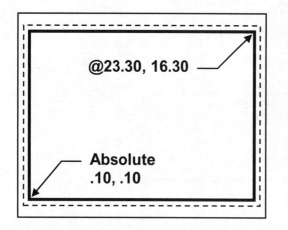

@23.30, 16.30

Absolute
.10, .10

Now, you do not want to draw the A-Size title block all over again. The next step is to create a block from the A-Size title block and then insert it into this layout. This is how thinking ahead saves you time.

M. Select the "**A Size**" Layout tab.

 1. You need to be in "Paper Space".
 2. Select the **Create Block** command.

 a. Create a BLOCK from the "Title Block" ONLY. Do not include the Border Rectangle. <u>Notice where the "Basepoint" is selected below</u>.

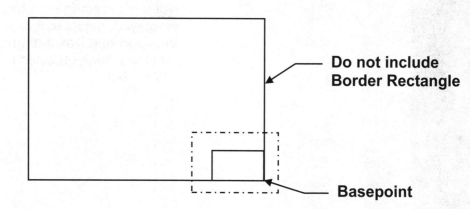

Do not include
Border Rectangle

Basepoint

N. Select the **C Size** Layout tab.
 1. **Very important:** Change to Layer = Borderline.
 2. Select **INSERT** command
 3. Select the "Title block" block from the list of blocks then select **OK**.
 4. Insertion Point should be the lower right corner of the Border Rectangle on the screen.

Do not scale the inserted Block. It may look smaller because the border rectangle is larger than the previous border, but the title block is the same size it was in the A Size layout.

O. Create a Viewport approximately as shown below. (Use Layer Viewport)

P. Save as: **My Decimal Setup.dwt**

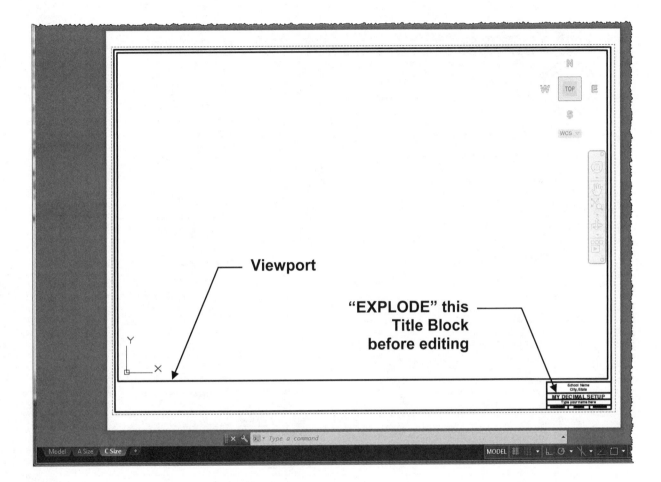

Now you have 2 master layout borders. One to be used when plotting on a sheet size 8-1/2" x 11" and one to be used when plotting on a sheet size 24" x 18". But you are not quite done yet. Next you need to set the plotting instructions. Continue on to next page.....

Q. Create new **Plot Page Setup**.
1. Select **Plot**
2. Change the settings to match settings shown below:

R. **ADD** a page setup name: **Plot Setup C**

S. **Apply to Layout**

T. Select **Cancel** (This closes the dialog box but your settings are still saved)

U. Save again: **My Decimal Setup.dwt**

Now you are ready to do the Exercises.

How to make a space in a dimension

When inserting geometric dimensioning symbols in a dimension you need to make a space in the dimension line.

Example:

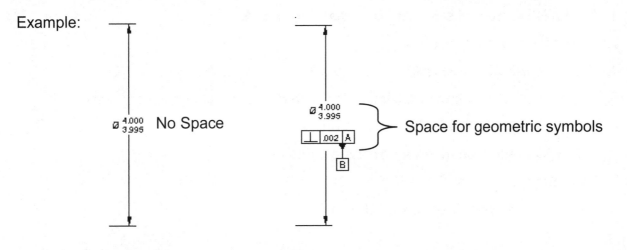

No Space

Space for geometric symbols

1. Place a linear dimension like you normally would.

2. Left click on the dimension and then right click and select **Properties**

3. Scroll down to: **Text** category and **Text Override**

Text	
Fill color	None
Fractional type	Horizontal
Text color	ByBlock
Text height	.125
Text offset	.060
Text outside align	Off
Text pos hor	Centered
Text pos vert	Centered
Text style	TEXT-CLASSIC
Text inside align	Off
Text position X	1.074
Text position Y	5.586
Text rotation	0
Text view direction	Left-to-Right
Measurement	4.000
Text override	

4. Type **<>** and the **\P** for every space you would like to enter. **<>** represents the

 Associative dimension. *(Note: the P must be uppercase)*

 Example: For the dimension above it would look like this:

<> represents the dimension and \P\P\P means 3 vertical spaces

EX-MECH-1

INSTRUCTIONS:

1. Start a **NEW** file and select **My Decimal Setup.dwt**

2. Select the **C Size** layout tab

4. Draw the **ECCENTRIC HUB** shown below.

5. Use Layers **Object line** and **Dimension** with geometric dimensions. (Lesson 12)

6. Refer to page Mech-9 for instructions on:

 "How to make a space in a dimension line".

7. **Save** the drawing as: **EX-MECH-1**

8. Plot using Plot page Setup: **Plot Setup C**

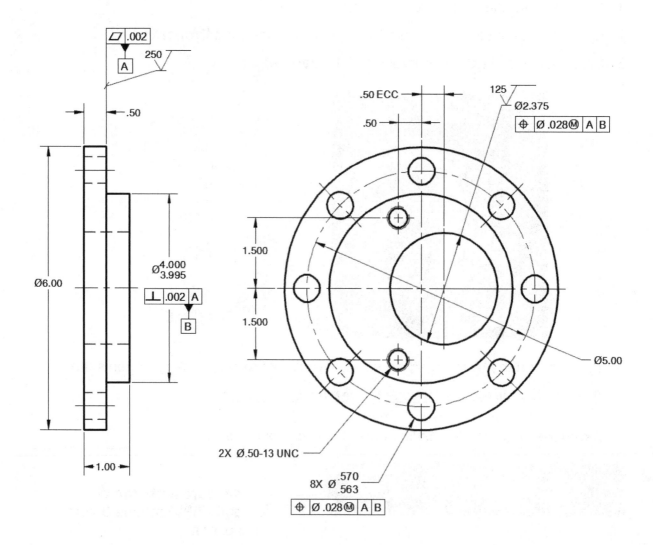

EX-MECH-2

INSTRUCTIONS:

1. Start a **NEW** file and select **My Decimal Setup.dwt**
2. Select the **C Size** layout tab
4. Draw the **SPLINE HUB** shown below.
5. Use Layers **Object line, Hatch, Hidden line, Center line** and **Dimension**
6. Refer to page Mech-9 for instructions on:

 "How to make a space in a dimension line".
7. **Save** the drawing as: **EX-MECH-2**
8. Plot using Plot page Setup: **Plot Setup C**

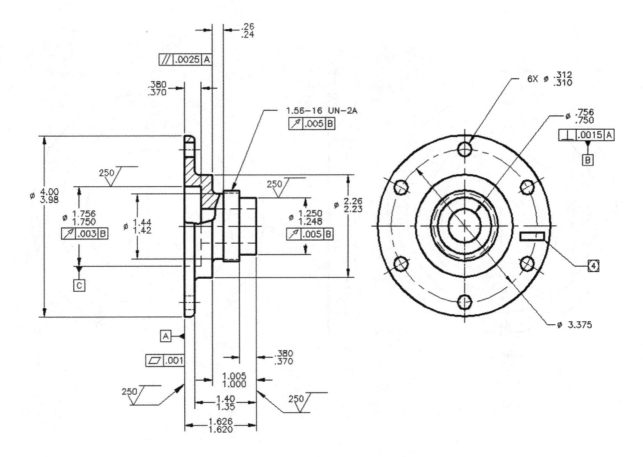

EX-MECH-3

INSTRUCTIONS:

1. Start a **NEW** file and select **My Decimal Setup.dwt**
2. Select the **C Size** layout tab
4. Draw the **Guide Ring** shown below.
5. Use Layers **Object line, Hatch, Hidden line, Center line** and **Dimension**
6. **Save** the drawing as: **EX-MECH-3**
7. Plot using Plot page Setup: **Plot Setup C**

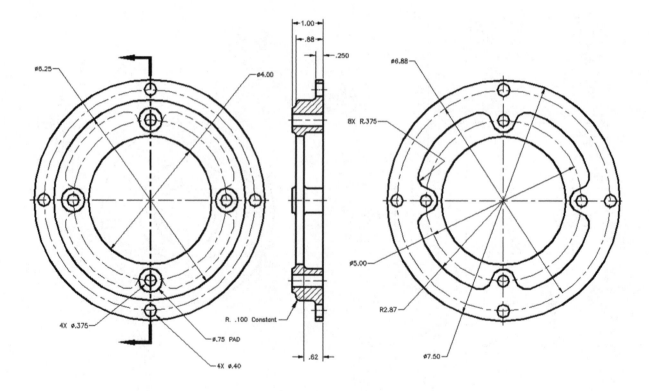

APPENDIX A
Add a Printer / Plotter

The following are step-by-step instructions on how to configure AutoCAD for your printer or plotter. These instructions assume you are a single system user. If you are networked or need more detailed information, please refer to your AutoCAD Help Index.

Note: You can configure AutoCAD for multiple printers. Configuring a printer makes it possible for AutoCAD to display the printing parameters for that printer.

A. Type: **Plottermanager <enter>**

B. Select **"Add-a-Plotter"** Wizard

 Add-A-Plotter Wizard
Shortcut
1.20 KB

C. Select the **"Next"** button.

D. Select **"My Computer"** then **Next**.

E. Select the **Manufacturer** and the specific **Model** desired then N**ext**.

(If you have a disk with the specific driver information, put the disk in the disk drive and select "Have disk" button then follow instructions.)

E

F. Select the **"Next"** box.

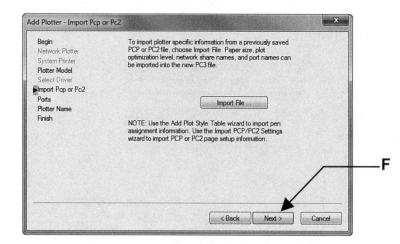

F

G1. Select **"Plot to a port"**.
G2. Then select **"Next"**.

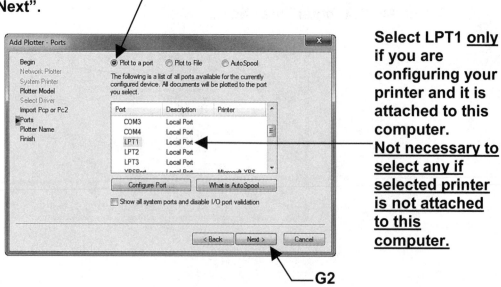

G1

G2

Select LPT1 <u>only</u> if you are configuring your printer and it is attached to this computer. <u>Not necessary to select any if selected printer is not attached to this computer.</u>

H. The Printer name that you previously selected should appear.
Then select **"Next"**

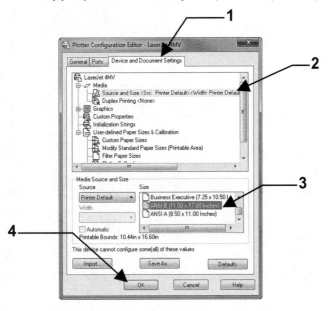

I. Select the **"Edit Plotter Configuration..."** box.

J. Select:
1. Device and Document Settings tab.
2. Media: Source and Size
3. Size: (Select the appropriate size for your printer / plotter)
4. OK box.

K. Select **"Finish"**.

L. Type: **Plottermanager \<enter\>** again.

Is the printer / plotter there?

LaserJet 4MV.pc3
AutoCAD Plotter Configuration File
1.07 KB

The new configured printer should
be in the list of printers.

APPENDIX B – AUTODESK 360 CONNECTIVITY

Autodesk® 360 is a set of secure online servers that you can use to store, retrieve, organize, and share drawings and other documents.

Over the next few pages the Autodesk 360 "documents" will be discussed.
Use this service to store your design documents in the cloud, so you can access them anytime, anywhere and easily share them with colleagues, clients and other users. Viewing capabilities enable users to open and review 2D and 3D DWF files through a web browser, without the design software used to create the files. 5 GB of storage space is available for free. Autodesk subscription customers receive 25 GB of storage space for each seat of software on Subscription for the duration of their Subscription contract term.

In AutoCAD 2015 you can connect directly to the Autodesk 360 for online file sharing, customized file syncing and more. You can sign into the Autodesk 360 from the InfoCenter toolbar using your Autodesk single Sign-In account. If you do not yet have an account, you can create one.

After signing in, your user name is displayed and additional tools are displayed in the drop-down menu including the option to sync your settings with Autodesk 360, specify online options, access Autodesk 360 documents, sign out, and manage account settings. You may access the Autodesk 360 in various ways. Here are a few examples.

Autodesk 360 tab/
Online Files panel/
Open Autodesk 360

New Tab Page/ Create Page/ Connect

Save As or Open dialog boxes

Continued on the next page...

How to save a file to Autodesk 360

1. Select the **Application Menu**

2. Select **Save As** ▶

3. Select **Drawing to the Cloud**

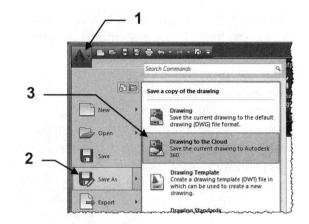

The **Account Sign In** box should appear.

4. If you have not previously created an account select **Need an Autodesk ID?**

 If you have already created an account skip to 8.

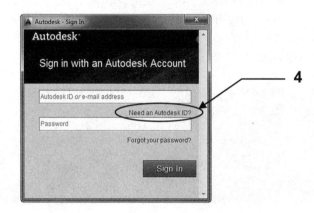

The **Create Account** box should appear.

5. Fill in the boxes

6. Select **Create Account** and then sign in.

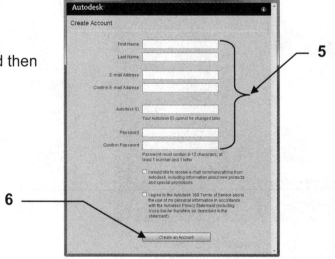

Continued on the next page...

How to save a file to Autodesk 360....continued

The <u>first time</u> you access the Autodesk 360, you have the opportunity to specify default Autodesk 360 settings. You may modify these selections later using the **Autodesk 360 ribbon tab.**

7. Make your selections then select **OK.**

Click here to learn more about the settings

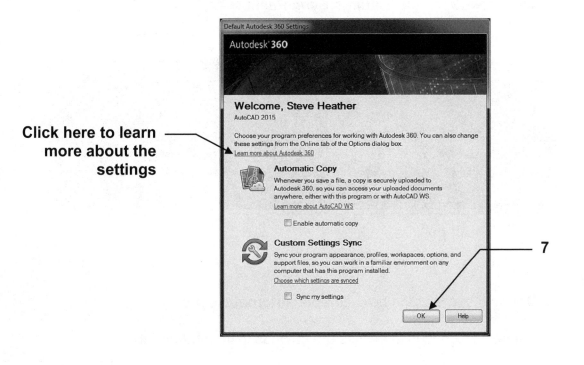

8. Enter the file name

9. Select **Save** button.

Notice "Autodesk 360" Account

Notice "Autodesk 360" directory selected

How to save a file to Autodesk 360 automatically

You may set AutoCAD to automatically save the file to the Autodesk 360 every time you save a file.

1. Select the **Autodesk 360** tab.

2. Select the arrow ⬎ on the **Settings Sync** Panel.

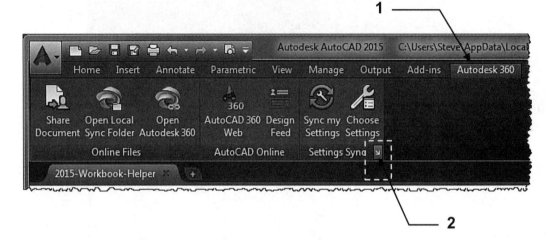

3. In the **Online** tab, check the box: **Enable automatic sync**.

Note: You must be signed in to access the settings in the **Online** tab.

How to Open a file from Autodesk 360

1. Select **Open**

2. Select the **Autodesk 360** directory

3. Select the **file** to open.

4. Select the **Open** button.

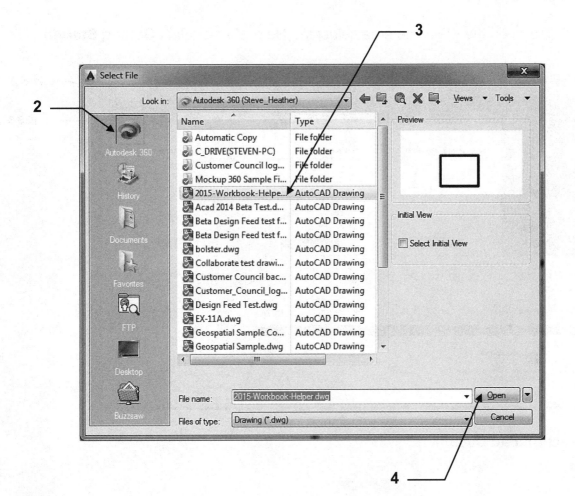

How to Upload a document to Autodesk 360

You may **upload** your files to the Autodesk 360 to share with others.

1. Select the **Autodesk 360 tab / Online Files panel / Open Autodesk 360**

 The Welcome area allows you to browse some of the options and view a video. This area can be temporarily closed by selecting the Close button in the upper right corner.

 To re-open the Welcome area select the Help ▼ and select **Getting Started.**

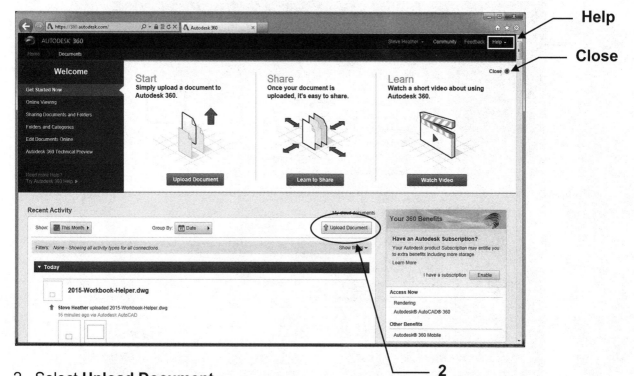

2. Select **Upload Document**

3. Select **Select Documents**

Continued on the next page...

How to Upload to Autodesk 360....continued

4. Locate the file to upload and select **open**

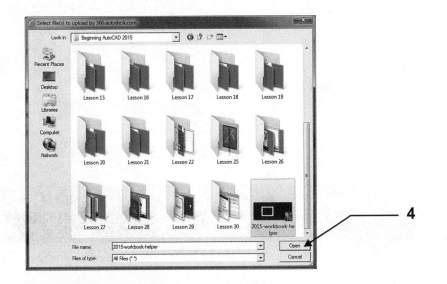

5. Select **Upload Now**

The uploaded document appears in the **My Cloud Documents** area

How to Delete an Uploaded document

How to Delete an uploaded file from My Cloud Documents

1. Select the document to be deleted

2. Select **Actions ▼**

3. Select **Delete** from the drop-down menu

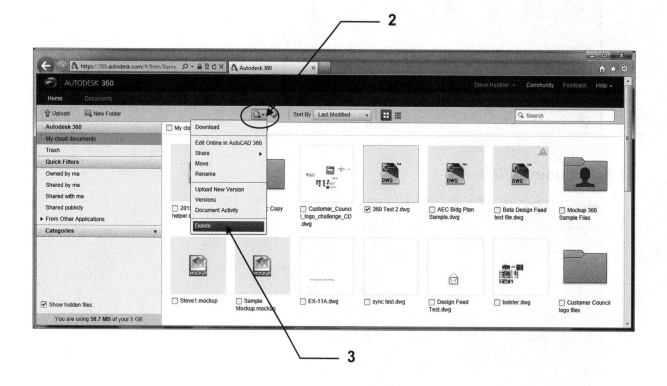

Note: You can also right-click on the document to access the same menu.

How to Download from Autodesk 360

1. Select the **Autodesk 360 tab / Online Files panel / Open Autodesk 360**

2. Select the document to download

3. Select **Download** from the **Actions** drop-down menu.

4. Depending on your internet browser, select **Open**

Do you want to open or save **bolster.dwg** (108 KB) from **api.autodesk.com**? Open Save ▼ Cancel ×

5.

If asked select **Allow**

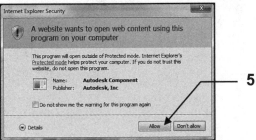

The document should have opened on to the AutoCAD screen. You may view, edit, print, save etc. You may place documents in the Autodesk 360 for others to download.

Autodesk 360 Design Feed Palette

The Design Feed palette allows you to enter text messages and attach images which can then be shared online with other users who are sharing your document. You can also use the Design Feed palette to post messages and images on a document that is shared with you by another user.

You can associate a message to an area in the drawing by using a location pin or by specifying a rectangular area.

To use the Design Feed palette you must first save the drawing to the Autodesk 360, you can then tag colleagues to be included in the discussion.

To open the Design Feed palette.

Ribbon = Autodesk 360 tab / AutoCAD Online panel / Design Feed
or
Keyboard = designfeedopen <enter>

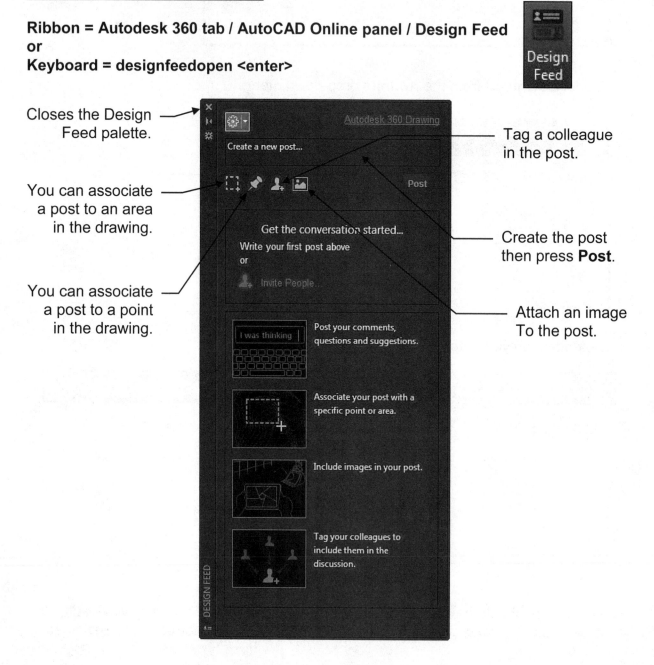

Closes the Design Feed palette.

You can associate a post to an area in the drawing.

You can associate a post to a point in the drawing.

Tag a colleague in the post.

Create the post then press **Post**.

Attach an image To the post.

How to tag a colleague in the Design Feed

You can tag as many people as you want to the Design Feed posts within your document, they will need to have access to AutoCAD or to the online AutoCAD 360. When you tag a colleague to a post they will be notified by e-mail.

To tag a colleague in the Design Feed.

1. In the Design Feed palette, select the **Tag in this post** command.

2. Select **+ Add People**.

3. Enter the e-mail address of the colleague to be tagged.

4. Click on **Add**.

5. Select **Save & Invite**.

Continued on the next page...

Appendix-B11

How to tag a colleague in the Design Feed....continued

After you have selected **Save & Invite**, the **Invite Sent** confirmation dialog box appears informing you that an E-mail invitation has been sent to the colleague to be tagged, also known as Connections. Select **OK** to finish.

Select **OK** to close
the dialog box.

A typical e-mail notification that is sent informing a colleague of being tagged in a Design Feed post is shown below.

Clicking on the link will take the tagged
colleague directly to the document at
their Autodesk 360 account.

APPENDIX C – COMMAND LINE ENHANCEMENTS

The Command Line in AutoCAD has been extensively modified to further assist the user in searching for commands.

AutoCorrect

If you mistyped a command in versions prior to AutoCAD 2014, the system would respond with "Unknown command". AutoCAD will now AutoCorrect to the most relevant command.

In the example below, if you entered **CIRKLE**, the system will respond with **CIRCLE**, and any other commands that contain the word **CIRCLE**.

Command Line entry **Dynamic Input entry**

AutoCAD also has an **AutoCorrect List** which is stored in the system, if you mistype a command three times or more, that mistyped command will be stored in the **AutoCorrect List** along with the correct spelling of the command.

You can access the AutoCorrect List by selecting:

Ribbon = Manage tab / Customization panel / Edit Aliases ▼ / Edit AutoCorrect List

An example of the **AutoCorrect List** is shown below with two commands that have been mistyped, and with their correct spelling.

AutoComplete

The AutoComplete in AutoCAD has been further enhanced and now supports mid-string searches. In versions prior to AutoCAD 2014 the AutoComplete only displayed command suggestions beginning with the word you entered, it will now display command suggestions with the word you enter, anywhere within it.

In the example below, if you enter **SETTINGS**, AutoComplete will respond with various suggestions with the word **SETTINGS** anywhere within a command

Command Line entry **Dynamic Input entry**

Adaptive Suggestions

When you first use AutoCAD 2015, commands in the suggestion list are displayed in the order of usage which is based on general customer data. As you use AutoCAD more and more, the commands will be displayed according to your usage, it adapts to your way of working, showing the commands you use most frequently in the suggestion list.

Synonym Suggestions

The command line in AutoCAD 2015 has a built in Synonym list. When you enter a word at the command line, AutoCAD returns a command if it can match it in the synonym list.

For example, if you enter **BREAKUP** at the command line, AutoCAD will return the command **EXPLODE**. Or if you want to type a paragraph of text and enter the word **PARAGRAPH** at the command line, AutoCAD will return the command **MTEXT**.

You can add your own synonym's to the list which can be accessed by selecting:

Ribbon = Manage tab / Customization panel / Edit Aliases ▼ / Edit Synonym List

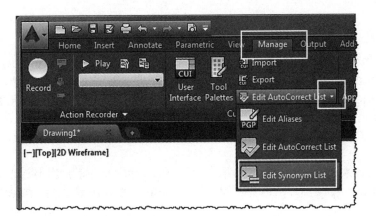

Internet Search

AutoCAD 2015 now allows you to search for more information on a command that is displayed in the suggestion list. If you move the mouse cursor over a command in the list, it will display a **Search on Internet** icon and a **Search in Help** icon.

You can click on either of these two options to get extended help on the command you entered. So for example, if you type in **ARRAY** at the command line and choose the **Search on Internet** option, your current internet browser will open and show internet suggestions for **AutoCAD ARRAY**.

Whichever command you choose to search for help on the internet, the word **AutoCAD** will always precede it. An example of the search and help icons is shown below.

Search in Help **Search on Internet**

ARRAY	⑦ ⊕
ARRAYRECT	
ARRAYPOLAR	
ARRAYPATH	
ARRAYEDIT	
ARRAYCLASSIC	
ARRAYCLOSE	
ARRAYEDITSTATE	+

✕ ⚙ ＞_ ▾ ARRAY ▲

Content

The Command Line in AutoCAD 2015 also allows you to quickly access layers, blocks, hatch patterns/gradients, text styles, dimension styles and visual styles. For example, if you have a drawing open that has block definitions with the name **DOOR**, and you enter **DOOR** at the command line, the suggestion list will display all the blocks with that name in it, so you could then insert that block directly from the command line.

The example below shows the command line suggestion list with block definitions of **DOOR**, you would simply click on the block you needed, and then insert it into your drawing.

Click on the block you require to insert it into your drawing

DOR (DIMORDINATE)	+
Block: DOOR 1	
Block: DOOR 2	
Layer: DOORS	

✕ ⚙ ＞_ ▾ DOOR ▲

Categories

The command line suggestion list is made easier to navigate by organizing commands and system variables into categories. To see the results you can expand the category by clicking on the **+** sign, or you can press the **Tab** key to cycle through each category.

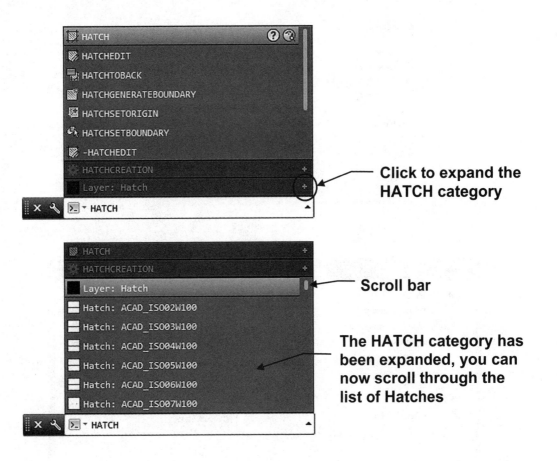

Click to expand the HATCH category

Scroll bar

The HATCH category has been expanded, you can now scroll through the list of Hatches

Input Settings

You can choose to turn on or off any of the new command line features by right-clicking on the command line and selecting **Input Settings**, you can choose between **AutoComplete**, **AutoCorrect**, **Search System Variables**, **Search Content**, and **Mid-string Search**.

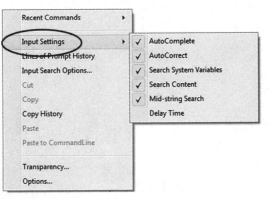

In addition to the **Input Settings**, you can further refine the settings by right-clicking on the command line and selecting **Input Search Options**. This will open the **Input Search Options** dialog box where you can change settings like the amount of times you can mistype a command before it gets entered into the **AutoCorrect List**.

Select to open up the Input Search Options Dialog box

INDEX

W

X

Z